Cult British TV comedy

MANCHESTER
1824

Manchester University Press

Cult British TV comedy:

From Reeves and Mortimer to *Psychoville*

Leon Hunt

Manchester University Press
Manchester and New York

distributed in the United States exclusively
by Palgrave Macmillan

Published by Manchester University Press
Oxford Road, Manchester M13 9NR, UK
and Room 400, 175 Fifth Avenue, New York, NY 10010, USA
www.manchesteruniversitypress.co.uk

Distributed in the United States exclusively by
Palgrave Macmillan, 175 Fifth Avenue, New York,
NY 10010, USA

Distributed in Canada exclusively by
UBC Press, University of British Columbia, 2029 West Mall,
Vancouver, BC, Canada V6T 1Z2

British Library Cataloguing-in-Publication Data
A catalogue record for this book is available from the British Library

Library of Congress Cataloging-in-Publication Data applied for

ISBN 978 0 7190 8377 8 hardback

First published 2013

The publisher has no responsibility for the persistence or accuracy of URLs for any external or third-party internet websites referred to in this book, and does not guarantee that any content on such websites is, or will remain, accurate or appropriate.

Typeset
by Action Publishing Technology Ltd, Gloucester
Printed in Great Britain
by T J International Ltd, Padstow

Contents

Acknowledgements

The following people read versions of some or all of the chapters in this book and offered feedback and/or encouragement: Susy Campanale, Milly Williamson, Tim Miles, Chris Ritchie, Sarah Harman and the anonymous reader of the manuscript. Chapter 2 was presented as a keynote at the Salford Comedy Conference in 2011 – I would like to thank Chris Lee for inviting me and to all those in attendance who offered helpful and confidence-boosting feedback. Sam Friedman kindly shared with me a copy of his essay on comedy and distinction prior to publication. I would not have been able to complete this book without Study Leave at Brunel University – many thanks to William Leahy in the School of Arts. And finally thanks to Matthew Frost and Manchester University Press for their support and patience because I (and they) had anticipated the manuscript being completed about a year earlier than it was. As it turned out, that year proved to be an interesting one for British comedy – no chapter was updated quite as much as the one on offence – so I hope that provided some compensation.

Preface

This book examines a range of 'cult' British TV comedy from 1990 to the present. Why have I taken the early 1990s as my starting point? The subtitle of Ben Thompson's *Sunshine on Putty* (2004), the only book to look at the 'post-alternative' scene in any detail, characterizes the period from 1990 to 2002 as the 'Golden Age of British Comedy'. Its best programmes, he claims, 'not only stand comparison with, but actually *overshadow* the small-screen landmarks of any previous era' (2004: xii). Such value judgements are always invitations to be challenged – Mark Lewisohn, for example, refers to the 1990s as being 'generally barren'.[1] But whatever one's tastes in comedy, there are good reasons for seeing this period as, if not *the* then certainly *a*, 'Golden Age'. It produced the best work of Vic Reeves and Bob Mortimer and some of Chris Morris's most controversial comedy, as well as *The League of Gentlemen* (BBC 2 1999–2002), *Father Ted* (Channel 4 1995–98) and *The Office* (BBC 2/BBC 1 2001–2, 2003). If we move beyond Thompson's cut-off point, we might also add *Little Britain* (BBC 3/BBC 2/BBC 1 2003–8), *Nighty Night* (BBC 3 2004–5), *Peep Show* (Channel 4 2003–), *The Mighty Boosh* (BBC 3/BBC 2 2004–7), *Psychoville* (BBC 2 2009–11), *Stewart Lee's Comedy Vehicle* (BBC 2 2009–) and *Limmy's Show* (BBC Scotland 2010–), amongst others. This period has been characterized as the 'post-alternative' era of British comedy, differentiating it from the performers (Rik Mayall and Adrian Edmondson, Alexei Sayle, French and Saunders, Ben Elton) and programmes (*The Comic Strip Presents*, *The Young Ones*) seen to comprise the alternative comedy of the 1980s.

This is the first sustained critical analysis of one of the richest periods in British TV comedy history. Thompson's book provides an invaluable overview of the period up to 2004, but while I am wary of polarizing academic and journalistic writing (which have more in common than tends to be acknowledged), his approach is very different from the one adopted here, often drawing on interviews and reviews that originally appeared in the *Guardian*. Academic writing, on the other hand, has been very selective in its coverage of the period, prioritizing sitcom and satire over other forms of TV comedy and visibly drawn to individual shows that serve current scholarly debates (*The Office* and the work of Chris Morris, for example). To say that there are some gaps to be filled would be something of an understatement.

This book is selective, too, of course. It emphasizes 'cult' over 'mainstream' comedy,[2] for one thing – however precarious, and even arbitrary, that distinction might be. Selectiveness is inevitable when examining over twenty years of TV, and when it comes to comedy, matters of taste intrude too. While I don't think it is necessary to find comedy funny in order to analyse it, it is certainly easier if it provokes some kind of reaction. Many of my favourites are here – *The League of Gentlemen* and *Psychoville*, Reeves and Mortimer, Stewart Lee, *Father Ted*, *The Mighty Boosh* and *The Fast Show*. After reading the chapter on offence, I don't think the reader will be surprised to learn that I am not an admirer of Frankie Boyle, but I cannot deny that he has captured my attention – for all sorts of reasons, he is certainly an interesting, and possibly even important, figure in recent comic history and one that it would be difficult to be indifferent to. I have neglected some 'important' shows – like *The Royle Family* – that I admire without feeling that I had much to add to existing critical accounts of them. At the same time, while *The Office* has not lacked critical or scholarly attention, it was too central to my discussion of 'cringe comedy' to leave out. Others simply slipped through the net because other shows allowed me to make much the same arguments that I might have made about them. But mostly, I have paid particular attention to series and creators who seem to me to have been (often mystifyingly) overlooked by academic studies of

comedy. Such a book is fated to provoke cries of 'What about (insert name of show)?' but my aim was never to be exhaustive in my coverage. Chapter 1 maps out the terrain of post-alternative comedy and places it in a number of contexts. Firstly, it locates it within the history of British comedy and the shifts brought about by emerging comic 'generations' or 'waves' after the Second World War. It also positions post-alternative TV comedy within debates about 'cult' and 'quality' TV. Thirdly, it maps out some of the cultural and institutional contexts against which the post-alternative era played out. Chapter 2 turns to the career of Vic Reeves and Bob Mortimer, in some ways as important to the 1990s as *Monty Python* was to the 1970s and *The Young Ones* was to the 1980s – my focus is particularly on their reinvention of variety and light entertainment and their relationship to a tradition of so-called 'surreal' British comedy, as well as their relationship to an art/pop tradition (thus their being cited as evidence of comedy being 'the new rock'n'roll'). Vic and Bob are neglected figures in academic work on comedy, in contrast with their standing in fan and cult circles. Chapter 3 focuses on the sitcom work of Graham Linehan, a similarly marginalized figure – as co-writer of *Father Ted*, and the first series of *Black Books* and *Big Train*, writer of *The IT Crowd* and sometime contributor to projects involving Chris Morris and others, he is an important comic talent. Linehan's career offers an interesting insight into some of the shifts and tensions in TV comedy during this period – between 'dark' and 'silly' comedy, between the studio and the single-camera sitcom – and an interesting case study in comedy authorship. Chapter 4 looks at a specific sub-genre (or format) of TV comedy, the sketch show. While the sitcom underwent some significant aesthetic changes during this period, the sketch show did not undergo quite the same upheavals. But there would be some interesting developments in the form – *The Fast Show* accelerated the pace of the form while generating a plethora of running characters and catch-phrases but also contained unexpected tonal shifts (the pathos of Ted and Ralph), *The League of Gentlemen* would locate its characters in a single town and inject increasing levels of seriality into the sketch show, and *Big Train* (BBC 2 1998, 2002) would

play off a tension between the naturalistic and the surreal. The period would also produce *Little Britain* – simultaneously a huge crossover success and a growing source of controversy – which is also discussed in the chapter. Chapter 5 focuses on the affective relations mediated through two types of sound in TV comedy – the simulated 'liveness' and community of recorded laughter and the imaginary intimacy created by a DVD commentary. But the comedy commentary at its best doesn't just offer mediated 'friendship' – it can also offer a subsidiary and more spontaneous comic performance. The chapter looks at the debates surrounding the use of recorded laughter as well as textual examples of series that use live studio audiences (recorded either during filming or during playback). It also looks at a range of DVD commentaries, including those of Graham Linehan, the League of Gentlemen, Limmy/Brian Limond and the Garth Marenghi team. Chapter 6 takes as its starting point one of the defining features Umberto Eco identifies in the cult text, namely the creation of 'a completely furnished world' (1987: 198). In terms of cult TV, this applies more obviously to telefantasy than the relatively small domestic and work-related settings of much TV comedy. However, heightened televisuality (distinctive 'looks', rich production design) and the 'thickening' of TV texts via DVD extras and the multi-platforming of TV shows has allowed some shows to expand their world through design detail, intertextuality and online materials. The 'worlds' examined in the chapter include the 'nerd-scape' of *Spaced* and *Garth Marenghi's Darkplace* and the fantastical 'retro-scape' of *The Mighty Boosh* as well as the transmedia extended world that *Psychoville* offered in its online materials. The final two chapters look at how comedy negotiates ostensibly 'unpleasurable' sensations – intense embarrassment, bleakness, disturbing or potentially offensive material. Chapter 7 looks at two categories of 'uncomfortable comedy' – 'dark' and 'cringe' comedy – which it contextualizes within discourses of 'black', 'sick' and grotesque humour. Series discussed include *I'm Alan Partridge*, *The Office* and *Peep Show* in the category of 'cringe comedy', with *The League of Gentlemen*, *Psychoville*, *Jam* and *Nighty Night* taking us to the darker edges of TV comedy. The final chapter revisits a recurring issue in studies of comedy

– that of 'offensiveness'. Cult or 'edgy' comedy is often expected to probe the boundaries of taste while at the same time distinguishing itself from comedy that simply reinforces bigotry and hatred – some comedians, like Jerry Sadowitz, have made a career out of blurring the line between 'good' and 'bad' offence. But 'offence' also needs to be contextualized and so I will also look at two key 'moments' – the furore surrounding the generally well-regarded *Brass Eye* and the rather less clearcut ethical questions raised by 'Sachsgate' and its aftermath. As comedians like Frankie Boyle and Jimmy Carr provoked further outrage in the media, the question of offence, its legitimacy and acceptable boundaries, came increasingly to the fore. A topic that I originally saw as a sub-section of the chapter on dark/cringe comedy grew into the chapter that most needed periodic updates. At the time of writing, Ricky Gervais's sitcom *Derek* (Channel 4) – focusing on a character Gervais claims is not mentally disabled – is about to debut. It follows the controversy of his poorly received *Life is Short* (BBC 2 2011), with dwarf actor Warwick Davis playing himself, and the storm that raged around Gervais's use of the word 'mong' on the social networking site Twitter. The 'offence' debate will undoubtedly change in its reference points but I suspect that for the immediate future the ethical questions will remain those examined in my final chapter – on the one hand, freedom of speech and comedy's 'right to offend', on the other hand, the tendency towards comic bullying and playing either the 'irony' or 'only a joke' card in defence.

Notes

1 An eccentric judgement, given that he praises the usual suspects from that era – *The League of Gentlemen*, *Father Ted*, *The Royle Family*, *Spaced*, Reeves and Mortimer etc.

2 With BBC 1's ratings/audience appreciation success *Mrs Brown's Boys* (2011–), 'mainstream' comedy is back with a fascinating vengeance, to the consternation of critics and all those who thought that the British comedy wars had been won by the university-educated middle classes.

1

From alternative to cult: mapping post-alternative comedy

Putting the 'post' into 'alternative'

What is 'post-alternative comedy'? The 'post-' prefix sometimes signifies an opposition to the term it transforms (as in some versions of post-feminism), but can also imply a more complex relationship, a continuation as well as a break. There is a version of the post-alternative that hinges on a caricaturing of the alternative comedy of the 1980s as self-righteous, 'politically correct' at the expense of being funny – the *New Musical Express*, for example, judged Reeves and Mortimer to be a 'blessed relief' from 'a decade of ear-bashings about dole-queues and diaphragms' (Kelly 1990: 14), while Graham Linehan would characterize 1980s comedy as 'violently bad, po-faced and bludgeoning' (quoted by Rampton 1998: 10). Certainly, some post-alternative comedy has been seen as a backlash against 'political correctness' – in tune with the 'new lad' culture of the 1990s or the 'ironic incorrectness' underpinning some of the humour examined later in the chapter on offence. Perhaps a more significant shift was the rehabilitation of comedy's roots in variety, music hall and light entertainment – the former 'mainstream' that alternative comedy ridiculed for its alleged bland cosiness or reactionary politics, now revisited and reinvented. But there are continuities, too, between the two eras and I will return to this relationship shortly. What the alternative and the post-alternative share is some sense of opposition to a 'mainstream' – however that term might be imagined. With that in mind, my approach here is driven by the proposition that

'alternative' and 'post-alternative' comedy on TV can be seen as both categories of 'quality TV' (niche-oriented, requiring some kind of cultural capital) and cult TV (positioned in relation to an increasingly slippery 'mainstream').

Roger Wilmut, writing before alternative comedy had really impacted on television, identifies three waves of British comedians in the twentieth century. The first, dominant up to the Second World War but still a significant TV presence well into the 1980s, grew out of music hall and variety (1980: xvii). The second is what he calls the 'NAAFI comedians' (*ibid.*), which included Spike Milligan, Peter Sellers, Tony Hancock and others. The NAAFI comics signify an important shift in British comedy. According to Harry Secombe, they were 'more educated ... they brought a fresh approach to the whole thing' (Wilmut 1985: 156). *The Goon Show* (BBC Home Service 1951–60) is frequently positioned as the progenitor of a tradition of surreal, cultish broadcast comedy that delighted a core audience while frequently mystifying or alienating others who didn't 'get' it. Neale and Krutnik credit NAAFI comedians like Milligan (in particular) and Sellers with starting to deconstruct the conventions of traditional variety comedy (1990: 206). The third wave is what Wilmut calls the 'university comedians' (1980: xvii) – the 'Oxbridge Mafia' (*Ibid.*: xxii) would fuel both the 'satire boom' of the 1960s and the continuation of surreal British comedy via *Monty Python's Flying Circus* (BBC 2 1969–74). Neale and Krutnik suggest that there was also a significant transformation in the audience for comedy during this period. The expansion of higher education created a niche but loyal audience for 'clever' comedy that required a degree of cultural capital to enjoy the humour – *Monty Python*'s audience was 'a cult audience ... and relatively young' (1990: 207).

The twentieth century would arguably produce two further 'waves', the last of which has carried into the first part of the twenty-first. Peter Richardson would describe the *Comic Strip* performers and writers, rather disingenuously, as 'intelligent comedy by people who didn't go to university' (quoted by Double 1997: 191). In fact, most of the alternative comedians were university educated, albeit not at Oxford or Cambridge –

Rik Mayall, Ade Edmondson and Ben Elton were graduates of Manchester University, for example. The 'erudite middle-class approach of the university wits' (Wilmut and Rosengard 1989: xiv) was supposedly as much of a *bête noir* as the mother-in-law jokes of the club comedian. However, this antipathy – seemingly reminiscent of punk's hatred of progressive rock – was less evident on television, where alt-com and Oxbridge comedy would interact more amicably. Footlights performers Stephen Fry, Hugh Laurie and Emma Thompson would cameo (admittedly as over-privileged toffs from 'Footlights College, Oxbridge') in the 'Bambi' episode of *The Young Ones* (BBC 2 1982–84) and both Fry and Laurie would be regulars in the different incarnations of *Blackadder* (BBC 2/BBC 1 1983–89), a series that can be seen to belong equally to both traditions (its writers Richard Curtis and Ben Elton represented this alliance). *Not the Nine O'Clock News* (BBC 2 1979–82), manned by Oxbridge graduates Rowan Arkinson, Mel Smith and Griff Rhys Jones, and writer Richard Curtis,[1] had already anticipated some of the characteristics of alt-com. According to producer John Lloyd, its 'objective was to change what people were allowed to laugh at' (Musson 2011: 19) while William Cook claims that it 'liberated TV comedy from the clutches of Dick Emery, Benny Hill and the Two Ronnies' (1994: 307). One of *Not the Nine O'Clock News*'s sketches placed the primetime innuendo of the latter double act in the firing line, while Ben Elton's sniping at Benny Hill's sexism in interviews has been seen as a contributing factor in ending Hill's TV career (Hunt 1998: 45). It seemed that generational battle lines were being drawn.

Wilmut and Rosengard offer two slightly different definitions of alternative comedy. The first conforms to its place in popular history as an uncompromising punk-like kick-up-the-arse to British comedy, 'an alternative to the bland prolefeed of the situation comedies which form the staple diet of television entertainment; and ... a rejection of the easy techniques of racist or sexist jokes on which so many mainstream television and club comics rely' (1989: xiii). As we can see from *Not the Nine O'Clock News*, this was happening in other areas of British comedy, too. But Wilmut and Rosengard also position alt-com as part of a cyclical history in which each generation must

symbolically 'kill off' the previous one – thus they define it also
as 'simply a rejection of the preceding fashions in comedy'
(*Ibid.*). Stephen Armstrong presents 1990s comedy as reacting
against the alternative comedy 'establishment', but also credits
the latter with a more lasting legacy, 'the creation of savage but
inclusive gags [that] contributed to an attitude change across
the nation' (2008: 73). Post-alternative comedy would
continue a number of its predecessors' initiatives. Both Cook
(1994: 6) and Double (1997: 260) argue that the most lasting
legacy of alternative comedy was the rejection of what Double
calls 'gags with previous owners'. The current concern with
'joke theft' is probably not one that would have troubled most
pre-1980s comedians – even the more innovative Dave Allen, as
Double observes, mixed original observational material with
'packaged gags' (*ibid.*: 140).

Alternative comedy's place of origin is generally identified as
the unruly Comedy Store, situated above a Soho strip club from
1979. The BBC briefly showcased alternative stand-up in the
one-off *Boom Boom, Out Go The Lights* (BBC 2 1980), filmed at
the Comedy Store and featuring some performers (like Tony
Allen) who didn't subsequently make the transition to televi-
sion. But alternative comedy arrived more visibly on television
in 1982 – *The Comic Strip Presents ... Five Go Mad in Dorset* was
part of Channel 4's opening night, and *The Young Ones* would
follow on BBC 2 later that year. Some of the characteristics of
alternative stand-up have been detected in earlier comedians
such as Dave Allen or 'folk comedians' like Billy Connolly,
Jasper Carrott and Mike Harding (Double 1997: 140; Allen
2002: 81; Lee 2010: 4.) A distinction is sometimes made *within*
alternative comedy between the more politically confrontational
'alternative cabaret' performers, of whom only Alexei Sayle
really had a significant presence on TV,[2] and the 'ex-student
drama types' (Double 1997: 191) who founded the Comic Strip
(Mayall, Edmondson, Peter Richardson, Nigel Planer). The fact
that the latter achieved greater visibility on TV accounts for
there being a less radical shift from the fourth to the fifth wave
than is sometimes suggested. Alternative comedy on TV was
characterized more by comic actors who could also write than
by stand-ups articulating oppositional views, even though

Alexei Sayle and Jo Brand are successful examples of the latter. Shiny-suited motormouth Ben Elton ranting about 'Mrs Thatch' has become the stereotype of the politically right-on 1980s comedian. If Elton has gone out of critical fashion – which he certainly has – it isn't always clear whether it's because his apparent swing to the right betrays an earlier opportunism or because leftist comedy lost its currency in the more apolitical 1990s. Comics like Mayall and Edmondson were 'political' more by what they didn't say than what they did, although French and Saunders could puncture sexism more directly by padding up as two overweight men whose sexual harassment of women on TV would escalate into dry-humping the screen. Sangster and Condon describe Mayall and Edmondson's later *Bottom* (BBC 2 1991–95), a slightly more traditional sitcom than *The Young Ones*,[3] as 'gleefully apolitical and without an agenda' (2005: 131). Their comic violence, a kind of live action *Tom and Jerry*, would be re-worked by Reeves and Mortimer, who had been vocally dismissive of the more political alternative comedy.

William Cook sees post-alternative comedy as 'second generation' alternative, a continuation rather than a distinct break, a necessary infusion of fresh blood as the original generation was absorbed into mainstream light entertainment (1994: 8). Thompson, who gives rather more weight to the 'post-ness' of post-alternative, nevertheless characterizes the fifth generation (as I'm choosing to call them) as marking 'less a clean break and more a jagged edge' (2004: xiv). As he polices membership of the post-alternative canon, it's interesting to see who he makes a point of excluding. The case of Harry Enfield is worth considering in particular (even though, admittedly, he isn't especially prominent in this book either), given that his collaborator Paul Whitehouse is so central to Thompson's book while he draws attention to Enfield's exclusion (*Ibid.*: xiv).[4] Enfield came to TV prominence on the same show that made Ben Elton so popular, *Saturday Live* (Channel 4 1985–87), while at the same time his characters Stavros and Loadsamoney seemed to signal a move away from the politics associated with alternative comedy – an immigrant with a 'funny' accent and a character who in some ways anticipates the 'chav' character that has been widely

criticized in more recent programmes like *Little Britain*. Enfield was working with Whitehouse and Charlie Higson, who would contribute to *Harry Enfield's Television Programme* (BBC 2 1990–92), with Whitehouse also writing for *Harry Enfield and Chums* (BBC 1 1994–97). His use of catchphrases and recurring character sketches both looked back to programmes like *The Dick Emery Show* (BBC 1 1963–81) and ahead to *The Fast Show*, Higson and Whitehouse's own sketch show, and to *Little Britain*. Meanwhile, Thompson refers to Alexei Sayle as an 'erstwhile alternative overlord' (*ibid*.: xv) and positions him as the sour backlash against post-alternative comedy for making a thinly veiled attack on Reeves and Mortimer and 'the rise of stupidity' in a short story. But while few comics define 1980s alt-com more than Sayle, he had a transitional role to play too. Graham Linehan and Arthur Mathews (*Father Ted*, *Big Train*) were lead writers, with Sayle himself, on the frequently inspired *The All New Alexei Sayle Show* (BBC 2 1994–95) and they would make their first stab at sitcom with the ill-fated Sayle vehicle *Paris* (Channel 4 1994).

If one is searching for evidence of the 'post' as a break, then the arrival of *Vic Reeves Big Night Out* (Channel 4 1990–91) in 1990 and Frank Skinner's Perrier Award in 1991 can be read as two signs of a climate change in British comedy. The former is central to the re-forging of connections between cult and traditional comedy,[5] a characteristic also found in Harry Hill. It became popular to find (flattering) similarities between cult performers and their more mainstream predecessors – Reeves and Mortimer/Morecambe and Wise, Lee Evans/Norman Wisdom.[6] Maverick promoter Malcolm Hardee told William Cook, 'The right-on political stuff has more or less gone … Now it's veering towards silly stuff, rather than clever wordy stuff' (Cook 1994: 280–281). Skinner's award, on the other hand, was interpreted by some as not so much a turn towards the apolitical as a political backlash, even though he is one of the most technically skilled and quick-witted comics of his generation. Skinner is as scrupulously non-racist as an alternative comedian, but his more unreconstructed take on sexual politics would make him a figurehead in the 'new lad' culture that flourished in the 1990s. Michael Bracewell sees the 1990s emphasis

on 'attitude' – conservative views cloaked in rebellion – as growing out of a 'new authenticity', part of the legacy of which was the *Loaded* magazine culture of football and unreconstructed masculinity (2002: 42). The flipside of this view is to see Skinner *et al.* as having 'liberated TV comedy' (to borrow Cook's phrase) from the likes of Ben Elton – *Jennifer Saunders: Laughing at the 90s* (Channel 4 2011) offers 'silliness' and an escape from the straitjacket of 'political correctness' as the two defining features of 1990s comedy. More recently, Jimmy Carr celebrated this new 'freedom' while defending himself against criticisms of a questionable joke about Down's syndrome – 'You've got a great freedom of speech and you're allowed to say what you want as a comic, you can do anything you like. It's a brilliant time to be a comedian' (quoted by Chipping 2011).

But if comedy was in some ways more polarized in the 1980s – alt-com and its aftermath on the one side, variety performers, club comics and allegedly 'bland' sitcoms on the other – the political picture isn't always as clear as it initially appears. In the same year that alternative comedy, a very London-centred phenomenon, launched at the Comedy Store, the adult comic *Viz* appeared in Newcastle. *Viz* shared with alternative comedy a punk sensibility of shock and offence, an 'underground' aura (its first issue had a print run of 150), and an oppositional savagery towards a mainstream form – in this case, children's comics like the *Beano* and the *Dandy* which it 'metaphorically ripped ... to pieces' (Sabin 1993: 117) just as Vivian in *The Young Ones* tore into the 'niceness' of middle-class sitcoms like *The Good Life* (BBC 1975–78).[7] As Roger Sabin observes, if *Viz* had more in common with alternative comedy than the bigotry of 'old-wave comedians' like Bernard Manning, its politics were 'if not right-wing, then at least not right-on' (*Ibid.*: 121). Where alt-com put not only female comedians but explicitly *feminist* comedians on stage, *Viz* gave us The Fat Slags (sexually voracious working-class girls) and Millie Tant (a grotesque, stridently humourless feminist), although as is often the case with comedy, its sexual politics are open to different readings (see Huxley 1998). The regionalism of *Viz* can be linked to Reeves and Mortimer (also from the north-east) and *The League of Gentlemen*, while its 'politically incorrect' cruelty anticipates

recent figures like Jimmy Carr and Frankie Boyle – one contro-
versial strip, 'The Thieving Gypsy Bastards', anticipates the hot
water Carr would get into over a joke about gypsies.
Paradoxically, *Viz* more recently took a swipe at comedians who
deployed irony as a cover for politically suspect cruelty. The
'Thoughtful Bully', called in to explain his actions to the head-
master, offers the defence that his motives have been
misconstrued:

> The bullying persona that I adopt is one of supreme callousness.
> It is deliberately contentious. I use the overtly intimidating
> approach as a means of exploring the boundaries of taste and
> acceptability within the school corridor environment.
> ('Thoughtful Bully', *Viz* 191, Christmas 2009)

Meanwhile, back in the world of alternative stand-up, Jerry
Sadowitz was performing at the Comedy Store by 1985,
exploding alt-com taboos around gender, race and sexuality
while managing (like *Viz*) to not simply look like a throwback to
the old-school bigotry of club comics. For some, he was just as
bad. Stephen Wagg characterizes Sadowitz as a right-wing liber-
tarian and quotes left-wing comic Jeremy Hardy – 'What is the
difference between Gerry Sadowitz[8] and Bernard Manning?
£1000 an hour' (Wagg 1996: 330). Oliver Double includes
Sadowitz in the 'backlash' sub-section of a chapter on alterna-
tive comedy – 'There's something there to offend everybody,
particularly the left wing-social worker types who still
dominated the scene when Sadowitz first started shouting at
audiences' (1997: 210). But like a lot of critics, Double can't
quite pin down where Sadowitz is coming from, partly because
this involves the complex comic politics of 'saying the
unsayable' to 'wind the audience up by assaulting their values'
(*Ibid.*: 210). 'Offensive' comedy that reaffirms versus offensive
comedy that seeks to genuinely offend – sometimes with 'irony'
added to muddy the waters further – is a fine distinction that I
shall return to in the final chapter of this book. For now, it
suffices to offer Sadowitz as further evidence that even the
political shift from the alternative to the post-alternative was not
a straightforward one.

The usefulness of thinking of twentieth- and twenty-first-

century comedy in terms of 'waves' is that it suggests that key shifts are often about a particular generation (however loosely comprised) gradually replacing a previous one. In that respect, the 'post-alternative' era is as much as anything about a change of personnel. In the early 1990s, there are two particularly important nexus points. Firstly, there is Vic Reeves and Bob Mortimer, who would work with several of the performers and writers later involved in *The Fast Show*, while Matt Lucas (*Little Britain*) would first come to prominence as George Dawes in *Shooting Stars*. As an influence, they connect to a range of important shows, including *The League of Gentlemen* and *The Mighty Boosh*. Secondly, there is the group of writers and performers surrounding Armando Iannucci and Chris Morris, working on *On the Hour* (Radio 4 1991–92) and its TV spin-off *The Day Today* (Channel 4 1994) and *Brass Eye* (Channel 4 1997, 2001) before moving on to other notable series – Stewart Lee and Richard Herring (*Fist of Fun, This Morning with Richard Not Judy, Stewart Lee's Comedy Vehicle*), Graham Linehan and Arthur Mathews (*Father Ted, Big Train*) Steve Coogan (*Knowing Me, Knowing You ... With Alan Partridge, I'm Alan Partridge*), Doon Mackichan (*Smack the Pony*), Rebecca Front (*Nighty Night, The Thick Of It*), David Schneider and Peter Baynham (*I'm Alan Partridge*) amongst others. Other key talents such as Julia Davis would later be drawn into the acerbic Iannucci/Morris orbit. This signals two tonal directions for the early post-alternative period. On the one hand, there is silliness, 'surrealism', a re-imagining of music hall and variety (including the comedy catchphrase); on the other hand there is a new 'satire boom' with its eye particularly on the language of news and factual TV. One can discern both of these strands feeding into the trend for 'dark comedy' that emerged at the end of the 1990s. A later satirical initiative *The 11 O'Clock Show* (Channel 4 1998–2000) would kick-start the careers of Sacha Baron Cohen (as Ali G) and Ricky Gervais. Other groups would emerge as the 1990s progressed. While alternative comedy was an almost entirely white affair, the post-alternative era has brought about some modest shifts. Particularly notable was the emergence of British Asian comedy, most visibly in the work of Sanjeev Baskar and Meera Syal. The title alone of *Goodness Gracious Me* (BBC 2 1998–2001) announced that it was calling time on the racist

impersonation that dogged South Asian representation in British comedy from Peter Sellers' eponymous song to shows like *It Ain't Half Hot Mum* (BBC 1 1974–81). *The Kumars at No. 42* (BBC 2/BBC 1 2001–6), an addition to the 'mock' chat show, was enough of a mainstream hit to make the transition from BBC 2 to BBC 1. A more loosely connected contingent was defined primarily by their fannish enthusiasm for cult film and television (particularly fantasy and horror). This grouping would include the teams who produced *The League of Gentlemen* (Jeremy Dyson, Mark Gatiss, Steve Pemberton and Reece Shearsmith) and *Psychoville* (Pemberton and Shearsmith), *Spaced* (Channel 4 1999–2001 – Simon Pegg, Nick Frost, Jessica Stevenson and director Edgar Wright) and *Garth Marenghi's Darkplace* (Channel 4 2003 – Matthew Holness, Richard Ayoade and Matt Berry). The supposed Oxbridge taboo that had informed early alternative comedy meant even less in the post-alternative era, which was packed with Oxford and Cambridge graduates – Iannucci, Lee and Herring, David Baddiel and Rob Newman, Alexander Armstrong and Ben Miller, David Mitchell and Robert Webb. While alt-com, like many punk performers, disavowed its educated middle-class background (the Edinburgh Festival, too, became unfashionable for a time), cult/alternative/post-alternative comedy remains almost exclusively the humour of the university educated.

Trends in post-alternative comedy

If the alternative comedy of the 1980s is seen to be character-ized by its (explicit or implicit) politics, its uncompromising subcultural aura, its hostility to TV as 'light entertainment', what sort of characteristics define the post-alternative era? Less easy to group as a unified 'moment' in British comedy history, it manifests a number of trends (not all of them at the same time, and some of them in tension with one another), of which the following seem to me to be especially significant:

1. Laddishness and 'political incorrectness'. Some of the fears commentators had about Frank Skinner's post-Perrier promi-nence might have been confirmed by the homosocial atmosphere of *Fantasy Football League* (BBC 2 1994–96), the

programme he co-hosted with David Baddiel. A certain lairy atmosphere pervades a number of panel shows, fuelled by masculine competitiveness – in particular, *They Think It's All Over* (BBC 1 1995–2006), *Never Mind the Buzzcocks* (BBC 2 1996–) and none more than the testosterone-drenched *Mock the Week* (BBC 2 2005–).

2. The 'Comedy of Linguistic Exactitude' – a maddeningly undeveloped label coined by Ben Thompson (2004: 42) that one would nevertheless struggle to improve on. Referring to George Orwell's attack on the use of cliché and jargon to obliterate meaning in 'Politics and the English Language' (1950), what the term seems to suggest is the banalities of everyday discourse judged and found wanting. Its key practitioners are Chris Morris and Armando Iannucci, but interestingly, given that his greatest success came some years after Thompson's book, he identifies Stewart Lee as its 'most complete expression' (*Ibid.*: 59). This belongs to a tradition of 'clever', wordy comedy, more specifically one that is either satirical or in some way deconstructive – whether of the rhetoric of factual TV (*Brass Eye*) or the language and structures of comedy itself (*Stewart Lee's Comedy Vehicle*).

3. 'Northern comedy'. If alternative comedy was initially very London-centred and wary of the 'north' represented by working men's club comedy, the 1990s saw a resurgence of northern comedy. Two noticeable strands are identifiable. One is more affectionate (or even sentimental) and seems to evoke a sense of belonging on the part of its writers and/or performers – in particular, the work of Caroline Aherne and Craig Cash (*The Royle Family*, *Early Doors*) and Peter Kay (*Peter Kay's Phoenix Nights*). The other stresses the strangeness of the north, a grotesque and slightly archaic vision articulated by writers and performers who would achieve early success in London – such 'displaced northerners' include Reeves and Mortimer and the League of Gentlemen.

4. 'Dark' and 'cringe' comedy. This is a literally *fin de siècle* phenomenon in British TV comedy that stretches several years

into the new century and encompasses sitcom and the sketch show. It includes *The League of Gentlemen*, *Human Remains* (BBC 2 2000), *Jam* (Channel 4 2000), *The Office*, *Peep Show* and *Nighty Night*, with *Psychoville* a more recent addition.

5. 'Mock TV'. Television that parodies the look, mode of presentation and presenters of TV has certain precedents in the use of idents, continuity announcers and end title sequences to generate laughs in *Monty Python*, the fake TV channel in *Rutland Weekend Television* (BBC 2 1975–76) and the spoof headlines on *Not the Nine O'Clock News* – as Craig Hight observes, such strategies manifest comedy's potential for 'reflexivity and intertextuality' (2010: 166). A more recent, and perhaps more direct, influence would have been the film *This is Spinal Tap* (US 1984), which clearly left its mark on a generation of British comic talent – in a recent poll of 200 comedians in *Time Out*, it was voted 'the funniest film of all time' (Jenkins 2011: 80). *Spinal Tap* was influential not only for its 'mockumentary' style, but its particular approach to filming and performing comedy. As critic David Jenkins notes, the film 'doesn't have any "jokes", per se … Gags are built around deadpan edits and dialogue pauses rather than slick punchlines' (*Ibid.*: 80). The news/factual TV satire of Chris Morris (*The Day Today*, *Brass Eye*), the 'mockumentary' format (*Human Remains*, *People Like Us*, *The Office*) and the fake chat show host or interviewer made TV-about-TV one of the major comic modes of post-1990s TV comedy. We might also add the note-perfect retro look of *Garth Marenghi's Darkplace*, the comic conceit of which is the rediscovery of a never-broadcast low-budget Channel 4 horror series from the 1980s, and the pastiche 1970s science show *Look Around You* (BBC 2 2002, 2005). Fake chat show hosts or interviewers would include Alan Partridge (who had first appeared in *On the Hour/The Day Today*), Ali G, *The Mrs Merton Show* (BBC 1 1995–98), *The Keith Barret Show* (BBC 2 2004–5), *Man to Man with Dean Learner* (Channel 4 2006) and *The Kumars at No. 42*. Three different types of 'comic impersonation' (as Pickering and Lockyer (2009b) call it) have been predominant. Alan Partridge and Dean Learner inhabit entirely fictitious universes. Alan

Partridge might behave inappropriately with guests (even killing one of them), but the guests in question are fictional, too. Mrs Merton, Keith Barret (Rob Brydon's *Marion and Geoff* character) and the Kumars (a British Indian family with their own home-made TV studio) interview celebrities who are to a certain extent 'in on the joke', even if their good-humoured participation might be tested out by barbed comments from the host, particularly in the case of Caroline Aherne's Mrs Merton. Sacha Baron Cohen as Ali G adopted a tactic similar to Paul Kaye's prankster Dennis Pennis and Chris Morris's hoax interviews with celebrities. While Morris could flawlessly mimic the authoritative or solicitous manner of a middle-class TV interviewer, Ali G was presented to interviewees as the voice of ill-informed 'yoof', 'a disaffected wannabe homeboy of the suburbs, the kid stuck in Staines who dreamed of Compton or Watts' (Harry Thompson, quoted by Pickering and Lockyer 2009b: 186).

6. 'Light entertainment' and variety rehabilitated and/or re-imagined. This includes Reeves and Mortimer, Harry Hill, the catchphrase comedy of Harry Enfield, *The Fast Show* and *Little Britain*.

7. Changes in the 'look' (and sound) of television comedy. In his book on 'televisuality' – the emergence of programmes in the US with 'identifiable style-markers and distinct looks' competing for audiences in the post-network world – John Thornton Caldwell largely excludes TV comedy from these developments (1995: 5–6). In 1995, that was probably still true in both the US and the UK. While *The Young Ones* was stylistically 'radical' in some ways in its disruption of fourth-wall tele-'realism', it still conformed to a studio-bound, three-camera, video look which now looks cheap and dated (fortunately, this tattiness still fits the 'punkish' aura of the show). Brett Mills observes the emergence of 'comedies of distinction', in which markers of quality are given more of a visual dimension (2009: 134), as opposed to simply the traditional markers of comic 'quality' such as authorship and performance. He detects two trends in particular – the 'comedy

vérité' that either critiques the conventions of factual TV (the 'mockumentary') or borrows the look of drama or soap (*The Royle Family*, *Gavin and Stacey*) (*Ibid.*: 127) and one which offers an 'explicit display of the image' (*Ibid.*: 129). Programmes like *The Mighty Boosh* and *Psychoville* epitomize Caldwell's 'style-markers and distinct looks'. At the turn of the century, it looked as though the three-camera, studio sitcom with recorded laughter might be in decline, but it would rally somewhat – sitcoms like *The IT Crowd* (Channel 4 2006–12) and *Miranda* (BBC 2 2009–) would use their more traditional look and sound as a way of signalling inclusivity. The current status of studio audience laughter is an interesting one – cult/alternative discourses might position it as outdated 'spoon-feeding', but in the uncertain post-9/11 world, there seemed to be a desire on the part of TV channels and writers to produce something lighter, more inclusive and accessible, closer in style to the 'classic' mainstream TV comedy of the past.

8. 'Comedy is the new rock'n'roll'. While there are competing claims for the originator of this phrase, it was the music magazine *Select* that put it on its front cover in 1993. However, in many ways this connection had a longer history. When Monty Python began doing live shows – culminating in their famous Hollywood Bowl show in 1982 – they took the form of a 'greatest hits' package, like a classic rock group reforming. Alternative comedy had been linked to punk – Wilmut and Rosengard note the appropriation of rock terms like 'gig' and 'set' and it was not uncommon for comedians to perform as support acts to bands (1989: xiv). Stewart Lee claims to have been inspired to become a comedian by seeing stand-up Ted Chippington open for The Fall (2010: 1). As Stephen Wagg puts it, 'like rock, the new comedy has primarily been sensual, to do with identity and with allowing individuals to engage with thoughts and feelings perhaps unacknowledged or forbidden' (1996: 343). But two things distinguish the 1990s in conceptualizing the subcultural appeal of comedy in this way. Firstly, as Michael Bracewell reminds us, it became popular to characterize a whole range of things as 'the new rock'n'roll' – football, opera, contemporary art, cooking (2002: 4–6). To this we

might add politics, given Tony Blair's successful co-opting of Britpop to briefly take on the aura of the first rock'n'roll prime minister – his musical past, his connections to Damon Albarn and Noel Gallagher, his championing of indie label Creation records as the epitome of 'New Labour' (Harris 2004: 308). When he was presented with a Fender Stratocaster by Virgin Records' Paul Conroy, Blair was introduced as 'a person of our generation who understands us and our industry' (*Ibid.*: xvi). Secondly, a turning point for modern comedy seemed to come when Newman and Baddiel, a double act that traded on indie band looks and references, performed at Wembley Stadium. Double characterizes this moment as 'the triumph of marketing over the altcom circuit' (1997: 225). He contrasts the scale and spectacle of the show with the 'standard fare' of the performance and material, but notes how they were 'received with the kind of rapturous excitement that you might expect to see at a concert by teenybopper bands like Take That' (*Ibid.*: 226). Stewart Lee has noted (and mocked) the ubiquity of the 'big landfill indie-rock tunes and dry-ice entrance' in contemporary stand-up (2012: 19). Comedy's 'rock' credentials might come via an 'underground' or subcultural dimension (*Monty Python*, the 'punk' sensibility of alternative comedy), an art school sensibility (Reeves and Mortimer, *The Mighty Boosh*), pop or rock star looks (Russell Brand, Noel Fielding) or an actual musical component in the comedy (the 'folk comedians', Tim Minchin, the Boosh), but stand-ups performing in huge stadiums like Wembley and the O2 Arena has become one of the defining features of contemporary comedy as a hugely profitable industry. This is closely connected, too, to the rise of more powerful comedy promoters such as the companies Avalon, Off the Kerb (both also production companies) and PBJ. Wagg suggests that as comedians wrote newspaper columns, did advertising voiceovers or hosted 'ironic' makeovers of familiar TV formats, they assumed a new position, not as fools and outsiders but as 'truth-tellers in a world of blandishment ... sharp consumers, seldom fooled ... value-free ironists' (1996: 342).

TV comedy forms and formats

Defining comedy is a book in itself (or, more probably, a library) but defining TV comedy should in theory be easier. A TV comedy, as Mark Lewisohn succinctly puts it, is 'made with the express intention of causing amusement' (2003: 11). As we're discussing mostly *British* (and mostly terrestrial) TV comedy, another of his defining features is useful – such programmes are likely to have been commissioned by the comedy or light entertainment departments of their respective broadcasters. However, Lewisohn's criteria for inclusion and exclusion confirm that comedy still refuses to be entirely nailed down – it bleeds into the chat show format and variety shows that feature other kinds of entertainment. He excludes the quiz/panel show, while I would suggest that *Never Mind the Buzzcocks*, *Shooting Stars* (BBC 2 1993, 1995–97, 2008–11) and *Mock the Week* exist primarily to make us laugh and that the comedy panel/quiz show has been one of the most reliable comic formats in the last twenty years or so. Quiz and panel shows gained a cultish reputation that they had not previously enjoyed – it's harder to imagine 1980s alternative comedians going near such a traditional light entertainment format. *Have I Got News for You* (BBC 2 1990–), drawing on traditions of satire and Radio 4 panel shows, arguably paved the way for other shows to come, not least in its periodic rudeness (sometimes more deserved than others) towards certain guests. Subsequent panel shows would mix comedians and sporting personalities (*They Think It's All Over*) or take a rather more direct approach to comedy being 'the new rock'n'roll' (*Never Mind the Buzzcocks*). Reeves and Mortimer's unique contribution to the genre, *Shooting Stars*, will be considered in the next chapter. As mentioned earlier, the panel show tends to be one of comedy's most homosocial environments and while the ostensible competition built into the format tends to be of negligible importance, the competition between male wits can be more visible. No show illustrates this more than *Mock the Week* during the round in which the panellists dash to the single microphone to deliver their 'spontaneous' gags. The panel show can make the careers of particular comics, especially those who thrive on punchy gags

– Jimmy Carr and Frankie Boyle arguably owe much of their success to the format. Another enduring TV comic format offers a hybrid of stand-up, sketches and even musical performances. It clearly derives from variety traditions, but even alternative comedy would use this most traditional of formats in *Saturday Live* (Channel 4 1985–87) and *Friday Night Live* (Channel 4 1988). The variety format is a popular way of showcasing stand-up, either by simply featuring a series of comic sets (*Live from the Apollo, Michael McIntyre's Comedy Roadshow*) or featuring a comic or double act in a combination of stand-up and sketches. *The Mary Whitehouse Experience* (BBC 2 1990–92), *Fist of Fun* (BBC 2 1995–96), and *Harry Hill* (Channel 4 1997–2000) and the first series of *Stewart Lee's Comedy Vehicle* (BBC 2 2009) follow this convention – it has been the default vehicle for stand-ups and double acts on TV, with varying degrees of success. The second series of *Stewart Lee's Comedy Vehicle* (BBC 2 2011) would find a more innovative approach in alternating Lee's stand-up (already quite deconstructive in style) with 'Stew' being interrogated by Armando Iannucci about his show for that week. Lee disrupted the form in other ways, leaving in audience walkouts in one episode (2.4), one of which makes him visibly lose his temper to the evident discomfort of remaining studio audience members. This is something we rarely see in the carefully edited stand-up performance, often punctuated by shots of audience members laughing at the 'best' jokes. *Comedy Vehicle* briefly brought some of the unpredictable dynamics of live comedy into a pre-recorded comedy series.

Sitcom and the sketch show (the latter overlapping with the 'variety show' format) are arguably the two most recognized TV comedy formats, even if the panel show has sometimes seemed to be more robust in recent years – less dependent on writers having to come up with new material, and easily replacing performers who leave, grow stale or fall from grace (as Angus Deayton did on *Have I Got News for You*). In the early 1990s, cult sitcoms still seemed to be the province of the previous generation of alternative comedians – *Bottom* and *Absolutely Fabulous* (BBC 2/BBC 1 1992–), for example – while *Red Dwarf* (BBC 2 1988–99, Dave 2009) would span the two eras

and in its comparatively sophisticated visual effects and elaborate fantasy 'world', would anticipate some of the more 'televisual' comedies to come. *Father Ted* by Graham Linehan and Arthur Mathews is one of the first key sitcoms by the new generation of writers of performers, but in many respects is a traditional sitcom with fantastical touches, rather than subverting the genre in the way that 1980s alternative sitcoms sought to do. The same can be said of Linehan's later sitcoms, *Black Books* (Ch 4 2000–4) and *The IT Crowd*. Larger upheavals would take place in sitcom in the late 1990s and early noughties, reflecting those changes in the 'look' of TV comedy discussed earlier. The single-camera sitcom with no recorded laughter was a growing presence – *The Royle Family*, *The Office*, *15 Storeys High* (BBC 3 2002–4) – while, in addition to the 'comedy vérité' look (Mills 2009: 127), there were other signature 'looks' to set shows apart (*Spaced*, *Green Wing*, *The Mighty Boosh*). If sitcom was perceived to have hit a new peak around the time of *The Office*, this optimism was soon followed by predictions of the form's 'death' (*Ibid.*: 124). As Mills observes, that these popular debates happened at all testified to the cultural weight accorded to the genre and the desire for something 'era-defining' and high-rating to emerge (*Ibid.*: 126). This desire for a populist show that unites audiences as opposed to dividing them into cult niches has been increasingly noticeable in recent years. *Gavin and Stacey* (BBC 3/BBC 1 2007–9) conforms to the established conventions of the emergent 'quality' sitcom – single camera, no recorded laughter, touches of non-comic drama and pathos – but is a more upbeat 'feel-good' show than *The Office* or even *The Royle Family*. *Miranda* is more populist again – its direct-to-camera looks and monologues are the closest it gets to anything non-traditional. It is, as its title suggests, entirely a vehicle for its star, with Miranda Hart playing on her considerable likeability, and range of sidelong looks to the audience. But it also belongs to a tradition of what Deborah Chambers calls comedies of 'female singlehood' – Miranda is 'unruly and vulnerable', while at the same time confirming the 'disruptiveness and failure' of 'singleton' status (Chambers 2009: 180). When she finally achieves romantic success at the end of Series 2, the studio

audience whoop and cheer. In its narrative of the 'ugly duckling' getting her man, *Miranda* is traditional in more ways than one. The sketch show would not undergo the same crisis or rebirth, but would exhibit some interesting developments (in degrees of seriality, for example) and produce some influential and innovative shows that are examined in Chapter 4.

Cult, 'quality' and comic cultural capital

While the distinctions between alternative and post-alternative TV comedy are slippery at best, I want to suggest here that both can be seen as examples of two other related categories – cult television and 'quality' television. In some instances, they could even be considered as forms of 'art' television (Caughie 2004: 125–151). They are predominantly niche oriented, sometimes subcultural in appeal (whether through their 'rock'n'roll' qualities or fan practices like fan fiction and dressing up that surround shows like *The League of Gentlemen* and *The Mighty Boosh*), sometimes stylistically unusual, and perceived by their fans to be 'better' than the comedy consumed by a 'mainstream' audience. Debates around 'cult' and 'quality' TV have often converged to account for the shifts in post-network US television that also account for the 'televisuality' that Caldwell writes about. Roberta Pearson calls this 'mainstream as the new cult' (2010: 9). In the UK, the re-booted *Doctor Who* (BBC 1 2005–) manifests this 'mainstreaming' of cult – as Matt Hills argues, 'cult' and 'mainstream' can co-exist so long as there is 'a range of totemic "Others"' to define the cult series against (2010: 68). Nevertheless, I would suggest that marginality predominantly remains a defining feature of cult TV comedy (in the present and recent past, at least) – mainstream success hasn't done much for *Little Britain*'s cult capital, and while *The Office* transferred to BBC 1 for its Christmas specials, Ricky Gervais's and Stephen Merchant's decision to end it as its success was peaking sustained its cult 'credibility'.[9] The 'quality television' that has interested scholars in recent years is a 'niche-broadcasting phenomenon aimed at the "right" demographics' (Pearson 2010: 15). Jancovich and Lyons (2003) and McCabe and Akass (2007), for example, deal almost exclusively with US television.

British television has undoubtedly been transformed by 'televisual' quality TV, but the legacy of public service broadcasting means that the word 'quality' has other usages. There are some important differences between the discourses of 'quality' that continue to inform the BBC and to a lesser extent Channel 4 and those associated with such North American network buzzwords as 'must-see', 'appointment TV' and 'watercooler TV'. Put crudely, it's the difference between a set of ideals that at their best have fostered 'minority TV' – 'all of the people some of the time' as Channel 4's first Director General Jeremy Isaacs put it (Harvey 1994: 121) – and TV that aspires to be a 'media event' and a magnet for affluent consumers. As a fan of cult American shows, I don't intend this as a value judgement. Rather, my point is that while certain cult British TV comedies have taken on some of the aesthetic qualities of the second type of quality TV (albeit within the constraints of a TV comedy budget), they probably still belong slightly more to the first type. It's a tradition that allows programmes like *Monty Python's Flying Circus* and *Vic Reeves Big Night Out* to continue with the hope but not the expectation that they will attract larger audiences, although the picture has been complicated in recent years not only by the more mainstream success of *The Office* and *Little Britain* but by DVD sales figures – programmes like *The League of Gentlemen* made up with DVD sales what they lacked in audience figures. While Channel 4 has largely jettisoned its public service origins in its pursuit of 'the right demographic', it still supports a consistently low-rating series like *Peep Show* because of its loyal cult audience and critical acclaim. Rightly or wrongly, the channel continued to defend Frankie Boyle's lamentable *Tramadol Nights* (2010) in the face of both poor ratings and complaints upheld by Ofcom. Alternative TV comedy has largely been institutionally specific – it is the province of BBC 2 (and sometimes 1), Channel 4 and more recently the terrestrial digital channels BBC 3 and 4, both of which have played important roles in testing new comedy. An interesting contemporary cult surrounds *Limmy's Show*, which thus far has only been broadcast on BBC 2 Scotland but whose popularity has spread to other comedy fans in the UK via social networking sites like Twitter. With some exceptions, the only

digital channels to produce much original material of note to date have been BBC 3 and 4. Armstrong and Miller would make their first sketch series for Paramount Comedy Channel (1997) before moving to Channel 4, where the first of three series of *Armstrong and Miller* (1997–2001) was co-produced with Paramount. The now defunct BBC-owned UK Play produced Matt Lucas and David Walliams's *Rock Profiles* (1999–2000), an inspired precursor to *Little Britain*, and *The Mitchell and Webb Situation* (2001). While Dave, the self-styled 'home of witty banter', would produce three new episodes of *Red Dwarf* in 2009, it has otherwise been reliant on repeats from the terrestrial channels – at the time of writing, the predominance of panel shows is telling.

'Cult television', according to Jones and Pearson, is 'often loosely applied to any television program that is considered offbeat or edgy, that draws a niche audience, that has a nostalgic appeal, that is considered emblematic of a particular subculture, or is considered hip' (2004: ix). Pearson has more recently sounded a more sceptical note about the term because a 'term that means everything means nothing' (2010: 7). However, I would suggest that 'cult TV comedy' *does* mean something and that all the terms employed by Jones and Pearson's catch-all definition do apply – cult/alternative/post-alternative comedy must be considered edgy, it will appeal to a niche audience and it has subcultural appeal (although 'nostalgic appeal' can transform the mainstream hits of another era into the cult comedy of today). It is as institutionally specific in its way as the 'quality cult TV' of post-network US TV. As we have seen, it is supported in the UK by public service ideals – the desire to innovate, the targeting of niche audiences as something other than 'the right demographic'. In addition to the BBC's 'minority' channels (whether digital or, in an earlier time, BBC 2), BBC radio (Radio 4 in particular) has played an important role in fostering cult comedy – *The League of Gentlemen*, *Little Britain*, *The Mighty Boosh* and Mitchell and Webb all had radio series before moving to TV. Edinburgh Festival/Perrier Award success followed by a Radio 4 series and then a TV series: this has become a familiar trajectory for cult comic performers and writers.

As with any other kind of cult media, cult TV comedy cannot
be defined by textual qualities alone (although I do think that
certain textual qualities play an important role). As Jancovich
and Hunt argue, 'cult texts are defined through a process in
which shows are positioned in opposition to the mainstream, a
classification that is no more coherent as an object than the cult'
(2004: 27). Cult mobilizes what Sarah Thornton (1995) calls
'subcultural capital', the process whereby consumers and fans
distinguish themselves and their tastes from an Othered 'main-
stream' that lacks their cultural savvy. Jancovich and Hunt argue
that the mainstream stands in for the 'middlebrow' – cult
'opposes itself to the easy and transparent readings that distin-
guish popular taste and draws on the terms and strategies of
legitimate culture' (2004: 28). However, David Cardiff (1988)
offers an account of 'middlebrow' BBC comedy that suggests
that 'cult' and 'middlebrow' might be less antithetical than
consumers of the former would like to think. He reminds us
that the BBC actually invented the word 'middlebrow' and
suggests that the word 'may refer to forms which appeal to a
middle-class public which is educated to a degree but not highly
cultured' (*Ibid.*: 43). It is characterized by ambiguity – vulgar
enough to 'cock a snook at the highbrow' but cultured enough
to 'keep the lowbrow at bay' (*Ibid.*: 41). Above all, it is defined
by 'knowingness', permitting 'a range of allusion which is
beyond the reach of the less educated' (*Ibid.*: 43). *Monty
Python*'s allusions to high culture don't necessarily require you
to be familiar with the canonical names and texts they reference
– it is sufficient to recognise the names and enjoy their juxtapo-
sition with the mundane and the absurd (the high-pitched
voices of the 'Pepperpots' gossiping about Jean-Paul Sartre, for
example). The allusions of *The League of Gentlemen* are to cult
film and television, popular media that is largely the province of
the educated and 'discriminating' fan. 'Low' comedy makes
allusions, too – count the topical references in a Christmas
panto – but they are more likely to be current and inclusive, the
stuff 'we' all know about. 'Knowing' middlebrow comedy has
three distinguishing features, according to Cardiff – 'everyday
modernism', self-reflexivity and cultishness. Everyday
modernism 'borrows the language and gesture of the avant-

garde and uses them to defend middle-class values' (*ibid.*: 59).
Self-reflexivity is characterised in this instance by 'sifting the
entire output of broadcasting, debunking the pretentious and
self-important, exposing artifice, jettisoning the hackneyed
formula' – it is 'designed to accelerate the process of stylistic
change' by jettisoning clichés and stale conventions, but can
lack moral judgement (*Ibid.*: 57) – an accusation sometimes
levelled at Chris Morris. And Cardiff's view of BBC comedy's
cultishness accords with most recent scholarly accounts in
detecting 'highbrow exclusivity' accorded to accessible, popular
forms. Few comedians are more 'knowing' or 'self-reflexive'
than Stewart Lee, with his deconstructive approach to stand-up.
After his opening gag in the first episode of Series 2 of *Stewart
Lee's Comedy Vehicle*, he offers the following analysis of the joke,
its reception amongst the studio audience, its anticipated
reception amongst the TV audience and its function in the set
he is about to do:

> Quite a good uptake for that joke in the room, but how's that
> being received out there in TV land? It's not a good opening
> joke, that – it's a bit of a weird joke, innit? A bit of a hard joke to
> have at the top of the show. There's a lot of information at the
> beginning of the sentence in that joke. And you have to
> remember it, don't you, all the way to the end? Why is it there,
> that joke? Why is it at the top of the show when it's such a prob-
> lematic, strange joke? I'll tell you – it's not there for big laughs.
> The reason that joke's there at the top of the show is because the
> granddad and the nest [in the joke], they're going to keep
> coming back and in about 25–30 minutes' time there's going to
> be one joke that ties in both the granddad and the nest with all
> sorts of other things that I'm going to talk about over the rest of
> the show, and it's very satisfying [laughter from audience]. And
> I guarantee you, you may not be laughing now, at home, but at
> the end of the show when you turn it off, you'll go 'Oh, I see
> now. It was good.' ('Charity' 2.1)

There are a number of familiar Lee techniques here. There is the
exposing of the mechanics of comedy – announcing the
callbacks and reincorporation at the start, which ought to ruin
what follows but in fact becomes itself the joke (the payoff at
the end of the show is deliberately weak – funny because it

wasn't really worth the wait). There is the sub-dividing of his audience into those who 'get it' and those who don't – 'This room is unworkable,' he complains at one point, 'you can't work a mixed ability room.' There is the studied arrogance and condescension (when he addresses the audience at home, the camera is positioned so that he literally looks *down* on them). This allows him to find humour in his reputation as 'the thinking person's comedian', while at the same time affirming that that is exactly what he is. When one of his imaginary characters asks 'Stew' if he's read the latest *Harry Potter*, the elitism of his stand-up persona is hard to distinguish from the real thing in his response – 'No, I haven't, but I have read the complete works of the romantic poet and visionary William Blake, so fuck off!' ('Toilet Books' 1.1).[10] The applause that follows that joke is telling. 'Stew' riffs on the conventions of comedy, while other comics are judged to be blandly unchallenging (default whipping boy Michael McIntyre) or cruelly hateful (Frankie Boyle and the *Mock the Week* team). His contempt for the popular is part of his arrogant persona but the targets – McIntyre, Dan Brown, Adrian Chiles, Jeremy Clarkson, Chris Moyles – are mostly those that his audience is likely to share and thus in context relatively 'easy' ones.[11] When he sends up the views of the ill-informed and ignorant, he broadens his West Midlands accent to exaggerate their stupidity. In a routine on those who think 'political correctness has gone mad', his climactic example is his elderly 'Nan' – 'there's a whole generation of people who've confused political correctness with health and safety regulations. But they *will* die soon' ('Political Correctness' 1.3). It would be wrong to say that Lee lacks moral judgement – he is very self-aware and self-critical – but the 'middle classness' of his humour can sometimes support some dominant values while attacking others. The 'Political Correctness' routine attacks the thinly veiled bigotry in such rhetoric but also reinforces the stereotype of older, working-class or lower-middle-class people being more inclined to ignorance and prejudice. Lee is technically 'challenging' in many respects, requiring the patience and trust of an audience when it isn't clear where a lengthy routine is going – a long imaginary telephone conversation with an estate agent, for

example, during which both participants (real and fictional) start to analyse how the routine is being received by the audience and whether they should keep it going ('London' 2.2). And Lee clearly has no time for the tired cliché that analysing comedy is a futile, arid intellectual exercise – his books *How I Escaped My Certain Fate* (2010) and *The 'If You Prefer a Milder Comedian, Please Ask for One' EP* (2012) between them analyse his four most recent live shows, not unlike a literary DVD commentary. However, if we use Cardiff's definition of 'middlebrow' – knowing, 'modernist', self-reflexive, cultish, infused with middle-class values – only Lee's accessibility (or comparative lack thereof) doesn't quite fit. He clearly *does* alienate many (wilfully so, it seems), talks about 'refining' his audience both in interviews and on stage and draws attention to the three walkouts in episode 2.4 ('Stand-Up'). However, two points need to be made here. Firstly, we might want to question whether 'highbrow' comedy would necessarily be a desirable thing and consider the possibility instead that the 'middlebrow' is more complex than it is generally thought to be. And secondly, we probably shouldn't be surprised that 'middlebrow' is another term that can be used in different ways. As interesting and convincing as Cardiff's usage of the term is, it probably isn't the sense in which it is more popularly understood – rather than offering a privileged distance from the 'low' and the 'high', it is often seen as inferior to either (see Jancovich 2001).

In his study of comedy fans, Sam Friedman concludes that 'comic cultural capital' is 'mobilized less through taste for certain legitimate "objects" and more through the expression of rarefied but diffused *styles* of comic appreciation' (2011: 367). This supports the idea that cultification is a matter of reception, but also suggests that certain textual qualities might be required for such hierarchies of taste to be mobilized. Some object choices in his audience survey illustrated exactly the kinds of distinctions one might expect – those with high cultural capital more predisposed towards Stewart Lee, those with low cultural capital liking Roy 'Chubby' Brown (*Ibid.*: 354), but Friedman cautions against overemphasizing 'objectified cultural capital', which has been weakened by 'omnivorous' consumption practised by many, over 'embodied cultural capital' (the style of

appreciation) (*Ibid*.: 348). The comedy fan high in cultural
capital valued 'intelligence', 'complexity' and 'difficulty' over
comedy actually being funny – some of Friedman's respondents
rejected laughter altogether (*Ibid*.: 361) – manifesting
Bourdieu's notion of a 'disinterested aesthetic' (*Ibid*.: 360).
'Dark comedy' met such requirements perfectly:

> 'Good' comedy provoked a wide range of emotions, and many
> respondents expressed preferences for 'dark' or 'black' comedy
> where disturbing subjects are probed for humorous effect. These
> respondents argued that by invoking negative as well as positive
> emotions, the comedian was better placed 'to challenge' them
> intellectually. (*Ibid*.)

For those lower in cultural capital, comedy was 'fundamentally
and inextricably linked to laughter' – its cultural currency was
immediate pleasure, 'relaxation' or 'escape' (*ibid*.: 362).
Bracewell (2002: 50), Thompson (2004: 73) and Double have
little evident regard for 'the comedy of recognition' – 'lifestyle
comedy, exploiting the comic potential of vacuum cleaners and
washing machines, of buying clothes or making toast' (Double
1997: 220). This contempt for the 'safe' and easily recognizable
pervades the contemporary cultist's antipathy towards Peter
Kay, Michael McIntyre and John Bishop. But Friedman's low
cultural capital respondents enjoyed this everyday quality,
'showing us things we all know are there but don't necessarily
see' (Friedman 2011: 363). Some comedians, such as Eddie
Izzard, seemed to appeal to both groups, but the criteria of
appreciation was very different – 'Absolutely mental!' for one, a
'clever' and 'beautiful flight of fancy' (*Ibid*.: 358) for another. A
lot of cult comedy lends itself to 'disinterested' appreciation –
The League of Gentlemen can be enjoyed for its darkness, Chris
Morris or Stewart Lee for their 'cleverness'. In any case, the
'disinterested aesthetic' offers only one route through which
comedy takes on cultural or comedy value – other cultish
practices (learning sketches, dressing up, collecting) clearly play
an important role, too.

As the category of 'mainstream cult' suggests, cult has ways
of negotiating wider popularity, but maintaining subcultural
capital often involves a 'policing of the boundaries' (Jancovich

and Hunt 2004: 28). While Michael McIntyre seems to have been pushed firmly into the 'mainstream' by cult comedy fans, other performers or shows sit troublingly on the boundary. Few series illustrate this more than *Little Britain*, which in making the transition from cult (Radio 4, opening night of BBC 3, connections to *The League of Gentlemen* and Reeves and Mortimer) to mainstream (from BBC 3 to 2 to 1, sell-out tour, merchandising, US series, appearances in TV commercials) not only caught flak for its representations of class, gender and ethnicity but suffered the inevitable backlash that such popularity often brings. The following Amazon customer positions himself as an admirer of Lucas and Walliams's earlier work, but soon reproduces some familiar negative tropes around the series, including its 'unsophisticated' audience:

> Mash & Peas and *Rock Profile* showcased what genuine talents Lucas and Walliams are. *Little Britain* is the tragic, wasted opportunities both have become.
>
> While season one was sporadically enjoyable, two and three descended into the very worst kind of British comedy, pandering to the lowest common denominator (sadly now the majority) with catchphrase-comedy – cheap, lazy writing essentially portraying exactly the same joke with next to no progression or development, just minor situational alterations in each episode ... When all else fails, Lucas and Walliams opt for bad language to get the inevitably [*sic*] laugh from their audience, most of whom wouldn't know well written, sophisticated comedy at all.
>
> *Little Britain* is a waste of two very funny people and further adds to the decaying state of British comedy. That it became so popular says it all. (Tusepack 2008)

A series might retain its cult following, but produce splits within that following. Just as Jancovich and Hunt observe fans of cult fantasy series being derided for fancying cast members, Sarah Harman (2011) observes a similar condescension towards the 'fangirl' in *Mighty Boosh* fandom:

> characterised by those above as an immature sexualised obsession with Noel Fielding (seen as the most commercial aspect of *The Mighty Boosh*) and furthered by a characterisation of youth, and inarticulate command of language in communication – primarily

online – a position of being undereducated, uncouth, lacking in self-control. This is reflected in the derogatory referencing of these fans as 'OMGFIELDINGZ' by those above in the hierarchical system.

As Harman suggests, this is a version of the 'fangirl' partly facilitated by the comedy/rock'n'roll connection – rock and pop, too, have their screaming 'hysterics' in opposition to the 'legitimate' (implicitly male) fan (*Ibid.*). Thus there was a category of 'legitimate fan' who asserted her or his superior taste by registering their admiration for the first two series of *The Mighty Boosh* and of Fielding's partner Julian Barratt and their distaste for Series 3, where Fielding's alleged 'rock god' ambitions were seen to have been detrimental to the comedy and attracted the 'wrong' kind of fan. One Amazon customer characterizes Series 3 as 'Suitable for female teenagers, but people who like actual comedy should stay clear' (*Ibid.*).

A 'golden age' and its contexts

When cultural histories are written, decades generally refuse to start or finish on time – it can take a couple of years for what we come to understand as the 'sixties' or 'seventies' to come into focus. However, the 1980s and 1990s seem more coherent than most because of the Thatcher government, elected in 1979 and its figurehead deposed by her own party while still in power in the autumn of 1990.[12] Cook (1994) and Thompson (2004), amongst others, observe the synchronization of alternative comedy with the reign of Margaret Thatcher – her election and the opening of the Comedy Store in 1979, claims Cook, 'were to shape British cultural life throughout the 1980s' (1994: 1), which possibly accords alt-com rather more power and influence than it actually had. Thompson casts Thatcher as 'mother-in-law' of alternative comedy, noting that she was more than a 'necessary object of antipathy' (2004: xiv) – her Enterprise Allowance Scheme (enabling would-be entrepreneurs to work while on benefits) nourished a few comic talents, while the deregulation of TV aided the rise of new production companies such as Hat Trick, Channel X, Talkback and later Baby Cow, run by comic writers and performers. The John Major years and the

Interesting

New Labour campaign that followed both relied on nostalgic images of Great Britain, but of a very different kind. Labour would shrewdly co-opt 'Britpop', already trading on a retro image of 1960s vibrancy and hedonism – the culture myth of 'Cool Britannia'. All Major could offer, in contrast, was 'a country of long shadows on country grounds, warm beer, invincible green suburbs, dog lovers and pools fillers, and, as George Orwell said, old maids bicycling to communion through the morning mist' (quoted by Harris 2004: 69). Given that Major defeated Labour comfortably in the 1992 election, this backward-looking (and widely ridiculed) vision might have had more currency than first appeared. Bracewell defines retro as 'the Past robbed of its history' (2002: 242) – throughout the 1990s, the past would be looted by comedians (referring to the disposable culture of their childhoods), musicians (desperate to get back to the 'swinging sixties') and politicians (seemingly invoking either *The Titfield Thunderbolt* or *Smashing Time*). Major – 'a sometime bank clerk' with a 'complete lack of charisma' (Harris 2004: 22) – was easier to mock than to demonize; the satirical puppet show *Spitting Image* (ITV 1984–96) represented him as a grey little man, bland but essentially harmless, in contrast with the hatchet-faced harridan that their Thatcher puppet embodied. Thatcher appeared to polarize popular culture – John Harris detects a similar cultural split in pop music to that in comedy in the opposition between the political pop of Billy Bragg, Paul Weller, movements like Red Wedge and Rock Against Racism and what he sees as the Thatcherite ethos of wealth and consumption represented by bands like Duran Duran (*Ibid.*: 4). By the early 1990s, pop subcultures, too, seemed to be more apolitical, like the 'Acid House' scene that emerged in 1987, the year of Thatcher's third election victory, and the 'Madchester' scene of the early 1990s – both would be characterized by a 'frantic hedonism' (*Ibid.*: 11). The 'Madchester' scene was in tune with both the northwards turn of British comedy and the 'laddishness' that defined comedians like Frank Skinner. Bracewell sees a mid-1990s shift in British culture from an embrace of irony and 'self-conscious artifice' (2002: 23) to the 'pursuit of authenticity' that fueled laddishness and 'political correctness' (*Ibid.*: 42), but I'm not

sure that this climate change is quite so clear. One can already see an embrace of regionalism and 'brute authenticity' in both the 'Madchester' scene – The Happy Mondays combined 'authentic' proletarian excess with conservative politics – and the breakthrough of Skinner. But certainly, the fusion of football, comedy, music and a celebration of heterosexual masculinity in the mid-1990s marks a key point in the decade's popular culture. The brief period of optimism surrounding New Labour – D:Ream's 'Things Can Only Get Better' was their election theme – would quickly sour. This period of political disenchantment coupled with anxieties following the events of 11 September 2001 in New York and 7 July 2005 in London coincide intriguingly (initially at least) with the cult of 'dark comedy' and then a visible search for something 'warmer' and more affirmative. Currently, there are signs of British comedy responding to the austerity measures of the coalition govern- ment, although it is too early to tell whether this signals a turn back to more political comedy – Stewart Lee would devote an episode of *Comedy Vehicle* (2.6) to David Cameron and the Bullingdon Club, while younger comedians like Josie Long have made a visible switch from whimsy to political engagement.

Mapping any cultural form – especially an unruly one like comedy – onto 'the times' that produced it can lead to sweeping reflectionist generalizations that paper over a multitude of contradictions. The backward-looking Major years of much of the 1990s don't just give us the ambivalent nostalgia of Reeves and Mortimer but the more gimlet-eyed satire of Chris Morris. 'Dark comedy', on the other hand, ran roughly from the first series of *The League of Gentlemen* in 1999 to the second series of *Nighty Night* in 2005; a period also characterized by fading optimism in the 'New Labour' government, the events of 11 September 2001 and the moment when global terrorism came 'home' in Britain on 7 July 2005. However, TV comedy is often catching up with material that has a longer life in a live context – the League of Gentlemen had been developing some of the characters and material that would feature in their TV series since their early shows in the mid-1990s, just as much of Vic Reeves's early work was building momentum in live shows

during the late 1980s. Moreover, while 'darkness' began to lose some of its currency (and the enthusiasm of programme commissioners) from the mid-noughties, *Peep Show* currently seems to be building to a longevity that might yet make it the *Last of the Summer Wine* of 'dark comedy'.

One can more confidently place British TV comedy in its institutional context during this period. William Cook characterizes Channel 4 as 'the TV station that invented the 80s' (1994: 1) and it would certainly play an essential role in showcasing alternative comedy from its opening night onwards. As Sylvia Harvey suggests, Channel 4's legacy is a mixed one. On the one hand, it had a 'legislative requirement to *experiment*, to *innovate* and to *complement* the service offered by the existing television channel' (1994: 102), a remit that 'affected the whole ecology of British broadcasting, extending the range of subjects that might be dealt with by television' (*Ibid.*: 118). But it also led the way in the deregulation of British broadcasting – it 'published' programmes rather than producing them and would transform the industry by characterizing 'the new lean, fit and flexible independent sector' (*Ibid.*: 104). Comedy would benefit from both of these developments: the desire to innovate brought in new talent and new formats; the 'flexible' structure paved the way for production companies specializing in comedy. If the channel did in some way define the culture of the 1980s, the 1990 Broadcasting Act would add further impetus to the more commercial direction Channel 4 was already taking by the end of the 1980s – it became a trust independent of the IBA (Independent Broadcasting Authority) and would now sell its own advertising. At the risk of over-stressing 'personalities', two Channel 4 Directors General would prove important to directions in the channel's comedy. Michael Grade (1988–97) was a populist figure with links to mainstream light entertainment whose appointment signalled the new emphasis on ratings and demographics. Grade would champion Jonathan Ross (an important gatekeeper figure in new comedy) and Reeves and Mortimer, and be characterized by the tabloids as 'pornographer-in-chief' for both broadcasting and defending programmes like *The Word* (1990–95). While it has a deserved reputation for showcasing seminal musical performances

(Nirvana, L7), *The Word* also epitomized the crass heartlessness that would start to characterize some of Channel 4's output. When the channel recently defended *Tramadol Nights*, that support seemed closer to the controversy surrounding *The Word* than that surrounding the more challenging *Brass Eye*. Grade was not sympathetic to *Brass Eye* and had tried to pull it, perhaps stung by the earlier 'pornographer-in-chief' label. His replacement Michael Jackson (1997–2001) came in as a critic of 'the pursuit of demographics' – in particular, 'young, lager-drinking, upwardly mobile men' (quoted by Brown 2007: 209). But he would leave with a controversial speech that dismissed public service broadcasting as 'another shibboleth whose time has come' (*Ibid.*: 267). Maggie Brown divides the Jackson era into 'early' and 'late' – the 'late Jackson era' (1999–2001) establishing the future direction for Channel 4: aspirational 'leisure shows and undemanding factual strands built around the dilemmas of real people' (*Ibid.*: 248) and of course the cross-platform success of *Big Brother* (Channel 4 2000–10, Channel 5 2011). Jackson is clearly the target for Harry Hill's ventriloquist's dummy Director General Gary in his Channel 4 series (1997–2000), obsessed with American sitcoms like *Friends* that helped make the channel so commercially successful in the 1990s. But as late as 2001, Jackson would defend the *Brass Eye Special* more robustly than Grade had done with the earlier series. While he is remembered by co-workers as a cold, reserved figure, he seems to have been good for comedy on the channel – *Smack the Pony* (1999–2003), a sketch show with three female leads, would emerge out of discussions between Jackson, Director of TV Kevin Lygo and Talkback's Peter Fincham (*ibid.*: 229). *Spaced, Black Books, The 11 O'Clock Show* and *Peter Kay's Phoenix Nights* all emerged during the Jackson era, but before we get carried away, so did *Dom Joly's Trigger Happy TV* (2000–2). Since Jackson's departure, *Peep Show* is Channel 4's most notable achievement in comedy, while *Tramadol Nights* and *The Morganna Show* (2010) are symptomatic of the ugly envelope-pushing that has sometimes characterized its pursuit of a young middle-class demographic.

The comparative lack of turbulence surrounding the BBC in the 1990s – in spite of its charter being up for renewal in 1996

– might be attributed to the convergence of a 'light touch' Major government and the cautious appeasement Director General John Birt has been seen to have exercised (Goodwin 1998: 124–129). The BBC's own *Extending Choice in the Digital Age* (1996) would pave the way for its move into digital terrestrial broadcasting provision. Prior to the arrival of BBC 3 (in 2003) and BBC 4 (in 2002), BBC 2 would be the most common home for cult comedy, often integrating shows into scheduled 'comedy nights'. BBC 2 was re-positioned in 2000 by controller Jane Root, away from younger audiences, with 35 the 'new centre of gravity' and an emphasis on comedy that might make the transition to BBC 1 (Brown 2000). More recently, it has re-discovered edgier, more cultish comedy with *Psychoville* and Stewart Lee, albeit pushing the latter's second series into an unenviable late night-slot. BBC 3 – characterized by controller Stuart Murphy as 'populist, edgy and reckless' (Born 2004: 485) – would identify new comedy as one of its strengths. *Little Britain* made its TV debut on BBC 3's opening night and it would produce other well-regarded comedies like *Nighty Night* and *The Mighty Boosh*. However, its youth orientation has over time led to accusations of 'dumbing-down' and demographic-chasing – for Graham Linehan, the channel epitomizes the 'charmlessness' of contemporary comedy in its desire to be 'risky' at the expense of taste and judgement (Hemley 2008: 5). More recently, BBC 4 has in some ways played a more important role in fostering acclaimed cult comedy shows – *QI* (2003–) and *The Thick Of It* (2005–) would make the transition to BBC 1 and BBC 2 respectively while both supported BBC 4's reputation as 'the new BBC 2', a channel of culture and education, of innovative and 'challenging' TV.

The BBC's digital revolution – 'a free-to-air public service system in digital media' (Born 2004: 490) – was overseen by Birt's iconoclastic successor Greg Dyke. Dyke fell victim to the political fallout from the the Hutton Report (2004) that exonerated the Blair government but heavily criticized the BBC for its editorial and management procedures (*Ibid.*: 462.)[13] The BBC would continue to be under siege in the new century, and its second scandal – the so-called 'Sachsgate' affair – would impact more directly on TV comedy. As we will see in the final

chapter, the media topicality of 'offensive comedy' is difficult to separate from political attacks on the BBC.

This chapter, then, has aimed to map out post-alternative comedy and to place it in a number of contexts: its relationship with the alternative comedy of the 1980s and position within the larger post-war history of British comedy; its status as 'cult' and 'quality' TV; the forms of and trends within TV comedy during the last twenty-two years; the cultural context that shaped cult TV comedy and the institutional context in which it was broadcast. We now turn to a series of case studies, starting with the double act often identified as the starting point for post-alternative comedy – Vic Reeves and Bob Mortimer.

Notes

1 While her career in comedy didn't subsequently develop, Pamela Stephenson's contribution to *Not the Nine O'Clock News* anticipates the, if not new then different, prominence given to women in alt-com – compare her role, for example, with Carol Cleveland's in *Monty Python*.

2 Alternative comedy's most volatile performer Keith Allen worked in a relatively low-key capacity on *The Comic Strip Presents* and would later find success as a reliable character actor and continued notoriety as an off-screen personality.

3 *Bottom* largely abandons those jokes that attack the representational codes of TV or introduce fantastical elements such as talking animals or vegetables. It is closer to the sort of classic sitcom 'trap' found in shows like *Steptoe and Son*.

4 'I don't make the rules', claims Thompson (2004: xv), while doing precisely that.

5 Again we shouldn't over-stress the alt-com demonization of all forms of traditional comedy. Slapstick was central to Mayall and Edmondson's comedy, while innuendo was permissible if accompanied by a self-conscious 'Ooh-err, sounds a bit rude!'

6 Currently, Miranda Hart puts me in mind of a post-alternative Joyce Grenfell.

7 While *The Good Life* had ceased production well before *The Young Ones*, it was still very much part of the British TV-scape in the form of repeats.

8 Sadowitz spelled his first name 'Gerry' earlier in his career, switching to 'Jerry' later.

9 Series 2 had just become the BBC's fastest-selling DVD release (Walters 2005: 48).

10 This slipperiness is often evident in the stand-up personas of comedians who are in some way contentious. The persona may say the opposite of what the comic thinks or exaggerate an aspect of their own personality so that it becomes comic. Lee admits himself that he is arrogant and elitist, but he has arguably found a way of making that character trait funny by exaggerating it.

11 They're a bit less comfortable when he seems to be having a go at likeable comic Russell Howard ('Charity' 2.3), although Howard turns out not to be his real target.

12 The Poll Tax riots earlier that year had constituted the most large-scale political demonstration in Britain in the 1990s and were instrumental in Thatcher's fall from grace.

13 In 2003, David Kelly, an employee of the Ministry of Defence, committed suicide after being named as the source for a BBC news report claiming that the Blair government had deliberately exaggerated Iraq's possession of 'weapons of mass destruction'.

2

Britain's top light entertainer and singer: Vic Reeves, Bob Mortimer and the cultification of light entertainment

> We want to be treated as mainstream comics doing bog standard entertainment. (Bob Mortimer, quoted by Viner 1995: 5)

> Personally I think of it as family fun. It should be liked by everyone, from the very young to the very old. (Harry Hill on his Channel 4 series, quoted by Williams 1997: 29)

Whatever constitutes 'post-alternative comedy' is widely taken to begin with Vic Reeves and Bob Mortimer. According to Bruce Dessau, *Vic Reeves Big Night Out* marked 'a watershed in TV comedy history' (1999: 125). Such claims have not just emerged in hindsight, as they perhaps did for *Monty Python* (sharing with Reeves and Mortimer's earlier work a significance not necessarily evident in their ratings). Indeed, such claims were being made even before the first episode had been broadcast. In the first move towards positioning comedy as 'the new rock'n'roll', *New Musical Express* proclaimed the coming of Vic and Bob with a zeal usually reserved for rock's 'next big thing'.

> It's spring 1990, and British comedy is no laughing matter. But this Friday night will change all that. At 10.30 (synchronise watches!) Channel 4 will screen a programme that will waft a typhoon of fresh, inspirational air through the smug staleness that hangs over our community. (Kelly 1990: 14)

These epochal claims carried a self-deprecating disclaimer that 'The article below contains unusually high levels of journalistic hype, drooling anticipation and unquestioning devotion' (*Ibid.*). The magazine also provided a 'Cut Out and Keep Guide' to 'How to Watch *Vic Reeves Big Night Out*'. The *NME*'s main points of comparison were with *Python* and *The Young Ones*, reference points guaranteed to bestow the kind of subcultural capital that would resonate with the young, largely middle-class readership of the music press. But another comparison looms large in the critical and popular perception of Reeves and Mortimer, namely with what Graham McCann calls 'the most illustrious, and the best-loved, double-act that Britain has ever produced' (1998: 4), Morecambe and Wise. This is a comparison that I shall return to later, but for now it signals another defining feature of the double act as a turning away from alternative comedy, which would not have invited such an association with traditional light entertainment.

This ambiguous relationship (affectionate? ironic?) with supposedly outdated entertainment forms can be found in at least one other key cult comic from this period – Harry Hill. If Vic and Bob recall Eric and Ernie, then Hill's 'bumbling, mole-like demeanour' (Thompson 2004: 176–177) is most reminiscent of an earlier Harry, Harry Worth ('My name is Harry Worth – I don't know why, but there it is'). Robin Nash, director of Harry Hill's Channel 4 series and a veteran of *The Generation Game* and *The Two Ronnies*, saw Hill as an entertainer in the classic light entertainment mould.

> I suppose I'm old-fashioned, and I love people who can be funny without cruelty, without use of language that couldn't be listened to by a maiden aunt. He's a genuinely funny man, like Eric Morecambe or Benny Hill. (Leith 1999: 70)

But like Reeves and Mortimer, there is something very contemporary about Harry Hill, too. Thompson sees in both 'the combination of laser-guided contemporary pop-cultural precision and a yen for old-school showbiz' (2004: 176). Vic and Bob would also use the old school know-how of a veteran TV director, in their case John Birkin (*The Two Ronnies, Mr Bean*) who would oversee their first series for the BBC, *The*

Smell of Reeves and Mortimer (BBC 2 1993–95). In terms of pop cultural referentiality, Vic and Bob are more likely to refer *back* to the minutiae of the past – TV series like *Daktari* or *How?*. The banality of these nostalgic referents might be connected to the nostalgia for 'non-places' Michael Bracewell identifies as a trend in the 1990s, a combination of retro-irony and infantilism. The success of books like Martin Parr's *Boring Postcards* (1999), a collection of faded picture postcards of motorway service stations, ugly shopping centres and unprepossessing holiday sites manifests 'a portal to nostalgia … a quasi-ironic metaphor of some lost state of innocence' (Bracewell 2002: 285–286). Vic and Bob express a nostalgia not for boring places but boring 'things' – cultural memories that only have value by virtue of *being* memories. Hill suggests something similar in his enthusiasm for chops or mash, but more often he offers a portrait of someone more at home with an earlier era trying to fathom contemporary pop culture – an embarrassing dad or uncle who insists on performing the 'pop hits' of today in a manner that confirms his incomprehension. He has commented himself on this backward-looking persona:

> It's an image of Britain in what is to me a golden age: armchairs, roast beef, trifle, *The Generation Game* and *The Two Ronnies* on TV, manual cars, the war. (Martin 1997: 19)

That sounds like several 'golden ages' combined rather than just one, but underlines Hill's evocation of a parochial 'past'. Thompson contrasts Vic and Bob's 'devil-may-care spontaneity' with the 'high levels of discipline and structure' that characterize Hill's stand-up (2004: 176), in which a sequence of seemingly unrelated gags gradually coalesce into meticulously structured callbacks. If his seemingly wandering train of thought initially suggests a cross between an absent-minded uncle and a badly tuned radio, by the end it's more like the virtuoso spinning of multiple comic plates. As Andy Medhurst observes, spontaneity is often valued over precision in comedy criticism (2007: 85), the former romantically anarchic, the latter perceived as sterile and over-rehearsed. Thompson avoids this kind of value judgement, but does observe how quickly Reeves and Mortimer adjusted to television compared with Hill.

Reeves's art school interest in creating environments seemed to translate into a facility for re-shaping TV formats; the variety show, quiz, game and panel shows. Hill, on the other hand, was primarily a stand-up. His talent for reincorporation meant that short slots like his early *Saturday Live* (ITV 1996) appearances did him few favours, but finding the right format for stand-up comedians can be fraught with difficulties. Hill's institutional environment is equally significant. Channel 4 didn't seem to be a congenial home for him, although his 1997–2000 series *Harry Hill* had many inspired moments. Instead, he would combine commercial and critical success on ITV – British terrestrial TV's most frequently disparaged channel would prove to be a natural environment for Hill, even though he hit his commercial peak as a TV light entertainer by mocking much of its output. *Harry Hill's TV Burp* (ITV 2004–11) turned a critically disparaged genre, the clip show (see Leggott 2010), into one of the most consistently inspired comedy shows on TV. Rather than corrode Hill's cult credibility, *TV Burp* is often regarded as TV's most successful use of Hill's talents – Mark Lawson saw it as '[skewering] the strange mannerisms and repetitions of ... soap opera or news by focusing on a single line, gesture or inflection' (2008: 35). Leggott traces the clip show's origins back to the popular 'blooper' compilation *It'll Be Alright On the Night* (ITV 1977–), but locates *TV Burp* in the 'comic/critical commentary' sub-category that includes Victor Lewis-Smith's *TV Offal* (Channel 4 1997), and *Charlie Brooker's Screenwipe* (BBC 4 2006–) and *Newswipe* (BBC 4 2009). The tone of *TV Burp* is less savage than Brooker and less misanthropic than Lewis-Smith, but Harry's avuncular innocence still allows him to be cruel enough to elicit a shocked 'Oh!' from the audience when he adds talent show runner-up Gareth Gates to Hitler and Judas as examples of famous losers. At its best, the programme is astoundingly creative, such as when editing together a version of 'Old McDonalds Farm' from a series of growls, howls and other cries by assorted soap opera characters. And while in some ways it tones down some of the less accessible aspects of Hill's stand-up, *TV Burp* facilitates his penchant for elaborate callbacks – as Leggott observes, recurring gags and references will sometimes cohere at a later

point in the series into 'one gratifying set-piece' (2010: 29). It
is easier to make a case for Reeves and Mortimer's innovations
in TV comedy with their unique brand of art school music hall
– they were prolifically creative throughout most of the 1990s,
only being overshadowed by newer talents like the League of
Gentlemen at the end of the decade. But if these two comic
forces genuinely sought mainstream acceptance (without having
to sacrifice their reputation), then Hill would prove to be the
more successful over time, bang in the middle of ITV's Saturday
night schedule with *You've Been Framed* and *TV Burp*.

Music hall/variety/light entertainment

Andy Medhurst observes in Reeves and Mortimer a 'clear, if
sometimes oblique, appreciation and continuation of English
comedy's music hall heritage' (2007: 125). The 'obliqueness'
is evident in the frequent qualifiers that either precede ('the
postmodern ...') or follow ('... on acid') any phrase that
situates Vic and Bob within this tradition. When Vic Reeves
presented his 'Variety Palladium' at a wine bar in Deptford in
1986, he was introduced, probably rather archly, as 'the north-
east's top light entertainer' (Dessau 1999: 51). By the time *Big
Night Out* was broadcast on Channel 4, he was announced
weekly as 'Britain's top light entertainer and singer'. *Big Night
Out* had been the title of a popular ITV variety show in the
1960s, at one point hosted by another double act, Mike and
Bernie Winters (sometimes described, not without some justi-
fication, as 'the poor man's Eric and Ernie'). *Vic Reeves Big
Night Out* is framed as a variety show hosted by Vic, starting
and ending with a song, encompassing the bizarre talent show
'Novelty Island' and a collection of character turns (mostly
performed by Vic and Bob). In the late 1980s, one of the
manifestations of the turn away from alternative comedy was 'a
return to variety roots, but with a contemporary twist' (*Ibid.*:
87), although very little of this filtered through to mainstream
popular culture. Nevertheless, this was the context in which
Reeves developed the original version of *Big Night Out*,
sprawling and anarchic three-hour shows that gained an enthu-
siastic cult following first at Goldsmiths Tavern in New Cross

(from 1986) and then at the Albany Empire in Deptford in 1988. Some of the characters and items like Novelty Island, the Man with the Stick, dome-headed assistant Les with his love of spirit levels and fear of chives, and the permanently aggrieved Lister, would transfer to the more polished TV version. Perhaps the most visible debt to music hall was the participatory nature of *Big Night Out*, drunkenly and rowdily so in its live incarnation but still present in the catchphrases and songs that the studio audience were invited to join in with on TV – the 'Wheel of Justice' song ('see how fast the bastard spins') or the cry of 'What's on the end of the stick, Vic?'. When the *NME* primed its readers on how to watch the series, it wasn't just the catchphrases that it prepared them for – it encouraged them to be 'right royally pissed' while viewing (Kelly 1990: 15). For fans who remembered the Goldsmiths Tavern shows, the TV *Big Night Out* was sometimes seen as a toning down of the full experience of its predecessor, just as variety is often seen as a middle-class taming of the proletarian excess of music hall. We shouldn't extend this analogy too far, however, given that, as Medhurst observes, class is the most telling difference between traditional music hall (and even variety) and Reeves's 'postmodern' take on it. The 'authenticity' of those early shows tends to be asserted in terms familiar to the middle-class subcultural consumer – 'like seeing the Sex Pistols before they signed their recording contract' (Dessau 1999: 54).

When Morecambe and Wise worked at the BBC, they famously insisted on performing on an eighteen-inch-high rostrum, from which they performed 'over' the cameras to the audience as though on stage (Wilmut 1985: 225). *Vic Reeves Big Night Out* doesn't go that far, but it's an important part of its *mise-en-scène* that we are watching something on a stage – a stage with a curtain (something else Eric and Ernie made use of). Vic's desk is positioned permanently to the right, with the live band behind him. Entrances are made by opening part of the backdrop and the programme makes a point of showing scene changes, with exits timed long enough to allow Vic and/or Bob to change into another character, reinforcing the simulation of a show being performed in real time. In Series 2, ad breaks are preceded by a shot from the back of the audience

as the curtains close on the stage. *The Smell of Reeves and Mortimer*, by contrast, adopts the look of a different kind of 'light entertainment'. We still hear the studio audience but never see them, and there is more pre-filmed material, even in studio sequences such as the musical numbers. This allows some complex visual jokes, such as the brilliant perspective gag in a musical number where two stools in the foreground are revealed to be much tinier than we thought when Vic and Bob dance their way towards them, crouching as they approach before perching precariously on them (2.4). The set is more elaborate, less theatrical, more 'televisual' – white with Greek pillars, a huge 'R&M' at the back, a space that they can move through and around. It mutates in an instant according to their perfor-mative needs – after Vic and Bob's weekly opening song, their cluttered desks suddenly appear for the cross-talk routine that leads into the rest of the show. There are many more filmed items, with recurring characters appearing in their own sketches rather than being brought out on stage – Slade at home (the glam rockers re-imagined as *Beano*-style miscreants), Pat Wright and Dave Arrowsmith, two gruff Geordies convinced that people are staring at their bras, Corbusier et Papin (flatulent Jacques Tati-like Frenchmen) and the easy listening duo Mulligan and O'Hare. A series of scratchy, faded pseudo-public information films bear some resemblance to the retro stylings of Mr Cholmondley-Warner's Pathé News pastiches in *Harry Enfield's Television Programme*. More studio-bound are Marvin Gaye and Otis Redding, controversially blacked up in the first series (a detail abandoned in the second) – Vic and Bob's heads on tiny puppets, their hands operated by sticks. As in *Big Night Out*, the unpredictable 'liveness' of this item guarantees some of the humour – when a moustache comes loose or the door of the wardrobe they sit in threatens to close, tiny puppet hands struggle in vain to rectify the gaffe. *Big Night Out*'s opening songs were always cover versions performed live, Vic cavorting with the microphone stand rock star style. In *Smell*, the songs are mostly original and seem to be mimed in order to facilitate more elaborate choreography and visual jokes. Vic and Bob retain, like Eric and Ernie before them, a signature song on which to close – Vic's 'Mr Songwriter' in *Big Night Out*

replaced by the 'Smell' song in which each sing alternating lines (slightly different each week):

> VIC: (*singing*) I love the smell of manure.
> BOB: (*singing*) I love the smell of the poor.
> VIC: (*singing*) I love the smell of Frank Muir.

To a certain extent, *Bang Bang, It's Reeves and Mortimer* (BBC 2 1999) feels less like a fresh format than a pared-down third series of *The Smell of Reeves and Mortimer*. The openings are virtually identical – a song followed by some behind-the-desk cross-talk. The songs are the most consistently inspired elements in the series, from the opening episode's Hollywood show tune about Bob's ambitions to be a film star to a classic piece of double act love–hate regarding a new vacuum cleaner:

> VIC: (*singing*) I've got a new hoover, what do you think of it?
> I've got a new hoover, I'm over the moon with it!
> It's got what can only be described as a headlamp on the front
> Adjustable height and a low maintenance filter!
> BOB: (*singing*) I sold him that hoover – it's a pile of shit!
> I sold him that hoover – what's left of it!
> It couldn't suck off a fly from your carpet if it tried
> And the low maintenance filter – I lied!
>
> (Episode 2)

The song quickly mutates into a variation on 1970s hit 'Thank Your Lucky Stars', climaxing in Bob's line 'You should thank your lucky stars that I didn't make you pay a delivery charge'.

Filmed around the same time as their Saturday evening BBC 1 game show *Familes at War, Bang Bang* also seems to have been intended as a bid for greater mainstream appeal (Thompson 2004: 4). Its most obvious concession is the series of celebrity interviews conducted by Donald and Davy Stott who usually manage to embarrass their guests with their weekly question about their preferences regarding 'a nice relaxing poo'. However, the sketch characters are perhaps less accessible than the Bra Men or the alternative universe Slade dreamed up by Vic and Bob. Tom Fun and the ravaged-looking Derek search for a 'little bit of fun' in various locations – when Tom climbs into a

coin-operated seaside attraction, he finds himself sexually assaulted by a mechanical dancing monkey (Episode 1). 'The Club', an ongoing 'mockumentary' about the activities of Paul Baron's sub-Stringfellows Nightclub, is less significant in its own right than in paving the way for Reeves and Mortimer's most sustained attempt at a sitcom, *Catterick* (BBC 3 2004). *Bang Bang*'s ratings were comparable to the first series of *The League of Gentlemen* (around the two million mark), also shown early in 1999. The *League*, too, would be more of a critical and cult hit than a ratings one, but also displayed a team at the height of its powers doing something that no one else seemed to be doing – in that respect, it wasn't far from being where *Big Night Out* had been at the start of the decade. *Bang Bang*, by contrast, and for all of its inspired moments, probably carried a lingering sense of diminishing returns.

If Reeves and Mortimer's critical reputation rests largely on *Big Night Out* and *The Smell of Reeves and Mortimer*, their most popular work on TV undoubtedly explored other avenues of light entertainment – the quiz show, panel show and game show. The distinction between these three formats is a permeable one at best. The panel format has been particularly important for comedy because of the opportunities it provides for celebrities to be 'spontaneously' amusing. I qualify 'spontaneously' because some successful panelists have writers preparing material for them – Frankie Boyle would road-test potential *Mock the Week* quips in front of a live audience. The panel show may have elements of the quiz or game show, but it has two distinct properties of its own. Firstly, its competitive participants are usually *all* celebrities (although members of the public may play subordinate roles). This sets it apart from celebrity quizzes like *Blankety Blank* or *Celebrity Squares* where 'ordinary' people compete but with the help or hindrance of celebrities. Secondly, competition is of secondary importance and often of no conse-quence – it is first and foremost a display of wit. The downplaying of competitiveness characterizes some quiz and game shows, too. While some play for high stakes – a generous cash prize (*Who Wants to Be a Millionaire?*) or the avoidance of humiliation (*The Weakest Link*) – Fiske and Hartley observe even in an earlier time how entertainment is more important

than competitiveness in *The Generation Game* (1978: 117), essentially the format that Vic and Bob adapted into *Families at War*. Still, there are tasks to be performed and prizes (however tatty) to be won. In the celebrity panel show, the rules and the awarding of points can be arbitrary to the point of impenetrable – who can fathom (or care) how an episode of *QI* or *Mock the Week* is won or lost? Sometimes, points are simply awarded on the basis of how entertained or amused an unpredictable host is by the contribution of a panelist. The link to comedy isn't particularly new either – Sangster and Condon characterize *Blankety Blank* as being '(a)s much a comedy as it was a game show', with its 'famously cheap prizes' (2005: 109) milked to perfection by a perpetually sour and sarcastic Les Dawson when he hosted the show from 1984–90. The show's promise that 'no one goes home empty-handed' – the scant consolation of a Blankety Blank chequebook and pen – was adapted into *Shooting Stars'* assurance that 'nobody goes home empty-hearted'. Reeves had even allegedly called the show '*Blankety Blank* without the pens' (Dessau 1999: 200–201). The consolation prizes on *Shooting Stars* are appropriately bizarre – a rock-saw, for example, worn on the head to enable the sawing of wood while headbanging to heavy rock.

Shooting Stars, then, is attuned to some of the fun and the silliness that are already part of the genre in its less aggressively competitive incarnations. But it also sits alongside *Have I Got News For You*, *Never Mind the Buzzcocks*, *Would I Lie to You?* and others as 'the panel game(s) for the cooler TV addict' (Sangster and Condon 2005: 510). Like *Buzzcocks* and *Have I Got News For You* it mixes 'knowing' with 'unknowing' celebrities or other public figures who either don't get the joke or don't realize that they might be its butt. *Shooting Stars* is less confrontational in its handling of 'uncool' celebrities than the other two shows (as a satirical panel show, *HIGNFY* is expected to be crueler in its mockery of certain guests, while *Buzzcocks* has less excuse for some of its occasional borderline bullying). *Shooting Stars* contestants such as Cannon and Ball or Richard Whitely are allowed to have fun, but it seems a requirement that at least one guest is visibly mystified by the format – *The Krypton Factor*'s Gordon Burns's tight smile is emblematic

here. Conversely, other guests will occasionally attempt to be more funny than is clearly required of them or wreck Vic's 'tumbleweed' gag by laughing.[1] There is a clear hierarchy on *Shooting Stars* with Vic, Bob and Matt Lucas's unruly 'big baby' scoremaster George Dawes at the top. Next are the team captains, initially Ulrika Jonsson and Mark Lamarr,[2] sufficiently in on the joke to participate in pre-filmed sketches that wouldn't look out of place in *Smell* or *Bang Bang*. But Lamarr's surliness (only some of which seems to be his persona in the show) are punctured by him being teased as a '50s throwback' or (sung by Bob in a George Formby voice) a 'crafty Cockney conman'. Meanwhile, for someone in on the joke, Johnson can be strangely competitive, even as she, too, is teased mainly by Bob – 'You're not even supposed to be in this country, Ulrika, so shut it!' Remaining contestants can be seen to fall into two groups; those familiar with the premise of the show and those clearly not. As stated earlier, the latter might be the more valued of the two in establishing the cult credentials of such a mainstream format. Questions with 'proper' answers are interspersed with others such as 'What is my favourite part of a monkey?' One member of the winning team will take the bonus challenge, an inventively silly task such as Richard E. Grant being rolled down a slide in a barrel, knocking plums into a chamber pot. None of these surpass Lamarr's 'Mammal Challenge' in an episode from Series 2. Positioned on a podium in protective padding, clutching a shield, the brylcreemed comic must deflect a series of stuffed mammals propelled at him by Vic from behind a privet – a mouse, a rabbit, a leopard ('the most spotted of all mammals'), culminating in a grizzly bear. As Vic prepares to launch the bear, holding it by its back legs, the constructed nature of the already unlikely contest is underlined by dramatic close-ups of the eyes of Lamarr and the bear.

If the pre-TV *Big Night Out* is positioned by hardcore Reeves cultists as the undiluted essence of his comedy, *Shooting Stars* is sometimes regarded within this same elitist framework as the cheapening of Vic and Bob's talent. It would tour successfully as a live show (as *Big Night Out* had done, too, after being on TV) and has proven the safest format for getting Vic and Bob back on TV – a sketch show pitched to BBC 2 was rejected. *Families*

at War would only run for one series – given that *Shooting Stars*
remained on BBC 2, the brief stint on Saturday evenings is the
closest Reeves and Mortimer might have come to a *TV Burp*
style crossover into light entertainment proper. If *Shooting Stars*
has *Blankety Blank* somewhere in its DNA then *Families* steers
closer to simply having Vic and Bob add some eccentric touches
to *The Generation Game*. The involvement of members of the
public – two teams consisting of three family members – gives
the programme a more populist feel. Some of the games do
require actual skills from the contestants, even if they are ulti-
mately dancing to Vic and Bob's idiosyncratic tune. In one
episode, a teen amateur boxer must punch a shed until he
reduces it to below the height of an Alsatian. A runner jogs on
a treadmill with Leo Sayer on his back, singing 'When I Need
Love'. While some family members look as bemused as some of
Shooting Stars' less savvy contestants, they are allowed in on the
fun, singing their own introductions at the start of the show.
Surreal touches include a 'challenge garment' worn by Vic to
signal the challenge round, such as a 'shoe within a shoe … if
only we had Voltaire to describe it for us'. *Families at War*'s
equivalent to *The Generation Game*'s conveyor belt of Goblin
Teasmades and other modest luxuries is to have Vic in a spider
suit (rasping 'I am the spider!') manipulated like a coin-
operated mechanical claw grabbing gifts at a fairground. In its
mix of family fun and trademark oddness, it's likely that *Families*
satisfied neither Vic and Bob's existing fan base or the more
mainstream one they seemed to be aiming for. Nevertheless, it
remains an intriguing oddity in their career.

Regional comedy revisited

> Their unapologetic use of phrases and terms that either were
> peculiar to their region, or seemed like they might be to people
> from the south, made the whole thing feel kind of true, even
> when it was anything but. (Jonathan Ross, quoted by Thompson
> 2004: 8)

Vic and Bob's pronounced regionality was a key component in
distinguishing them from the previous generation of comic
performers. Paul Whitehouse overstates the case a little when

he claims that 'there were no northern accents in comedy' in the late 1980s (Dessau 1999: 108) – Alexei Sayle was one of the most distinctive comic voices in the alternative scene. It is perhaps fairer to say that regionality was played down and that the 'northern' was to a certain extent tainted with negative connotations – Peter Rosengard identifies the 'northern club comics and their mother-in-law jokes' (Wilmut and Rosengard 1989: 2) as everything that the alternative comics offered relief from. In other words, while northern comedians were by no means invisible, 'northern comedy' carried a certain stigma. By contrast, the 1990s mark a return of the regional and a particular valuing of the 'northern', from the League of Gentlemen to Peter Kay and the work of Caroline Aherne and Craig Cash.

'Northern humour' is as much of a construction as the 'north' itself – a 'space-myth' (Shields 1991: 208) offering 'an undifferentiated unity no more diverse than the motorway signs to "the North"' (*Ibid.*: 207). And yet it clearly means something, given its pejorative connotations in the 1980s and the way that the 'north–south' divide once structured live comic industries – TV series like *Comedy Map of Great Britain* (BBC 2 2007) adhere to the notion that the *what* of comedy is inextricably connected to the *where*. Northern comedy had the reputation of being 'less brash' than its southern counterpart, more 'angled against the performer' (Wilmut 1985: 30). According to radio producer and writer James Casey, northern comics were less likely to 'kick down' in their humour:

> the traditional northern comic gets great sympathy. The southern comics ... were smart, they would basically tell you how they topped somebody. The northern comedian would tell you how he was made a fool of. (*Ibid.*: 169)

Reeves and Mortimer are closer to this tradition than the 'harder' northern comedy of the working men's club (which often had to hit harder to compete with the surrounding distractions of drinks and dinner – a contextual factor sometimes overlooked). This delightful routine from *The Smell of Reeves and Mortimer* locates them firmly within this tradition of the 'idiot' at large – Vic has bought a 'magic carpet' from a

'little lad' in a black and white suit:

> BOB: Did this little lad have wings like that? (*holds his arms out like a penguin's flippers*)
> VIC: (*quietly*) Yes, he did.
> BOB: And did he have webbed feet and what can only be described as a beak?
> VIC: (*sullen*) Yes.
> BOB: It wasn't a little boy at all, was it Vic?
> VIC: (*angrily*) No, it was a penguin, alright? You satisfied?
> BOB: (*exasperated*) Every time you go to that zoo, you get conned by those penguins!
>
> (2.2)

Northern comedy has been primarily a comedy of the north-west – Lancashire resonates particularly (with Blackpool as its Mecca and Morecambe giving its name to its most illustrious comic son). Reeves and Mortimer stood out because they were not only northern, but audibly from the north-east. If the north-east had any comic associations before that, it was with a certain unreconstructed lairy masculinity – *The Likely Lads*, the 'politically incorrect' *Viz* with characters like Sid the Sexist, Roy 'Chubby' Brown. Vic and Bob's world is resolutely homosocial to the virtual exclusion of women, but this is a more childlike, whimsical masculinity. Adult sexuality seems to have eluded them – Vic's would-be lecherous knee-rubbing in *Shooting Stars* may have been appropriated to more laddish ends but in context it suggested an uncertainty about what came next in the seduction process. Moreover, when the subject of homosexuality comes up, Vic has never heard of such a thing – 'You must think I'm stupid!' (*Smell* 2.5.) When Julian Hall ascribes a 'surrealist strain' to the north-east (2006: 227) – adding Ross Noble and *The League of Gentlemen*'s Mark Gatiss – this is probably not a 'strain' that would have been perceived to exist before Vic and Bob. Reeves characterizes north-east humour as 'taking something very trivial and taking it very seriously' (Dessau 1999: 51). When Dessau describes the Darlington accent as a 'soft, concerned' one, he supports the impression that Reeves and Mortimer fashioned a comic effect out of something that might have originally emerged without

conscious intent. This tone of disproportionate concern heightens shopkeeper Mr Dennis's antipathy towards the Curly Wurly ('I find them far too elaborate') or the catchphrase that Bob added to Series 2 of *Big Night Out* – 'Oh Vic, I've fallen' (following what might best be described as lowering himself carefully to the floor). When Bob castigates Vic for spoiling part of the show and letting down the audience, he adds sadly that 'some of them are pensioners'. Given that Hall can only marshal three examples of north-east 'surrealism', it's probably more the case that the juxtaposition of fantasy and mundane concern works to produce particular comic effects. The north-east accent has become much sought after by call centres and the Samaritans, and seemed to offer a narrational counterpoint to the tensions and tantrums in the UK *Big Brother* house. It has undoubtedly aided Sarah Millican's rise to being currently the most popular female stand-up in the country – her live act weds the companionable warmth of the accent with an impressive capacity for filth. Stuart Maconie ascribes the accent's pleasing musicality to a 'wow and flutter' in the vowels 'as if someone had stopped a vinyl record with a finger and then let it go again' (2008: 291).

For Jeff Nuttall and Rodick Carmichael, pre-alternative northern comedy had a symbiotic relationship with 'us' humour, the 'perpetual celebration of common factors' as opposed to the demonstration of superiority that defines southern 'me' humour (1977: 24). There are many reasons why that distinction is harder to maintain now, even though one could still find examples to support it – a comparison of Peter Kay with Jimmy Carr, for example. In this instance, it's telling that Reeves and Mortimer manifested an ostensibly northern comedy that initially blossomed as a south London phenomenon. While their accents and demeanour might still evoke 'common factors', this was something that only a select few would 'get' (and possibly enjoy others not 'getting') – Mark Lewisohn characterizes their humour as a series of 'private jokes' (2003: 645). The exclusiveness of this 'Big Night Out' comes more into focus when revisiting the comparison with the most successful of all northern double acts.

'Greatest British double act'

Eric, you've found your Ernie. (Fred Aylward (Les) allegedly to Vic Reeves, quoted by Dessau 1999: 170)

Two Christmases. On Christmas Day 1977, more than half the population of the United Kingdom tuned in to watch *The Morecambe & Wise Show* on BBC 1. On Boxing Day 1993, Reeves and Mortimer celebrated their first year with the BBC with a themed evening on BBC 2 that included favourite clips and episodes (*Rutland Weekend Television*, *Dad's Army*, *Meerkats United*), sketches featuring popular characters from *Smell* (Corbusier et Papin, the Bra Men, Slade) routines filmed at their 'home', and the debut of what would prove to be their most commercially successful show, *Shooting Stars*. Like the 1953 coronation, Morecambe and Wise have come to be one of the emblems of pre-digital 'one nation' television, 'when it was still considered desirable, as well as practiceable, to make a television programme that might ... excite most of the people most of the time' (McCann 1998: 5). *An Evening with Vic and Bob* meanwhile is self-consciously quirky and cultish, its most 'Christmassy' elements (Vic and Bob living in a large over-decorated house, log fire blazing) seemingly parodic. Three years earlier, in a piece entitled 'Greatest British double act', Paul Morley made the following characteristically extravagant claim:

If this was the better world, a world we could call our own, the Christmas Day BBC voice of the nation comedy celebration of self and society would be Vic and Bob's, not Russ and Bruce's. (1990: 34)[3]

This is a recurring fantasy amongst Vic and Bob's staunchest admirers – that they *should* have been the 'one nation' comics of the 1990s, or at least as close to it as the new TV era would allow. *At Home with Vic and Bob* is no 'voice of the nation comedy celebration', nor does it appear to seek to be. '[B]road-casting had changed', observes Dessau. 'No comedian could ever hope to unite a nation like that' (1999: 206). McCann, on the other hand, has little regard for 'the easy security of a "cult following"' when Eric and Ernie 'did their best to draw people

together rather than drive them apart ... always aimed to
entertain the whole nation' (1998: 6). Intriguingly, McCann's
and Dessau's books (at least in their first editions) were
published in the same year, bang in the middle of Ben
Thompson's second 'Golden Age' of British TV comedy. And
yet there is not one mention in McCann's book (either deroga-
tory or approving) of the double act seen as Eric and Ernie's
'cult' or 'postmodern' successors.[4]

In his discussion of the evolution of the double act, Michael
Bracewell compares arguably the two canonical pairings from
British TV comedy's 'Golden Age' – Morecambe and Wise and
The Two Ronnies. They represent the two templates for the
double acts that followed them – one pairing that performs
sketches and remains largely, if not entirely, in character and one
that performs a relationship. The 'Two Ronnies' model has
been easier to follow and is more visible in contemporary
comedy – Armstrong and Miller, Mitchell and Webb (who feel
more like the other type of double act in *Peep Show*), and above
all, *Little Britain*, once described by BBC 3 controller Stuart
Murphy as '*The Two Ronnies* for a sicker millennium'
(Thompson 2004: 441). The other type deploys music hall
conventions such as cross-talk, a designated 'straight man' and a
bond that in its combination of hostility and affection suggests
either the fraternal (literally in the case of Mike and Bernie
Winters) or the matrimonial. There is, according to Bracewell,
'a soft core of domesticity at the heart of most double acts'
(2002: 319) manifested as a 'mutually dependent but frequently
arguing couple' (*Ibid*.: 320). Eric and Ernie's domestic bond
was most evident in their bed-sharing, while Dessau points to
the way that Vic and Bob 'bickered with each other but then
ganged up on anyone else who tried to assert themselves' as
suggestive of a marriage (1999: 132). The double act that
performs a relationship has been harder to find since
Morecambe and Wise, perhaps because it was perceived as being
devalued by some of their poorer relations such as Little and
Large and Cannon and Ball. Rik Mayall and Adrian Edmonson
largely channeled the sado-masochistic love-hate side of their
comic relationship into sitcom, rather than a front-stage double
act. The other most popular double act of the early 1990s,

Newman and Baddiel, performed sketches together but stand-up separately. Baddiel would form a stronger homosocial bond with Frank Skinner in *Fantasy Football League* (BBC 2 1994–96) and *Baddiel and Skinner Unplanned* (ITV 2000–5), but their domestic bond (they were known to have shared a flat in real life) lacked the comic tension of a double act proper, even if Skinner's quicker wit forever condemned his friend to the unenviable status of 'straight man'. Stewart Lee (sarcastic, cynical) and Richard Herring (childlike, hopelessly ill-informed) felt more like a classic double act, but would go on to achieve greater success later as solo acts – that they were commercial also-rans to Newman and Baddiel now seems one of the injustices of early 1990s comedy. Each episode of the first series of *The Mighty Boosh* commences with front-of-curtain cross-talk between Howard Moon (Julian Barratt) and Vince Noir (Noel Fielding) as if to underline that the real heart of the series was not its excursions into fantasy and pop-cult savviness, but the antagonistic 'marriage' between the deluded 'jazz maverick' and the shallow Goth hipster.

The shift in billing from 'Vic Reeves' to 'Reeves and Mortimer' suggests an initial (and in some respects, ongoing) uncertainty about their status as a double act. In the live *Vic Reeves Big Night Out*, Mortimer was one of a number of collaborators and it seems to be specifically on television that the notion of him being Vic's 'Ernie' came to fruition. In the first episode of *Big Night Out*, Bob does not appear as 'himself' at all. During Vic's opening song 'I'm a Believer', Bob is dressed as Isambard Kingdom Brunel, holding a stuffed Husky under his arm. He then goes on to play the Man With the Stick, Donald Stott and Judge Nutmeg, but makes the biggest impression as Lister, pushing lard through the face of 'the pop star Mickey Rourke' on Novelty Island.

> VIC: Mickey Rourke's not a pop star, he's a film star.
> LISTER: (*indignant, but trying to keep his temper*) Mickey Rourke is a pop star.
> VIC: He's not, he's a film star.
> LISTER: Shut it, Reeves … I asked my newsagent this morning. If you care to take it up with him, do. I advise you not to.

This will be one of the most compelling relationships in *Big Night Out* as Lister returns weekly to Novelty Island, with a growing sense of entitlement and self-righteousness ('You are dealing with Lister'), not to mention a series of increasingly lamentable acts (Nibbles the Comedy Duck regurgitating shrimps while Vic recites 'any of the Ten Commandments'). Lister craves recognition and status ('I know doctors and dentists'), but seems forever fated to be thwarted by 'the fop'. When he wins Novelty Island at the end of Series 1, to Vic's horror, he is exultant :

> Victory is mine! The truth is out, Reeves – no longer the smug get, eh? Quality has prevailed and the voices in my head are silenced.

(1.7)

Lister is a beautifully realized character locked in permanent conflict with his nemesis. He's also the earliest indication in *Big Night Out* that if Vic was the star and possibly greater authorial force then Bob was the more versatile performer. *Big Night Out* script editor Jack Docherty is credited with recognizing that this was a double act (Dessau 1999: 118) but it takes a while for that to be entirely apparent in the first series. From Episode 2, Mortimer starts to make brief appearances as 'Bob' but continues to make the biggest impression as Lister and other characters. At the end of the second episode, he impersonates Rick Astley, his song interrupted by Vic dressed as Eric Morecambe, shouting 'Wa-hey!', waggling his glasses and slapping Bob/Rick's face. It's a slightly self-conscious scene (reworked in the final episode of Series 1, with Bob this time as Nigel Kennedy) as though to signal an emerging dynamic between them. By the end of the series, running references to various 'Reeves and Mortimer' products start to underline a progressive equalization of their status. In the first episode of Series 2, Bob has his first 'fall' and thus gains his first catch-phrase as himself. A competitive edge creeps into their relationship. When Bob finds Vic building an airfix kit as the climax to the show (2.2), he compliments him to his face but mocks him internally. Vic 'hears' these derogatory thoughts and comes back with an internal retort and their thoughts stage a

battle of insults. In another episode (2.7), Bob notices that his desk is of a poorer quality that Vic's and he livens it up – 'I've got this pipe which comes quite near this pen, which I've inserted in an onion. But best of all ... I'm now offering a news service as well.' Sure enough, he's added a worn piece of wood with 'News Service' written on a serviette and two headlines glued on – 'Australian Gold Medalist in Hospital' and 'Oil Change'. Vic judges Bob's desk to be 'very poor' (another catchphrase – pronounced 'poo-or') but again his internal monologue suggests the opposite – 'The thing is, I think it's an absolutely *brilliant* idea, especially the news service, and it makes my desk look really dull.' He hatches a devious plan to take Bob's desk as his own.

Who is 'Eric' and who is 'Ernie' in this relationship? If anything, it's Lister who most resembles the 'Ernie' fashioned by Morecambe and Wise's best writer Eddie Braben – a small man with big dreams (Lister refers to 'my little world'), 'a simpleton posing as a sophisticate' (McCann 1998: 214). The only difference is in the poverty of Lister's big dreams – Ernie seeks cultural elevation through 'the plays what I wrote', while Lister can imagine no greater accolade than the approval of doctors and dentists. While we were left to imagine Ernie's 'short fat hairy legs', Lister's bare legs are visible underneath his raincoat to suggest something rather more unsavoury than the nation's favourite double act might have felt comfortable with. McCann characterizes Braben's 'Eric' as 'the fast-talker, the free-thinker, the face-slapper, sharp-witted but unfocused, naughty and saucy, an irresistible misfit ... devious and dangerous' (*ibid.*). Bracewell may be right to see Morecambe and Wise and The Two Ronnies as the two classic British double acts, but it's worth remembering that The Two Ronnies only recently came back into favour and were once mocked by *Not the Nine O'Clock News* in a manner that suggested they were no better than other unfashionable light entertainers like Benny Hill or Dick Emery. That Morecambe and Wise never suffered such a spell in the critical wilderness perhaps has less to do with the comparative lack of sexism and smut than the way that Eric Morecambe remained so irresistibly modern, even in the sometimes dated surroundings of the shows (the musical inter-

ludes, in particular, are postcards from another time). Eric is anarchic, unpredictable, simultaneously plain-speaking and razor-witted. In Nuttall and Carmichael's terms, he blurs the 'me' and the 'us' – sufficiently a man-of-the-people to appeal widely, but faster on his feet than we could ever hope to be, playing all the right notes 'but not necessarily in the right order' (a line rightly celebrated as Braben/Morecambe's best). There are aspects of this to both Vic and Bob. Vic's manner is more suggestive of Morecambe and the respective heights of the two pairs invite us to see them that way round. But Bob gets the better of Vic as often as the other way round, trapping him with childishly simple tricks:

> BOB: Vic, have you farted?
> VIC: (*indignant*) No!
> BOB: What, never?
>
> (*The Smell of Reeves and Mortimer* 2.1)

Bob makes particularly lethal use of that 'concerned' accent, which always carries within it the possibility of mockery. But he can play the delusional idiot, too, such as the sequence in *Bang Bang, It's Reeves and Mortimer* where Vic reads out the letter to a movie mogul stolen from Bob's Scooby Doo bag:

> Dear MGM Movie Mogul. I want to be a big star. I am a 25 year old hunk and have seen the following movies – 1. *Indiana Jones* 2. *Pickwick Papers*. I have the following skills – 1. Rock hard fire and 2. Monkey trainer. P.S. Although I am not bent, I am willing to do stuff to get to the top.
>
> (Episode 1)

According to Michael Grade (who would bring Vic and Bob to Channel 4), Morecambe and Wise were 'the first double-act to develop an intimate style, they were the first to talk *to* one another, to *listen* to one another ... the first ones to really have a proper relationship on stage' (McCann 1998: 81). To this, Braben added 'his own kind of comic *riff* ... like jazz pieces, "word riffs"' (Frank Muir quoted by McCann: 207) and located them in a coherent world implied beyond the stage and sometimes shown when we saw them at home. Reeves and Mortimer would re-work the intimacy – the double act as

coherent relationship – and add their own 'word riffs', most visibly from the second series of *Vic Reeves Big Night Out* to the first series to cement their double act status in its title, *The Smell of Reeves and Mortimer.* Their roles might 'rotate by the minute' (Dessau 1999: 190) – no one seems to want the thankless role of 'straight man' these days – but were strangely coherent. Their 'world' would be fashioned from light entertainment, pop culture minutiae, art school eccentricity and the remnants of dialect humour ('you lyin' get!') Their own 'riffs' were very much their own, a combination of the regional, the archaic and the 'surreal' ('I don't know about you, but about this time of night I like to slip a petri dish under a squirrel').

Surrealism

'Oh, I fucking *hate* that word,' splutters Mark Gatiss in a documentary about the making of the third series of *The League of Gentlemen* (BBC Choice 2002). 'Is Dali in it?' He's responding to an unsympathetic review in the *Daily Mail* that concludes 'Perhaps I need to be taught surrealism.' The word 'postmodern' is thrown around with equal abandon in discussions of contemporary comedy – Lewis Jones complained of *Big Night Out* in the *Daily Telegraph* that 'the more unfunny it was, the funnier the audience found it. That's postmodernism for you' (1991: 20). Given that postmodernism is partly defined by its very slipperiness, its proponents shouldn't be too upset at it being bandied about so carelessly. Surrealism has arguably accrued a certain slipperiness, too, as it has passed through various media forms. Andre Breton's 1924 manifesto identifies the essence of the surreal as the 'belief in the superior reality of certain forms of associations hitherto neglected, in the omnipotence of dreams, in the disinterested play of thought' (Breton quoted by Walz 2000: 5), although there are other versions of surrealism such as René Magritte and the Brussels Surrealists. As Robin Walz points out, surrealism wasn't just something that its proponents created, it was something to be *discovered* – in popular culture such as *Fantomas* novels, for example (2000: 6). We perhaps shouldn't be surprised then to find the term applied to comedy produced by people who would not regard their own

work as surrealist. Surrealism is sometimes very funny precisely
because it shares with comedy the quality of *incongruity* –
comedy that is judged 'surreal' tends to push incongruity to
extremes. In effect, then, the universes of *Monty Python* and
Luis Bunuel are not always so different. Bunuel and Dali's *Un
Chien Andalou* (France 1928) treats us to a man overcome with
lust who cannot reach his object of desire because he suddenly
finds himself dragging a piano, a dead donkey and two Catholic
priests. My students invariably laugh at this scene in class, even
after having flinched from *that* eyeball or expressing mild
disgust at ants emerging from a hole in someone's hand.
Bunuel's later episodic French films feature scenes that Chris
Morris would kill for – the social conventions and taboos
surrounding eating and defecation reversed at a party where
guests sit on toilets around a table but shut themselves in a
cubicle to eat, a 'missing' child who is visibly in the presence of
her concerned parents and even converses with them (*The
Phantom of Liberty*, France 1974.) Terry Jones's description of
Monty Python's structure/non-structure sounds not unlike the
apocryphal tale of how Dali and Bunuel conceived their *success
de scandale* – 'We had the idea of a flow, one thing leading to
another by association of ideas' (quoted by Thompson 1982:
35). In both cases, this produced a structure of interruption – in
Python's case, sketches that overlapped or disrupted one
another. In his eccentric quasi-religious take on comedy, Peter
L. Berger characterizes the 'surreal effect' as 'a view of reality as
full of immense incongruities reaching all the way to divine
Throne' (1997: 94). If we take the 'divine Throne' out of the
equation (and I think we probably should), we might arrive at
what Murray S. Davis calls 'an energizing strange *parallel
universe* in which elements incongruous to our original universe
are congruous' (1993: 311): a universe where, for example, the
audience is asked to show its appreciation for a selection of
habitable structures:

> A big round of applause for the Victorian terrace house! [studio
> audience applaud] And a round of applause for the post-war semi!
> [more applause] The prefab portaloo! [applause] And let's not
> forget the tithe barns, ladies and gentlemen! [further applause].
>
> (*Big Night Out* 2.1)

All of this suggests that there is something that we might reasonably call 'surreal humour', even if it arrives at its extreme incongruity by a different route. Comedy is likely to be less 'automatic' than the practices Breton had in mind because the intention to produce laughter requires some conscious design (but then, I doubt that much surrealism, *Un Chien Andalou* included, springs quite as directly from the unconscious as it might like us to think). Gatiss's ire seems to have been roused by a more casual useage in which 'surreal' is simply a synonym for the strange. When we hear someone say that something 'surreal' happened to them, we rarely assume that it involved melting clocks or elephants on stilts – rather, that it was in some way incongruous or bizarre. I would venture that what routinely gets categorized as surreal comedy falls into one of the following four categories.

Whimsical flights of fancy. Anthony Easthope identifies 'a tendency towards fantasy and excess' as one of the three corner-stones of (specifically) English humour, alongside irony and 'the exposure of self-deception' (1999: 163). He never satisfactorily resolves where that leaves his contention that the English are characterized by relentless empiricism, except to imply that it offers an escape from such national constipation.[5] Music hall and variety already contained acts that Oliver Double locates 'somewhere between whimsy and pure surrealism' (1997: 153). There's Max Wall's Professor Wallofski playing piano 'with the aid of an AA map and a spirit level' (Wilmut 1985: 221) – is that the first comic usage of the spirit level? Les Dawson, meanwhile, evokes a 'surreal kind of marital disharmony' (Double 1997: 129) – when 'the wife's mother' (a funnier phrase than 'mother-in-law', for some reason) comes to stay, the mice throw themselves on the traps. While he can occasionally veer into the grotesque, representing Channel 4's controller as a ventrilo-quist's dummy forever wailing 'Why do they stare?', Harry Hill's 'surrealism' is largely in the vein of whimsy – a fly suffering a mid-air heart attack has his heart restarted by crashing into an electric fly-killer. Anthropomorphized animals are rarely far from Hill's comic universe, from his Channel 4 series' weekly Badger Parade to his deliberately poorly realized

(and ventriloquized) puppet cat Stouffer, who goes limp whenever Harry's attention wanders. Vic and Bob are equally committed to the comic potential of animal puppets, from Morrissey the Consumer Monkey to a dog with the unlikely name of Greg Mitchell.[6]

Incongruous juxtapositions. 'It's just ironic juxtaposition at the end of the day,' Vic Reeves observed of his own comedy. 'It's the oldest form of comedy going' (Dessau 1999: 137). Kevin Jackson made a similar observation less sympathetically in the *Independent*, identifying a formula for 'British comic surrealism':

> think of a humble domestic object (such as a bowl of custard), then of an appropriately exotic animal (such as a Brazilian puma), and finally come up with some activity and setting to link the two, as in 'a pack of Brazilian pumas rag-rolling the walls of the Sistine Chapel with a bowl of cold custard'. (1990: 32)

Some of Vic and Bob's surreal juxtapositions are exactly as formulaic as this – 'Milli Vanilli trying to create negative gravity in their tights' (*Big Night Out* 1.3). Others, meanwhile, are strange without necessarily being very funny – one of the drawings on the Man with the Stick's hat reveals 'a shepherd's eyeball blocking up the exhaust of the mayor's helicopter' (*Big Night Out* 2.1). But others add additional felicities to the mix such as this variation on a weekly routine in *Big Night Out*:

> VIC: You would not *be-lieeeeeeeve* what's going on round the back there now. There was Large out of Little and Large and he was examining the couplings twixt two railways carriages to see if there was any possibility of them being made into a smart belt. And, you know (*oily, insincere smile at audience*), I'm sure there's every possibility.
>
> (2.1)

The gag adds the pop culture (specifically a dated or unfashionable pop culture reference) that is missing from Jackson's alleged formula. Vic delivers it as though he's making it up as he goes along (which may or may not be the case) – it has all the characteristics of a *riff*. What raises it above some of the other

routines like this are words and phrases like 'couplings', 'twixt' and 'smart'. 'Couplings' suggests a man who knows just a bit too much about the mechanics of the railway, while 'twixt' is an exotically archaic word (and sounds even funnier in a Darlington accent). The couplings aren't destined to simply form a belt, but a 'smart' belt. 'Smart' is a word that has lost its currency as a compliment – a shop promising 'smart clothes' is not destined to attract the fashion-conscious. It's a word that Vic's young audience are likely to associate with older relatives.

Non-sequiturs. 'I'm pleased to see the Red Arrows are still flying formation. Makes my job a lot easier,' observes Vic from behind his desk in the first episode of *Big Night Out*. The non-sequiteur has lost its contextual bearings, but in the case of 'surreal' humour the pleasure also derives from the knowledge that no context could possibly drag these observations back to the world of logic and order. Instead, they are snapshots of this 'parallel' universe. 'If the geese ever invade again, we'll be ready for them, won't we?' insists Harry Hill in his 1995 live show, the 'won't we?' making the audience complicit in this silliness.

The grotesque. As the *Daily Mail*'s comment about *The League of Gentlemen* suggests, 'surreal' comedy can refer to material that embraces the grotesque and even borders on the disturbing. This is a feature of some of the acts on Novelty Island – Hugh the Heretic is a cloaked figure above whose shoulders a doll's head rotates on a stick (*Big Night Out* 1.1). As *The Smell of Reeves and Mortimer* and *Bang Bang, It's Reeves and Mortimer* incorporated more sketch material, this dimension became more prominent. A series of atmospheric sketches in period settings in *Smell* reveal mysterious figures with vegetable body parts, followed by an incongruous on-screen caption – 'Cauliflower 55p', for example. *Bang Bang* has a series of running sketches in which Vic and Bob park their car between two other objects and can't get their doors open; this always leads to the death of an incidental character, an egg popping out of their mouth as they expire. From *Smell* to *Bang Bang*, the cartoon violence derived from Mayall and Edmondson moves in an increasingly bizarre direction. This

culminates in a strangely troubling fight in the third episode of
Bang Bang. Vic stretches Bob's tongue and rubs it between his
legs, then applies washing pincers to his testicles, forcing him
into a washing machine head first. Bob retaliates by driving Vic
into a spindryer with a rounders bat. Vic emerges with his head
horribly misshapen, one of his eyes halfway down his cheek.
Most episodes end with the Stotts' celebrity interviews, leaving
their guest sitting awkwardly alone on the sofa as the end music
plays. But in this episode, the credits and serene end music play
over Bob beating a now disfigured Vic with a bat and laughing.

Some of the most celebrated sketches in *The Smell of Reeves
and Mortimer* are the spoofs of contemporaneous light enter-
tainment programmes such as *Stars in Their Eyes*, *Noel's Telly
Addicts* and *Masterchef*. The celebrity impersonation or carica-
ture generally works by exaggerating a recognizable
characteristic of the victim. Bob's Noel Edmonds and Matthew
Kelly partially conform to this – Edmonds's forced jollity
becomes a mirthless expelling of air that no longer resembles a
laugh, while Kelly's sartorial loudness is magnified into a
waistcoat bearing lightbulbs. But other aspects of these imper-
sonations seem to have emerged less from satirical intent than a
stranger corner of Reeves and Mortimer's imaginations. As
Edmonds, Bob dons a flesh-toned, hairy-chested bodystocking
stuffed with padding to give the impression of protruding bones
(1.4), while Kelly has a small gallows on his head (2.1). But it is
Vic's Loyd Grossman in *Masterchef 1995* that really takes this
approach to impersonation to its furthest extreme. One can only
speculate that it was Grossman's lugubrious voice that somehow
suggested this *Nosferatu*-like figure, with a huge bulbous head,
trousers rolled up to the knee and a knife and fork extending
from each index finger. When 'Loyd' moves around the set, he
floats on air, accompanied by a tolling bell. His contestants are
equally bizarre – a woman who has made the face of Jesus out of
fried eggs (the eyes), a sausage (mouth), tomato (nose), crinkle
chips (eyebrows) and her own severed ears to top it off; a man
presenting a 'cakey shoe … it's a shoe-cake, a cake like a shoe!'.
The credits roll over Grossman pursuing the 'winning dish', the
owner of the naked buttocks that have earlier been displayed on
a plate. This is a version of the grotesque – one that hovers

between the comic and the disturbing – that I shall return to later in the chapter on 'dark comedy'.

Art into pop into comedy

According to PBJ's Caroline Chignall, 'Vic and Bob didn't really come out of the comedy world: what they were doing seemed to be referring more to art and pop traditions' (Thompson 2004: 16). Comedy's status as the 'new rock'n'roll' in the 1990s had precursors such as the *Monty Python* team being marketed in the US as 'the Beatles of comedy – youthful and exuberant, violating norms, experimenting with media, and introducing new forms and styles' (Landy 2005: 28). American stand-up has not lacked comics with a self-destructive rock star aura, from Lenny Bruce through Bill Hicks to Doug Stanhope. In 1990s Britain, the rock aura often amounted to little more than a resemblance to contemporaneous indie bands – in one live show, Rob Newman arrived onstage carrying a guitar that would not be touched again for the remainder of his act. If Python were 'the Beatles of comedy', Bruce Dessau briefly toys with an intriguing point of comparison for Vic Reeves – fellow north-east art school boy made good Bryan Ferry (1999: 58).[7] The art school connection is important in distinguishing Reeves from most of comedy's other pop pretenders. In an influential study of the art–pop relationship in British culture, Frith and Horne credit the art school tradition with contributing 'bohemian dreams and Romantic fancies' to British pop music (1987: 73). Even the 'hip' or ironic take on music hall has precursors in British pop art and psychedelia, most famously in Peter Blake's *Sergeant Pepper* LP cover or his 'sentimental use of the old English designs of fairground machinery and shop fronts' (*Ibid.*: 104). Frith and Horne judge Ferry to be 'systematic in his application of Pop theory to pop music', deploying 'throwaway clichés and amusing phrases that you found in magazines or used in everyday speech – stylistic juxtapositions' (*Ibid.*: 115). Dessau suggests that Reeves did something similar, but the source and the use of these clichés and phrases is quite different. Ferry looked to the worlds of fashion, advertising, classic Hollywood, mass-produced artefacts – the raw material

of pop art – while Reeves re-contextualized the detritus of light entertainment and regional clichés that became comic out of context, most famously 'You wouldn't let it lie!'. Both, of course, were notable dandies – or fops, as Lister might put it – sharply dressed and immaculately presented, usually in a self-consciously retro style (Ferry's white tuxedo, Reeves's Edwardian collars). When Reeves performed 'The "In" Crowd' while pushing a vacuum cleaner in *Big Night Out* (2.6), it was Ferry's definitive arrangement he adopted rather than Dobie Gray's 1965 original. There is even an uncanny similarity between the way Ferry curled his lip in early 1970s 'lounge lizard' mode and Vic's facial contortions when saying 'uvavu' or 'eranu' on *Shooting Stars*. What Ferry and Reeves ultimately shared was the sense of a fully designed world fashioned around pop and comedy respectively, whether the pop art glamour of Roxy Music's album covers or Vic's surreal drawings and 'homemade' approach to make-up and costuming.

When Harry Hill performs pop songs, the comic effect lies in his awkward 'daddishness'. He shares with Vic, too, a fondness for accompanying cover versions with jarringly mundane or eccentric activities; chopping fruit with a machete while singing James's 'Sit Down', for example. Reeves's comic main weapon when performing cover versions is his accent – its exaggeration is the main thing that keeps his collaboration with The Wonder Stuff on 'Dizzy' from being a fully fledged bid for rock stardom. When the song formed the climax of the post-*Big Night Out* tour, audiences would dance to it as if at a music gig. The tone of his earlier hit 'Born Free' seems more ironic, the comic at odds with the easy-listening classic and performing a strange spoken section that provides background information on the song. In the cover versions in *Big Night Out*, there is a tension between the comedy and the dynamics of a less ironic rock performance. The 'liveness' adds an excitement and energy to the music – 'Dizzy' simply took this a stage further. When *Big Night Out* showcased an original song, the effect was different – 'I Remember Punk Rock', a cheesily nostalgic song, reduced anarchic pop to banalities about 'Mr Buzzcock on my shoulder/Singing in his own special way'(2.3).

The pop/art/comedy connection is at its most fruitful in the

opening song in the first episode of *Smell*. The song runs through a series of surreal images that 'constantly irritate our minds' – 'Like a sardine in a hairnet and he's staring at a priest' is one such mental irritant. Each of these images is illustrated by one of Vic's distinctive drawings popping up or rotating between the Greek pillars in the series' main set. Each verse is punctuated by the final image popping up just behind or in front of Bob, striking him with a satisfyingly hyperbolic crunch. While a number of comedians aspired (all too desperately, in some cases) to rock star allure, the art–pop connection would not be applied so fruitfully to British comedy again until the whimsical psychedelia of *The Mighty Boosh*.

Postscript: experiments in sitcom land

One of the distinctive features of Reeves and Mortimer's career is that while they remained a cult phenomenon, their most lasting achievements have been in adding their distinctive art–pop sensibility to light entertainment formats. In terms of commercial success, it is telling that a revival of *Shooting Stars* would be the vehicle that recaptured some of their former popularity, in spite of their apparent ambivalence towards the series (Dessau 1999: 283). But the duo have also made several attempts at fashioning a sitcom format, with mixed but usually interesting results. 'The Meat Festival' was the pilot episode of the unmade sitcom *The Weekenders* (Channel 4 1991), one of a series of pilots broadcast under the title *A Bunch of Fives*. Made on the back of the success of *Big Night Out*, it feels more like a sketch that outstays its welcome than a format that has legs for sitcom longevity. That said, much of its first half is frequently inspired, such as an escalating visual joke about a pint glass sticking first to a beermat, then tearing off part of the table's surface before finally lifting the entire table as Vic (here playing 'Jim') drains the final dregs. Some of the most reliable gags again fall back on classic double act cross-talk.

> JIM: What do you think you're doing throwing partially drunk milk bottles through my window?
> BOB: Well, you haven't got a doorbell, have yer?

JIM: I *know* we haven't got a doorbell, but you could have knocked, couldn't you?
BOB: No, I couldn't actually 'cos I've sprained me wrist.
JIM: Have yer? How'd yer do that?
BOB: Throwing a bottle through the window.

In an otherwise patchy second half that is more self-consciously strange than funny, there's another delicious reminder of their music hall antecedents:

BOB: Jim, you're an honest man, a nice man, right? A pleasant fella. But you're a gullible, guileless simpleton, aren't you?
JIM: (*laughs idiotically*) It's true, man!

The Weekenders is most successful when it plays on their established double act personas, but struggles to establish a narrative world for them. They would have more success in the format by playing more obvious 'characters'. Paradoxically, it would be in a sketch format that Reeves and Mortimer would find another, indirect, route into sitcom. *Bang Bang, It's Reeves and Mortimer* adopted the mock-doc format for 'The Club', a weekly visit to Baron's, 'Hull's top nightclub'. The first sketch provides most of the best jokes, dealing with the club's upcoming Erotic Night. The club's erotic ambience is given dubious enhancement by knickers sellotaped to bar stools, tights hanging from the bar and a cocktail called 'Simply the Breast' that tops vodka off with a chicken breast. What *Catterick*, their second attempt at sitcom, takes from 'The Club' is not its 'mock-doc' format (largely played out by then anyway), but some of its characters. Carl and Chris Palmer, the two bouncers at Baron's nightclub, become the separated brothers at the centre of *Catterick*, in which Carl returns home in search of his abandoned son. *Catterick*'s Carl (played by Bob) is a rather different one from the version in 'The Club', but Chris survives the transition unchanged. Heavy of beard and rather less than bright, Chris's slightly intimidating appearance belies his child-like innocence (with hints of autism). In *Catterick* he is first introduced staring with serial killer intensity at a large widescreen television before an alarm clock stirs him to action. His default response is 'I know!' (pronounced 'I kner!'),

a sometimes slightly defensive utterance that suggests he not only doesn't understand but doesn't expect to understand most of what is said to him. While Chris is a larger-than-life grotesque, Vic gives him a more visible emotional life than in his earlier, broader characters. What Chris is most defensive about is his intense love for his brother – he brings him some unimpressive flowers for their initial reunion, thinks better of it and drops them on the floor, claiming that they were 'just there'. At its best, *Catterick* pursues a dark character-based comedy that shares a sensibility with *The League of Gentlemen*. As if to underline the influence (which arguably went both ways), two members of the League appear in *Catterick*. Mark Gatiss is confined to a cameo as a weaselly shop assistant, conning Carl out of his money with a series of unlikely and increasingly self-contradictory sob stories. Reece Shearsmith is a more substantial presence to the point of stealing the show as psychotic mother's boy (and, it turns out, Carl's son) Tony. We first encounter him using a nostril hair remover with an intensity normally reserved for heavy machinery, then flossing his teeth until they bleed, eyes filled with rage. When Tony affects polite normality in search of information, the words come quickly like a well-rehearsed speech that he must rush through before he loses control. His face visibly struggles to remain affable, and the threat is poorly concealed. More often, he lurches unpredictably between brittle bonhomie and naked aggression – a pleasantry such as 'Thanks for your help' is suddenly loaded with impending violence. In the first episode, Tony holds up a used car dealer's, torturing its salesman with the nostril hair remover before shooting him. His murderous intentions towards Carl and Chris are prompted by them stealing the car containing the stolen money during a supposed test drive. Not all of *Catterick* is as successful as this and Vic and Bob seem fated to produce curate's eggs in the sitcom format. Matt Lucas's Asian-accented hotel owner with a severed penis preserved in a jar is one thing, but in another seeming nod to *The League of Gentlemen*, Reeves, Mortimer and Lucas double up as other characters. Vic's American police inspector Keith Fowler is effectively Kinky John from 'The Club', with the same milk-bottle glasses, padded mouth and 'New Yoik' accent. It

isn't just Fowler's mouth that feels padded here – rather, a sense that again, Vic and Bob can't quite make the distance in a narrative format and throw in characters better suited to sketch comedy. *Catterick* and *Shooting Stars* represent the two sides of Reeves and Mortimer's recent work – a flawed but sometimes brilliant attempt at something new and an enjoyable but unadventurous return to a proven success. Nevertheless, both vehicles testify to the ongoing importance of arguably the most important British double act of the last thirty years.

Notes

1 Each week at pretty much a set point, Vic halts proceedings to tell an excruciating punning joke met with (rehearsed) appalled silence by the contestants, a tolling bell and literal tumbleweed blowing through the set. With flawless timing, Bob then proceeds to explain the rules of the next round as though nothing has happened. It's the same joke every week, but it never stops being funny.

2 Lamarr's spot was later filled by Will Self and, for the series' recent return, Jack Dee – sardonic, bordering on hostile, indifference seemed to be the job description for the role.

3 The Russ and Bruce in question being Abbot and Forsyth.

4 The connection came full circle in the TV biopic *Eric and Ernie* (BBC 1 2010), in which Reeves (billed as Jim Moir, his real name) played Morecambe's easy-going father.

5 Interestingly, both Jenny Eclair and Jo Brand both see surreal comedy as a very male tradition, an avoidance of more confessional or emotionally expressive humour (Oddey 1999: 23, 291).

6 *TV Burp* continues with the puppets, most notably Knitted Character, who joined Harry as a character in the re-launched *Dandy* comic. Bestowing singularly prosaic names on fanciful creatures is a popular device in this type of humour; Hill is fond of the name Alan (given to a series of ill-fated dogs in *Harry Hill's Fruit Fancies*), Reeves and Mortimer also have Alan Davison the Cheeky Foul Mouthed Fox and more recently *The Mighty Boosh* introduced the octopoid shaman Tony Harrison.

7 Technically, Reeves did a foundation course, but his work still exhibits an art school sensibility.

'Careful now':
Graham Linehan – a case study
in post-alternative sitcom

For the alternative comics of the 1980s, the sitcom seemed to particularly represent all that was bland and conservative about TV comedy – something to be deconstructed in *The Young Ones* or extended more imaginatively in the different incarnations of *Blackadder*. However, in some ways, the genre underwent more significant changes in the late 1990s and early 2000s – the heightened naturalism of *The Royle Family*, *The Office* and *Gavin and Stacey*, the stylistic quirks of *Peep Show* and *Green Wing*, the retro-fantastic of *The Mighty Boosh* (never categorized as a sitcom, even though it clearly is), the pervasive trend for single-camera shows with no studio audience. It might seem perverse, then, to focus here on a figure who in many ways seems to have resisted these developments. His most recent sitcom *The IT Crowd* is filmed three-camera style in a studio in front of a live audience – he describes it as 'like *Father Ted* before it, just a device for generating laughter' (Linehan 2007: 2). Why Graham Linehan then? Firstly, like Reeves and Mortimer, he seems to me to highlight the gap between popular and journalistic perceptions of recent comedy (*Father Ted*'s 'classic' status) and the priorities of academic work on TV comedy. As Brett Mills observes, 'the academic community seems much more comfortable writing about ... "comedies of distinction" rather than "traditional sitcom", and does so using criteria which foregrounds those aspects of such programming which most actively distinguish them' (2009: 134). Of course, this book is complicit in that practice, too – in demarcating 'cult

comedy' as its focus, it betrays its investment in the 'distin-guished' and the 'special'. However, one of the characteristics of the post-alternative era is its complication of the relationship between 'distinction' and the 'traditional' – like Vic Reeves and Harry Hill, Linehan manifests a blurring of this line. On the one hand, most of his work has appeared on either BBC 2 or Channel 4 (all four sitcoms he authored or co-authored were made for Channel 4). On the other hand, he has consistently stressed the attempted inclusiveness of his writing:

> That's my aim at the moment, to make television where the dad doesn't have to get up and make a cup of tea out of embarrass-ment. I don't see why something can't be aimed at everybody and still work. (Musson 2007: 21)

There is, however, an interesting paradox in Linehan's output. His non-sitcom writing – mainly on sketch and satirical shows – has sometimes been at the forefront of what might be seen as some of the more innovative and challenging forms of TV comedy in the last two decades. With co-writer Arthur Mathews, Linehan contributed to several Chris Morris projects – *On the Hour* and *The Day Today*, *Brass Eye* (including the paedophile-themed *Special*, from which Linehan had his name removed)[1] and *Jam*. Linehan and Mathews also created their own sketch show *Big Train* (BBC 2 1998, 2002 – Mathews wrote the second series without Linehan), which used some of Morris's stock company (Kevin Eldon, Mark Heap, Amelia Bulmore, Julia Davis, Rebecca Front).[2] It shared some of Morris's formal qualities, too – a 'mock-doc' shooting style, a lack of obvious punchlines, a semi-naturalistic acting style. *Big Train* is stranger, more oblique and sometimes darker than Linehan's sitcom work, albeit with the populist addition of recorded laughter.[3] *Big Train*'s style – a mix of surrealism and naturalism – is eccentric and potentially alienating in the same way that *Monty Python* was. But Linehan's conception of sitcom is clearly very different – it is a form of 'entertainment' with some quirky touches that show the influence of alternative comedy. With the exception of some of *Father Ted*'s (relatively mild) digs at Catholicism, it has 'nothing to say' – it is 'a device for generating laughter'. However, achievements in generating

laughter are valuable in themselves and too often overlooked in writing about comedy. Academic work on British sitcom has prioritized two qualities in particular – a social realism that allows the sitcom to be seen as a kind of drama (the gritty tragi-comedy of *Steptoe and Son* or *The Office*) or whatever 'innovation' is permitted by the restrictions of sitcom as a format (the 'anti-sitcom' of *The Young Ones*, the stylistic quirks of *Peep Show*). It is little surprise, then, that *The Royle Family* (Medhurst 2007: 144–158) and *The Office* (Mills 2004a and 2005; Walters 2005; Gray 2009; Hight 2010) have loomed so large in recent critical writing – and it is not my aim to downgrade the achievement of either series. However, Linehan has a distinguished and successful track record as writer or co-writer of sitcom, even if it is harder to claim him as an 'innovative' writer who pushed the genre in new directions. Far from being regarded as a 'sitcom luddite', swimming against the tide of the single-camera recorded laughter-free series, he seems to have recently assumed the status of a kind of sitcom 'guru'. He has given masterclasses on sitcom writing (at the Edinburgh International TV Festival), while the DVD commentary on Series 4 of *The IT Crowd* is framed as 'A Guide to Sitcom Writing'. At the 2009 British Comedy Awards, he was given the Writers' Guild Ronnie Barker Award. Some of this can be attributed to current 'back to basics' attitudes towards sitcom, but at the same time few recent writers have been as consistent as Linehan in this area.

Several other factors make Linehan of particular interest. Firstly, he complicates the 'Britishness' of this book, blurring the line between developments in British TV comedy and an 'explosion' of Irish comic talent (Dixon and Falvey 1999). Ireland would develop its own alternative scene in the 1980s, partly influenced by alt-com from the UK and US, and Dixon and Falvey situate Linehan and Mathews as part of a 'second wave' of Irish comic talent to flourish in Britain, alongside people like Ardal O'Hanlon (*Father Ted*'s Dougal), Dylan Moran (creator and star of *Black Books*) and Dermot Carmody (*Ibid.*: 8). Significantly, however, *Father Ted*'s star Dermot Morgan was virtually unknown in the UK but already a cult comedian of some notoriety in Ireland. This explosion of comic talent is sometimes linked to a period of

optimism in Ireland, a 'Cool Hibernia of economic wealth, cultural and sporting success' (*ibid.*: 9). Linehan has played down the 'Irishness' of his comedy – 'It's not that they're Irish, they're just people!' (Musson 2007: 17) – but earlier interviews that included Mathews seem to invest more in *Father Ted* being an 'Irish sitcom', a question I shall return to. *Black Books* has an Irish lead (the project was initiated by Moran), while Linehan insists that Roy being Irish in *The IT Crowd* was purely a coincidence of casting Chris O'Dowd (*Ibid*).[4] Secondly, Linehan (alongside Mathews) is part of a generation of sitcom writers arguably more influenced than earlier writers by American TV comedy. The British sitcom 'canon', especially its realist and 'surreal' strands, has seemed relatively remote from American sitcom; the latter was sometimes regarded as an inferior import, sentimental and over-affirmative, slick, made-by-committee and lacking the distinctive authorial voices associated with British 'quality' sitcom. However, as Thompson observes (2004: 205–207), a new wave of American sitcoms dealt with dysfunctional individuals and families, and were darker and more cynical in tone – 'no hugs, no learning' was *Seinfeld*'s supposed maxim (Lewisohn 2003: 690). Some of them were animated, which gave them an overlapping visual rhetoric with the surreal and fantastical elements of some post-1980s British sitcom. Programmes like *Roseanne* (1988–97), *The Simpsons* (1989–), *Seinfeld* (1989–98), *The Larry Sanders Show* (1992–98), *South Park* (1997–) and others played to cult audiences in the UK on BBC 2 and Channel 4 (or on Sky, for those who had it) – controversy surrounded the scheduling of *Seinfeld*, a ratings giant in the US buried in a late-night BBC 2 slot (in the channel's defence, it had failed in the UK as anything other than a relatively exclusive cult). Linehan and Mathews frequently cited *Seinfeld* and *The Simpsons* as major influences – in an extended interview in the *Father Ted* box set, Linehan talks of them trying to make it a 'live-action *Simpsons*'. If anything, the *Seinfeld* connection has grown stronger in his work – according to Linehan, it has 'a lovely structure and that's kind of what *The IT Crowd* is; two friends, a woman and a kind of crazy Kramer type figure' (Musson 2007: 16). Barring his first sitcom with Mathews, the poorly received Alexei Sayle vehicle *Paris* (Channel 4 1994), all of Linehan's sitcoms have been three- or four-handers – even

Hippies (BBC 2 1999), which he co-created but ultimately left Mathews to write by himself. The fourth figure, a grotesque comic monster (Father Jack, Denholm and later Douglas Reynholm), is absent from *Black Books*, which otherwise moves closer to *Seinfeld* by having the female character be a friend of similar age to the central male character (unlike Mrs Doyle in *Father Ted*). As Musson notes in his interview with Linehan, one of the male characters manifests a childlike innocence or stupidity (*ibid.*) – Father Dougal, Manny (Bill Bailey), Moss (Richard Ayoade). But Manny strikes me as less clearly defined than Dougal's 'holy fool' or Moss's unsocialized geek, more obviously a vehicle for comedian Bill Bailey than an actual character; sometimes stupid or naive, sometimes more assertive, calling Bernard (Moran) a 'filth wizard, friend only to the pig and the rat' ('The Grapes of Wrath' 1.3). Another characteristic pushes all three sitcoms closer to the tragi-comedy that pervades so much British sitcom – the notion of the 'trap in which people must exist – like marriage' (Barry Took, quoted by Neale and Krutnik 1990: 253). This is most pronounced in *Father Ted*, the final episode of which has Ted narrowly miss escaping to America – as Dougal tells him, 'you're here to stay with me and Mrs Doyle and Father Jack forever and ever and ever …' ('Going to America' 3.8). 'Ted's situation is awful,' Linehan said at the time of the first series, 'he's quite an intelligent man and he's stuck in the arse-end of nowhere with these two awful people' (Thompson 1995: 2). If there is a trap in *Black Books*, it is Bernard himself – his own coruscating misanthropy – given that he owns his own second-hand bookshop and that both of his friends are nicer people than he is (in Fran's case, maybe only slightly more so). Bernard is virtually identical to Dylan Moran's stand-up persona – 'I have a very low tolerance for enthusiasm generally,' he observed at the time of the first series (Rampton 2000: 4). Interestingly, considering that the 'trap' usually imprisons a male protagonist, if anyone is trapped in *The IT Crowd*, it is Jen (Katherine Parkinson) – relegated to the basement of Reynholm Industries after being shown the view from the top floor ('Yesterday's Jam' 1.1), put in charge of socially incompetent nerds who, while not as 'awful' as Ted's fellow priests, fall below the status she feels she is entitled to. Like Ted – and perhaps also like Harold Steptoe and his descendants – Jen maybe deserves

better but not necessarily everything that she feels she deserves. Smart in some ways, Jen – like many British sitcom protagonists – has an uncertain grasp of her own limitations and several episodes find comedy in her pretensions or professional overreaching. But generally, *The IT Crowd* strikes me as a more optimistic sitcom than *Father Ted* and *Black Books*. While work in the IT department is ostensibly tedious (except perhaps for Moss), it also facilitates a lifestyle that seems fun and lacking in adult responsibility. Roy and Moss are avid consumers (geek masculinity is the series' true theme); Jen's love life is eventful and she doesn't seem overly concerned by romantic fulfilment. She is professionally ambitious up to a point, while Roy and Moss have no visible aspirations beyond their current situation, but when an opportunity arrives for escape, unlike Ted she remains out of a sense of belonging rather than the discovery that the new job isn't everything it first seemed ('Tramps Like Us' 3.3). The episode ends with her in an uncharacteristically maternal mode ('Who wants tea?') – Roy and Moss have suffered misfortunes in her absence. She has also discovered a geek affinity – she now reads comics and listens to cult indie bands like Guided By Voices.

Finally, Linehan provides an interesting case study in comedy authorship because he has worked in different capacities and in different combinations – as sole writer and co-writer (mainly with Arthur Mathews), as contributing writer (to sketch and satire shows, again usually with Mathews), as creator or co-creator (in one instance, of a show he didn't then write) and as director – he began directing the location work on the third series of *Father Ted*, directed the first series of *Big Train*, co-directed the first series of *Black Books* and has directed all of *The IT Crowd* thus far, while also using a 'studio director' to oversee the technical aspects of studio recording.[5] Of Linehan's writing partners, Arthur Mathews is undoubtedly the most important – their status as a team is underlined by Ben Thompson calling them 'a potential Galton and Simpson for the millennium's end' (2004: 193). Together, they contributed sketches and other items to *Alas Smith and Jones* (BBC 2 1984–88), *Harry Enfield and Chums*, *The Day Today*, *The Fast Show*, *Saturday Night Armistice* (BBC 2 1995–99), *Never Mind the Horrocks* (Channel 4 1996), *Brass Eye*, *Jam/Jaaaaam*,

were lead writers (with Sayle) on *The All New Alexei Sayle Show* and contributed two episodes to the Steve Coogan vehicle *Coogan's Run* (BBC 2 1995). They co-created and co-wrote *Paris, Father Ted* and *Big Train* and co-created *Hippies*. As this suggests, focusing a chapter on 'Graham Linehan' is problematic in some respects, given Mathews's contribution to some of his most celebrated work. Nor is it my intention to attempt to extricate and separate their respective contributions to the shows they co-authored. There are two reasons for retaining the focus on Linehan. Firstly, Mathews's solo work is harder to give an account of – *Hippies* was not well received, the second series of *Big Train* isn't radically different from the first, and Linehan co-created both of these shows. Mathews would also co-write an episode of *Black Books* with Dylan Moran after Linehan's departure ('The Fixer' 2.3), which further complicates any sense one might get of him as a solo comic writer. Linehan's post-Mathews work – writing with Dylan Moran or by himself – has been more visible and easier to assess. Secondly, the collaborative nature of much of Linehan's output is part of what makes it interesting. He has provided an interesting account of how his writing partnership with Mathews worked and then ceased to work. The two met as journalists on the Irish rock magazine *Trouser Press* and would also write for *Select* (the magazine that had dubbed comedy 'the new rock'n'roll') after moving to London. Mathews was already writing and performing comedy, and Linehan would contribute to his spoof U2 band The Joshua Tree (performances included an earlier version of Father Ted played by Mathews). Mathews was nine years Linehan's senior and early interviews present Linehan as initially deferential to and slightly in awe of his older, more experienced, partner but then 'on a more equal footing now, and I'm not so worried now what he thinks' (Feay 1997: 51). More recently, Linehan has suggested that a degree of deference was central to how the partnership worked:

> I used to be a bit scared of him. So if he wrote something I didn't like, I'd go 'oh it's great, I'll just change one little thing' and I'd have to make it so funny that he couldn't object to the rewrite. And that really got my funny muscles working.

But once I started getting a bit more confident, I would just be able to say I didn't like it. That broke the way we wrote together, and now it's hard to resurrect that relationship.

(Musson 2007: 19)

Black Books is Linehan's only sitcom that he didn't create or co-create – an unbroadcast pilot episode written by Dylan Moran had already been shown at the 1998 Channel 4 Sitcom Festival at Riverside Studios. If Linehan–Mathews come over as a team whose writing partnership 'broke', Linehan's collaboration with Moran seems to have been more problematic from the start, particularly during production – 'We fought like cat and cat,' Moran quipped at the time, albeit in an interview that included the pair of them (Rampton 2000: 4). Linehan would leave after the first series.

'The roads have been taken in': *Father Ted*

In 1996, Ray Galton and Alan Simpson, writers of *Hancock* and *Steptoe and Son*, named *Father Ted* their favourite current sitcom (Dixon and Falvey 1999: 58) – such an accolade from two of British sitcom's most revered writers seemed to confirm that *Ted* was on its way to 'classic' status. The following quotes are representative of the widespread perception that it had arrived at that exalted destination:

Father Ted has gone to sitcom heaven, where it shares the very best cloud with a select few others. (*Ibid.*: 54)

the writing blends originality with respect for form, in that the three main characters are, in the classic tradition of *Porridge* and *Steptoe and Son* 'trapped somewhere with people they don't necessarily want to be with'. (Thompson 1995: 2)[6]

dangerous and surreal enough to be a favourite among students and trendy Londoners, yet simultaneously warm and nostalgic enough to appeal to middle-aged mums and dads. (Sangster and Condon 2005: 304).

Others have claimed that it was Channel 4's first unqualified 'classic' sitcom. While noting distinguished exceptions like *Desmonds* (Channel 4 1989–94), a seminal black sitcom, and

the satirical *Drop the Dead Donkey* (Channel 4 1990–98), Mark
Lewisohn suggests that Channel 4 had been 'less adept at devel-
oping home-grown sitcoms' (2003: 281) – specializing in
sketch, variety and satire, its biggest sitcom hits were American
imports. Alkarim Jivani, in *Time Out*, called *Father Ted*
'Channel 4's funniest sitcom after 15 years on air' (1998: 179)
while Terry Staunton, in *New Musical Express*, judged it
'probably the only "classic" sitcom Channel 4 has commis-
sioned … a show that is destined for the TV hall of fame
alongside the likes of *Fawlty Towers*, *Porridge* and *Only Fools and
Horses*' (1996: 26). It would inspire fan conventions like the
2007 'Ted Fest' and as Channel 4's '*Father Ted* Night' on New
Year's Day 2011 proved, it was the kind of show where fans can
be asked to vote for their favourite episode – the very title of
'Kicking Bishop Brennan Up the Arse' (3.6) perhaps gives it an
unfair advantage in such polls. *Father Ted*'s reputation, then, is
of being Channel 4's 'breakthrough' sitcom; of combining
traditional virtues ('respect for form', something 'middle-aged
mums and dads' can enjoy) with a degree of originality; of
creating lines that could be quoted ('that would be an ecumeni-
cal matter', 'These are small, but the ones out there are far
away') – some of them catchphrases ('Feck! Arse! Girls!', 'Ah,
go on, go on, go on') – and characters one could impersonate.
The 'respect for form' that Thompson mentions can be seen in
the series' aforementioned 'trap' – the remote hell of Craggy
Island itself, of Ted having to co-exist with idiotic Dougal, filthy
and violent Father Jack (Frank Kelly), the passive–aggressive
servility of Mrs Doyle (Pauline McLynn) and her endless cups
of tea, and Ted's frustrated ambition. The series encompasses
sometimes tightly plotted farce (the attempts to conceal hordes
of rabbits from Bishop Brennan in 'The Plague' 2.6 are remi-
niscent of *Fawlty Towers*' 'Basil the Rat'), slapstick (of a violent
post-*Young Ones* kind) and other visual jokes. Linehan and
Mathews are particularly fond of pull-back/reveal gags – as Ted
tries (seemingly gently) to tap out a minor dent in an expensive
car with a hammer, Dougal comments reassuringly that 'you'll
never get it absolutely right', just before a cut to a wider shot
reveals the car utterly destroyed ('Think Fast, Father Ted' 2.2).
Linehan has retained the pull-back/reveal gag, with possibly the

most inspired appearing in the second episode of *Black Books*
('Manny's First Day' 1.2). What appears to be a shot/reverse
shot sequence finds a very drunk Bernard offering a job to a
very confused looking Manny. The pull-back reveals the source
of his confusion – they aren't actually facing each other (they're
sitting back-to-back) and a further reveal shows that Bernard
has just offered the job to a complete stranger, a baffled older
woman. But *Father Ted* is also celebrated for a verbal interplay
that hinges on a strong sense of character. The most frequent of
these exchanges are between Ted and Dougal, both because
they are the most 'rounded' characters (comparatively speaking
– Mrs Doyle and Jack have single character traits) and because
they function like a double act (one stupid, the other frustrated
by his partner's stupidity while himself not quite as clever as he
thinks he is). In 'Flight into Terror' (2.10), they are on a plane
and Dougal has bought a squeaky dog toy in the shape of a
bright yellow telephone which he believes to be a 'joke
telephone'.

> TED: Dougal, this is a dog toy.
> DOUGAL: No, it's not, Ted – it's a joke telephone.
> TED: Dougal, this is a toy for dogs! This is something people give
> dogs on their birthday.
> DOUGAL: No, seriously, Ted – it's a joke telephone. Look – you
> give it to someone and tell them it's a phone and they'll try and
> make a phonecall on it.
> TED: Dougal, who would think this was a telephone? Even a dog
> would know this isn't a phone.
> DOUGAL: Well, Ted, we'll agree to differ, alright?
> TED: (*starting to get angry*) No, we *won't* agree to differ because
> you're very, very wrong!
> Look (*holds the packaging up*) – does the picture on the packet
> not give you a clue? Why do you think the dog looks so happy?
> He's happy because someone has given him a yellow rubber
> telephone that makes a noise!
> DOUGAL: (*also getting a little angry*) No, no! He's laughing
> because someone's tried to make a phonecall.

The dog toy will have two pay-offs. When Ted wants to shut
Dougal up, he distracts him from talking about plane crashes by
squeaking the toy, but Dougal shrieks with laughter when Ted

tries to make a call on his mobile and finds himself holding the squeaky toy to his ear. The latter underlines the fact that Dougal is not funny simply because of his stupidity, but because his child-like intellect sometimes liberates him from accepting some commonly accepted 'truths'. His explanation for the squeaky phone is only slightly less stupid than the real one (a dog toy shaped like a phone), and Ted's absentmindedness makes this alternative logic come true. As a result, Dougal is sometimes a subversive figure, innocently exposing Ted's lies or driving home his humiliation, as when Mrs Doyle's poem triumphs over Ted's in a TV competition.

> I'm hugely confused, Ted! The only thing I can think of that must have happened is that Mrs Doyle's poem was better than yours. But that couldn't be, could it? That your poem was actually *worse* than Mrs Doyle's? But that couldn't happen, could it? (*scene transition music starts, but Dougal still hasn't finished*) *Could it?*
>
> ('Night of the Nearly Dead' 3.7)

Written down, this looks like the cruelest sarcasm, but as Dougal visibly struggles to fathom this mystery, the comic effect is quite different – Ted grimaces, enduring tortures of humiliation that Dougal has no idea he is inflicting. While *Father Ted* takes a light satirical touch to religion, it's often Dougal who questions whether the Emperor is wearing any clothes – one bishop unwise enough to enquire about Dougal's faith is converted to atheism by his reply ('Tentacles of Doom' 2.3). But an exchange in 'Hell' (2.1) where Ted describes the 'magic road' where water flows upwards, is softened by the pay-off.

> DOUGAL: That's nearly as mad as that thing you told me about with the loaves and the fishes!
> TED: (*suddenly serious*) No, Dougal, that's *not* mad! That's when our Lord got just one or two bits of food and turned it into a whole pile of food and everyone had it for dinner.
> DOUGAL: (*wide-eyed enthusiasm*) God, he was *fantastic*, wasn't he?
> TED: (*wistful*) Ah, he was *brilliant*.

Here, religious faith is rendered as a kind of fannish enthusiasm, as if Jesus was primarily a particularly celebrated and accomplished performer.

'Almost all English sit-coms are about "losers",' states Kate Fox, 'unsuccessful people, doing unglamorous jobs, having unsatisfactory relationships, living in, at best, dreary suburban houses' (2004: 215). *Ted* suggests either that this 'rule' extends beyond 'English sit-com' or, more pertinently, that the programme knowingly positions itself within this tradition. Episode 1 establishes Ted's aspirations (the opportunity to be in a TV documentary about priests in isolated communities) and his character flaws (he lies about the documentary to ensure that he is Craggy Island's sole contributor) and proceeds to frustrate them – he ends up trapped on a dangerous-looking fairground ride while Dougal is not only interviewed in his place but identified in an on-screen caption as 'Father Ted Crilly' as he talks idiotic nonsense about 'spider babies' ('Good Luck, Father Ted' 1.1). Ted can be selfish, childish (his competitive feud with Father Dick Byrne), insensitive and arrogant, even criminally dishonest; banished to Craggy Island because money intended to send a sick child to Lourdes was found 'resting in my account' as he defensively puts it – 'It was resting for a good long time,' responds Dougal guilelessly ('The Old Grey Whistle Theft' 2.4). But he is not a monster because Ted must retain a degree of pathos to work as a classic sitcom 'loser'. 'Are You Right There, Father Ted?' (3.1) establishes that he is crass enough to make a racist joke when he thinks he's in safe company (Dougal) – a lampshade prompts him to narrows his eyes, put it on his head and do a 'Chinese' impersonation. A pull-back/reveal captures him unwittingly performing this gag to a group of actual Chinese, staring aghast through the window. Ted has enough sense of social propriety to at least recognize that being thought racist is not a good thing, and organizes a 'Celebration of Craggy Island's Diversity' that confirms his ethnocentric ignorance (he thinks that *The Karate Kid*'s Mr Miyagi and *The Pink Panther*'s Kato, both Japanese, are likely sources of Chinese pride) but seems to establish (temporarily) his good intentions. But the episode's farcical drive endeavours to make Ted seem more racist than he is – a

'perfectly square bit of black dirt on the window' (its contrivance is part of the joke) makes him look like a gesticulating Hitler and a subplot about a priest collecting Nazi war memorabilia also incriminates him unjustly. Elsewhere, Ted can be heroic – saving Dougal from vengeful milkman Pat Mustard ('Speed 3' 3.3), or conquering his fears just long enough to fix the fuel line on the wing of a flying plane ('Flight Into Terror' 2.10) before dissolving into shrieking abject panic ('What am I doing on this feckin' wing?').

If *Father Ted*'s central character has some of the traits of the classic sitcom, some of its stylistic features owe more to a set of sitcom aesthetics that emerged in the 'alternative' 1980s. Neale and Krutnik characterise *The Young Ones* and other alternative shows as 'anti-sitcom' sitcoms:

> In these shows there is a blatantly aggressive attack on the *decorum* of the traditional sit-com ... In this process, they make a point of deliberately rupturing the sit-com's conventions of 'naturalistic' representation. (1990: 245)

Ted 'ruptures' naturalism in many ways, not least in the spatial 'incompleteness' of Craggy Island – at one level, a location that promises sitcom's enclosed world but also one where the roads can be taken in and stored in a warehouse during bad weather ('Kicking Bishop Brennan Up the Arse' 3.6) or that can suddenly produce a substantial Chinese community from nowhere ('Are You Right There, Father Ted?' 3.1). A series of gags have Dougal see unlikely sights out of the window, like the hordes of Wildebeest he sees through binoculars from the caravan in 'Hell' (2.1). However, it has been established that Dougal's grasp on reality is precarious at best – in episode 1.1 Ted shows him a diagram of his head designed to demarcate 'Dreams' (inside his head) from 'Reality' (outside his head). *Ted* never seeks to demolish the 'fourth wall' in the way that *The Young Ones* did – no one addresses the camera, there are no visual jokes underlining the fact that we are *watching a sitcom on television*.[7] The world of *Father Ted* may not be naturalistic, but nevertheless establishes its own version of verisimilitude – characters who act consistently, chains of events that have some internal logic. The contrivance of the 'perfectly square bit of

black dirt' that turns Ted into Hitler might wink at the audience, but it is also the diegetic means by which Ted's embarrassment is achieved (in one episode of *The Young Ones*, we see spectacles, moustache and beard being drawn over the TV image of Neil's face by some extra-diegetic character as he speaks).

'Hell' (2.1), one of the most fondly remembered episodes of *Father Ted*, displays the balancing of 'classic' sitcom containment and the fantastical 'surrealism' of the 'anti-sitcom'. The opening sequence is another riff on narrative contrivance – a laborious explanation of the two buttons on a sewage truck (one opens the doors, the other ejects the effluent) where the joke is the obviousness of the set-up. When the truck reappears at the end of the episode, we know immediately what Ted's final humiliation will be. 'Hell' sees Ted, Dougal and Jack go on holiday, their caravan so grottily dilapidated that it provides them with even more of an enclosed 'trap' than the parochial house on Craggy Island. A good deal of the first half plays, in an almost *Hancock*-like way, on a combination of enclosure and boredom. Dougal has forgotten to bring the Scrabble and so they must entertain themselves by watching the kettle boil or playing 'Hide and Seek' (in a caravan!). One of these sequences is amongst the most-quoted in the series' history as Ted attempts to teach Dougal about distance and perspective.

> TED: (*holding up model cows*) Okay, one last time. These are small (*Dougal nods*). But the ones out there are far away. (*Dougal visibly concentrates – he's really trying to follow*). *Small. Far away*. (*Dougal shakes his head, Ted throws the models down in disgust*). Ah, ferget it!

One farcical strand has already been established – the three priests initially set up in the wrong caravan, the first of a series of embarrassing encounters with a couple that will culminate in the man clinging, naked and angry, to Ted's car as he and Dougal try to drive away. Jack's misadventures, meanwhile, are characteristically fantastical – his wheelchair rolls up the Magic Road and off a cliff, later finding him on a yacht surrounded by beautiful women. The second half of the episode escalates the encounters with the couple but also introduces the nightmar-

ishly excitable Father Noel Furlong (Graham Norton) whose aggressive attempts to generate participatory fun lead to a bout of 'riverdancing' that topples the caravan. 'Hell' is tightly structured and strongly rooted in character, but punctuated by cartoon violence, knowingly signaled contrivances, larger-than-life performances.

According to Bruce Dessau, 'there isn't anything here that couldn't conceivably have happened to Hancock or Frank Spencer. But Linehan and co-writer Arthur Mathews are thumpingly original' (1996: 169). Part of what might have made *Father Ted* seem original as well as familiar might lie in its comic articulation of 'Irishness' – whimsy, eccentricity (reviews often referred to the novels of Flann O'Brien), images that risked (and occasionally received) accusations of stereotyping (Ireland as rural backwater, drunkenness, stupidity, 'paddy-whackery'). With studio scenes shot in London, produced by Hat Trick for Channel 4, *Father Ted* was commissioned by Seamus Cassidy, directed for its first two series by Declan Lowney, written by Linehan and Mathews with four Irish leads and the cream of Irish stand-ups in other roles, and used locations in County Clare – if it doesn't qualify fully as an 'Irish sitcom', it has been described as 'a quasi-Irish production' (Free 2001: 220) or even 'securely Irish' (Pettit 2000: 195).[8] Both Free and Pettit view the series' 'stereotypes' positively, indicative of a post-colonial reflexivity (Free 2001: 223), an 'expansive, confident identity associated with the Irish in mid-90s Britain' (Pettit 2000: 195) that allows for a 'self-directed humour' (*Ibid.*: 197). *Ted*'s 'Ireland' is partly a knowingly globalized one – Roddy Doyle novels, Eurovision Song Contest victories, *Riverdance*, the rural idyll of contemporaneous drama *Ballykissangel* (BBC 1 1996–2001), the latter directly parodied with cameos from its characters in 'A Christmassy Ted' (Christmas Special 2006). But Linehan also spoke of wanting to illustrate 'a one-way thing – which is that the English know nothing about the Irish, but the Irish know everything about the English, because they watch British TV' (Thompson 1995: 2). While the 'Lovely Girls' competition in 'Rock a Hula Ted' (2.7) parodies the sexism of beauty contests in a way that is widely accessible (the contestants walk around bollards like

trained animals and are complimented on their 'lovely bottoms'), it is also a more direct reference to Ireland's Rose of Tralee, one of the things British audiences knew 'nothing' about.[9] Mathews claimed that 'we are constantly slipping in little in-jokes for the Irish audience, references that the British don't quite get' (Lappin 1998: 17).

As Pettit observes, *Father Ted* followed a series of controversies concerning the Catholic Church, while handling them in a relatively uncontentious way (2000: 196). There is only one reference in the series to paedophilia (the biggest contemporary Catholic scandal), when Ted defends the Church against the Sinead O'Connor-like rock star played by Clare Grogan – 'Say if there's 200 million priests in the world and 5% of them are paedophiles, that's still only 10 million' ('Rock a Hula Ted' 2.7). Bishop Brennan's 'love child' referenced the resignation of Bishop Eamon Casey in 1992, who had used church money to support an illegitimate child (*Ibid.*: 191). Going by early interviews, it's tempting to attribute much of *Ted*'s particular take on Catholicism to Mathews:

> I have a lot of Catholic Irishness in me, and Graham really doesn't. It's partly an age thing, and partly the fact that I grew up in the country and he grew up in the city. I remember the whole Catholic grip on Irish society more strongly than Graham does. (Feay 1997: 50)

In the same interview, Linehan speculates that 'this is the last generation that was upset by the gory elements of Catholicism. It hasn't touched me at all, and I think that's true of my generation' (*Ibid.*: 51). *Father Ted*, then, is the work of a younger atheist with no apparent axe to grind (at the time, at least) about Catholicism and his older partner who both regarded himself as Catholic and recalled those aspects (embodied by Jack and the terrifying Bishop Brennan) described by Linehan as 'gory'. In *Father Ted*, it isn't so much that faith is misguided as less directly relevant to Ted's career than one might expect. 'That's the great thing about Catholicism,' he tells Dougal, 'it's so vague and nobody really knows what it's all about' ('Tentacles of Doom' 2.3). In documentaries like *Unintelligent Design* from Channel 4's *Father Ted* Night (2011), Mathews

fondly recalls priests who seemed reluctant to talk about religion, and displays a photo of priests playing cards and smoking that seems to illustrate his point. *Ted* ultimately secularizes the Catholic priesthood by representing it as work, and in the world of sitcom, work is a trap to escape and an unwelcome burden to be avoided or subverted.

Misery loves company: *Black Books*

> BERNARD: (*to customers*) Right! The shop is closed – everyone out! ... Come on, all you time-wasting bastards – back on the street!
>
> ('Cooking the Books', *Black Books* 1.1)

Father Ted's 'classic status' is partly aided by its appearance before the single-camera, laugh-track-free aesthetic became such a dominant signifier of 'quality'. By the time of *Black Books*, *The Royle Family* and *Spaced* signalled in different ways the stylistic shifts in sitcom, and *The Office* was just around the corner. However, James Rampton acknowledges that bucking the apparent trend for moving away from studio sitcoms did not stop *Black Books* from winning a Bafta award (2000: 4). In other ways, *Black Books* was very much in keeping with developments at the turn of the century – it's the darkest of Linehan's sitcoms, which probably has much to do with its star and creator, Dylan Moran. In some respects, Bernard Black is as much like an articulate Father Jack as he is like the more sympathetic Ted (although he is easier on the eye) – dissolute, ill-tempered and inebriated. In one scene, he wheels his office chair to the toilet and urinates while continuing to read his book ('Manny's First Day' 1.2). His treatment of Manny risks making Bernard unlikeable – there is a semi-serious scene in 'He's Leaving Home' (1.6) in which Fran berates him for his cruelty towards his departed whipping-boy and even Bernard shows a glimmer of regret. His rudeness towards his customers provides a more immediate source of pleasure both because they are undeveloped verbal cannon fodder and because of the enjoyable transgression of the codes of courtesy and customer service. In the opening scene of the first episode, a customer attempts to

get service from Bernard while he is on the phone. The misan-
thropic bookseller doesn't look at the customer, continues to
talk and smoke, but sticks a post-it note on his forehead with
the words 'On Phone' on it. *Fawlty Towers* made a virtue of the
poetry of rudeness and the following exchange is worthy of
Basil Fawlty at his least courteous.[10]

> BERNARD: (*noticing a customer at the door*) Just look at this
> bastard. (*sarcastically to the customer, who can't hear him*) That's
> right! That's right, we're having lunch – come on in! (*to Manny
> and Fran*) Look! What do they want from me? Why can't they
> leave me alone? I mean, what do they *want* from me?
> MANNY: Well, they want to buy books.
> BERNARD: Yeah, but why me? Why do they come to me?
> MANNY: Because you *sell* books.
> BERNARD: Yeah, I know but … (*opens door. To customer*) What?
> CUSTOMER: Er, I want to buy a book.
> BERNARD: (*sighs, then hands him book that just happens to be
> within reach*) Here's one.
> CUSTOMER: No, I was …
> BERNARD: This one's very good.
> CUSTOMER: Oh, is it?
> BERNARD: (*impatiently*) Yes! You'll laugh, you'll cry, it will
> change your life. £5.99.
> CUSTOMER: Okay. (*hands over a £10 note. Bernard takes it and
> starts to close door*) Er, my change?
> BERNARD: Can you come back later?
> CUSTOMER: Well, no, I'm not coming back this way.
> BERNARD: Where do you live?
> CUSTOMER: 17 Gallexia Gardens.
> BERNARD: Okay. Now go there and await my instructions. (*closes
> door*)
>
> ('Manny's First Day' 1.2)

Moran showed he was capable of playing a character part in
another sitcom – as a fish-out-of-water photographer who
moves to a *Straw Dogs*-like countryside with his wife in Simon
Nye's underrated *How Do You Want Me?* (BBC 2 1998–99).
But Bernard is more visibly rooted in Moran's stand-up persona
– rambling, seemingly a little drunk, more than a little sour,
inclined towards surreal flights of fancy. Like *Father Ted*, *Black*

Books has two stand-ups amongst its leads, but Moran and Bailey seem to be playing versions of 'themselves' more than Morgan or O'Hanlon did (even though neither of those two had any real acting experience before *Ted*). While Manny initially seems to be the Dougal/Moss figure, he becomes more and more like Bailey – a beardy, good-natured oddball (Bernard gives him a series of derogatory nicknames, such as 'Hawkwind' and 'Gandalf'). Moran's original pilot was never broadcast, but Linehan's account of it suggests that part of his role was to impose some sitcom structure on it.

> When I saw the pilot that Dylan had written on his own, it was very nearly brilliant … But it was surreal and structureless. When it's too surreal, you don't believe in it and it breaks the reality. So when I came in, we worked on the way it was constructed and made it more believable. Rather than relying on Dylan's stand-up, we wanted the series to stand on its own two feet. (Rampton 2000: 4)

This suggests a similar balance to that of *Father Ted* – between structure, character and a coherent sitcom setting on the one hand, and surreal and fantastical elements on the other that don't threaten the integrity of the fictional world . Episode 1 ('Cooking the Books') has a very clear structure with three interconnected storylines – Bernard struggling with his accounts, Manny's transformation from stressed accountant into Bernard's assistant and Fran puzzling over an object in her gift shop. This encompasses fantastical elements – Manny's body absorbing *The Little Book of Calm*, Bernard fashioning 'a smart casual jacket' from his accounts – while stressing character dynamics (Fran functions similarly to Elaine in *Seinfeld*) and the enclosed space of the bookshop. If this 'respect for form' is one of the things that Linehan brought to *Black Books*, it seems to have remained after his departure – there is little visible change of style in the second and third series. By the end of the slightly patchy second series, a stable writing team of Moran, Kevin Cecil and Andy Riley was in place and the third series would be the strongest of the three.

Ich bin ein nerd: *The IT Crowd*

JEN: You know what's very 'in' at the moment?
ROY: I don't.
JEN: Geeks. You lot. The whole nerd thing. Geek chic. It's very 'in'.

('Calendar Geeks', *The IT Crowd* 3.6)

In January 2006, Alan Yentob presented an episode of the series *Imagine* entitled *A Funny Thing Happened on the Way to the Studio* (BBC 1 2006), although perhaps the more telling title was the one he used in an article in the *Independent* on the 'Rebirth of the Sitcom' (Yentob 2006). For the sitcom to be 'reborn' it first had to 'die' and there were was a popular prognosis in circulation that, having peaked with *The Royle Family* and *The Office*, it had subsequently fallen into terminal decline; Channel 4 would broadcast *Who Killed the Sitcom?* in the same year as Yentob's more optimistic overview. As Brett Mills observes, such debates confirm the shared assumption that sitcom is important (2009: 126). It is clearly not only important to Linehan, but important as *entertainment* – he has resisted producing anything that aspires to be 'more than' a sitcom. This is how Yentob presents him in his article, and Linehan and *The IT Crowd* (which would debut shortly after) featured heavily in the programme:

> Just when you might think the traditional studio sitcom is 'like, so last-century', along comes Graham Linehan ..He's a real believer; so much so that he chooses not only to write but also to direct his latest show in the unfashionable environment of a TV studio with invited audience. And surprise, surprise; it's on Channel 4 and produced by *The Office*'s Ash Atalla ..This show may be about the world of information technology and computer geeks, but it's squarely aimed at a family audience: 'No jokes that children won't understand,' Graham says. We shall see if his aim is true. (Yentob 2006)

The subheading for this section of Yentob's piece is 'Back to the Future', and *The IT Crowd* is presented as boldly old-fashioned (a studio sitcom) but with cultishly fashionable elements (the IT 'geek' theme, Attalla's involvement – he might also have

mentioned the appearances by Chris Morris and Noel Fielding).
The IT Crowd is often presented (not least by Linehan himself)
as swimming against the tide in other ways, an antidote to the
'darkness' and cruelty of recent comedy. But this would be
increasingly in accord with statements made by TV commis-
sioning editors about comedy needing to become less
envelope-pushing, more accessible. According to Sarah
Mahoney at Paramount UK, 'I think that we've got a bit nasty
and quite brutal . . . it's water cooler TV but there is no real class
behind it' (Davis 2008: 35), while the BBC's comedy controller
Lucy Lumsden urged writers 'to think about audience sitcoms'
(*Ibid.*: 35). *Gavin and Stacey* was taken as the writing on the
wall – single camera and laugh-track free, but seeming proof of
an 'appetite for warm, funny, accessible comedy' (*Ibid.*: 32). Of
the new studio sitcoms, *The IT Crowd* and *Miranda* have
perhaps been most successful in delivering the mix of inclusive-
ness and cult appeal that these commissioners seemed to be
looking for.

While *Father Ted* and *Black Books* arrived on screen with
strong first series (and even better to come), Linehan has been
candid about the fact that *The IT Crowd* took longer to hit its
stride. He has even said that the first series was 'overhyped', its
distinguished personnel (himself, Atalla, Morris) raising expec-
tations of something more than 'just an old-fashioned, silly
sitcom, which is what I intended in the first place' (Pettie 2007:
51). But he evidently felt that more needed to be done than
simply adjusting people's expectations – the first series was
'trying a bit too desperately to please' (Widdicombe 2007) and
for Series 2 he was aiming both for 'more naturalism' (*Ibid.*)
and again for a resemblance to 'my favourite show: *Seinfeld*'
(Pettie 2007: 51).

Of the changes made from Series 1 to 2, two are particularly
notable. Chris Morris was replaced by Matt Berry as
Reynholm's wayward son, Douglas. Berry, like Richard
Ayoade, had been part of the 'Garth Marenghi' team, both of
them specializing in dated and slightly stilted or overstated line
delivery, as though appearing in a 'bad' film (exactly the effect
Garth Marenghi's Darkplace was aiming for). Berry's
trademark fruity voice is pitched somewhere between a 1970s

voiceover and the lead in a trashy sci-fi movie.[11] In 'Tramps
Like Us' (3.3) he is forced to wear trousers that dispense
electric shocks when he becomes sexually aroused – a condition
of his legal settlement with Jen after he attempted to put
Rohypnol in her tea. The trousers malfunction and administer
painful jolts as he reads *What Car?* magazine. When he shouts,
'God *damn* these electric sex pants', his emphatic delivery of
the last three words make the trousers sound like the product
in a commercial. Berry is no more naturalistic a performer than
Morris was, but his performance integrates more successfully
with the core team (especially Aoyade). The other change is in
the look of the main set – the IT office in the basement of
Reyhnolm Industries. In Series 1, it already has some of the
posters and collectible figures that Roy and Moss have person-
alized their workplace with, but it is still very much a workplace
– littered with keyboards and monitors. Discarded computer
parts are less visible from Series 2 and the 'geek aesthetic' is
more pronounced, on walls and on every available surface.
There is a sofa, there are games consoles – we see them playing
Guitar Hero and other games on the Wii. The workplace has
not only become a shared flat, but one populated by the hyper-
consuming nerd displaying subcultural capital to what I am
going to call a 'nerd gaze'. I saw this 'nerd gaze' up close (and
exercised it myself) at a studio recording of the show – there
was a palpable excitement over the richly detailed set as people
in the audience spotted a comic they collected or an obscure
band that they liked. According to Karen Lury, sets in TV
genres like soap (and, I suspect, sitcom) display a 'relative
visual poverty' but are 'time-rich through familiarity and
emotional investment' (2005: 16). The main sets in *Father Ted*
and *Black Books* conform to this perfectly – pre-'televisual'
sitcom sets, lacking in detail but pleasurably familiar. The *IT
Crowd* office conforms to this in some ways – as we have seen,
it is an idealized sitcom 'home' – but it also displays a richness
of production design that belongs to an age of DVD and HD
televisions, rewarding the scrutiny of the invested fan. There is
a 'Set Tour' on the Series 3 DVD, in which Linehan guides us
through cult items like Fantagraphics Comics (*Love and
Rockets, Eightball, Hate*) and the comedy fanzine *Mustard*. The

'nerd gaze' is regularly drawn, too, to Roy's clothes – his collectible T-shirts, such as the limited edition *Ring/*Sadako shirt made by cult T-shirt designers Dark Bunny Tees.

The IT Crowd offers us two slightly different versions of nerd masculinity. Moss is more closely associated with the nerdiness of knowing about IT in the first place – he is comically enthusiastic about the 'boring' subject of computers, in contrast with Roy's weary or impatient mantra ('Have you tried turning it off and on again?'). When Jen finds Moss laughing to himself, she makes the mistake of asking him what the joke is:

> Moss: (*still chuckling*) This *flippin'* circuit board, Jen! Some *chump* has run the data lines right through the power supply. (*sing-song voice*) Amateur hour! I've got tears in my eyes!
> ('The Red Door' 1.4)

When he recovers from a concussion in 'Tramps Like Us' (3.3), we hear the Windows fanfare, as though he is rebooting himself. In every other respect, Moss is as child-like as Dougal – almost autistic in his inability to connect to the social world. He looks like his mother has dressed him (he does still live at home) – big glasses, short-sleeved shirt with a tie, a sensible coat for outdoors. His body language is guarded, mechanical, particularly in the company of women. He speaks in deliberate cadences, stiltedly, as though he's memorized and rehearsed what he's going to say. He's a pedant – when Roy sings 'We don't need no education', Moss can't resist the rejoinder 'Yes you do – you've just used a double negative' ('The Red Door' 1.4). When he attempts slang, the effect is incongruous, either because it's outdated – 'ruddy' is his default swear word – or just sounds wrong coming out of his mouth. His little verbal flourishes might sometimes be ingenious, but there is never any danger of them making him sound cool. He's clearly spent some time (probably too much time) fashioning the following response:

> Prepare to put mustard on those words, for you will soon be consuming them along with *this* slice of Humble Pie (*mimes slicing a pie*) that comes from *this* oven (*mimes pulling a tray out of the oven*) of shame set at Gas Mark Egg On Your Face.
> ('Smoke and Mirrors' 2.5)

Roy's IT knowledge makes him employable, but brings him no pleasure. On the contrary, like Bernard Black's bookshop, it brings him into contact with more people than he would wish – 'People! What a bunch of bastards!' ('Moss and the German' 2.3). Like Bernard, we first see him ignoring someone who requires his assistance – ignoring the ringing phone, sighing, appearing to reach for it but in fact picking up his coffee ('Yesterday's Jam' 1.1). When he eventually answers the phone, his unconcealed contempt for the person who is struggling with their computer is contrasted with Moss's enthusiastic handling of a similar enquiry – he bores the other person into hanging up. Roy's nerd-dom is more that of the subcultural consumer – Linehan has said that he's the character most like himself (Musson 2007: 23). He may share some of Bernard's contempt for others, but – in contrast with the vicious treatment of Manny in *Black Books* – never for Moss. Where the male pairs in *Father Ted* and *Black Books* are forced together to the frustration of one of them, *The IT Crowd* presents an unconditional friendship between two men, one of whom is more worldly than the other. One might go so far as to say that Roy would be harder to like if it was not for his friendship with Moss, a character who sometimes elicits 'Aaaahs' from the studio audience. One such 'Aaaah' follows the opening (non-studio) scene in 'From Hell' (3.1) in which Moss is bullied by a gang of lads on the way to work, again reinforcing the image of a brainy, but socially unsuccessful, schoolboy. Roy attempts to help him with some roleplay, even if he accidentally reduces Moss to tears – 'It's too real, Roy – it's too real!'

As Jacinda Read suggests, the nerd, the geek, the 'fanboy' and the 'anorak' are associated in popular discourse with an 'immature homosocial world' and a 'failed masculinity' (Read 2003: 64). In *The IT Crowd*, work offers a haven for the male nerd – with conditional membership for a female nerd-in-training like Jen, an apprenticeship that involves becoming 'one of the boys' (Hollows 2003: 39). Outside the office, nerd masculinity is assailed on two fronts. On the one hand, there is a heteronormative masculinity that channels homosociality through drinking, football and violence and the preposterous retro-masculinity of Douglas, a sex pest and wife-murderer. On

the other hand, there is both the homosexuality that, with comic inevitability, threatens to invade the relationship between Roy and Moss and a more assertive homosexuality that Roy feels is being 'slapped in [my] face' ('The Work Outing' 2.1). In 'Are We Not Men?' (3.2), Roy and Moss survive a frightening excursion into 'real' masculinity – mimicked via a website called bluffball.com that enables Moss to say 'football things in a football voice'. This quickly leads to disenchantment and anxiety when they fall in with a group of 'Essex lads' who turn out to be bank robbers. 'We're in too deep, Roy,' Moss frets, 'and I'm worried they're going to find out I don't know what a pony is.' The tedium of sitting through a football match does little to assuage his misgivings – 'I want to go back to being weird. I *like* being weird. Weird's all I've got. That and my sweet style.' But Roy has a more laddish side to him and is reluctant to give up this newfound 'normality' until he finds himself unwittingly driving a getaway car – at one point he sits in the driver's seat sobbing in terror. When the police arrive, alerted by Roy during the robbery he had no idea he was participating in, Moss directs attention away from their involvement by slamming Roy against a door and kissing him passionately (twice). A return to nerd normality involves finding an equilibrium between these two masculine 'extremes'. In 'The Work Outing' (2.1), Jen's current boyfriend (who Roy suspects is gay) takes her to the theatre, and Roy and Moss tag along. The show is called *Gay! A Gay Musical* (big laugh from the studio audience). Roy's periodic callousness allows him to be slightly homophobic to comic effect – 'Aren't all musicals gay? This must be the gayest musical ever.' However, it's difficult to avoid the impression that it isn't just Roy who doesn't want to be 'slapped in the face with *their* sexuality'. Roy and Jen are both uncomfortable with the show – Jen because her date is enjoying it a bit too much and Roy because songs like 'I Like Willies' make him squirm with embarrassment. However, the joke doesn't seem to be entirely at his expense – we're clearly meant to find all this loud queenery as embarrassing as they do. Moss's enjoyment of the show – 'Every value I've ever had has been questioned and *I'm loving it*' – only serves to damn it all the more. This is one of the more contentious episodes of *The IT*

Crowd – another strand in this tightly plotted episode has Roy use the disabled toilet, pull the emergency cable by mistake and have to pretend to be disabled for the remainder of the night. These jokes work rather differently, often aimed at the condescending good intentions of the able-bodied and giving Roy a suitable comic punishment for his insensitivity. But the episode appears to share his unease with loudly gay men. Roy and Moss's status as homosocial couple is joked about throughout the series (they're 'outed' during *Gay!*), with Moss complaining that they're an old married couple and embarrassing Roy by shouting 'You're my wife, Roy!' ('Moss and the German' 2.3). But ultimately the series presents both homosexuality and heterosexual laddishness as equally unwelcome intrusions into male nerd-dom.

This leaves Jen in an interesting position. Linehan has said that he finds it difficult writing female characters but makes a 'special effort to write comically interesting' ones:

> I never want women in my shows to just be commenting on how silly the men are being. They also have to have negative characteristics to make it funny. (Musson 2007: 16)

There is little doubt that Mrs Doyle is the most fondly remembered, and many would say funniest, of Linehan's female characters – her virtuoso falls from the window sill in the Christmas Special feature prominently in clips compilations. But Fran and particularly Jen are visible attempts to create female characters who have a certain agency as characters as well as being funny. In Series 1 of *Black Books*, Fran runs the shop next door, Nifty Gifty – after Linehan's departure, her shop closes and she simply functions as a friend of the two male characters. As I observed earlier, Jen in some ways has the characteristics of a central character – the series begins with her arrival, she is the most goal-oriented character and the one with the traits of a classic sitcom character. In 'The Speech' (3.4), winning Employee of the Month goes to her head:

JEN: Have you ever won it?
ROY: Er, no, no, I haven't. (*sarcastically*) I dunno, Jen, sometimes I think it's because I want it *so **damn** much*.

JEN: (*proudly*) I *am* employee of the month.
ROY: And yet, to a casual observer, it would appear that you do very little around here.
JEN: (*oblivious to the slight*) Yeah, they must have seen through that.

This isn't a sexist puncturing of ambitious women in the workplace – it's Jen joining a legion of (usually male) sitcom characters who lack insight into their limitations. When she has to make a speech to the shareholders, Roy and Moss plot her downfall by providing her with a small black box they tell her is 'the internet' – Jen's ignorance of IT is a recurring Achilles' heel. The plan appears to backfire when Jen's audience prove to be as IT-illiterate as she is, cooing like excited children. But when 'the internet' is destroyed in a fight involving Douglas, the ensuing panic proves to be a satisfactory one (and one that actually bypasses the need to humiliate Jen).

In 'Men Without Women' (2.6) and 'Tramps Like Us' (3.3), Jen functions rather differently. In the first episode, a stint as Douglas's PA removes her from the office and suggests that she does contain, and stand in opposition to, male 'silliness' – her job title, after all, is 'Relationships Manager'. Roy and Moss play endless childish games until she returns, working their way through a list of things that she won't let them do – 'Mummy' is away, it seems. In 'Tramps Like Us', she is interviewed for another job, feeling that she's 'going nowhere' at Reynholm Industries. She bluffs her way through not even knowing what the letters IT stand for and gets the job by giving voice to a dawning realization.

> They've turned me into one of them. I *am* one of them! (*realises*) That's why you need me. I am your conduit. I am your bridge. *Ich bin ein nerd*!

But being 'one of the nerds', like being 'one of the boys',[12] is provisional and comes with certain restrictions. Maternal protectiveness will make her refuse a much better job – she can't entirely escape embodying the world of adult responsibility that women are often associated with in comedy.

The title of this chapter quotes a popular exchange from

Father Ted as Ted and Dougal are forced by Bishop Brennan to protest against an allegedly blasphemous and obscene film ('The Passion of Saint Timulus' 1.3).

> TED: Down with this sort of thing!
> DOUGAL: Careful now.

Linehan is often vocally critical of this or that 'sort of thing' – BBC 3, tasteless and cruel comedy – and is a principled political voice on social networking sites like Twitter. But while quoting the line 'Careful now' out of context should not be taken to imply over-cautiousness, he challenges the idea that sitcom survives through innovation alone. While *The IT Crowd* is set to finish with a one-off Special rather than a final series, if sitcom survives (which it almost certainly will in some form) it is hard to imagine one of its most distinguished writers not playing a significant role in its future.

Notes

1 'There was a lot of stuff [in the *Brass Eye Special*] that was quite harsh and unpleasant. I thought it was like throwing a live grenade' (Linehan quoted by Randall 2010: 232).
2 Another of its stars, Simon Pegg, was not a Morris regular but later appeared in the *Brass Eye Special*.
3 *Father Ted* was at one point envisioned as a one-off spoof documentary.
4 Away from sitcom, groundsman Ted in *The Fast Show* (played by Paul Whitehouse) is the most visible Irish character co-created by Linehan (with Mathews). This again seems to have been partly a fluke – Whitehouse based his performance on watching Linehan act out the character.
5 At the recording of *The IT Crowd* I attended in the autumn of 2008 ('Tramps Like Us' 3.3), Linehan was on the studio floor visibly directing the performers, sometimes asking for multiple takes of individual lines to get them as he wanted (in particular, Katherine Parkinson's delivery of the line 'Piss off, Jane' and Matt Berry's 'Damn these electric sex pants' – the former seemed to be about getting it 'right', the latter having a variety of deliveries to choose from).
6 The quote-within-the-quote is from Mathews.
7 One partial exception is Ted's reminder to Dougal that 'this is the real world' when he has caught him swearing as a result of reading Roddy

Doyle novels ('Hell' 2.1). We are meant to laugh because we know this is a silly sitcom, not 'the real world', but it also seems to be a joke about competing fictional 'Irelands'.

8 When stressing *Father Ted's* Irish credentials, there is a danger of leaving out one important non-Irish contributor to Series 1 – producer Geoffrey Perkins, a distinguished writer, performer and producer who would subsequently become BBC Head of Comedy from 1995–2001.

9 Although non-Irish *Ted* cultists probably know about it now.

10 The difference between Bernard and Basil is that Fawlty (like Harold Steptoe, like Father Ted) is a social climber who thinks he deserves better. Bernard's hatred of his shop seems driven simply by it forcing him to encounter other people. When he sacks Manny, his assistant points out that he 'sold a lot of books and got on well with all the customers'. 'It's … not that sort of operation,' replies Bernard ('Manny's First Day' 1.2).

11 Actor Patrick Allen, a former voiceover maestro, found a new career in the 1990s doing an ironic version of the delivery he had formerly done straight – he can be heard (and briefly seen) in *The Smell of Reeves and Mortimer.*

12 Interestingly, Roy tells Jen in 'Italian for Beginners' (4.4), an episode in which she becomes competitive with a female colleague, that 'You're one of those women who don't like women.'

4

Patchy in places: developments in post-alternative sketch comedy

DAVID: Okay, so running order for the show. I was thinking: Hit. Miss. Hit. Hit. Miss. Miss. Hit. Miss. Hit. Miss. Hit. Miss. Miss. Miss. Hit. Hit. Miss. Hit. Miss.

ROBERT: Are we definitely going for the whole 'Hit and Miss' thing?

DAVID: It's a sketch show. It's got to be hit and miss, that's what people expect.

ROBERT: It's just ... it *is* quite time-consuming writing and filming all the 'misses'. It always feels a bit, you know, pointless.

DAVID: Well, it's the other writers I feel sorry for, the ones who have to, you know ...?

ROBERT: Write the hits?

DAVID: Yeah.

ROBERT: Mm, well, tough. They should get their own show. But I mean, still, we've done two hit-and-miss series now. Can't we go for something different?

DAVID: Look, if we didn't perversely include about fifty percent deliberately unamusing material, then people would have to think of something else to say, wouldn't they?

ROBERT: What? Like we're too self-referential? (*self-satisfied grin*)

DAVID: (*also grinning*) Ah – clever!

ROBERT: And people call us smug! (*both their grins widen*)
(*That Mitchell and Webb Look*, 3.2)

The above sketch – partly designed to head off, with disarming self-deprecation, the accusations that it is owning up to – is indicative of a certain self-consciousness about the sketch show as a format. Graham Linehan and Arthur Mathews even consid-

ered giving *Big Train* the title *Patchy in Places* (Dessau 1998: 14) regardless of the fact that it's arguably one of the most consistent sketch shows of recent years. While 'patchiness' is a criticism that can be levelled at a sketch show that the critic or viewer has misgivings about, the format also seems to have a certain licence to be uneven as long as the 'hits' are in the majority or are funny enough to transcend their surroundings. The Mitchell and Webb sketch seems to hinge on both of these assumptions – a certain inconsistency is inevitable, accepted, and therefore a lazy and unimaginative criticism to make. Sitcom, with its emphasis on structure, narrative and coherence, probably carries the burden of greater expectations of consistency and precision, but that also means that we can have favourite sitcom *episodes* where every element seems to work perfectly, whereas we are more likely to have favourite *sketches*. The comedy sketch is the quintessential 'segment' in what traditional TV theory calls the broadcast 'flow' – a reminder, as Neale and Krutnik observe, that TV has been a 'variety form' for most of its history (1990: 179). The sketch can be mixed with stand-up (Dave Allen, Stewart Lee, Harry Hill) or form part of a variety format that includes non-comic items. It can be extracted from its original programme and voted for on a Channel 4 list show or put on YouTube, in most cases requiring little contextual background. We don't need to have seen the original programmes to be familiar with Lou and Andy at the swimming baths (*Little Britain* 1.1), jockeys being stalked by the Artist Formerly Known as Prince (*Big Train* 1.2) or a party of rowdy Indians 'going for an English' (*Goodness Gracious Me* 1.1), although an isolated Ted and Ralph sketch from *The Fast Show* might mystify the uninitiated. Ian Hislop, one of the first critics to 'get' *The Fast Show* during the mixed reaction to its first series, acknowledged that part of its secret was (as its title suggested) using sheer speed to compensate for the inevitability that not everything could be expected to appeal to every viewer – 'the whole point of the programme is that all the items are very short. If you don't like them then they are over quickly and another one comes along in no time' (Hislop 1994: 47). It scarcely matters, then, that I've never particularly warmed to Ron Manager or Dave Angel Eco Warrior – *The Fast Show*

remains one of my favourite comedy series because I rarely have long to wait for Ted and Ralph, Arthur Atkinson, Unlucky Alf, Competitive Dad, later arrivals like silver-quiffed used car dealer Swiss Toni ('[insert activity] ... is very much like making love to a beautiful woman'), Arabella Weir's poison-tongued South African cosmetics assistant ('No offence!') and Caroline Aherne's merciless supermarket checkout girl ('Aw, microwave meal for one – live on your own, do yer?'). Nor has inconsistency harmed the series' 'classic' status (a prestigious BBC 2 theme night in 1999, a cameo appearance by celebrity fan Johnny Depp) any more than it did the equally hit-and-miss *Monty Python*.

Considering its popularity and longevity, the sketch show is under-theorized and critically neglected compared to sitcom – its conciseness and comparative lack of narrative or character complexity makes it harder to get to grips with. With some exceptions, it also seems to be regarded as the poor relation of sitcom. In a recent article supposedly announcing the sketch show's death (sitcom having miraculously recovered), Alexi Duggins dismissed it as an inferior comic form because 'it just cannot match the depth of sitcoms' (2012: 111). Sitcom, it seemed, had grown up – it was 'subtle, layered and meta' (the usual very selective suspects were cited) – while the sketch show was stuck with its catchphrases, punchlines and 'one-dimensional characters' (*Ibid*.: 111). There are useful (if inevitably dated) discussions of sketch comedy by Neale and Krutnik (1990), Wilmut (1980, 1985) and Neale (2001), but what little other work exists mainly focuses on single series – *Python* is the form's canonical object (Wilmut 1980; Thompson 1982; Landy 2005), while more recently studies have examined *The League of Gentlemen* as a 'TV Classic' (Hunt 2008) or considered *Little Britain* as a popular cultural phenomenon (Lockyer 2010b). The sketch show has two very different pedigrees – its origins are in music hall and variety, but Footlights revues would make the sketch part of the post-war embourgeoisement of British comedy. While the Cambridge University Footlights Club was founded in 1883, it was not until the 1950s that it featured the kinds of performers who would make a broader impact on British comedy (Jonathan Miller, Peter Cook, John Bird,

Eleanor Bron). Thus, the comedy sketch acquired a new cultural capital – it might be satirical, surreal or contentious, its relative lack of structure disembedded from its music hall origins and seemingly aspiring to an anarchic whatever-next aura. *Monty Python*'s elevated status is aided by it standing in stark opposition to every other sketch show of its time, apart from Spike Milligan's *Q5*, which appeared just ahead of it in 1969 – Milligan remains a rogue figure in British comedy history because he doesn't fit easily and simply into either the music hall/variety or Footlights traditions.

Of the more populist, variety-affiliated sketch shows that existed contemporaneously with *Monty Python*, *The Dick Emery Show* (BBC 1 1963–81) now seems to be the most important point of reference for recent sketch comedy, albeit without enjoying the same 'classic' status that *Morecambe and Wise* or *The Two Ronnies* now do. Emery's show was unashamedly familiar and populist – while the closest *Python* got to a catch-phrase was 'And now for something completely different', Emery brought back a recurring set of characters each week. Blonde, busty Mandy and voracious spinsterish Hettie would appear in pseudo-vox pop items – the former picking up on unwitting double entendres by her interlocutor to deliver the series' most popular catchphrase 'Ooh, you are awful! But I like you!' (accompanied by a doesn't-know-her-own-strength shove).[1] Other characters included a skinhead 'bovver boy', phlegmy old man Lampwick (who anticipates two *Fast Show* characters, Unlucky Alf and Coughing Bob Fleming), a toothy vicar and Clarence, the kind of flamboyant gay man ('Hello, Honkytonk, how are you?') that alternative comedy would sentence to stereotype hell, only for him to return as a more ambivalent figure in *The League of Gentlemen* (predatory Herr Lipp), *Little Britain* (waspish and infatuated Prime Minister's aide Sebastian; Dafydd 'the only gay in the village')[2] and *The Catherine Tate Show* (her 'How *very* dare you!' character). Music hall sketches had moved away from one-line gags towards more structured items with character observation in the 1920s – Wilmut credits Will Hay, with his Schoolmaster character, as being particular innovative (1985: 99, 105). Emery, like another contemporaraneous sketch performer Stanley Baxter

(who specialized also in impressions), added versatility to the form, too – a quality that would later also be celebrated in Harry Enfield, Paul Whitehouse, *The League of Gentlemen*, *Little Britain* and Catherine Tate. Emery was already an unfashionable figure by the time of his death, but his final vehicle was designed to further stress his versatility with characters – the two series of *Emery Presents* (BBC 1 1982–83) comprised two six-part stories in which he played multiple characters.

When Harry Enfield developed his sketch series *Harry Enfield's Television Programme*, he effectively became the modern Dick Emery, even though he had acquired a vaguely alternative aura through his appearances on *Saturday Live* – he had even more recurring characters and (particularly) catchphrases than his predecessor did. As suggested in the first chapter, Enfield is a transitional figure. He was a little too fond of racial and class stereotypes to fit comfortably into alternative comedy and came to prominence when it was losing impetus. But it would be his 'sidekick' (Whitehouse) and former writers (Whitehouse and Charlie Higson) who would have a greater impact on the form from the mid-1990s. Enfield's second and last BBC sketch series *Harry Enfield and Chums* appeared the same year (1994) that *The Fast Show* made its debut. Whitehouse and Higson apparently found inspiration from seeing a cut-down preview of Enfield sketches that stressed the catchphrases and they would use at least one item that Enfield had rejected for his show (the lascivious menswear assistants whose 'Suit you, sir!' catchphrase was one of *The Fast Show*'s biggest successes). Speeding up Enfield might suggest a coarsening of character sketch comedy, but *The Fast Show* would largely be more nuanced and complex than Enfield's shows – where Enfield caricatured comic 'types' (the toff, the 'slob', the interfering old man), the *Fast Show* cast inhabited them rather more and exhibited greater warmth towards them.[3]

In a review that he now seems to regret, the *Evening Standard*'s Matthew Norman dismissed the first episode of *The Fast Show* as 'the most dizzyingly awful sketch show for a very long time' (1994: 45). He was not alone in that view at the time, but Norman's review made a point of singling out Whitehouse for criticism, casting him as the sidekick who didn't know his place –

referring to Enfield as a 'genius', and likening Whitehouse to an Ernie Wise foolish enough to think he could prosper without Eric. The show's failure, he judged, was because 'Whitehouse doesn't seem to have the talent … With Enfield he's great; without him he's nothing' (*Ibid.*). This is not to chide Norman for backing the wrong horse – a TV reviewer evaluating a first episode is in a difficult position – but does underline how the picture changed. By the end of the decade, *The Fast Show* had undergone a huge live tour in tandem with *Shooting Stars*, had a theme night on BBC 2, seen its catchphrases taken up so widely that the *Sport*'s heartlessly funny 'Shoot you, sir' headline after the murder of Gianni Versace was instantly understood. Enfield, meanwhile, had fallen so far out of favour by the end of the decade that *Harry Enfield's Brand Spanking New Show* (2000) was made for Sky 1. Ironically, it would be a collaboration with Whitehouse, *Harry and Paul* (BBC 1/BBC 2 2007–), that would bring him back to the BBC.

In the same paper in which Norman dismissed *The Fast Show*, Victor Lewis-Smith – who would have seen more of the series by then – observed that 'we're getting some idea of how much Harry Enfield owes to [Whitehouse]' (1994: 51). He summed up the programme as having 'its feet in Dick Emery, its brain in Monty Python, its groin in Benny Hill, and its heart in *Viz*' (*Ibid.*). In some ways, *The Fast Show*, like Enfield, owed more to Emery than to *Python*, but Lewis-Smith's reference to *Viz* is astute, too. *Viz*'s main satirical target was the kind of single attribute characters who were the mainstay of children's weekly comics. By stressing their grotesque, scatological and sexual qualities, never seeking to disguise the repetitive nature of these characters' escapades (even making it part of the joke), it made them more like sketch show characters – the pleasure lay in seeing how many variations could be wrung from the same scenario (the prodigious versatility of Buster Gonad's 'unfeasibly large' testicles, the tyrannical emotional blackmail of Spoilt Bastard). *The Fast Show* has a number of single attribute characters – Coughing Bob Fleming, the Fat Sweaty Coppers, Chip the hearing-impaired stuntman ('Go and check your make-up with Ruth'/'Chuck myself off the roof? Right!'). But none of Lewis-Smith's reference points account for the character development and unexpected pathos that would define some of the

sketches, none more so than country squire Ralph and the Irish groundsman he adores, Ted. *The Fast Show* – innovative in some ways (its pacing, its pathos and ongoing narratives) and very traditional in others (its catchphrases) – captures the tension between *variety* and *repetition* that seems to me to be at the centre of the post-alternative sketch show.

Formats, characters, catchphrases: the poetics of the comedy sketch

Claims for *Monty Python*'s originality rest on both its individual sketches and its format as a sketch show. Its sketches evaded 'the tyranny of the punchline' (Wilmut 1980: 197), laid bare the artifice and conventions of TV itself (Neale and Krutnik 1990: 201), or displayed the Magritte-like surrealism of Terry Gilliam's animation. Its format might appear to follow a stream of consciousness, like 'automatic writing', but there was a kind of artful structuring at work, too – sketches that were interrupted, that overlapped or returned unexpectedly. Wilmut provides some useful terminology in his attempt to account for *Python*'s innovations with the format of the individual sketch. He acknowledges that the 'reversal sketch' – 'taking a basic premise and reversing it' (1980: 198) – pre-exists them but that they found a fresh spin on it. One example of this was the 'format sketch', which would take a TV format (the quiz show, the vox pop, the studio interview) and 'empty the content out of it, replacing it with something ludicrous' (*ibid.*). Thirdly, there was the 'escalation sketch' in which a situation gets out of hand 'so that absurdity builds on absurdity' (Ibid.). In some cases, I suspect that what seemed original about *Python* was their particular use of these formats rather than their creation of them. A less 'anarchic' version of the format sketch can be found in more mainstream comedy, such as Dick Emery's vox pop interviews with Mandy and Hettie or Benny Hill's celebrated 1961 parody of *Juke Box Jury* (as *Soap Box Jury*) in which he played both host David Jacobs and all of the contestants. The format sketch remains a mainstay of the sketch show. *That Mitchell and Webb Look* (BBC 2 2006–) has had two different running game show parodies; *Numberwang*, with its incompre-

hensible rules and seemingly arbitrary cries of 'That's Numberwang!', and the sickly hued post-apocalyptic quiz show featured in Series 3 that makes ominous references to 'the event' while urging viewers to remain indoors.

Newer media formats inevitably provide fresh inspiration – most commonly, the fly-on-the-wall mock-doc that also pervades sitcom, or the dating agency videos featured regularly in *Smack the Pony*. *The Fast Show*'s Chanel 9 sketches offer a fresh take on the combination of format and reversal sketches by focusing on familiar formats (news, soap, variety, weather forecasts) made strange by their appearance on a channel that is vaguely Mediterranean (Spanish? Greek? It isn't a million miles from certain types of Italian TV). Chanel 9 reflects the opening up of newer, stranger formats by satellite and cable TV. Similarly, 'Adventure Call' in *Limmy's Show* takes the kind of tatty programme found on low-rent satellite channels that make money via expensive phone-in lines, here enabling viewers to take part in an uninspiring role-playing game hosted by the elfin Falconhoof. But 'Adventure Call' also functions as a kind of character sketch (a format I shall return to). Falconhoof must maintain the fragile atmosphere of fun and adventure in the face of callers who are aggressive, depressed, or former tormentors from his schooldays. An upset mother phones about her son who has spent hundreds of pounds calling the show and still not received his paltry prize money – 'He's skinned me, son, he's skinned me.' A helpless Falconhoof attempts to cheer her up by inviting her to play.

> FALCONHOOF: You awake in a castle tower. There is a window. On the floor is a ring.
> CALLER: (*too depressed to really care*) I don't know – climb out the window.
> FALCONHOOF: (*smile fading*) You climb out the window and fall from the tower. (*pause*) You are dead. (*pause – sound of phone being put down. Falconhoof looks shaken but attempts to lighten the mood*) Let's take another call!
>
> (1.1)

One of the most memorable format sketches appears in the first series of *Big Train* – the World Stare Out Championship,

the show's sole recurring item. The premise itself is a surreal reversal – the most inert non-event imaginable presented as an exciting spectacle (at one point, the camera pulls back to reveal a packed stadium around two motionless men). The 'format' component of the sketch is its parody of sports commentators who must inject excitement into 'uneventful' sports like snooker and darts. Football commentator Barry Davies and skilled impressionist Phil Cornwell react breathlessly to incidents that we have to take on trust – 'Suddenly it's come to life!' one of them cries even though nothing has perceptibly changed since they were complaining about its tedium (and the audience was slow handclapping) a few moments earlier (1.5). A further joke is that, while the rest of the series is live action, the World Stare Out Championship uses animation to represent the virtually inanimate.

The reversal sketch can be used as a way of exploring or simply playing with cultural identity. *Goodness Gracious Me*'s exploration of British-Asian identity and cultural exchange is often expressed through comic reversals – the upwardly mobile assimilationist Kapoors who insist on pronouncing their name 'Cooper' and act out a strange unwitting parody of 'Englishness', the father who insists that everybody and everything from Santa Claus to Da Vinci is originally 'Indian!' Looking at 'The Last Supper' with his son, he explains his reasoning for re-assigning its nationality – 'Twelve men sitting around the table waiting for dinner – where are the women? They're in the kitchen!' *Goodness Gracious Me* is sometimes damned with faint praise – Sangster and Condon call it 'a true groundbreaker' but ultimately judge it 'a competent but never spectacular sketch show' that yielded 'only a few that were real classics' (2005: 339). But unlike the other key 'ethnic' sketch show of the nineties *The Real McCoy* (1991–96), at least one of *Goodness Gracious Me*'s sketches has been allowed entry into the canon – 'Going for an English' was number six in Channel 4's *50 Greatest Sketch Shows* (2005). Set in an English restaurant in Bombay, it reverses the rowdy chauvinism of white Little Englanders insulting Indian waiters on a Friday night and engaging in homosocial competitiveness to consume the hottest curry. Here, the Indian customers mimic a kind of Cockney

accent ('awright, moit!'), call the white English waiter (James) 'Jamez' or 'Jahms', articulate the phrase 'bread rolls' as though savouring its exoticism and ask for 'the blandest thing on the menu'; meanwhile, the women giggle over 'what they say about white men', glancing in the direction of James's crotch. This simple reversal carries considerable satirical force (even if it now seems slightly overplayed) and it's interesting that *Goodness Gracious Me*'s best-remembered and most celebrated sketch not only doesn't feature any of its recurring *Fast Show*-like characters or catchphrases ('Cheque, please', 'Kiss my chuddies') but is one of the series' more cutting sketches. Mark Lewisohn suggests that 'it made a particular impression on the white audience who recognized its truths' (2003: 329) but a quick glance at YouTube comments suggests that it still resonates with Asian viewers, too. Armstrong and Miller, meanwhile, sometimes find comedy in class reversal. Their Channel 4 series features a sketch in which dodgy academics (dressed as tweedy Oxford professors but with Cockney 'wide boy' accents) sell poorly researched or referenced dissertations from a van – 'I got a 20–page speech on agricultural land usage and its effects on migration in thirteenth century France. I mean, it's all referenced up, you know, it's all sourced. It's in the back – yours for a tenner.' As they drive off, their victim realizes too late that he's been had – 'This is all over the place – most of it's about Germany' – and we cut to them laughing in the van (4.5). Their most popular characters in their more recent and more mainstream BBC 1 series are the Second World War airmen, filmed in black and white, who articulate the slang and outlook of contemporary urban youth with officer-class enunciation while smoking pipes. As they prepare for the Normandy landing, they interpret it as a trip to the seaside:

> ARMSTRONG: Is you gonna get chips and shit?
> MILLER: Oh yeah, I is gonna get chips and shit and saveloy and all this and I is gonna put on so much vinegar that my lips turn all blue and I look like my Nan did when her neck stopped working.
>
> (3.1)

In another sketch, a modern sense of consumerist entitlement makes the concept of rationing hard for them to grasp. 'Yeah,

but the thing is, grocerman,' Armstrong objects, 'we want *more* than you said we is allowed. And not giving us what we want is actually against our rights. It might make us experience issues around not having any ham' (3.2)

If the escalation sketch, perhaps the most 'Pythonesque' of Wilmut's categories, is defined by successive logical absurdities, the more recent emphasis on character comedy might explain why it seems less common than in Python. Chris Morris is an exception – *The Day Today*, *Brass Eye* and *Jam* allow absurdities to escalate in a manner that destabilizes some piece of conventional logic or moral value. Otherwise, even the most *Python*-like of modern sketch shows, *Big Train*, is more likely to explore a single absurd idea – Jesus and Satan as office antagonists, child-like showjumpers pretending to be firefighters (both 1.1), Ming the Merciless on his day off (1.3) – than escalate it further. In *The League of Gentlemen*, the logical escalation surrounding Papa Lazarou pushes into horror as much as comedy. Modern sketch shows are more likely to escalate a character's behaviour, like *The Fast Show*'s Sir Geoffrey Norman MP, whose denial of the words attributed to him during a TV interview spin off into the denial of and disagreement with everything said to or of him – the logic is in some ways reminiscent of *Python*'s escalating 'Argument Sketch'.

We might add further formats to those set out by Wilmut. Some of the sketches in *Limmy's Show* operate as a kind of *monologue sketch*, in which Limmy/Brian Limond both delivers a stand-up routine (often a rant of some sort) and inhabits a diegetic world. The 'Having a Swing' sketch (in the pilot episode), set in a children's playground, is largely a straight-to-camera monologue (with some illustrative inserts) about being cheated by the social imperative to grow up and 'fit in':

> (*jumping off the swing*) Right, well, there's me fittin' in! Ye happy? There's me fittin' in, right? That's me aff the swing, right? What've you got for me now, then? I'm twelve years old, what have you got for me now to replace that swing wi'? Nuttin'! Nuttin'! Fags, booze, drugs – nuttin'! In fact, forget about me being twelve years old, I'm thirty-four years old and I still want to go on that swing, but ye still willnae let me. So

what have you got to replace that swing wi'? I tell ye what
you've got – work! That's what ye got – work! Monday to
Friday – work!

As he continues to rant, a small boy gets on the swing and
Limmy orders him off, a little put out when the boy tells him
he's 'horrible' – 'I'm no'! Wee man, I'm no', right? You'll
understand when you're older, right?' He addresses the camera
again – 'I can't believe I just said that.' The sketch climaxes with
him enjoying standing on each swing and propelling it upwards
with a kick off to wrap around the cross beam – the first one
wraps itself all the way round (to Limmy's satisfaction) but the
second only partially does so. 'Bastard!' he mutters, stalking off.

The *character sketch* – stretching from Will Hay through to
Dick Emery and Harry Enfield – needs to be seen as a category
in itself. *The Fast Show* would use it in two ways – one that (like
Emery and Enfield) stressed *repetition*, usually with variations
but little progress, and one that stressed *seriality*, an unusual
characteristic in sketch comedy before the 1990s but one that
The League of Gentlemen in particular would take further. The
most common form of repetition is the catchphrase, but it is not
the only one. It can be a character trait, a particular type of
behaviour, like *The Fast Show*'s Different-with-Boys, the
Arabella Weir character who is tough-talking until a man (*any*
man) enters the room, whereupon she transforms into a
simpering, baby-talking 'girly'. Ben Miller's trendy school-
teacher (in the Channel 4 *Armstrong and Miller Show*) tells his
pupils to 'fuck off' every week, but what really defines him is his
mercurial shift in attitude from energized commitment to
hostile indifference. One minute, he's making his class abandon
their surly resistance to learning or coaxing out the troubled boy
within the school bully, dressing and talking like 'one of them'
(denim jacket, earring), only to abruptly switch off and open his
newspaper the minute the school bell rings.

Sometimes, the recurrent feature is an inevitable outcome
that the character is locked into – the running sketch can be
even more of a 'trap' than the sitcom because of its creation of
an endless loop. TV historian Dennis Lincoln Park (in the BBC
1 *Armstrong and Miller Show*) is doomed to endlessly destroy

priceless artefacts in spite of increasingly elaborate efforts not to. *Monkey Dust*'s (BBC 3 2003–5) Ivan Dobsky is trapped in a cycle that forever takes him back to the sketch's originating point – his release from prison after thirty years, followed by his inability to fit into contemporary Britain (all of his reference points belong to the early 1970s, including his only friend, a space-hopper called 'Mr Hoppy'). Ivan has a catchphrase of sorts ('I'm the meatsafe murderer, only I never done it') but what really distinguishes him as a character is that he is a wrongly convicted man driven to murder in order to be allowed to return to the comfort zone of prison. The following week, he is released again – as if for the first time – and the cycle is repeated. Another *Monkey Dust* character, Divorced Dad, manages to break the cycle of committing suicide weekly while his son Timmy visits. The twist is doubly unexpected, given that he has just worked out that Timmy isn't biologically his child, his biggest disappointment yet – nevertheless, he decides to play Ludo with him instead of ending it all again (1.4).

While *The Fast Show*'s Unlucky Alf is more of a catchphrase character – his Yorkshire-accented 'Oh, bugger!' is ripe for impersonation and merchandising – he is the most interesting example of a looped sketch show character because of his own anticipation of (predictable) misfortune. In the first episode of *The Fast Show*, there are two Unlucky Alf sketches, as if to establish from the start that part of the joke lies in its repetition. In the second of these two sketches, not only do we now know the rules, but Alf demonstrates (addressing the camera directly) that he does, too. He points out a 'ruddy big hole at end of road', observing – not inaccurately – that 'knowing my luck I'll probably fall down that'. The camera remains static as he walks down the road, almost disappearing into the distance – in a show that is otherwise so impatient to get to the next item, it almost seems to last as long as Alida Valli walking past Joseph Cotton at the end of *The Third Man*. The audience chuckle in anticipation before a powerful wind takes hold of Alf and forces him to walk into the hole – the delayed but inevitable payoff gets a big laugh and applause. Some of Alf's sketches are quite simple – a parrot that refuses to speak ('Bugger!') then, after a pause, starts calling him 'wanker' and 'twat' (prompting

another 'Bugger' from Alf) (1.2), a cat belonging to the widow he's courting that claws him 'in me privates' (2.6). Others are more elaborate – his attempted journey to propose to a different widow is presented as a series of frustrated attempts segmented throughout episode 2.5 – a bird defecates on him as he leaves the house and he must go back to change (attempt 1), he narrowly avoids dog shit on the pavement but another bird (or maybe even the same one) splatters him again so that he steps back into the dog shit, slips and then falls over a wall (attempt 2), he is sprayed with manure (attempt 3) and finally arrives in time to see the object of his affections being carried from her home in a coffin. This is the kind of cycle of misfortune that sometimes drives cartoon characters to an awareness of their creators tormenting them, like Daffy Duck in *Duck Amuck* (1953), and Alf almost seems aware of his status as a sketch show character who cannot escape its formula. He even embraces his fate, to a degree. In one sketch, he appears to win the pools and receives (unwelcome) sexual advances from a buxom neighbour. He's relieved when he wakes from this dream, even when crumbling plaster lands on his face – 'Here we go!' he says to camera just before the ceiling falls in on him. The payoff is that he's the happiest we've ever seen him when his cycle of misery resumes – 'That's more like it!' (1.6).

Comic catchphrases are not the sole province of the sketch show – they are sewn into the history of stand-up and sitcom, too. However, I suspect that when references – particularly pejorative ones – are made to 'catchphrase comedy', they are most likely to have sketches in mind because the economy of the sketch inevitably makes the phrase seem more repetitive. There is a difference between Victor Meldrew saying 'I don't believe it!' in an *episode* of *One Foot in the Grave* and hearing 'Suit you, Sir!', 'Yeah but no but ...' or 'Am I bovvered, though?' possibly several times in a sketch that can be as short as a minute. Johann Hari, ironically in an article about *Little Britain*'s contempt for the less privileged, characterizes catchphrase comedy as:

the lowest form of wit ... humour for people without a sense of humour: you can watch a sketch waiting for the dull, repeated

phrase ... and feel like you've Got It and you are In On the Joke without any mental dexterity or understanding. (2005)

Such denigration of catchphrases and their fans can be found even in comedy itself – the 'mindless' sitcom in which Ricky Gervais's character is cast in *Extras* (BBC 2 2005–7) is summed up by his gurning delivery of his catchphrase 'Are you 'avin' a laff?' And, paradoxically, *The Fast Show* – probably responsible for more catchphrases than any other series – ridicules part of its own fan base through the figure of Colin Hunt, the tiresome office 'joker' whose endless parroting of catchphrases and other 'wacky' utterances suggests that he is compensating for the kind of humour deficiencies that Hari refers to. In both of these examples, the implication is that a catchphrase is a substitute for a 'proper' joke. Catchphrases are unapologetically populist – repetitive and crowd-pleasing. As Brett Mills observes, none of the major humour theories can explain their comic appeal (although some of them are pretty incongruous – 'Where's me washboard?', 'You're *my* wife now'). They are 'empty, meaning-less phrases' around which 'hover the quotation marks' that draw attention to an exchange between performer and audience (2005: 78). The catchphrase 'helps to bind the audience together' by establishing a shared understanding of the programme's conventions (*Ibid.*: 89).

The catchphrase can perform a number of different functions. It can sum up a character economically. Vicky Pollard's mantra (in *Little Britain*) of 'Yeah but no but ... so anyway *shut up!* ... OMIGOD I *so* cannot believe you just said that' has been contentious for its apparent mockery of 'chav' speak (Hari 2005; Lockyer 2010a; Jones 2011),[4] but it also encapsulates the way she grinds her verbal gears while trying to think up a suitable lie, her stroppy defensiveness, her wandering train of thought ('so anyway *shut up*' usually follows a diversion into irrelevant gossip), her inability to take responsibility for any of her actions. In *The Fast Show*, Archie's insistence that the profes-sion of whoever he strikes up a conversation with is 'the hardest game in the world' establishes his desperation to talk (he will later steer the one-way conversation to his favourite subject, Frank Sinatra), hinting at the loneliness that will become more

visible in later sketches. The catchphrase can also exist inde-
pendently of a recurring character. The most interesting
example of this type is what I would call *the covert catchphrase
sketch* in which we don't realize that the recurring catchphrase is
coming until it arrives. Armstrong and Miller's BBC 1 series
provides a good example in their 'Kill them!' sketches. A priest,
a football manager, a camp estate agent, or the manager of a pop
group (always played by Armstrong) waits for his audience to
leave before switching manner abruptly to that of a Bond villain
as he orders their death. In Series 2, the 'Kill them!' sketch
didn't appear until several episodes in, making it even harder to
anticipate and consequently even funnier. Other covert catch-
phrases do belong to a regular character but we still might not
always recognize them immediately. Paul Whitehouse's 'Anyone
fancy a pint?' character in *The Fast Show* isn't automatically
distinguishable from other Whitehouse characters, and so can
pop up at a theatre, at Alcoholics Anonymous or interviewing
an animator of Wallace and Gromit. Mark Williams's 'I'll get me
coat' character is usually more recognizable – visibly out of his
depth amongst the pretentious 'chattering classes' or not
listening properly before making a social gaffe. But he can also
turn up in disguise in a period setting, attempt to follow flowery
talk and then announce 'I'll get me cloak' when required to join
in (1.6). A sketch in *The Fast Show* Christmas Special signals that
we are probably in catchphrase territory but initially misdirects
us about which one. In a parody of Jean Luc Godard's *Le
Mepris*, Arabella Weir (in the Bardot role) asks Charlie Higson
in subtitled French whether he likes various parts of her body. It
isn't unreasonable, given the casting of Weir, to expect her final
question to be 'Does my bum look big in this?', but instead
Whitehouse enters unexpectedly and asks (also in French)
whether anyone fancies a pint. However, the sketch returns later
in the show and this time we get the expected payoff.

One final type of catchphrase is, not surprisingly, less
common – the *meta-catchphrase*, where the joke lies in the very
idea of a catchphrase being funny because of its mechanical or
arbitrary nature. *That Mitchell and Webb Look* features a
formulaic sitcom pastiche *Get Me Hennimore* in which the joke
is the laborious and contrived way that each episode sets up the

inevitable misunderstanding that leads to the hapless protago-
nist's boss angrily shouting '*Hennimooooooooore!*' More
elaborate are the Arthur Atkinson sketches in *The Fast Show*,
which show 'archive' footage of Arthur's music hall act and the
kind of acting work that such a past-his-sell-by-date star might
move on to (creaky sitcom, a bid for respectability doing
Beckett, a 1970s *Confessions* sex comedy). It is one of *The Fast
Show*'s most technically complex sketches, intercutting Arthur
with actual archive audience footage – in one instance, they
appear to be joining in with his baffling song about the London
Underground, knowing the words immediately (1.5). Atkinson
is a composite of Tommy Trinder, Max Miller and Arthur Askey
(the Beckett reference brings Max Wall to mind, too). His
catchphrases are either mystifying ('Where's me washboard?') or
have taken on a different meaning at a historical distance (''Ow
queer!'). To a certain extent, they are funny precisely by *not*
being funny. The humour rests on the recognition of the
temporal and contextual nature of humour – the strange experi-
ence of watching footage of audiences in hysterics over
something that required a certain set of shared understandings
and expectations that time has made unavailable to us. Arthur's
act consists almost entirely of catchphrases, nonsensical patter
and audience banter – 'I've seen you wrapping presents when
it's nobody's birthday', 'Look, mother – I'm skipping!'[5] He has
little actual 'material' beyond this.

Seriality and running sketches

Given that the sketch show has less room to develop character
than a sitcom does, the injection of seriality into selected series
is a notable development. Ongoing storylines within sketches
are a central feature of *The League of Gentlemen*, to such an
extent that its origins as a sketch show were less apparent by
Series 3. Unlike *The Fast Show*, the League developed many of
their most popular characters on stage and introduced a degree
of seriality partly as a matter of expediency – as a way of getting
audiences to return to their weekly shows at the Canal Café in
London in 1996, where the posters promised 'Never the same
show twice!' (Hunt 2008: 11). Their radio series *On the Town*

with the League of Gentlemen (Radio 4 1997) took this a step
further by placing the characters in the same town, Spent, which
would become Royston Vasey on TV. Nevertheless, a good deal
of the first two series works as self-contained sketches – 'It's a
shop sketch' comments Jeremy Dyson on the Series 1 DVD
commentary as they watch the first Local Shop sketch. Series 1
and 2 feature a number of ongoing storylines within sketches
(Benjamin kept prisoner by the Dentons, Restart Officer
Pauline taking Ross hostage after he gets her fired), while other
items are more self-contained and/or repetitive (Mr Chinnery
the vet constantly killing the animals in his charge, Charlie and
Stella bickering via a third party). Each series has a loose
ongoing storyline – the 'new road' that threatens Tubbs and
Edward's Local Shop (Series 1), the nosebleed epidemic caused
by butcher Hilary Briss's 'Special Stuff' (Series 2) – but these
impinge on some characters more than others. The new road
really only affects Tubbs and Edward and the businessmen
Geoff, Mike and Brian. The nosebleed epidemic feels more like
an 'arc', but even that affects few of the regular characters
directly. Nevertheless, it's sufficient to make the show feel less
segmented than other sketch series – *The League of Gentlemen*
takes place in its own 'world', a cult characteristic that I shall
return to in Chapter 6.

The Fast Show would not make seriality a defining feature of
the series overall, but Ted and Ralph appear slightly ahead of the
League's ongoing storylines. They are in some ways exceptions
to the way the rest of *The Fast Show* works. In a show that
averages a sketch or link a minute, the Ted and Ralph sketches
are slower paced and less dependent on catchphrases – the
closest they have to the latter is Ted's awkward 'I wouldn't
know about that, sir' when Ralph miscalculates their shared
reference points. One of their most memorable sketches is
entirely wordless. Ted is sitting under a tree smoking as Ralph
walks over to him from the house. Rather than the usual
awkward conversation, avoided eye contact, pregnant pauses,
Ralph smiles, nods, looks around, makes some gestures that
suggest he's building up to something, but then looks at his
watch. The audience knows by now what this gesture with the
watch means; it's the point where he usually retreats with some

excuse, except that this time he simply walks back to the house without ever saying anything (2.2). In other ways, Ted and Ralph are very much attuned to *The Fast Show*'s segmented flow, sometimes stripped into fragments across an episode for comic effect. In the Christmas Special, we return to them a number of times as Ralph tries to persuade Ted to come in from the snow:

RALPH: (*pleading*) Ted!
TED: (*quietly but firmer than usual*) No, sir.

We return to this repeated exchange several times – emphasizing its lack of progress – before the sketch is resolved towards the end of the show. Where most other sketches in *The Fast Show* adhere to Whitehouse's avowed formula of 'get in, see the character, do the catch-phrase and be gone' (quoted by Thompson 2004: 158), the Ted and Ralph sketches stretch out a relatively simple idea – unspoken homoerotic desire further complicated by a vast class divide – so that the humour lies in silences, glances, gestures, sentences left unfinished. It requires more patience and investment in the characters than the sketch form would traditionally be expected to. *The League of Gentlemen* uses glances, silences, things left unsaid and a lack of obvious jokes to different (macabre) effect in the scenes featuring Hilary and the 'Special Stuff'. In the first episode of *The Fast Show*, which economically establishes the ground rules for so many of its characters, the Ralph and Ted scenes withhold as much as they reveal. Their first appearance finds them having a strained conversation about the fence Ted is mending before Ralph broaches a rather different subject.

RALPH: Ted? (*grunt from Ted*) Are you ... interested in ... French cinema at all, Ted?
TED: (*quietly, clearly not wishing to have this discussion*) I wouldn't know about that, sir.
RALPH: No, no. Nonono, indeed, no. It's just, they're showing a rather good (*clears his throat*) Gerard Depardieu film in town and I ... (*tails off into silence*)
TED: Right, sir.
RALPH: (*quickly and slightly under his breath*) It's *Manon des Sources*. (louder) But, erm ... Good Lord, yes (*looks at his watch*)

I've got to get over to Winslow, Ted, erm, pick up some shoes, so er ... Yes, well, goodbye, Ted. (*walks back to house*)
TED: Goodbye, sir. (*waits until he's out of earshot*) Shoes. (*goes back to his hammering*).

(1.1)

It's in keeping with the nature of these two emotionally inarticulate men that the majority of their sketches tail off anti-climactically (and are no less funny for doing so). In subsequent episodes, the 'biggest' jokes are based on class incomprehension – Ralph taking Ted to a French restaurant and unwittingly making him even more uncomfortable by failing to recognize how far out of his comfort zone he has taken him (2.3). When he suggests a trip to Wembley to see Tina Turner (including staying in London and going shopping together), the clues are growing stronger that Ralph's feelings for Ted are probably more than platonic, whether he realizes it himself or not (1.2). One sketch begins with Ralph's romantic daydream of Ted striding through the field in slow motion (2.6). Because the sketches invite an emotional investment in these characters, this sometimes prompts laughter of an interesting type. In the Christmas Special, Ralph finally persuades Ted to come inside and they warm themselves by the fire. Another awkward conversation looks like it's about to become even more uncomfortable when Ralph quotes Kipling. 'Do you like Kipling, Ted?' he asks, an enquiry that would normally prompt a muttered 'I wouldn't know about that, sir.' But instead, Ted brightens – we see him not only thinking up a joke but permitting himself to tell it to his social 'superior'. 'I quite like the fruit slice, sir,' he responds and cannot suppress his laughter. Ralph takes a moment to register the reference and then joins in with the laughter, and Ted pushes the joke further with an impersonation – 'He does make exceedingly good cakes.' It isn't difficult to explain why the scene is moving – it's the most dramatic breakthrough we've seen in this relationship, the camera pulling back as the two men laugh together. But if it makes us laugh (which in my case it always does), it isn't at the quality of Ted's rather obvious joke. Rather, it's because emotional investment in these characters makes their laughter infectious – there's probably also an element of relief

in seeing their awkwardness for once dissolve into communi-
cation of the most sublime kind.

'I'm afraid I was very drunk': pathos and sentiment

As he observes the sketch show seemingly on life support, Alexi
Duggins proposes a method for its resuscitation – 'stop sketch
shows being entirely comedic. Why shouldn't some skits be
tragic? Why not have romantic moments?' (2012: 111). It's an
interesting question, but in fact such tonal variation can be
observed in several sketch shows from *The Fast Show* onwards –
Jam perhaps came closest to abandoning the comedic alto-
gether. If *Monty Python* and Spike Milligan challenged the
'tyranny of the punchline', some of Ted and Ralph's episodes
challenge the idea that a sketch needs to be particularly funny or
even funny at all. It's quite common for sitcoms to include non-
comic interludes, most frequently 'moving' ones that are more
likely to be successful if the audience feels that they have been
'earned' – that is, that they are rooted in characterization. The
economy and broader strokes of the sketch might mitigate
against this, but *The Fast Show* manages it not only with Ted and
Ralph but in one of the sketches featuring the permanently
inebriated and mostly incomprehensible Rowley Birkin QC.
Whereas we can normally only make out isolated phrases ('I was
quite flummoxed by a large cat'), Birkin is significantly more
coherent in the sketch in question. We understand enough to
know that he is remembering a woman he was in love with – 'it
happens to every young man, I'm sure' – and that 'of course,
the war came along'. He grows more serious as his monologue
continues – 'I held her in my arms ... (*long, unhappy pause*) I'm
afraid I was very drunk' (2.7). Birkin's catchphrase is trans-
formed from an expression of unrepentant and slightly
self-satisfied amusement ('what an absolute *rogue* I am', he
usually seems to be saying) to an expression of unspoken
tragedy. The studio audience initially laugh at some of his
eccentric observations – 'She had a very long neck' – but soon
recognize that the usual formula is being broken. There is a
pause after he delivers his 'very drunk' line, during which we
can only hear the clock ticking, followed by applause. Given Ted

and Ralph's embodiment of unspoken love and emotional reserve, they are *The Fast Show*'s most obvious candidates for a greater emphasis on pathos and an occasional de-emphasis on laughter. When Ted's wife dies, it is initially played for bigger laughs than usual. Ralph is forced to break the news in the form of a pub game ('Tomato Ted Aubergine Your Potato Wife's Turnip Dead') and the scene is played as black comedy (3.6).[6] But the end of the final episode of Series 3 finds them by her grave. Mrs Ted, we learn, thought it a shame that Ralph never had children.

> RALPH: Yes, well, this land is my legacy, Ted. I will live on through the work we've done together here. (*becomes more emotional, his voice breaking*) The trees and flowers and the shrubs that we have planted (*wipes tears from his eyes*) ... that *you* have planted, I think of those as *our* children ... (*Ted looks rather taken aback*) Ted.
>
> TED: I really think I should be getting back to work, sir. The drainage in the lower field ...
>
> RALPH: (*upset and angry*) Oh, bugger the drainage in the lower field, Ted! (in a calmer voice) I'm sorry ... I, I ... sorry, Ted but you really, you really don't need to work today.
>
> (3.8)

As they walk off together, music swelling further, Ted stumbles, a very old man for the first time, and Ralph puts his arm around him to support him. The credits roll and the final full series of *The Fast Show* very nearly ends with this tear-jerking scene – only at the end does it provide a brief reprise of Ken and Kenneth, the 'Suit you, sir!' characters to bring the series to a more obviously comic end. The scene is sentimental in many ways and deploys some fairly manipulative tactics to move the audience – swelling music, choked delivery, Ted's little stumble. An audience might find it harder to 'buy' this heartstring-tugging in a non-comic context – there are enough comic cues (Ted's reaction to them 'having children' together) to permit this sentiment. The music seems to me double-edged – it can be read as parodic (and does get some laughs), and yet it is in the affective nature of music that it can simultaneously encourage a more emotional reaction. I would speculate that this particular sketch has probably prompted more tears than giggles over the

years (at the same time that I suspect that this probably amuses Higson and Whitehouse enormously). Ted and Ralph have 'earned' laughter over time, by building up rich character details out of nuanced performances. As a result, bringing the sentiment to the fore doesn't require a huge shift in tone and plays as a logical culmination of their relationship, although they would return in the *Last Fast Show Ever*, an ill-advised feature-length Special and the recent web series. The Special seemed to confirm that developing Ted and Ralph beyond the sketch format dissipated emotional engagement with them rather than giving them the 'depth' of a sitcom. Their pathos emerged out of the segmented, repetitive, interrupted structures of the sketch format.

A one-off sketch at the end of Series 4 of *That Mitchell and Webb Look*, by contrast, moves into sentiment via an unexpected shift in tone, as Dr Watson visits an ageing Sherlock Holmes, suffering from dementia and placed in a nursing home. Mitchell (as Holmes) plays the early part of the sketch in a more obviously comic fashion and the humour in his forgetfulness is played up. But Webb mostly plays Watson straight from the start, heartbroken by the condition of his friend. The unexpected shift comes when Holmes has a brief moment of clarity – 'I know, John ... I *do* know. I can't get the fog to clear.' Watson cannot answer and is close to tears, and even though the sketch climaxes with Holmes soiling himself and calling for the nurse, it is no longer played for laughs (the studio audience have laughed at his delusions and memory lapses but are now silent). There is an interesting discussion in the YouTube comments for this sketch about whether this pathos is 'earned' or a rather too blatant bid for prestige:

> Totally devastating. Mitchell portrays the total futility of someone who has fallen so far from grace with such subtly [*sic*], as does Webb when at an utter loss of what to say, as he's the only one on whom Holmes could place that burden. Excellent piece of dramatic acting ... And yet, am I the only one who thinks this scene was somewhat out of place in a sketch show? It seems these characters are introduced right at the end, purely for the sake of poignancy.[7]

Sketches can de-emphasize the comic in other ways – stressing menace and unease (*Jam*, *The League of Gentlemen*) or producing a kind of anti-sketch that deconstructs the form and renders it humourless. The latter is understandably rare, but the apple shop sketch in *Stewart Lee's Comedy Vehicle* (1.6) is one example: a customer is frustrated in his attempts to buy apples by impenetrable bureaucracy – a variation on *Monty Python*'s (comparatively conventional) 'cheese shop' sketch, it aims to be shrill, mechanical and vaguely disturbing rather than funny (incongruous canned laughter reinforcing the effect). However, pathos and tragedy are probably more common because of the way they can be enabled by the seriality that featured in some sketch shows – such sequences grew out of an emotional invest-ment in characters built up over time and that was formerly more of a feature of sitcom.

'Broken' and integrated sketch shows

Big Train, like *Smack the Pony,* mostly defied the trend for recurring characters and catchphrases. It was indicative, too (like *The League of Gentlemen*) of how the changing look of TV comedy was evident in sketch shows at the end of the 1990s. While it retained studio audience laughter, it was shot single camera on film – other series would 'grade' the video image in post-production to take on a filmic look. Influenced by 'Bunuel, Python, Chris Morris' (Taylor 1998: 18), *Big Train* was voted 'Best Broken Sitcom' at the 1999 British Comedy Awards (Lewisohn 2003: 93). Stylistically, it applies comparatively natu-ralistic performances and a 'mock-doc' shooting style to surreal situations. 'The thing about docusoaps,' commented Arthur Mathews, 'is that they provide a reason for the camera to be in the room. It helps to get the understated style. It's something we learned from Chris Morris' (Dessau 1998: 14). One of *Big Train*'s specialities is what we might call the 'natural antago-nists' sketch. A fly-on-the-wall doc set in an office finds a disgruntled Jesus striding down a corridor to find the perpetra-tor of a practical joke (a plastic spider in his sandwich and the words 'HA! HA! YOU BIG TWAT!' written on the paper plate) – when he points at the culprit, the camera searches for him in a

crowded office and a group of people part to reveal a red-faced horned devil (1.1) who proceeds to behave like a stroppy schoolboy. Another variation on the 'natural antagonists' observes a group of people in a pub, two of whom happen to be a human-size cat and mouse (1.2). They start to needle each other, and things kick off outside the pub when one of them pelts the other with chips. The fight is filmed in the style of a reality police show – the men swear, the women become distressed, the camera observes from a safe distance – remove the cat and mouse costumes and it might be less obvious that we're watching a comedy. The title sequence of *Big Train* emphasizes incongruity as similarly shaped but mismatched images are joined – someone blowing a flute/toothpaste emerging from its tube, a lava lamp/a ketchup bottle, a leg/an arm – and subject matter is often set in tension with style. A man (Kevin Eldon) visits his friend (Mark Heap), who owns a large, excitable dog (1.5). We first see 'Rudy' through frosted glass, but it is already glaringly obvious that he is a man in a dog suit, standing upright on two legs. Eldon is increasingly uneasy, and part of the scene's curious humour lies in our uncertainty about what Rudy actually is. Does Heap have a man in a dog suit as a pet? One can imagine a *Python* version of this sketch in which the Eldon character (a Terry Jones role if ever there was one) tries to point out to Heap that his dog is actually a man – *Python*'s 'surrealism' often sets the rational and the 'silly' in conflict. Or is Rudy actually a large, over-excited dog who simply becomes much funnier by being played by a human actor in a dog suit? Further humour lies in the underplayed acting (particularly by Heap, oblivious to either Eldon's terror of the reason for it) and the shooting style. As the two men sit in the garden, we see glimpses of Rudy in the foreground or blurred shots of him in the background, but a clear view is withheld. As he gallops towards a terrified Eldon, the moving camera is positioned behind him. This oblique shooting style ought to give Rudy the aura of a barely glimpsed creature in a monster movie, except that we have already seen enough of him to recognize the incongruity between how he is being filmed and what he actually is. Our most complete view of Rudy is reserved for the final scene as Eldon tries to drive off – the 'dog' running up and

down (on two legs) beside his car and then sprinting after him, legs pounding, arms swinging.

There is little doubt about which sketch show has been the most successful – and most controversial – in recent years. *Little Britain* combined qualities from *The Fast Show* and *The League of Gentlemen*, but its popularity exceeded both of them with ratings of 9.5 million and a 40 per cent audience share by the time of its third (less critically well received) series (Mowatt 2010: 23). With the *League*, it shared a richness of production design and character acting and the sense of a coherent world. *Little Britain* doesn't seek to locate its characters in a single place or to suggest narrative continuity, but Tom Baker's linking narration conveys a similar sense of 'Britishness' to 'local' Royston Vasey (the title seemingly a reference to the 'Little England' mentality), one that is limited in its horizons, living on questionable past glories. Edward's meaningless blustering claim in *The League of Gentlemen* that 'I used to be in a war' ('Welcome to Royston Vasey' 1.1) is not dissimilar to Tom Baker's absurd nationalistic rhetoric in *Little Britain*:

> Britain, Britain, Britain. Land of technological achievement. We've had running water for over ten years, an underground tunnel that links us to Peru, and we invented the cat.
>
> (1.1)

The opening titles present a montage in slow motion, over 'patriotic' music, of its cast of characters – Marjorie Dawes the bullying leader of the 'Fat Fighters' club; Jason, a boy sexually attracted to his best friend's grandmother; Sebastian and Daffyd; Dame Sally Markham, a Barbara Cartland-style hack; 'rubbish transvestite' Emily Howard; eccentric Scottish hotelier Ray McCooney; and perhaps its biggest stars, Vicky Pollard and Lou and Andy.[8] But this is also a montage of environments that come to represent the comic nation: country houses, tower blocks, an urban school playground, council houses and the English seaside. Like *The League of Gentlemen*, this is a comedy of place as well as character. Considering the reputation the series later acquired for 'kicking down' at the disadvantaged, the elderly and the disabled, early episodes score some socially satirical points, particularly in Baker's narration:

> Tower blocks were introduced to Britain in the 1960s and were
> an instant success. People loved the sense of social alienation and
> entrapment and the stench of urine in the lifts.
>
> (1.3)

Such material suggests that another comparison is worth
making, with a series that debuted on the same night and the
same channel as *Little Britain*. As Claire Monk points out, while
Monkey Dust and *Little Britain* were both part of BBC 3's
launch night on 9 February 2003, they would subsequently
enjoy very different fortunes (2007: 337) – one of them became
modern British comedy's biggest crossover success from cult to
mainstream, while the other (already a darker, less accessible
prospect) was so marginalized that its second and third series
have never been repeated or released on DVD. Monk goes so
far as to present *Monkey Dust* as being effectively 'killed' by the
BBC, even down to removing its website. But there are also
some points of similarity between the two series. Both use
linking sequences to convey a sense of unity across different
sketches (even though *Monkey Dust* has different animators and
animation styles in different items) – visual jokes and Baker's
narration in *Little Britain*, the nightmarish streetscapes in
Monkey Dust. Both offer a contrast between 'official' versions of
a nation or city and its less glamorous reality. Monk identifies
the socio-geographic specificity of *Monkey Dust*, mostly set in
London, more specifically the 'run-down *local* London' rather
than the '*official* London of Government, public relations
initiatives, tourism, the media and increasingly globalised
corporate and financial power' (*Ibid.*: 346). *Monkey Dust*'s
London is 'all night, rain, knives, rats, garbage, urine and
syringes in an urban wasteland' (Christopher Howe, quoted by
Monk 2007: 337) – and that's just the title sequence. In
contrast with *Little Britain*'s Comedy Map Of The Nation,
Monkey Dust's title sequence strips away the idyll (children
eating ice cream, rainbows, a summer's day in the park, a
bandstand with a brass band playing) to expose the dystopia of
urban reality (kids in hoods producing knives, a man shooting
up, strip clubs and lapdancing bars, a man pissing against the
bandstand, the camera following the stream of urine to rats in a
pile of garbage). Of *Little Britain*'s characters, tower block

gerontophile Jason (dropped after Series 1) might be most at home amongst the internet paedophiles, nervous cottagers and university professors who murder their daughters in an incestuous frenzy. While *Monkey Dust* clearly had greater satirical ambitions than *Little Britain* (the rebranding company Labia, who re-launch Cancer as 'Closure', for example), its default setting was misanthropic (it wasn't quite as dark as *Jam*, but both clearly aimed to disturb and offend as much as amuse). One might judge *Little Britain* to be the 'safer' series (as Monk does), and there's some justification for that view, but at its best it's also a 'warmer' and more inclusive series that initially seems to have had some affection for its characters before diminishing returns coarsened its humour into the crassness of some of its later characters (a pensioner who urinates prodigiously in public, a transsexual 'Thai bride'). As Sarita Malik observes, its first series was 'far more abstract and overtly politically astute than the subsequent ones' (2010: 91). Nevertheless, it has been at the centre of discussions of comedy's handling of class (Lockyer 2010a), race (Malik 2010), disability (Montgomerie 2010) and gender (Finding 2010), or emblematic of 'catchphrase comedy' as a 'dumbing down' – 'the comedy equivalent of junk food' (Finding 2010: 143). As the latter comment suggests, this is as much a reflection of its huge mainstream success as it is of it being one of comedy's worst offenders in kicking down at its targets. *The League of Gentlemen* was more innovative and fully achieved (and prepared to take risks), *The Fast Show* perhaps more influential (particularly on the pacing of sketch shows), *Monkey Dust* and *Jam* more 'experimental' (albeit arguably sometimes at the expense of being funny), but *Little Britain* was the cultural phenomenon and an interesting (and often very funny) summation of some of the trends and developments in modern sketch comedy. A former BBC 3 controller once called it '*The Two Ronnies* for a sicker millennium' (Thompson 2004: 441). That now sounds like a double-edged compliment – critiques of *Little Britain* make it seem more like the *Two Ronnies* that *Not the Nine O'clock News* tore into than the *Two Ronnies* who are now celebrated for classic sketches about 'fork handles'. But the 'patchiness' of the sketch show has a way of accentuating the positive over time, and *Little*

Britain is likely to be remembered for sketches and characters that clearly left their mark on the popular imagination as much as its later misjudgements.

The sketch show is one of the most expensive forms of TV comedy – even with recurring characters, it is likely to use more sets than most sitcoms, and programmes like *The League of Gentlemen* and *Little Britain* were comparatively design-intensive in terms of costume and make-up. Consequently, it is likely to be a casualty of the more cost-conscious climate in recession-hit broadcasting. *The Fast Show* would return as an internet series, sponsored by Fosters, but has thus far been a disappointingly pale shadow of its former glories. And yet *Limmy's Show* – a much more rough-and-ready show, some of the sketches of which originated as 'home-made' videos on his YouTube channel – demonstrates that the form can thrive in other ways. Before we switch off the life support machine on the sketch show, we might also consider another notable success, CBBC's much-awarded *Horrible Histories* (2009–), a children's series sharp enough to also pick up an adult audience along the way.[9] Sketch shows aimed at children have some distinguished predecessors – most notably *Do Not Adjust Your Set* (ITV 1967–68), which featured such emergent talents as Eric Idle, Terry Jones, Michael Palin and David Jason. An upcoming episode of *Horrible Histories* is set to feature cameo appearances by the League of Gentlemen, while *The Ministry of Curious Stuff* (CBBC 2012–) starring Vic Reeves, suggests that children's TV is once again proving a congenial home for cultish sketch shows. *Limmy's Show* and *Horrible Histories* – a sketch show from BBC Scotland and one from CBBC – indicate that far from being on life support, the sketch show is prospering in different parts of the changing TV landscape.

Notes

1 *Ooh, You Are Awful* would be the title of a film vehicle for Emery in 1972.

2 The involvement of one gay writer-performer in each programme (Mark Gatiss and Matt Lucas, respectively) hasn't protected *Little Britain* in particular from accusations of homophobia (Hari 2005, Finding 2010).

3 Characters like Loadsamoney and Wayne and Waynetta Slob seem to me to kick down at the working classes more than anything in *Little Britain*. Class is handled in a much more interesting way in *The Fast Show* by middle-class Higson and working-class Whitehouse. Thompson attributes 'the poetry of social insecurity' to Whitehouse in particular (2004: 154–173) but the input of Aherne and Cash is key here, too – 'Red wine! You celebrating?' asks Aherne's checkout girl in one sketch. 'Wish I could celebrate something. £2.50 an hour – nowt to celebrate, is it?' (3.5).

4 Whether the 'chav' as comic type necessarily always kicks down or not, s/he has been more visible in sketch shows than other kinds of comedy, perhaps because language and/or dress establish the figure so economically – there are embryonic versions in Harry Enfield and *The Fast Show* (teenage mother Janine is a more affectionate version of Vicky Pollard in some ways) before the stereotype is consolidated by Vicky, Catherine Tate's Lauren and the language of Armstrong and Miller's airmen.

5 And yet, having said that, Arthur's 'patter' isn't significantly different from some of Harry Hill's, where incongruous phrases become funny by being repetitive and meaningless.

6 Significantly, this was the Ted and Ralph sketch that made it into Channel 4's top ten – uncharacteristically, it even has a punchline.

7 www.youtube.com/watch?v=Pp02ubGuTIU (accessed 26 October 2011).

8 Both of them would make Channel 4's top ten, although currency was on their side – Lou and Andy's visit to the swimming baths would be voted number one.

9 Some of its episodes would be re-packaged for a primetime BBC slot.

5

Community and intimacy: from laugh track to commentary track

According to Andy Medhurst, 'Comedy says to us: you're among friends, relax, join in' (2007: 19). While proponents of more confrontational or 'experimental' forms of comedy might challenge (or at least qualify) this proposition, it seems safe to accept that comedy does require some sense of belonging. The nature of this belonging might vary hugely, along lines determined by nation, class, ethnicity, gender, sexuality and age. It might also vary significantly in size (or imagined size) between the unifying community of mainstream entertainment that Medhurst seems to particularly have in mind, or the more subcultural belonging that 'cult' and 'alternative' comedy seem to offer. This chapter examines the role of two types of affective relations mediated by sound tracks accompanying TV comedy – recorded laughter and DVD commentaries – that can be seen as helping to position the spectator/listener by means of what Misha Kavka calls 'fictions of presence' or 'virtual relations' (2008: 12). Television, Kavka suggests, is 'a technology of intimacy, a machine that functions by drawing viewers *close*' (*Ibid.*: 5), but TV forms that involve a studio or 'canned' audience, from quiz to chat show to sitcom, also mobilize a rhetoric of communal belonging and even participation.

Recorded laughter has played a long and important role in broadcast comedy, simulating 'liveness', perceived as providing cues for the viewers' laughter and locating them within an electronic 'community'. While it reinforces nostalgic accounts of 'One Nation TV' – all of 'us' laughing 'together' – recorded

laughter has been contested to some degree from its beginnings as a broadcasting convention (Smith 2005) and seemed in danger of becoming obsolete, in sitcom at least, in recent years. The DVD commentary, on the other hand, offers what Thomas Doherty calls an 'imaginary friendship' between viewer and artist, not a community but 'a new order of intimacy' (2001: 78). This mediated intimacy takes on particular force in comedy – as a *League of Gentlemen* fan comments, 'it's like listening to a great private conversation between best friends' (quoted by Hunt 2008: 37). If recorded laughter is part of the legacy of broadcast TV, of being positioned within a mass audience, the DVD commentary belongs more to the era of 'new media' and 'individual consumer choice ... highly diversified content, atomized reception, and customizable interfaces' (Kompare 2005: 198). Both impact on the textuality of TV comedy. Recorded laughter or its absence can determine the pacing and performance of comedy, manage expectations around the tone and frequency of jokes. DVD commentaries form an 'intratext' (Brookey and Westerhaus 2002: 25) with the original programme, but the secondary text can sometimes break out of its supplementary role, perhaps most of all in the unruly field of comedy. Sometimes the DVD commentary doesn't know its place and might make us laugh as much as, if not more than, the primary text.

To laugh or not to laugh

Recorded laughter has, for much of its history, been perceived as 'an especially mundane part of the everyday TV existence ... by definition background, a part of the sonic wallpaper, effortlessly tuned out' (Smith 2005: 24). Recent developments have cast it as a more intrusive accompaniment, but for many years it was largely taken for granted as the accompaniment to TV comedy, from acclaimed 'classics' to the critically scorned and forgotten. The 'hearable audience' transferred from broadcast radio to television, providing 'a sense of authenticity, spontaneity, and "liveness"' (*Ibid.*: 34). By the 1950s its presence seemed to make a considerable difference to the commercial success of US sitcoms – some shows that initially eschewed the laugh track

improved their ratings by later adding one (*Ibid.*: 36). As Smith explains, one of the main rationales for its inclusion was the 'contagious laughter response' (*Ibid.*: 37). The 'infectious' nature of recorded laughter also underpins objections to its allegedly 'cheap and manipulative' function, particularly in the use of pre-recorded (or 'canned') laughter – as Graham Linehan commented more recently, some critics 'regularly complain about being told "where to laugh" by the audience's response (as if that was something that ruined their enjoyment of, say, *Monty Python* or *Dad's Army*' (2007: 2).

It seems fair to suggest that the aesthetic debates about recorded laughter apply primarily to sitcom and to a lesser extent the sketch show, which didn't appear to 'outgrow' the studio audience to quite the same degree that sitcom was perceived to have done. It is impossible to imagine a panel show or a stand-up/variety format without a studio or theatre audience because 'liveness' and 'working' an audience are so intrinsic to the formats and rhythms of these comic forms. But I suspect that the distinction is also related to that between narrative and non-narrative comedy – comic forms that stress story and characterization seem more vulnerable to the accusation that the laugh track is 'telling us when/where to laugh'. Moreover, as sitcoms and sketch shows became more filmic, using single cameras, locations and enhanced production values, they perhaps aroused the feeling that, like film comedy, they should be able to manage without this aural enhancement. Just as it has seemed 'natural' for TV comedy to be accompanied by the sound of laughter for most of its history, it is taken as read that film comedy must earn all of its laughs 'cold'. Prior to being shown on TV and other home viewing platforms, film comedy had no need to simulate its audience because of its public exhibition. However, given that film comedies are often more likely to be viewed at home nowadays, there are some instances where the lack of laughter can be more noticeable. The British sitcom movies of the 1960s and 1970s like the *On the Buses* series have a very different atmosphere when separated from the raucous studio audiences accompanying the TV shows; admittedly they might just seem like *Carry On* films to an audience unfamiliar with the TV episodes, but the 'Mickey

Mousing' music effects in the *Carry On*s already felt like a substitute for the sound of laughter.[1] The most revealing of these TV adaptations in this context is the first, least celebrated, of the *Monty Python* films, *And Now for Something Completely Different* (1971). Where the sitcom movies 'opened out' their world in their quest to justify extended running times (sending the characters on holiday was the most common) and the later *Python* films developed original stories, *And Now* ... simply re-stages sketches and animations that had already appeared in the first two series – now shot on film and with no recorded laughter. Usually passed over in discussions of *Python*'s movie work, the film provides an interesting glimpse of what the series might have looked like if it had been made in a style that we now take for granted. The sketches are often tighter and more atmospheric (if not necessarily funnier) and the strangeness of the material (especially the animation) is more pronounced because it is freed from the notional trappings of 'light enter-tainment'.

Roger Wilmut's discussion of the original TV *Python* sketches underlines another (inadvertent) value for recorded laughter – as a historical record of a particular audience in time responding to material later regarded as seminal or 'classic'. He observes the polite but 'muted' responses to 'The Parrot Sketch' and 'The Ministry of Silly Walks' (1980: 204, 207). In looking more like a contemporary TV sketch show, *And Now for Something Completely Different* might seem 'better' than the originals, but there is considerable historical interest (as well as entertainment value) in hearing an audience puzzled or completely silent. *The League of Gentlemen*, which abandoned its recorded laughter after Series 2, provides a more recent illustration of the studio audience as a part of the historical text. A good deal of the material in Series 1 and 2 (pre-recorded and then played to a live audience) originated in live performance and therefore is well suited to a studio audience – there are regular and clearly signalled laughs, recurring characters and catchphrases that invite a degree of participation. But there are scenes where the audience is audibly less certain of how to react – to Papa Lazarou, for example. They are even more quietly shocked by Herr Lipp burying schoolboy Justin alive in the garden, a small

tube in the soil his only source of oxygen ('Royston Vasey and the Monster from Hell' 2.6). During the first appearance of Pop, an ambiguously 'foreign' tyrant-father with a newsstand business and two terrified sons, the audience seems determined to find amusement even as the scene threatens to turn violent and Mark Gatiss and Reece Shearsmith play Al and Richey's terror absolutely straight ('The Road to Royston Vasey' 1.2). They are still laughing when Pop tells Al 'You are my son – my *only* son' as Richey is left sobbing, even though the scene turns more tragic than funny. In one of the sketches featuring snobbish Judee and her put-upon cleaner Iris, the audience laugh exactly once – at Iris claiming her husband was 'filling a crack' after they've been loudly having sex ('Death in Royston Vasey' 2.4) – but the grimness of Iris's home and her life otherwise generates silence. The League had never wanted a studio audience, but there's a case to be made that it enhanced some of the sketches now seen as 'classics' and produced interesting reactions for some of the more tonally ambiguous material. If the laugh track supposedly 'tells us where to laugh' (as it is often accused of doing), what is it telling us when we hear the sound of an audience uncertain whether to laugh or not?

Recorded laughter falls into three types – it can be recorded *before* filming ('canned laughter'), *during* filming (the studio audience witnessing a live performance) or *after* filming (a studio audience recorded during playback). The latter is commonly used for individual scenes in sitcoms otherwise recorded in front of a live audience, where locations are required or shooting is more complex than the studio/three-camera set-up allows – the pre-filmed scenes are shown to the studio audience at the appropriate point in the recording. Of the three, 'canned' laughter has the least currency now and has always had its detractors – seen as dehumanized and lacking the authentic spontaneity of human laughter (Smith 2005: 38) or, perhaps more damningly, suggesting that no real people could be found to laugh at the material in question. But as Smith points out, it was by no means unanimously accepted that the laughter of a studio audience was 'the bastion of human spontaneity' (*Ibid.*: 40) – the audience can be nervous, laugh too

loudly or for too long out of eagerness to please. Anyone who has ever been to a studio recording will know that spontaneous laughter mixes with 'performed' laughter – we may be asked to laugh through multiple takes of something we found funny the first time and must now re-create that hilarity (unless the performers can bring something fresh to subsequent takes),[2] and we are constantly being cajoled by the warm-up comic to keep the laughter coming. Graham Linehan, one of the studio audience's staunchest defenders, nevertheless acknowledges that their laughter can be problematic and claims that any post-production interference is more likely to reduce than increase it. He suggests that this is a particular problem for a new series, where the audience don't yet know the conventions, the characters or the 'rhythm of the show'. On the DVD commentaries for the first episodes of *Father Ted* and *The IT Crowd*, he worries that they're laughing too loudly at jokes that aren't that funny because it might arouse suspicions of 'canned' laughter.

> An audience comes in and they're trying to be nice and they're a little embarrassed and they want to do a good job of laughing and they just laugh at everything. And you just keep thinking 'Oh just stop laughing! It's not funny!' Then they start to realise, 'Oh wait – no, this *is* funny!' You know, they start laughing at the right points. They start *listening*.
>
> (DVD Commentary, *Father Ted* 1.1)

These issues notwithstanding, Linehan is clearly a believer in the 'contagious laughter response' – 'Audience laughter, when it's deserved, acts as a sort of fairy dust that makes funny moments not just funny but joyous' (2007: 2). The sound of laughter probably won't make us laugh at something we didn't already find funny – it might even alienate us further or make us suspicious of its authenticity. But Linehan is suggesting that it might make us laugh *more* at something that we already find funny. Shooting before a live audience clearly informs the style of the show even because it becomes part of the performance. The League of Gentlemen found even a studio audience watching pre-filmed material put the pressure on them to end sketches with a big laugh (DVD Commentary 1.6), even though the live origins of some of the material seems likely to have provided

that already. Significantly, they abandoned the studio audience when they began writing episodes that departed entirely from material that originated in live performance. Linehan welcomes the pressure of getting laughs 'live' because it 'pushes me to make the show funnier' (2007: 2) – the laughter points must be more frequent than in a programme without a laugh track and this pressure is probably even greater with a studio show.

The studio sitcom was probably the first to be deemed obsolete in the 'death of sitcom' debate. 'Sadly, the sitcom is dead,' declared Victoria Wood, who had written studio sitcom *dinnerladies* (BBC 1 1998–2000) not so long before. 'The likes of *The Office* are so good you can't go back' (Dowell 2008). Recording an audience during playback might be necessitated by complexities of shooting, but this approach potentially opens up the possibility of greater stylistic diversity than the three-camera 'live' recording. It is easier to imagine some of these shows dispensing with recorded laughter altogether. Early episodes of *The League of Gentlemen* offer a mixture of styles. Some of the sketches, like the Local Shop scenes, were timed to leave a gap for the audience to laugh (DVD Commentary, *The League of Gentlemen* 1.1) – that is, shot as if in front of an audience – while others (Pop, Hilary Briss) make fewer concessions to signalling where the laughs are. *Big Train* seems even less of a candidate for recorded laughter – shot single-camera style with relatively naturalistic performances and surreal situations. One of the reasons for Linehan's preference for recorded laughter is that it 'takes the edge off moments that otherwise might tip over into tragedy' (2007: 2.) In *Big Train* the laugh track manages the potential 'tipping over' of material that might be dark, tragic or violent. It asserts the comic intentionality of a scene in which Mark Heap discerns references to 'me not being married' in the most innocent of comments (even a conversation he overhears in French), telling a frightened Kevin Eldon that 'I'll put your fucking head through the wall', face twitching with barely controlled rage (2.1). While a lot of *Big Train*'s sketches are more whimsical, this is one of the sketches that wouldn't look out of place in Chris Morris's *Jam* (which Linehan and Mathews also contributed to) minus the laughter. In comic scenes that make use of long pauses or sentences trailing off – Ted and Ralph in *The Fast Show*, Hilary Briss in *The League of*

Gentlemen, *The Office* and *Peep Show* generally – recorded laughter can 'manage' those silences and reinforce their comic intent (Ted and Ralph), capture an audience's ambivalence (Hilary Briss), or in its absence allow them to become more uncomfortable (*The Office, Peep Show*). Audience laughter and pacing that mostly eliminates prolonged silences are two of the main things that separate *I'm Alan Partridge* from the fully fledged 'cringe comedy' that follows – 'cringe', by its very nature, must at least allow the possibility of the absence of laughter. Just as recorded laughter can be seen as 'joyous' or manipulative, there is almost as much justification for seeing its absence as either evidence of sophistication or a licence to be less funny – 'When you don't have to make people laugh all the time you can get careless' suggests comedian Lee Mack (Dowell 2008), co-writer and star of the sitcom *Not Going Out* (BBC 1 2006–).

While recorded laughter has always had its detractors, the broader perception that 'the sound of the crowd signals a lack of "quality"' (Lury 2005: 83) is a more recent one. The absence of laughter has sometimes made a generic distinction between sitcom and comedy-drama, a line subsequently blurred by the former aspiring to the implicit cultural capital of the latter. While the studio audience was one of the sitcom conventions alternative comedy mostly left intact (in *The Young Ones*, it actually enhanced the youthful, anarchic atmosphere), one of first 'quality' British comedy shows to abandon recorded laughter was *The Comic Strip Presents*. As Lury puts it, '[a]udiences at home are supposedly left to make up their own minds as to what is funny and to experience moments of pathos and empathy as well as humour' (*ibid.*). The lack of recorded laughter reinforces the 'disinterested aesthetic' Sam Friedman discerned in his respondents possessing high cultural capital, where the laughter was downplayed in favour of wider emotional responses, encompassing negative ones as well as positive ones (2011: 360). As mentioned earlier, on TV this is more true of narrative comedy – Stewart Lee is the quintessential 'difficult', high cultural capital comic, but we would still find it odd to see his stand-up material in *Comedy Vehicle* performed in an empty studio (admittedly, he's contrary enough to try it). Matters of taste and aesthetics are inextricably linked. Linehan's

preference for studio audiences is connected to his view that everything else is secondary to generating laughter. And the laugh-track-free comedy came to prominence through certain types of material – comedy-drama (*The Royle Family, Gavin and Stacey, Psychoville*), 'dark' comedy (*Nighty Night*, later episodes of *The League of Gentlemen*) and 'cringe' comedy (*The Office, Peep Show*). The DVD of *Jam* provides the option of playing two of its sketches with 'Original Audience Sound', which is clearly 'canned' – a father casually mentioning that his young son has been 'buggered quite a lot and then strangled' is met with applause. The intention here is obviously not to 'manage' the dark material but to emphasize how inappropriate recorded laughter would be. In the case of *The Mighty Boosh*, the pilot episode of which had recorded laughter while the actual series didn't, the lack of a laugh track reinforced not tonal ambiguity but the show's subcultural capital, its hip, retro pop culture vibe. In the unbroadcast pilot (some of the footage of which was included without the laughter in the broadcast version of 'Tundra' 1.4), the laughter works well with the double act cross-talk. But it's more intrusive when they do their 'Tundra' song (which even gets a round of applause at the end), perhaps because *Boosh*'s musical numbers seem to invite appreciation as actual music, rather than simply being weekly 'comic songs'.

Brett Mills points out that there is no evidence that audiences respond differently to sitcoms with or without laugh tracks and suggests that 'studies which see the laugh track as evidence of the socially cohesive nature of sitcom might too easily confuse a textual element with the feelings and readings of millions of individual viewers at home' (2009: 106). The de-naturalization of the laugh track had considerable textual significance, creating possibilities for different aesthetic approaches, but while the laugh track's revival cannot be mapped simply onto the turn to more 'inclusive' comedy (*Gavin and Stacey* had no need of it), there is a nostalgic tone to the way people like Linehan champion it, an apparent desire to connect contemporary comedy to its past while capturing an audience laughing together at the comedy of today. The real test for recorded laughter might be when television is no longer the default platform for what we currently think of as 'TV comedy'. Online

versions of Alan Partridge (*Mid Morning Matters* 2011–), Reeves and Mortimer (*Vic and Bob's Afternoon Delights* 2011) and *The Fast Show* (2011–) have all been laugh-track free (which admittedly they might also have been if they had been on TV). New media has its own affectivities, its own ways of mobilizing intimacy and feelings of connectedness. The following section focuses on a comparatively minority, cultish practice (the DVD commentary as source of humour and other affectivities), but it suggests some of the ways that the sound accompanying comedy might position us as viewers and (particularly) listeners.

'You can't say that!' DVD commentaries and TV comedy

I was talking to someone about the DVDs the other day, and he was referring to the commentaries more than the content of the programme .. You realize that you sit there and blabber on for three hours, and people actually listen to it – they get enjoyment from it. He was quoting bits of the commentary back to me! (Steve Pemberton, quoted by Richardson 2003: 26)

ADAM: In a way it's like receiving your own private tutorial from two masters of their craft.
JOE: But it's actually more like being bored slowly to death by a couple of self-obsessed wankers in a pub.
 The Adam and Joe Show (Channel 4 1996–2001)

The two quotes above are indicative of some of the different ways that the DVD commentary is seen and used. In an interview with a DVD magazine, Steve Pemberton marvels that the supplementary text has supplanted the actual programme for some fans of *The League of Gentlemen*. 'I only ever watch the series with the commentary on,' commented one online *League* fan (quoted by Hunt 2008: 37). Adam and Joe, meanwhile, spoof the authorial pomposity of what Catherine Grant calls 'digital auteurist "paratexts"' (2008: 103). We hear part of the 'extraordinarily insightful commentary' that supposedly accompanies their forthcoming DVD:

JOE: Oh, this bit's great, when you do that thing with your hands?
ADAM: What? Which thing?
JOE: Oh, no no no, I was thinking of a different bit.

But the reference to 'self-obsessed wankers in the pub' also locates the commentary in a domain of sociability.[3] The commentary track is, as Matt Hills puts it, 'a new type of fantasised co-presence', a 'mediatised watching-with' (2007: 52) – the 'self-obsessed wankers' are at least talking to us, watching with us, occasionally letting something slip – 'as in a tipsy late-night conversation,' Thomas Doherty observes, 'the speaker blurts out a private confidence or spontaneous insight' (2001: 78). Sometimes this blurting out can go beyond the frequently seen disclaimer that these views are not those of the parent company or label – the Series 1 commentary for *The IT Crowd* featuring Linehan, Chris O'Dowd and Katherine Parkinson is interrupted at one point for the writer to make the following announcement:

> On the advice of our lawyers, we've had to actually cut this section here. I do apologise – it got a little bit rambunctious, but we'll be back in just one moment.
>
> (Commentary, 1.1)

The League of Gentlemen never stray this far, but their candour extends to a recurring contempt for some of their extras:

> REECE SHEARSMITH: (*sarcastically*) The best actress in the world!
> JEREMY DYSON: You can't say that!
>
> (Commentary, 3.1)

'You can't say that!' virtually becomes the catchphrase of the League's commentaries, sometimes testing the boundaries of acceptability in this casual mode almost as much as they do on screen, but within different parameters. In this most 'sociable' of mediatized exchanges, it's of considerable note that on their Series 3 commentary, Shearsmith is in a sufficiently bad mood for Mark Gatiss to comment on the fact. 'We've already had an argument and it hasn't even started!' Shearsmith observes at the start of the first episode.

According to Jay David Bolter and Richard Grusin, while new media seems to manifest opposed drives – transparency (the disappearance of mediation or representation) and hypermediacy (foregrounding mediatization) – these two tendencies are united in striving to create a sense of immediacy and presence, 'an experience of the real' (2000: 71). The DVD commentary foregrounds its media-ness – it is ostensibly an 'unnatural' way to watch a film or programme (sound turned low, someone talking over the top) and we have to actively select it as an audio option. The in-vision commentary is even more intrusive, showing us the speaker(s) in the recording studio in a little square at the bottom of the screen; or the reverse, as on the *Limmy's Show* Series 1 commentary, where the original episode is squeezed into a little box in the top right-hand corner, while Limmy himself fills most of the screen. But while not all commentaries achieve transparent immediacy – we might hear an 'expert' reading out a prepared script, commentaries can be awkward, tedious, filled with long silences – I would suggest that there is a greater expectation that a commentary on a comedy DVD will aspire not only to intimacy but to spontaneous humour. Here, too, laughter can be contagious, hearing the League of Gentlemen or the *Spaced* team (Simon Pegg, Edgar Wright, Jessica Stevenson) make each other giggle.

Bolter and Grusin use the word 'remediation' to describe the way new media 'appropriates the techniques, forms and social significance of other media and attempts to rival or refashion them in the name of the real' (*ibid.*: 65). The DVD commentary can remediate both formal and informal media forms – the documentary, the interview, radio (a commentary is not dissimilar in some ways to listening to the radio while watching TV with the sound turned down). Catherine Grant suggests that the commentary track has a 'documentary status' within which the 'visual track is employed as graphic illustration of a teleological story of its own production' (2008: 111). The realization of the commentary-as-documentary can still achieve a degree of intimacy, of course. A good example would be Graham Linehan's commentaries for *The IT Crowd*. Series 1 offers a choice of commentaries, Linehan alone or Linehan with Chris O'Dowd and Katherine Parkinson. The two commentaries are

already designed to work in different ways – one informative and self-critical, the other 'rambunctious' (at one point, clearly too much so), chatty and gossipy. But as Matt Hills points out, the group commentary has a greater chance of seeming 'natural' – it 'enables a mediated performance of co-watching and jollity, which distant audiences can then imagine projecting themselves into' (2007). What's particularly notable about the Linehan/Parkinson/O'Dowd commentary is how closely it reproduces the dynamic of the actual show – while there's no 'Moss' figure (Richard Ayoade isn't involved), it is a little like listening to two Roys and a Jen. O'Dowd sounds very similar to Roy and he and Linehan play the two knowledgeable nerds, while Parkinson is the nerd-in-training, sometimes teased for never having listened to a DVD commentary (or even knowing that films have them, too) but starting to pick up geeky reference points from the 'boys'. As Hills suggests, the lone commentary risks artificiality (*Ibid.*), but Linehan is a particularly engaging solo commentator – it makes sense when he declares himself a fan of DVD commentaries who has listened to many of them himself (Commentary, *The IT Crowd* 1.1). At one point, on the *Father Ted* commentary, he makes fun of Mel Brooks simply describing what is on screen during his commentary for *The Producers*, thus indicating that he knows himself what makes a 'good' or 'bad' commentary. At the start of his solo commentary for Series 1 of *The IT Crowd*, Linehan refers to it as 'a very rough first series – I'm the first to admit that'.

> We were kind of trying things out, seeing what worked and what didn't and as a result I think of this first series as a rough draft of what I wanted the show to become.

Hills claims that such candid self-criticism is 'relatively unusual' (*ibid.*: 55), but I would suggest that it is a little more common on comedy DVDs. This is partly because 'failures' can be a source of humour – the League of Gentlemen often make flaws and mistakes very funny in their commentaries. But while Linehan is often funny about what he sees as weaknesses in his TV shows, his candour works here more by inviting us to invest in a work-in-progress. If *The IT Crowd* is initially flawed, the listener clearly likes it enough to have put the commentary on,

significant evidence of investment – listening to commentaries isn't a casual time-passing activity, it's something that fans and scholars do. By presenting himself as his 'own worst critic', Linehan seems to promise that a show we like already is going to get a lot better. Each subsequent series commentary finds Linehan happier with the show, closer to making it the show he originally envisioned. *Seinfeld* provides an ideal model for what he aspired to – a 'surrealism' that arises out of 'realistic' situations that accumulate and escalate. He perceives the emergence of 'what the show actually *is*' as being the result of 'failing' to copy *Seinfeld* but producing something more 'individual' as a result. Nevertheless, he's still citing *Seinfeld* as the model to aim for even as he feels the show is getting stronger – 'a flexible kind of structure where I can get in a lot of storylines that are really just about people hanging out' (Commentary, 2.1). By the time of the Series 4 commentary, two things have changed. Firstly, Linehan is seemingly finally happy with the show – 'I usually spend most of my time slagging myself off and kind of moaning about how we didn't get things right, but this series I really feel that we hit our stride and the show seems pretty good to me' (Commentary, 4.1). Secondly, as a result, the Series 4 commentary becomes 'a kind of – excuse the pomposity – Masterclass' (the DVD packaging uses that word less apologetically when listing its extras). Linehan devotes each episode to a particular practical topic – writing first drafts (4.6) or shaping sitcom formats by establishing 'limitations' (4.3). The delivery is no more formal than previous ones, but this is arguably no longer a commentary – Linehan only occasionally refers to what's on screen to illustrate a point. When he is distracted by something on screen, he apologises for the 'digression' – 'I actually started doing a commentary there, so let's not let that happen again' (4.2.) And yet, if we take the four commentaries as a narrative, there is a satisfying sense of closure – Linehan, having 'arrived' at the series he wanted, shares what he has learned during the process (and, of course, his extensive experience prior to it).

A DVD commentary can constitute a comic performance in itself. Thomas Doherty identifies two types of comic pleasure that the commentary track can provide – the 'gag audio track' (*This is Spinal Tap!* extending the 'mockumentary' to the DVD

intratext, performed in character) and the 'sassy raconteur' (2001: 79). He finds John Waters such a fine example of the latter that *Cecil B. Demented* is transformed from a 'merely semi-amusing film' to 'a consistent laugh riot' (*Ibid.*). *This is Alan Partridge* (Series 1, BBC 2 1997) and *Garth Marenghi's Darkplace* both provide in-character 'gag audio tracks' with different levels of success partly determined by their intratextual relationship to the original series. The *Alan Partridge* DVD also provides a more conventional commentary by Steve Coogan and co-writers Armando Iannucci and Peter Baynham that is actually (to my ears, at least) funnier than the 'gag' one. The joke commentary is provided by Alan and secretary Lynne (actress Felicity Montagu). It is intermittently funny – Alan finding it hilarious that Lynne thinks the 'V' in DVD stands for video, not versatile ('Oh, that's lovely, that – I'll dine out on that one!') (1.1). The problem is that it fails to establish a diegetic rationale for why Alan and Lynne would be watching a sitcom about themselves, offering the rather unconvincing conceit that they played themselves on screen in a dramatic recreation of real events.

Garth Marenghi's Darkplace, on the other hand, is able to use the commentary to extend the 'Marenghi-verse', given that the programme has already created an elaborate meta-fictional world – its cast playing fictitious actors who play characters in a 'bad' 1980s Channel 4 sci-fi/horror show. Thus, the commentary is by 'Garth' (Matthew Holness), 'Dean Learner' (Richard Ayoade) and 'Todd Rivers' (Matt Berry) watching themselves playing Dr Rick Dagless, his boss Thornton Rivers and his friend Lucien Sanchez, respectively. The absence of fourth cast member 'Madeleine Wool' (Alice Lowe) is explained away by her supposedly being dead – 'Died like a skunk in a hole,' Dean offers tactfully (Commentary, Episode 2). What follows is almost as comically inspired as the series, because it is able to make similar play on their blindness to the series' shortcomings ('That's a model,' Dean points out as the camera zooms in on a building that might have been made on *Blue Peter*) and their outdated attitudes. As they watch the episode 'Scotch Mist' (about a supernatural Highland curse involving ginger beards and kilts), the conversation turns to its representation of Scottishness:

GARTH: We got into a lot of trouble over this one because people deemed it racist.

DEAN: Well, it *was* racist.

GARTH: Well, that's your opinion and if it was your opinion at the time, you should have told me, Dean.

DEAN: No, it's fine.

GARTH: That was your professional capacity ...

DEAN: I don't like the Scotch. I was happy with it being racist.

TODD: No, *I* don't. I thought it was fine, though. I don't think there was anything there that stood out as being particularly offensive to the Scotsman.

GARTH: Well, I agree. I don't think there is anything.

DEAN: I don't see anything wrong with, you know, *some* racism. I think it's necessary.

TODD: Yeah, racism is quite sort of healthy.

DEAN: It's a tonic. It's like eating boogers to boost your immune system. A *bit* of racism is good.

(Commentary, Episode 5)

Limmy (Brian Limond) approaches the DVD-commentary-as-comic-performance differently, through the in-vision commentary. Paradoxically by making 'presence' visual, the in-vision commentary can seem less 'intimate' – seeing the participants in the recording studio, usually with headphones on, looking off screen at the monitor, stresses the artificiality, the media-presence, of the exercise. In some ways, Limmy pushes this further by 'squeezing' the original episodes on screen – we are no longer 'co-watching' in quite the same way (the episode is there for reference purposes). However, by looking into the camera more often that he glances at the monitor, Limmy shifts to a different kind of initimacy – he addresses 'us' directly and performs spontaneously, doing impressions of Robert Carlyle and John Hannah, making the commentary itself a comic spectacle through gesture and facial expression. One of his comic techniques in the series is to stand in front of an old clip from *Top of the Pops*, pause it and comment on the lyrics or performance, and the commentary has a not dissimilar feel. An on-screen comic rant about Americanisms prompts another in the commentary booth about abbreviated film titles and he affects getting so carried away that he misses the next sketch:

Y'see, it's got me that agitated that I've missed the whole Donna Summer thing! Gone! See? I had so many interesting things to tell you about that Donna Summer thing but it's gone! Gone forever! Gone!

(Commentary, 1.5)

Limmy, like Graham Linehan in a different way, demonstrates that the lone commentary can more than hold its own, but the group commentary is probably the most common dynamic for the generation of apparently natural, spontaneous humour, the sense of being in the company of amusing friends making each other (and us) laugh. There is no guarantee, of course, that the group commentary will always work like this. On *The Mighty Boosh* commentaries, two impressions emerge. Firstly, the Boosh seem to regard DVD commentaries as an un-cool chore to be subverted – at one point, Noel Fielding describes exactly what he sees on screen, 'Wings! Gorilla! Spin! Hands! Is that how you do commentaries?' (2.1). Secondly, while Fielding, Julian Barratt and Rich Fulcher (a man with a tendency to confuse 'louder' with 'funnier') are audibly amusing themselves, there is less sense (for this listener, at least) that we are always being included in the joke. Few things are more alienating than hearing hilarity at something that is incomprehensible to an 'outsider'. The League of Gentlemen, on the other hand, excel at the form to such a degree that their commentaries have a cult reputation of their own. They are discreet enough to avoid the intervention that removes part of the *IT Crowd* team's gossip:

MARK GATISS: He's based on an acquaintance of ours, isn't he?
STEVE PEMBERTON: Partly, Mark, partly.

(Commentary, 2.3)

But as mentioned earlier, supporting players who don't meet expectations are identified and skewered:

SHEARSMITH: Who is this man who asks the question?
GATISS: A fucking idiot!
SHEARSMITH: Oh, *Mark!* [laughter, cries of 'You can't say that!'].

(2.6)

It's Reece Shearsmith who perhaps most epitomizes the League commentaries in their candour and spontaneous humour. 'So we said that Geoff's house should have a slightly ... have some army memorabilia perhaps,' he recalls as we see Geoff Tipps's flat for the first time, 'and then we arrived and it's just *a bunker*' (3.3) – with those last two words, he actually seems to *become* Geoff. Because Shearsmith excels at such ill-tempered characters, his grumpier utterances during the Series 3 commentary, while they might appear sour on paper, are irresistibly funny in their delivery. His outbursts are also funny because they transgress the unwritten social contract of the DVD commentary, that this is a friendly, intimate address to the invested viewer/listener – it's hard to think of many commentaries that sign off (seemingly without irony) with the words 'see you for Episode 3, *if you can be bothered*' (3.2). On the *Psychoville Halloween* commentary, there is no pretence of respecting the validity of online critics:

> I've read lots of idiots' comments saying (puts on 'thick' voice), 'I thought Mr Jelly was dead. That's the third time he's died, isn't it?' Well, no! I *do* pay an iota of attention – they're *stories!*

At the same time, Shearsmith's take-me-as-you-find-me directness provides its own kind of intimacy and authenticity, while offering the listener the possibility of him being the 'gent' who is most like his own characters.

As suggested earlier, the continued survival of recorded laughter seems threatened less by its perceived obsolescence than by the growing rift between TV as 'content' and TV as 'delivery technology' because its 'naturalness' is so strongly rooted in the particular affectivity of the latter. The DVD commentary may prove to be a more short-lived phenomenon (as well as being a comparatively minority one). But as what we still think of as 'broadcast comedy' migrates progressively to different platforms, the commentary also suggests one way in which 'presence', 'liveness' and 'intimacy' can be mobilized against the 'atomized reception' of new media. As the selected examples demonstrate, not all commentaries work in this way. *Garth Marenghi*'s commentary works not through intimacy

but by extending the diegetic world of the series. It is this extended comic world that we turn to in the next chapter.

Notes

1 'Mickey Mousing', also known as parallel scoring, refers to music that mirrors a physical action (particularly a comic one) being performed on screen.

2 As Linehan suggests, some performers 'come alive in front of a crowd' (2007: 2).

3 Rob Brydon's *Director's Commentary* (ITV 2004) takes the 'self-obsessed wanker' idea further by having fictional director Peter Delane provide a commentary for episodes of TV series (*Mr and Mrs*, *The Bounder* and *Only When I Laugh*) he supposedly directed. The joke is both the inanity of his comments and his insistence on seeing himself as an auteur – 'I always try to include a dog-in-a-bucket scene in everything I do' – rather than the hack-for-hire he clearly is.

6

The 'Zooniverse' and other (furnished) comic worlds

Umberto Eco's '*Casablanca*: cult movies and intertextual collage' (1987) looms large in what we might call 'cult theory', an essay whose resonance transcends its blind spots and inevitable datedness – Matt Hills rightly calls it 'ground-breaking', but also warns that it 'has not aged well' (2002: 132). It is perhaps best to see Eco's essay as not dissimilar to the qualities he associates with cult texts – 'ramshackle, rickety, unhinged' – and to 'break, dislocate, unhinge' (1987: 198) those ideas that retain their currency and suggestiveness.[1] Of these, his notion of 'a completely furnished world' has lost none of its relevance. The cult text, he argues:

> must provide a completely furnished world so that its fans can quote characters and episodes as if they were aspects of the fan's sectarian world, a world about which one can make up quizzes and play trivia games so that the adepts of the sect recognize through each other a shared expertise. (*Ibid.*)

Eco was writing about film, but the 'furnished world' has proven to be equally, if not more, applicable to cult television because of the opportunities seriality provides to suggest a larger 'universe' than Eco probably had in mind. Sara Gwenllian Jones characterizes such a world as 'a vast, multilayered cultural territory which is only ever partially mapped and partially available at any given moment and yet which constantly presents the promise of fulfilment' (2000: 11). She suggests that it is more appropriate to see it as '*in*completely furnished', a quality that functions as an 'invitation to imagine' (*ibid.*: 12–13).

Royston Vasey in *The League of Gentlemen* seems to be both 'completely furnished' in Eco's sense and 'incompletely furnished' in the way that Jones means. On the one hand, its detailed production design (the toad-themed decor of the Dentons, Les McQueen's MOR record collection) suggests a world that is conspicuously and literally furnished. But the unresolved enigma of the Special Stuff and the exact nature of Papa Lazarou are an 'invitation to imagine' – Vasey seems clearly 'mapped' in most respects (a dismal, dying town in the north on the edge of a desolate rural hell), but its parameters are unfixed by the intrusion of the uncanny. It would be misleading to suggest that these enigmas are anywhere near as central as they are in a series like *Lost* (a quintessentially 'incompletely furnished' series), but given that TV comedy has largely taken place in relatively enclosed domestic and work-based settings, its exploration of the kinds of 'worlds' more associated with telefantasy is worth exploring.

According to Henry Jenkins, 'storytelling has become the art of world building' (2006: 114), and this is particularly true of telefantasy (science fiction, fantasy and horror). Such worlds are sometimes named by the addition of the suffix '-verse' – the 'Buffyverse' or the 'Xenaverse', 'a "virtual universe" encompassing … diegesis, industry and production conditions, cast, crew and creators, fandom and fan-produced texts, publicity and promotional material and merchandise' (Jones 2000: 10). The '(in)completely furnished world' starts to take on several senses. There is what Matt Hills calls 'hyperdiegesis' – the vast world that can only be partially represented (2002: 137). But Jones's '-verse' also sounds similar to the 'textual thickness' that Roz Kaveney talks about – the notion that a 'text' consists of all of its cultural and media baggage, which it carries like 'scars or vestigial organs' (2005: 5). I want to add a third kind of 'furnishing', which grows out of Caldwell's idea of televisuality – where the building of a diegetic world (which needn't be a hyperdiegetic one) manifests 'identifiable style-markers and distinct looks' (1995: 5). The 'northern Gothic' of *The League of Gentlemen*, the 'nerd-scape' of *Spaced* and the 'retro-scape' of *The Mighty Boosh* are examples of 'worlds' that are partly the result of 'style markers' and 'distinct looks'. Given that fantasy –

in all media – has a tradition of 'world-building', it is not surprising that earlier examples of 'furnished' TV comedy are comic-fantasy hybrids – *The Hitchhiker's Guide to the Galaxy* (BBC 2 1981) and *Red Dwarf*, for example. But if we go further back, *The Goon Show* suggests a different kind of comic 'universe' fashioned out of surreal flights of fantasy rather than generic fantasy. While the series developed a roster of recurring characters (Bluebottle, Eccles, Ned Seagoon etc.), they could materialize in different locations and historical periods. At the same time, what I'm tempted to call the 'Gooniverse' was fashioned from generic intertexts and broadcasting conventions. As a radio series, the 'invitation to imagine' was a media-specific one – an interesting attempt to transfer the series to TV (*The Telegoons*, BBC 1 1963–64) made use of puppets and simple animation to render this surreal universe.

The comic nerd-scape: *Spaced* and *Garth Marenghi's Darkplace*

If the enhanced televisuality of late 1990s TV comedy was one of the facilitators of these more fully realized worlds, another factor was the 'nerd' generation who brought an intertextual richness to their work – the League of Gentlemen, the teams behind *Spaced*, *Garth Marenghi's Darkplace* and the loving Brit-horror spoof *Dr Terrible's House of Horrible* (BBC 2 2001).

Of *Spaced*'s many intertextual references, one of the most suggestive occurs at the start of its final episode 'Leaves' (2.7) – the title sequence is a pastiche of the one from *The Royle Family*, its characters observed from inside a living room TV set. The two series represented the two different directions that the look of British TV comedy was taking at the turn of the century – an enhanced naturalism that stressed the enclosed nature of the sitcom world (the camera rarely leaves the sitting room where the TV is never turned off), the other hyper-stylized, with 'fast zooms, jump-cuts and disorienting edits ... Fantasy sequences, slow motion scenes, dreamy flashbacks and widescreen presentation' (Lewisohn 2003: 718). The Royles are 'glued' to the flow of 'ordinary' TV that they watch distractedly. Tim and Daisy are equally media-addicted, but they are presented as

omnivorous and cult-literate consumers – if they're slumped in front of the TV, they're more likely to be having a *Star Wars* marathon or playing *Resident Evil 2*. *The Royle Family* deals (mostly non-judgementally) with limited cultural horizons, while *Spaced* contrasts the limited career ambitions of the educated middle-class cultist with the accelerated mediascape that informs Tim and Daisy's imaginative life. *Spaced* is ostensibly almost as enclosed as *The Royle Family* – it's a flatshare sitcom that in its set-up plays like a postmodern *Man About the House* (ITV 1973–76). In the opening episode of *Man About the House*, Robin must pretend to landlords George and Mildred that he is gay in order to be allowed to share a flat with Chrissy and Jo. In *Spaced*, Tim (Simon Pegg) and Daisy (Jessica Stevenson) pretend to be a couple when answering the 'Professional Couple Only' ad placed by landlady Marsha (Julia Deakin) – in a reversal of the upstairs/downstairs division of *Man About the House*, she lives above them (with an unseen volatile teenage daughter). Mildred's sexual desperation is a product of George's withered *libido*, while Marsha pines after neurotic artist Brian (Mark Heap) who also lives in the house – like George and Mildred, they have a sexual history together but a mostly uneventful present. Flatshare sitcoms are always about lifestyle and *Spaced*, unlike *Man About the House*, benefits from its creators being of the same age and cultural predilections as its protagonists.

Spaced is set in a world of clubbing, recreational drugs, comic book stores (where Tim works), disappointing *Star Wars* sequels and games consoles. The release of *The Phantom Menace* (1999) is a running theme in Series 2. Tim loses his job at Fantasy Bazaar when he goes ballistic at a small boy who comes in to buy a Jar Jar Binks figure – 'What!? *Why?*' asks Daisy when he tells her he's been sacked, then after a pause, 'Not *Phantom Menace?*' ('Change' 2.2). But what really distinguishes *Spaced* is its representation of the mediatized imagining of its characters. Daisy and Tim argue after she's just been playing *Tekken* and their row is intercut with the game's characters Paul Phoenix and Nina Williams battling it out. As Daisy wins the argument, Nina knocks out Paul and her victory screen is pastiched in the next shot – Daisy mimics her victory pose, a health bar icon

appears at the top of the screen and the on-screen text reads 'Daisy Wins!' ('Ends' 1.7).

Unlike the 'hyperdiegesis' that Hills describes, comedy isn't always subject to the same 'principles of internal logic and extension' (2002: 137) as drama. 'Back' (2.1) features two *Matrix*-style agents played by Mark Gatiss and Kevin Eldon – when Daisy takes them on in a kung fu duel, the assumption that we're seeing her 'fantasy' is jokily punctured by her comment 'That just happened, didn't it?'. Perhaps the most commonly cited fantasy sequence in *Spaced* is the opening scene of 'Art' (1.3) where Tim playing *Resident Evil* is represented as an actual horror movie (with particular nods to George Romero and Sam Raimi), Tim splattering zombie brains around the flat, bathed in an eerie blue light. The press pack for *Shaun of the Dead* (2004), the theatrical 'rom-zom-com' Pegg, Edgar Wright and co-star Nick Frost would go on to make, cites the scene as the origin of the movie. Given that *Shaun* recruited some of its zombie extras from the *Spaced* fansite and deals again with underachieving twentysomethings and a similar homosocial 'romance' between Pegg and Frost, there is almost a sense of it being part of the same 'universe' – 'If it sometimes looks like a feature-length episode of *Spaced*, well that's a good thing,' commented Peter Bradshaw in the *Guardian* (2004: 15). The DVD box set of *Spaced* offers a 'Homage-o-Meter' as a subtitling option, identifying all of the references in the series (by Series 2, some of these are references to Series 1). In a neat joke, when Daisy refers to Mike (Nick Frost) as Tim's 'boyfriend' ('Art' 1.3), the Homage-o-Meter identifies it as a 'Future film ref: *Shaun of the Dead* (2004)'.

While similarly 'geeky' in conception, *Garth Marenghi's Darkplace* works rather differently. It references pulp horror fiction to establish the type of writer that Garth is – in a nutshell, Shaun Hutson if he imagined himself to be Clive Barker,[2] 'author, dreamweaver, visionary, plus actor'. Garth's novels have covers that suggest James Herbert, titles that recall either Hutson (*Afterbirth* 'in which a mutated placenta attacks Bristol') or New English Library's prolific 1970s hack Guy N. Smith (*Crab* – a reference to Smith's gruesome *Night of the Crabs* series). References to John Carpenter (Episode 5 'Scotch

Mist', a variation on *The Fog*) and H.P. Lovecraft (Episode 6 'The Creeping Moss from the Shores of Shuggoth') function to establish Garth's inferiority to (and plagiarism of) these more celebrated horror directors or authors. But otherwise, *Garth Marenghi* fashions its own 'universe' out of a layered diegesis – the loving pastiche of inept low-budget fantasy TV (a kind of Gothic *Acorn Antiques*) that is *Darkplace* itself and the mock framing material that presents Garth, Dean and Todd looking back at their 1980s series – as discussed in the previous chapter, the DVD commentary extends this 'hyperdiegesis' further by being performed in character.[3] In other words, the series is both about a creator of worlds who lacks the skills and resources to furnish them satisfactorily, and itself builds a coherent, multi-layered comic world around its eponymous 'dreamweaver'. The premise of the series is that *Darkplace* was made for Channel 4 in the 1980s but never shown. Garth has his own explanation for this:

> a television programme so radical, so risky, so *dangerous*, so *Goddam crazy* that the so-called powers-that-be became too scared to show it ... Only now, in the worst artistic drought in broadcast history, does the channel come crawling back, cap in hand and suitably ashamed, asking if your humble fabulist could once again retrieve *Darkplace* from the boxes in his spacious basement and let it loose on its unsuspecting public.
>
> (Episode 1 'Once Upon a Beginning')

By the time we have seen, in the opening minutes, a cat thrown into shot by a visible hand, we guess the real reason why it has never been shown. Each episode begins with Garth reading from one of his books and then offering a portentous greeting to his 'world':

> Greetings, traveller. Who am I? Perhaps you have met me twixt sleep and wake in the penumbra of uncertainty you call the unconscious. Or perhaps you've me at a book signing.
>
> (Episode 4 'The Grapes of Wrath')

The series' central joke is the contrast between Garth's hubris – 'I'm one of the few people you'll meet who've written more books than they've read' ('Once Upon a Beginning') – and his

artistic achievements on screen. The series puts almost as much
care into the textures of low-resolution 'bad' telefantasy as
Quentin Tarantino and Robert Rodriguez put into the
scratches, faded colours and missing reels of *Grindhouse* (2007).
The effects use outdated technologies like colour separation
overlay (a crude 'blue screen' effect often seen in 1970s *Doctor
Who*), ad breaks are announced by synthesized 'stings' and
cheap graphics, each episode is preceded by a 1980s Channel 4
ident and much use is made of ADR (Automated Dialogue
Replacement or Additional Dialogue Recording) to make the
line delivery seem even more stilted (and to slyly suggest that
the performance might initially have been even more inept). In
other words, there is an aesthetic density to this simulated inep-
titude. Further pleasure is provided by deliberate continuity
errors – in one scene, Thornton Reed/Dean Lerner is firing a
shotgun, but an alternate camera angle finds him in the back-
ground with no gun, calmly watching Rick/Garth in action
('Once Upon a Beginning'). When someone upsets Dr Liz
Asher/Madeleine Wool, the next shot reveals tear-stained
mascara tracks on her cheeks that have materialized from
nowhere. Dean's discomfort in front of the camera (often
glancing at it awkwardly) is a running joke – an 'atmospheric'
tracking shot that closes in on him is spoiled somewhat by him
becoming increasingly self-conscious as it gets closer to him
('Scotch Mist'). Like *The League of Gentlemen*, the
'Marenghiverse' is partly informed by nostalgia – as Helen
Wheatley suggests, such shows 'acknowledge that domestic
viewing of the horror genre produced a lasting effect on its
audience, whereby the child crouching behind the sofa, trans-
fixed by late-night horror television, becomes the knowing,
adult producer and viewer twenty or thirty years later' (2006:
88). In some ways, *Garth Marenghi* is the ultimate manifesta-
tion of this, by creating a 'hyperdiegesis' in which *Darkplace* is
re-written into the history of Gothic telefantasy.

'Come with us now on a journey through time and space . . .'

Unusually amongst British TV comedies that create fantastical
worlds, *The Mighty Boosh* does not look primarily to telefantasy

or make extensive intertextual references to film or TV. Rather, the 'Zoonisphere' is fashioned to a large extent from pop subcultures past and present. In his book *Retromania: Pop Culture's Addiction to its Own Past*, Simon Reynolds describes it as the 'most acerbic meta-pop commentary' of the noughties (2011: 173), citing the lyrics from the song 'Eels' in the episode of the same name – 'Elements of the past and the future combining to make something not quite as good as either' (3.1). The Boosh's 'furnished world' is, for the most part, a pop-literate retro-scape – 'pop history becomes phantasmagoric, a hallucinatory bestiary of absurd and sometimes grotesque memory hybrids' (*Ibid.*: 174–175). Electro pop (Gary Numan cameos in both animated form and in person), prog-rock, punk, Goth and contemporary indie (The Horrors appearing as The Black Tubes in 'The Chokes' 3.6) are the main referents – the audio-visual density and the fact that Julian Barrett has a real talent for musical pastiche make the *Boosh* an even more fully formed fusion of art/pop/comedy than Reeves and Mortimer (perhaps comedy finally justified the 'new rock-'n'roll' label). In the 'Zooniverse', the terminally hip *Cheekbone* magazine is delivered by ninjas because 'it goes out of date every three hours' ('Call of the Yeti' 2.1), Vince Noir was raised in a forest by Bryan Ferry and is hailed 'King of the Mods' by Mod Wolves ('Jungle' 1.5), and a Carlos Santana-like mystical guitarist with a door in his voluminous afro visits the Desert of Inspiration in search of The New Sound ('The Priest and the Beast' 2.2).

While pop and fashion are central to *The Mighty Boosh*'s cult appeal and 'retro-fantastical atmosphere', it has other components:

1. The double act, trading on cross-talk and 'word riffs' between its mismatched couple. Vince (Noel Fielding) is a vain, metrosexual hipster who 'dresses like a futuristic prostitute' – when Howard (Julian Barratt) tells him that it's what's inside people that counts, Vince replies 'I haven't got anything inside – I'm like a beachball' ('The Power of the Crimp' 3.3). Howard is a would-be 'jazz poet' whose bohemian aspirations – 'If I see a boundary, I eat a boundary and wash it down with a cup of

hot steaming rules' ('Killaroo' 1.1) – are sabotaged by his pedantry, his brittle non-tactility ('Don't touch me!') and his lack of actual talent. It's a little like seeing Harold Steptoe paired with Mick Jagger. In the inspired 'Nightmare of Milky Joe' (2.6), they enact a fantastical variation on *Steptoe and Son* episode 'Divided We Stand' in which Harold built a partition in their house to separate himself from his troublesome father. Marooned on a desert island, Howard is so annoyed by his friend that he draws a similar dividing line in the sand that cannot be crossed, noticing too late that all of the trees are on Vince's side of the island. Both of them lonely and bored, they make imaginary friends out of coconuts that become reflections of their respective views of themselves. Howard creates 'Milky Joe', another pedantic pseudo-bohemian bore who starts to irritate him. Vince, on the other hand – ever the narcissistic optimist – acquires two glamorous female coconut companions. When Howard persuades Vince to let him have one of the coco-girls move in with him, the relationship turns to domestic violence – she blackens his eye and he accidentally 'kills' her with a push during an argument. The finale turns nightmarish (as the title suggests) with the two of them tried and found guilty in a coconut court and their heads placed in a coconut shy – a coconut version of The Hitcher (a green-skinned man-witch, of whom more shortly) encourages punters to throw balls until there's 'twisted bone and meat all over the back wall'.

2. Psychedelia – the 'journey through time and space' promised in the opening titles, ranging from strange lands and planets to inner worlds. 'Journey to the Centre of the Punk' (3.2), is a rare movie homage (to *Fantastic Voyage*, 1966), although the surreal environment and monkey-headed submarine are also reminiscent of The Beatles' animated *Yellow Submarine* (1968). Howard must enter Vince's bloodstream in a shrunken submarine to save him from The Spirit of Jazz, a voodoo-faced entity returning from an earlier episode ('Electro' 1.7). From his blood cells to his brain and a brain-receptionist who resembles Amy Winehouse, Vince's cells and internal organs are represented as sentient individuals played by Noel Fielding, suggesting that Vince's narcissism is embedded in his very

biology. Tellingly, the episode outdoes its movie source in its imaginative, animated visuals.

3. Animation and puppetry. One-dimensional animation based on Noel Fielding's artwork (and reminiscent of garish 1970s children's shows like *Crystal Tipps and Alistair*) is used to illustrate surreal fables like Vince's story of Charlie, a pink bubblegum-like creature ('Charlie' 1.6), or the backstories of Old Gregg ('The Legend of Old Gregg' 2.5) and the Crack Fox ('The Strange Tale of the Crack Fox' 3.4). Simple animation effects are used to put Noel Fielding's shaving foam-covered face on The Moon, a benign idiot who might have stumbled from a Georges Méliès film. Puppets include some of the animals from the zoo in Series 1 and Sammy the Crab in 'The Chokes', while the Crack Fox is a mixture of puppetry and Julian Barratt made up with fur, fangs and contact lenses.

4. Folk tales/children's stories. The closest the Boosh get to referencing an actual folk tale is in initially naming The Hitcher 'Babu Yagu', after Baba Yaga the witch from Slavic folklore. The Hitcher – part Wicked Witch of the West, part Papa Lazarou, part Cockney 'geezer' – is one of several *Boosh* characters who are half comic, half monstrous. More overtly aggressive than Papa Lazarou – 'if you weren't a geezer I'd be raping you right now', he tells a quaking Howard ('Eels' 3.1) – his uncanniness partly lies in inexplicable details, like the polo mint over his eye or his prodigious capacity for spraying urine 'like a yellow cable' ('The Hitcher' 1.8). His precise nature is unfixed – 'Some say he is the devil himself. Others say he is a man pretending to be the devil with green make-up and special lighting' ('The Hitcher'). The Hitcher appears in at least one episode in all three series of *The Mighty Boosh*, but Howard and Vince never seem to remember the 'peppermint nightmare', always reacting as if encountering him for the first time. Similar figures include fan favourite Old Gregg, a hermaphrodite man-fish with a 'mangina' and a signature cry of 'I'm Old Greeeeeeegg!' ('The Legend of Old Gregg' 2.5), and the Crack Fox, part-cute part-terrifying part-abject, alternating between a high-pitched southern drawl and guttural threats

('The Strange Tale of the Crack Fox' 3.4). For such a whimsical show, these creatures often manifest a sexual threat of some sort, from The Hitcher's Golden Showers and his song about eels 'up inside yer, finding an entrance where they can' to the Crack Fox's promise 'to make you wear a little dress and hurt you'. It goes without saying that there's a reason why Old Gregg shows his 'mangina', uninvited to do so, to Howard. Nervertheless, there is a child-like dimension to this fairytale universe. In the documentary *The Mighty Boosh: A Journey Through Time and Space* that accompanied BBC 3's Boosh Night in 2008, Jenny Eclair offers a shrewd characterization of this dimension of the series:

> When you're very little and you go into a strange garden, you are in a jungle, aren't you? And that's where the witch lives over there. And what Noel and Julian have done is basically taken everybody's back garden and sort of put all the beasts back into it that we forgot were there.

No episode illustrates this better than 'The Strange Tale of the Crack Fox', which begins with Howard attempting to explain to Vince why he needs to put their binbags in the 'Designated Refuse Area':

> HOWARD: What do you think happens to the rubbish when you throw it out in the street?
> VINCE: I dunno – does it dissolve in the rain like a giant Berocca?
> HOWARD: No. No, it doesn't. The bin men take it away.
> VINCE: (*incredulous*) Who?
> HOWARD: The bin men!
> VINCE: Come off it – as if they exist! They're the stuff of legend, like unicorns.

As the episode progresses, the bin men will assume a mythical status – Howard explains that the urban fox is their 'nemesis'. When Vince, unmoved by Howard's lecture, slings the bin bag into the garden, a mountain of such bags is revealed, circled by crows and now forming a den for the Crack Fox, who lives on a diet of 'Head and Shoulders, toothpaste and shit', wears used condoms as 'squishy boots' and has discarded hypodermic needles protruding from his fingers. He tricks Vince into letting

him into the house so that he can steal the 'shamen juice' belonging to resident mystic Naboo (Michael Fielding, Noel's deadpan brother). When Howard and Vince retrieve it from his den, he pursues them in a cart pulled by his 'binbag bitches'. The story is embellished by already established elements from the 'Zooniverse' – the Council of Shamen, who have already put Naboo on trial once for the disastrous errors of his housemates (in 'Nanageddon' 2.3). The Council includes a character who had caught fans' imaginations in 'Nanageddon' – Tony Harrison (played by Noel Fielding), a pink peanut-shaped head with only tentacles for a body who refuses to recognize his physical limitations (we see him struggling up the steps to the guillotine in an executioner's hood after Naboo's trial).

In Series 1, the 'Zooniverse' is an actual place – the zoo run by Bob Fossil (Rich Fulcher), where Vince and Howard work as keepers. It encompasses talking animals like Bollo (who will become a regular character, as Naboo's familiar, from Series 2), magical environments like the Jungle House or a secret laboratory where owner Dixon Bainbridge conducts evil experiments ('Mutants' 1.2). But there is more indication of what the series will become when the pair set off on adventures, such as their quest for the Egg of Mantumbi in 'Tundra' (1.4). There are also more zoo-bound stories, making it the most fixed environment of the three series. The stylized elements of Series 1 are confined to individual setpieces, such as its animated sequences – it doesn't yet have a signature look, perhaps partly because some of these episodes had already comprised part of the radio series (Radio 4 2001). *The Mighty Boosh* is more fully realized in Series 2, which alters both the format and the look of the series. Howard, Vince, Naboo and Bollo share a flat in trendy Dalston, an exotic and bohemian space that nevertheless serves as a base from which the 'journey into time and space' can begin – five of the six episodes take place in other locations (a cabin in the woods, the inner world of an album cover, another planet, a fishing village, a desert island). The larger roles for Naboo and Bollo strengthen the series' magical connections so that it does start to feel more like a surreal 'universe'. The visual style draws on influences as diverse as Méliès, Jan Svankmajer and Michel Gondry. *The Mighty Boosh* now had a 'Visual Consultant', Tim

Hope, who came from a background in music promos, advertising and animation. According to director Paul King (in the 'Making of Series Two' DVD extra), the second series had a reduced budget from the first one – its distinctive 'look' seems to have been partly a matter of expediency. Just as the series drew its pop cultural references from the retro-scape, its hyper-stylized look was rooted in 'outdated' effects technologies (although it does also use some more modern green screen effects). Of these retro-effects, perhaps the most characteristic is the use of back and front projection, often with glaring discrepancies in scale that foreground the artificiality of the device. A signature setpiece has performers running (unconvincingly) on the spot in front of a travelling back projected shot. *Garth Marenghi's Darkplace* uses such effects as part of the 'so bad it's good aesthetic' that is being lovingly parodied, but in *The Mighty Boosh*, it is more in keeping with the values espoused by Vince and Howard's copyists 'Lance Dior' and 'Harold Boom' (in 'The Power of the Crimp' 3.3) – 'Everything's up for grabs', 'The future's dead – retro's the new thing, sir'. In Series 3, the Boosh move to that ostensibly most sitcom-stable of environments – the shop (which appears to be under their Dalston flat from Series 2). But the Nabootique – a second-hand retro-curio shop – is another hyper-stylized and fantastical environment, encompassing Stationery World (a street fashioned from neatly organized pens, Blu-Tack and paperclips, with a little bus driving through it), a sentient embodiment of Howard's anal need for order ('Journey to the Centre of the Punk' 3.2). In bringing together 'past' and 'future' (Vince's constant quest for 'the new thing'), rather than making 'something not quite as good as either', *The Mighty Boosh* arguably became one of British TV's most original comedy series.

Extending *Psychoville*: transmedia comic universes

One of the ways in which TV 'universes' are extended is through multi-platforming, where 'additional secondary or satellite texts' (Richard 2010: 182) can be experienced online, on mobile phones, as DVD extras, in videogames or on digital TV services. One manifestation of this is what Henry Jenkins

calls transmedia storytelling, which 'unfolds across multiple media platforms, with each new text making a distinctive and valuable contribution to the whole' (2006: 96). In order to fully explore this multi-platform 'world':

> consumers must assume the role of hunters and gatherers, chasing down bits of the story across media channels, comparing notes with each other via online discussion groups, and collaborating to ensure that everyone who invests time and effort will come away with a richer entertainment experience. (*Ibid.*: 21)

However, there are risks in making this transmedia 'universe' too integrated, in making those fragments of story that require some effort to find too essential – Jenkins cites the case of *The Matrix* trilogy, where confining important story information to videogames or supplementary animated shorts alienated some viewers who only intended to watch the films – 'going in deep has to remain an option – something readers choose to do – and not the only way to derive pleasure from media franchises' (*Ibid.*: 130). But even if a transmedia universe must retain some 'ricketiness' (to borrow Eco's term), this is another practice that arguably privileges generic fantasy. British TV's quintessential transmedia 'verse is *Doctor Who* – spread across three different shows (*Doctor Who* itself, *Torchwood*, *The Sarah Jane Adventures*) and multi-platform storytelling (including both 'old' and 'new' media – novelizations and original novels, audio-plays, DVD and web content; see Perryman 2008).

BBC Comedy online (BBC.co.uk/comedy) was relaunched in 2009 – previously it had been, as Executive Editor for Comedy Simon Lipton put it, '*about* funny' as opposed to aiming to *be* funny (RTS Futures Panel: Multiplatform Commissioning, 27 October 2009). The new online service would commission original material, not all of it necessarily connected to TV shows, but some of it exclusive content to support shows such as *Have I Got News For You* and *The Thick of It*. Much of this has taken the form of 'deleted' or extended scenes or interviews, but *Psychoville* was more integrated and ambitious – it was, as Martin Tricky (BBC Comedy Commissioning) observed, a 'certain type of show'. Advance publicity and interviews had stressed the series partly being

influenced by cult US shows like *Lost* and *Heroes*. According to Reece Shearsmith, the series is 'very detailed, so to give the characters a life outside of the programme on the internet was a great opportunity to add more jokes and a back story' (BBC Press Office 2009). The authenticity of this supplementary material was emphasized through it being mostly authored by Shearsmith and Steve Pemberton. 'I think it's got to come from the people who do the show,' Pemberton stressed, 'we've written the bulk of the material for the actual website' (*Ibid.*).

Multi-platforming and transmedia storytelling have 'old media' precedents – Jenkins gives the example of how in the Middle Ages Jesus's story would have been told through stained-glass windows, tapestries and psalms, amongst other things (2006: 125). Comedy series have been generating spin-off books of varying quality since *Monty Python's Big Red Book* (1971). A more recent example is *The League of Gentlemen*'s *A Local Book for Local People* (2000), which in some respects features similar kinds of material to that offered in 'The *Psychoville* Experience' – letters, diaries, flyers, ads and newspaper cuttings that extend the 'lives' of the series' characters and find ways of adapting their comic quirks to a different medium. One of the highpoints of the *Local Book* would move across different media platforms – 'The Curse of Karrit Poor', an Edwardian supernatural story told by Mr Chinnery's ancestor, was adapted into one of the stories in the *League*'s Christmas Special and the original turned into a DVD extra in the form of a parodic episode of *Jackanory*. Pemberton implies (with some justification) that *The League of Gentlemen* would have been eminently suited to the kind of online content produced for *Psychoville*. What makes *Psychoville* even more suited to this treatment is that it is more geared than most comedy series to narrative enigmas and story arcs – the identity of the blackmailer in Series 1, the mystery of Nurse Kenchington's locket, the activities of the Nanotech Corporation.

For Series 1, viewers could opt into weekly emails – 'Want your secret hidden?' asked the initial one – that asked questions that, when answered correctly, provided a password and a URL for the many different webpages that would become available as

Psychoville progressed. These webpages were 'metasites' or meta-
textual websites (Perryman 2008: 29), supposedly belonging to
characters and organizations in the series. Some of the webpages
were readily available from the start – www.murderandchips.co.uk
(the website of the Murder Mystery troupe David was a member
of) and www.bigginspanto.co.uk (the production company in
which Robert performs as a pantomime dwarf). Others could only
be accessed by finding the password, or by following links on other
pages. The Biggins panto site includes a link to Robert's 'fansite'
(www.robertgreenspan.co.uk), which pre-dates the events of
Series 1. We learn that he has a history of falling for his panto
leading ladies, one of whom was Lucy Davis from *The Office* (still
only an embryonic series at the time of Robert's out-of-date
entries). 'I've also made several short films,' he says – *Psychoville*
viewers would know all too well the precise nature of these 'short
films'. Just in case they don't, there is a small ad and link for
'Midget Gems' in the top right of the screen – 'Don't click on
that,' snarls Robert, his profile picture suddenly coming to life as
we click the link for the first time. After a second plea from Robert,
a third click takes us to www.midgetgemsvideo.co.uk, 'Purveyors
of fine dwarf, midget and fairytale porn' – amidst the smutty titles,
there's a clip from *Whore White and the Seven Dicks* featuring
Robert as 'Stiffy'. On Mr Jelly's webpage, www.jellyparties.co.uk,
clicking on his booking form will re-direct the browser to the site
of his rival and nemesis Mr Jolly (www.jollyparties.co.uk). While
Mr Jelly's attempted jolliness fails to disguise his sourness and the
unpleasantness of his act (a stag and hen version includes 'some
inoffensive racism'), Mr Jolly's betrays his medical background (he
refers to the children as 'patients') and his mediocrity as a clown
and children's entertainer – 'Mr Jolly was punctual and showed the
children some tricks', enthuses one of the testimonials. David has
two sites – www.bestmurders.co.uk, a tribute to his favourite serial
killers (and, at the end of Series 2, his late mother) and a YouTube
channel. David's site was updated for Series 2 (given that he was
one of the few original characters to survive to its end). A series of
'Cheer Up Tapes' add to the dance he and Maureen did to Black
Lace's 'Superman' in Series 1 – most sublime of these is their
recreation of Aphex Twin's terrifying 'Come to Daddy' video,
David bawling in Maureen's face while she shakes her cardigan to

suggest it quivering from the force of his scream. The metasites add little real narrative depth to the series, but a wealth of comic invention as well as the sense of an extended world. The 'Inside Ravenhill' site (www.insideravenhill.co.uk) provides more backstory through the charred case files on Joy, Robert, Lomax and David. Robert's case notes include some cultish in-jokes as Nurse Kenchington recalls an incident in the TV room:

> One of them wanted to watch the 3rd series of A League of Gentleman [*sic*], but as I never saw any trailers for this on the BBC I can only assume he was making it up. However Little Mouse (Robert) started getting agitated when a programme called The Office started its second series on BBC 2 (I had seen plenty of trailers for this). Started yelling about a carrot called Lucy and crying that 'Freeman took her'.

This references another web-only joke (Robert's backstory on his fansite, his crush on Lucy Davis, the 'Freeman' being Martin Freeman, Tim in *The Office*). But it also plays on the League of Gentlemen's well-known resentment of *The Office* being prioritized over their third series by BBC 2. The jokes depend on playing 'hunter and gatherer' across the different *Psychoville* sites and an intertextual fan knowledge of the series' connection to *The League of Gentlemen*.

While Series 2 of *Psychoville* was more ambitious and complex in its plotting, its online 'experience' was less so than that accompanying the first series. This time we were required to find a number each week that progressively revealed the code that would open the vault to the frozen head of Nazi scientist Ehrlichmann. After answering a series of questions correctly, the viewer was rewarded with a Nanotech voucher that allowed them to have a relative cryogenically frozen. The clues were simpler – some more like directions than actual clues – and the different sites felt less integrated than first time around. There were still some inventive and amusing touches, however – click on the 'Members' link on www.hoytitoyti.co.uk and you found yourself on Nazi-bay, 'Home of Antique Memorabilia for the Discerning Collector' (a drag and drop jigsaw featuring a doll replaced by one with a swastika).

The *Psychoville* Experience is thus far an isolated case in

British TV comedy, a series with just enough in common with story-arc oriented telefantasy to lend itself to similar online treatment (although the ultimate emphasis – rightly – was on that online content being funny). These 'furnished worlds' were in some ways exceptional, while at the same growing out of larger trends in shifting TV aesthetics. As British broadcasting enters a period of austerity, it is in some ways difficult to imagine anything as ambitious as these series in the immediate future, but *Psychoville* is suggestive of other ways in which comic worlds might be 'built'.

Notes

1 Most scholars find this is best done by ignoring what he actually says about *Casablanca*, an eccentric choice of 'cult film' to begin with.
2 Hutson is more self-deprecating than the arrogant Marenghi (and a better writer), but the author of *Slugs* (1990) is a man of modest literary ambition. Barker's more elevated reputation rests partly on him producing horror and fantasy across different media (fiction, film, comics, painting) – exactly the kind of Gothic 'Renaissance Man' that Garth aspires to be.
3 *Man to Man With Dean Learner* (Channel 4 2006), a mock chat show trading on Dean's lack of social awareness, included an episode focused on Garth (Mathew Holness played all of Dean's weekly guests). A highlight is a clip from Garth's Ed Wood-style film *War of the Wasps*.

Are you sitting uncomfortably?
From 'cringe' to 'dark' comedy

> It's so painful that at times I have my hands over my face, watching through the cracks in between my fingers. But behind my hands I'm laughing. (Sam Wollaston, Review of *Nighty Night*, 2004: 22)

These final two chapters are concerned with comedy's management of the unpleasurable into something perversely pleasurable – embarrassment, unease (even fear), disgust, offence, guilt. The negotiation of taste and one's personal comic boundaries can be a source of cult capital – how far will your favourite writers and performers go (and be permitted to go by the institutional limits of broadcasting) and how far are you willing to go with them? But for many, this will produce nothing but displeasure. Compare, for example, Sam Wollaston's 'through the fingers' enjoyment of *Nighty Night* quoted above with the distaste of *The Times*'s Hannah Betts:

> The series is renowned for being 'dark'. On the strength of last night, it is merely foul, a series of unfunny gags about sex, death and retardation, backed up with the lamest of slapstick. Described in its own inelegant terms it would be one big dick and a spaz joke. (Betts 2005: 31)

In October 2002, *Radio Times*'s Alison Graham wondered whether comedy was 'the new drama' (Graham 2002: 69). *The League of Gentlemen* was into its third series, *The Office* and *Peter Kay's Phoenix Nights* were into their second, Paul Whitehouse's melancholy midlife crisis sitcom *Happiness* (BBC 2 2001–3) had started the previous year, and even Steve

Coogan's cringe pioneer Alan Partridge was back. What connected these programmes for Graham was that, in contrast with the 'cheery time-passers' that comprised other British TV comedies, they were 'frequently bleak and often despairing, filled with unsympathetic characters who ... are uncomfortably authentic in ways that TV dramas cannot seem to achieve' (*Ibid.*: 69). *Peep Show* and *Nighty Night* would follow in the next couple of years – 'Blacker than Black is Back' announces the DVD sleeve of the second series of Julia Davis's misanthropic sitcom about her sociopathic beautician Jill Tyrell. 'Dark' and 'cringe' were the buzzwords in discussions of TV comedy, or what Edwin Page characterizes as 'the comedy of the horribly awkward' (2008: 7).

J.L. Styan equates 'dark comedy' with 'tragicomedy', united in their aim to create 'an uncomfortable state of mind' in which we are allowed neither the 'detachment of comedy' or 'the sympathy of tragedy' (1968: 257). Very little TV comedy aims for this. Rather, as Brett Mills points out, it provides 'metacues' that clearly signal comic intent (2007: 184). Even in *Jam*, which provides fewer such cues than most, there are comic signals in many of the sketches, most frequently in the performances; while some are relatively naturalistic, others overplay or underplay for comic effect (Mark Heap's gallery of furtive or passive-aggressive tics in the former category, David Cann's disquieting calm in the latter). Embarrassment and darkness, however, are no strangers even to classic prime-time sitcoms in the UK. Neale and Krutnik observe of *Steptoe and Son* that behind even its broadest comedy 'are actions which would ordinarily be branded disturbing or cruel' (1990: 258) while *The Fall and Rise of Reginald Perrin* (BBC1 1976–79) follows its protagonist to the edge of a nervous breakdown as well as anticipating *Peep Show*'s comic use of the contrast between internal thoughts and verbal utterances. Neale and Krutnik's use of the word 'ordinarily', however, is a significant qualifier, suggesting that the comedy immunizes us against much of the genuine pain or humiliation in such material. Stewart Lee seems to have something similar to Mills's 'metacues' in mind when he talks about giving an audience 'permission to laugh at something about which they may feel uneasy' (2010: 213). However, he

suggests that one can also encourage laughter by appearing to deny the audience this permission by presenting a joke as 'apparently serious'. *The Office*'s 'mockumentary' style could be taken as an example of appearing to deny its audience permission to laugh as a way of generating more laughter. However, unlike *Peep Show*, which signals its comic intent more consistently, *The Office* sometimes genuinely seems to designate laughter as an inappropriate response – to genuine distress or the humiliation of someone who doesn't deserve it. In one of its most talked-about sequences, it suggests that there are limits even to our permission to laugh at David Brent's humiliation when he breaks down and pleads for his job (2.6). Earlier in Series 1, we have seen David reduce Dawn to tears – through stupidity rather than actual malice – by pretending to sack her as a practical joke (1.1). That scene arguably gives us a choice about how to respond. We might laugh at David's embarrassment as his joke backfires so horribly, or at Dawn calling him a 'wanker ... a sad little man', but we might also be prevented from doing so by her obvious distress. The scene of David's tears, on the other hand, attempts to close off any possibility of laughter – rather than offer a comic comeuppance, the scene seems to aim instead for unexpected pathos. In the tragi-comic world that *The Office* inhabits, there are *limits* to the comeuppance and ridicule that such a character deserves.

'Dark comedy' and 'cringe comedy' overlap in many areas, particularly those determined by matters of taste – both trade on unacceptable behaviour, comic transgressions and gross imagery or language. 'Dark comedy' is in turn related to a number of categories, with which it is sometimes taken to be interchangeable – 'sick' comedy, 'black' comedy, gross comedy and the grotesque. Murray Davis combines sick, black and 'tasteless' comedy as sub-categories of the grotesque, a term that I shall be using in a different sense later in this chapter. 'Sick' and 'black' suggest different degrees of cultural capital and moral purpose. Black comedy has a certain literary cachet – J.L. Styan's 'dark' writers include such well-known masters of mirth as Beckett and Ionesco. 'Sick comedy' took on some subcultural cachet in the 1950s and 1960s, where it was applied to a new generation of stand-ups like Lenny Bruce and Mort

Sahl (Double 2005: 24–27), often credited with initiating a more informal, confessional and confrontational style of stand-up. But 'sick' no longer seems the right word for Bruce, widely regarded as one of the first stand-ups with 'important' things to say about sex, religion and race amongst other contentious subjects. More commonly, the 'sick' label has come to suggest the puerile, the callous, the purest example of Bergson's 'momentary anaesthesia of the heart' (1956: 63–64) – it evacuates the moral intent attributed to Bruce (or, later, Chris Morris). It aspires to be *wrong*. The 1950s are often seen as the birth of 'sick' culture – a 1958 book *'Shut Up and Keep Diggin': The Cruel Joke Series* collected 155 cruel or sick jokes (Dundes 1987: 6). But 'sick' jokes, like 'gallows' humour, have probably existed for as long as humour functioned as a coping mechanism in the face of horror. The earliest commercial form seems to have been Captain Harry Graham's *Ruthless Rhymes for Heartless Homes* in 1899, spawning a cycle of verses detailing the comic demises of a child called 'Little Willie' (*Ibid*.: 4); like Kenny in *South Park*, each rhyme resurrected the child only to kill him again. From the 'dead baby' jokes of the 1960s to the current popularity of paedophile gags, small children are the perfect subjects for sick gags, which work through a kind of moral incongruity, replacing pity or sympathy (or, perhaps, sentimentality) with laughter. 'The truth is that a joke is seldom, if ever, a victimless crime', claim Carr and Greeves (2007: 197) and the sick joke in particular loves a victim – of a natural disaster, of murder, of sexual abuse – the more inappropriate the better because the more indefensible the joke the 'better' it is. It 'plays with a reversal of the values of social life', as Mary Douglas puts it (1975: 97). The dead baby joke, Murray Davis suggests, combines 'the most helpless and therefore most sacred human beings ... with the most dehumanizing process – death', creating 'the most disorienting emotional effect' (1993: 146). Judging by *The League of Gentlemen* (with its predatory paedophile Herr Lipp and a sketch about two charity shop workers causing upset to a bereaved mother disposing of baby clothes) and *Jam* (which features small coffins for terminated foetuses and a plumber hired to fix a dead baby), this emotional incongruity has lost none of its hold on the comic imagination.

Richard J. Ellis sees what he calls the 'sick disaster joke' – topical gags about horrific real-life events – as manifesting a scepticism towards the 'grand narratives' of 'comprehensibility' and other cultural assumptions surrounding such events (1996: 235).[1]

If we were to sub-divide the 'sick' joke, it might branch off into the cruel (dead babies, paedophiles, jokes about famine and earthquake victims) and the gross (the body at its basest). Peter Hutchings (2007: 1) claims that television comedy has until recently been more circumspect in its handling of the 'gross out' that has been a defining feature of film comedies like *National Lampoon's Animal House* (1978) or *There's Something About Mary* (1998). That's broadly accurate, although I would struggle to think of a film comedy containing anything as graphic as the sketch in *Jam* that chronicles 'the gush' (Episode 2), a condition afflicting male porn stars whereby they ejaculate themselves to death. The sketch originated on the radio show *Blue Jam* (Radio 1 1997–99), where we were left to imagine these fatal 'money shots' (the description of blood being ejaculated in the final throes might now put us in mind of the film *Antichrist*). The TV version makes graphic use of prosthetic penises to show 'the gush' actually happening on screen (albeit in 'degraded' video footage that provides some aesthetic distance). Elsewhere, it is probably fair to say that TV's gross comedy marks a 'catching up' with some of the excesses of film comedy – an exploding flatulent dog in *The League of Gentlemen* (2.4), Mark noisily emptying his bowels during a bout of gastric flu (3.3) or Jeremy cooking and eating a beloved family dog they've accidentally run over (4.5) in *Peep Show*, Jill in *Nighty Night* pleading diarrhoea as a way out of her date with Glen, adding the unnecessary detail that she 'filled the bowl twice' (1.1). As William Paul argues, 'gross out' is predicated on going 'too far', but its boundaries must be regularly reset, so that it 'constantly changes its terms and parameters' (1994: 420). 'The gush' notwithstanding, TV comedy is more likely to explore less graphic boundaries, forever circling around 'tasteless' subjects such as incest (Tubbs and Edward in *The League of Gentlemen*), disability (Jill tormenting Cath in *Nighty Night*, the *League*'s charity shop workers' references to 'the spastics'), rape (the man in *Jam* who defends himself against his

wife's accusation of infidelity by pointing out that he was raping the other woman), racism (Mark wondering whether his new friend's references to 'blacks and pakis' are a kind of ironic 'racist horseplay' that he should join in with (*Peep Show* 2.2), David Brent reluctant to finish a joke about the queen and a 'black man's cock' when a black co-worker joins him (*The Office* 2.1)), terminal illness ('This is the chemo talking!' Jill tells husband Terry angrily in *Nighty Night* when he dares to disagree with her during his cancer treatment (1.1)).

If 'black comedy' has a literary-theatrical pedigree that enjoys greater cultural capital than most TV comedy, there are two canonical writers who seem to me to have quite a bit in common with the dark comedy that has appeared on TV in recent years – the artful 'bad taste' of Joe Orton and the 'comedy of menace' of Harold Pinter. In Orton's *Loot* (1966), stolen money is hidden in the coffin of one of the thieves' recently deceased mother, her body subject to all manner of indignities – her viscera is placed in its own small casket until heat causes it to explode. *Loot*'s murderous nurse Fay, who has killed multiple husbands for their money (and once terminated 87 patients in one week) anticipates *Nighty Night*'s Jill Tyrell – sexy, manipulative and amoral. By the time of *Loot*, Orton's dialogue was so laugh-out-loud sharp that it isn't hard to imagine him writing a sitcom – 'Use any form of proposal you like,' Fay tells her recently bereaved suitor. 'Try to avoid abstract nouns' (Orton 1976: 219). D.S. Lawson defines the 'Ortonesque' as 'an intensely farcical style characterized by fast-paced, witty word play involving elevated language applied to low and base situations' (2003: 16). The comedy hinges on the incongruity 'between elegance and crudity' (*Ibid*.: 16). John Lahr represents the most popular view of Orton as 'offensive, elegant, cruel, shocking, monstrous, hilarious and smart' (1976: 19), although Simon Shepherd has suggested that Orton's transgressiveness has been overstated, even in the context of the 1960s – 'audiences ... had little problem with Orton's naughtiness' (2003: 147–148). Either way, Orton's mischievous 'bad taste' anticipates the macabre comedy of *The League of Gentlemen* and *Psychoville*, while his fondness for defacing library books and writing pseudonymous letters to newspapers predates the pranks

of Chris Morris. As I have hinted already, Julia Davis's work is the most 'Ortonesque' of all, not least in its use of language – malapropisms crawling from the wreckage of elevated language ('through ... treating me like a leopard, they have shown me that I am a social piranha') or the creation of bizarre phrases of unknown origin ('we'd appreciate you not creeping up to us like a dog at a disco'). What makes Orton's humour still feel so modern is not only its defiantly queer sensibility, but its seemingly heartless misanthropy. There are two kinds of people in Orton's plays. The majority are amoral, if not sociopathic, often attractive, driven entirely by gratification (sexual and/or financial), skilled in coating their actions in pious or officious language. Fewer in number are the guileless people they prey on – kicked to death, imprisoned for someone else's crimes. But significantly, no great warmth or sympathy is invited for these people, any more than *Nighty Night* seems to particularly want us to empathize with the hapless Cath, a woman who might seem most deserving of our sympathy (suffering from MS, tolerant to a fault, saddled with a selfish, unfaithful husband).

Orton's plays, all of them farces to a degree, are more obviously 'comic' than Harold Pinter's – you'd need to perform them pretty badly (and I'm sure many have) to kill all of the jokes in the text – which again seems to ally him with the faster gag rate of TV comedy. Like Orton, Pinter has been awarded adjectival status (the 'Pinteresque') but he also inspired a much more interesting label for his early plays. Irving Wardle coined the expression 'comedy of menace' in 1958 (the year that *The Birthday Party* was first performed), characterized as 'dehumanized comedy' or 'the satirical distortion of cliché' (Wardle 1965: 91). But Francesca Coppa's more recent definition of the 'comedy of menace' pins it down with a bit more precision.

> Menace depends on ignorance; the terror of it stems from the vagueness of the threat. We do not know what is happening or why, and the lack of information leads us to fear the worst: that the threat is somehow beyond articulation – literally unspeakable. Black comedy, on the other hand, treats serious themes comedically, without the 'respect' they deserve; it says *too much*, it says what *should not be* said. (2009: 51)

This is an enormously suggestive distinction – black comedy says too much, the comedy of menace doesn't tell us enough. Does this explain why the latter often retains its power, while the former can quickly look tame (or, worse, not as shocking as it thought it was in the first place)? In *The Birthday Party*, we have no idea why Goldberg and McCann have come for Stanley, a second-rate pianist renting a room in a seaside town, why he is so terrified of them or why they are able to break him with what superficially appears to be nonsense, clichéd platitudes and childish games. They fire ridiculous questions at him – is the number 846 'possible or necessary'? – until he screams. *The Birthday Party* is often very funny – an attempt to intimidate Stanley into sitting down becomes another silly game – but the atmosphere of unease is in stark contrast with Orton's witty onslaught. There is a similar comic unease in Papa Lazarou in *The League of Gentlemen* ('Destination: Royston Vasey' 2.1) persuading a terrified housewife to become his wife by talking gibberish and managing to get her to do the same. There is something 'beyond articulation' about the comic menace represented by Papa. His insistence on calling her 'Dave' is funny in the most infectious and irresistible way, but it's also consistent with his ability to reshape reality around his semi-willing victims – we may laugh at his nonsense, his exaggerated swagger, his 'inappropriate' black face, but we might still be left 'fearing the worst'. As I have argued elsewhere (Hunt 2008: 84–88), there is something primal and nightmarish about Papa – he at once evokes Freud's primal father, Lon Chaney's top-hatted vampire in *London After Midnight* and *Chitty Chitty Bang Bang*'s Childcatcher (a figure who spawned many an adolescent nightmare). Each time the character returned, he seemed to come closer to escaping his comic constraints altogether and becoming purely uncanny – a satanic Santa Claus (Christmas Special), a demon who traps his victims inside circus animals ('How the Elephants Got its Trunk' 3.6). The 'comedy of menace' is more likely to be found in the TV sketch show than sitcom – TV comedy rarely displays the more sustained unease associated with Pinter's early plays.[2] The comic intent of the original Papa sketch is more evident than is the case with Pinter, even if we take the studio audience out of the equation. Two of

the actors in the scene are in drag and Reece Shearsmith's performance as Papa is designed to elicit laughter first and unease second (which is not to say that we might not experience them the other way round). Nevertheless, amongst the forms of discomfort that contemporary TV comedy has elicited, unease and a disorienting mixture of comedy and dread are significant developments.

Cringe benefits

Embarrassment is an intrinsic part of most comic forms, from slapstick through farce to the '*ewww!*' effect of the gross out. The phrase 'cringe comedy', however, suggests something more than that, a dissolution of whatever distance we might maintain between the embarrassment experienced by a character and an embarrassment that we somehow feel ourselves. If dark or cruel comedy 'anaesthetize the heart' then cringe makes us feel too much of something that we would usually not want to feel at all.[3] Embarrassment, suggests Frances Gray, 'is a real physical sensation on the skin and in the stomach; it leaves us with a sense of our own, real, damage' (2009: 149). Kate Fox sees embarrassment as the lynchpin of English comedy, a 'perennial English preoccupation' reflecting 'an unusually acute fear' in everyday life (2004: 217). Mark in *Peep Show* is presented as the quintessentially embarrassment-prone middle-class Englishman, so invested in moral propriety that every *faux pas* is guaranteed to provoke deep shame. Many of these embarrassments are connected to contemporary notions of 'political correctness', but others are rather more basic. After a steamy encounter with nerdy-but-sexy Dobby in the stock cupboard, he ejaculates in his pants and is forced to flee. Inevitably he runs into his nemesis Jeff and vengeful jilted nearly wife Sophie, and must explain away the damp patch on his trousers by claiming to have wet himself (5.2). But neither English nor British comedy have a monopoly on 'cringe', a label also applied to American sitcoms like *Curb Your Enthusiasm* (HBO 2000–). When HBO showed Gervais and Merchant's *Curb*-inspired *Extras*, they paired it with Larry David's show as part of a cringe double-bill (Stevens 2005).

Dana Stevens describes *Curb Your Enthusiasm* as 'the cringe-comedy pioneer' (*Ibid.*), which might be a reasonable claim to make were it not for a fictional sports presenter turned chat show host turned celebrity has-been named Alan Partridge. Partridge originated on radio as part of *On the Hour* (Radio 4 1991–92), which would transfer to TV as *The Day Today* (BBC 2 1994). When he moved to his own fake chat show *Knowing Me, Knowing You ... With Alan Partridge* (Radio 4 1993, BBC 2 1994–95), British and American comedy were, as Ben Walters reminds us (2005: 102), in sync again – another (US) comedy series about a fictitious chat show, *The Larry Sanders Show* was first broadcast in 1993. Given that both *Curb Your Enthusiasm* and *Larry Sanders* were more naturalistic than the Partridge vehicles, they almost certainly influenced later developments in British cringe-com – *Extras*, in particular, is visibly (some might say slavishly) in debt to them by having real stars play unflattering versions of themselves.[4] Disgraced after killing a guest live on air, Alan relocates to Radio Norwich in *I'm Alan Partridge* (BBC 2, 1997, 2002), living permanently at a 'Travel Tavern' where he waits for an opportunity to get back on TV. More of a conventional sitcom than *Knowing Me, Knowing You ...*, *I'm Alan Partridge* is a step closer to cringe-com – Walters cites 'nuanced character observation, hand-held camerawork, significant portions of location shooting and looser stories which reflected Partridge's aimless existence yet also had a degree of continuity across the series' (*ibid.*: 102) while Sangster and Condon describe it as 'deeply uncomfortable viewing ... with many moments of cushion-hugging agony' (*ibid.*: 390). Like David Brent, Alan stops just short of being a monster – his exultant 'Jurassic Park!' when he is offered a five-year TV contract audibly delights the studio audience who wish him some luck in spite of his often appalling behaviour. Provincial, ill-informed, defensive, self-important, simultaneously thin-skinned and insensitive to others, Alan's only redeeming feature is his naive if fragile belief in his own value as a professional entertainer. The final episode of the 1997 series ('Towering Alan' 1.6) finds him at his inappropriate worst. When the Head of Programmes (played by David Schneider) who has blocked his return to TV dies, Alan goes

to the funeral in the hope of charming his successor. During an awkward conversation with the widow, his mobile phone goes off and he takes it in spite of protests, snapping 'Alright!' irritably when she asks him to take it outside. As he pursues the new chief, he's increasingly impatient with anyone else who tries to engage him in conversation – 'Would it be terribly rude to stop listening to you and go and speak to someone else?' To his frustration, he finds himself back with the widow ('Yes, I've done her!'). Having exhausted his insincere platitudes and anxious to catch his wandering prey, he behaves like a bored child impatient to go out and play – 'I want to go and talk to him over there', he says sheepishly, pausing only to mime tears and make a perfunctory 'What can you do, eh?' gesture as he abruptly leaves the bereaved woman. However, as Walters observes, Alan remains 'too large to be considered naturalistic' (2005: 103). Steve Coogan is a much more versatile comic actor than Ricky Gervais (who has largely played variations on a character that he subsequently seems to have turned into in real life), but he gives a less naturalistic performance as Alan than Gervais would later give as David Brent. As a result, however atrocious Alan's behaviour, we possibly enjoy seeing such social codes transgressed in a safe comic environment rather than looking through our fingers. *The Office* distinguished itself both from Partridge and mock-doc predecessors like *People Like Us* (BBC 2 1999) through its refusal to 'provide relief, to let us all laugh in an affirming, cathartic way' (*Ibid.*: 60).

If cringe comedy hinges on inappropriate behaviour – as its most celebrated moments often do – then what separates David Brent's 'black man's cock' joke from Basil Fawlty impersonating Hitler in front of German hotel guests in *Fawlty Towers*? Basil is embarrassing his co-workers, but the scene is not framed in the visual or performative rhetoric that has come to characterize 'cringe' – nervous glances (often into the camera), uncomfortable silences (which work better without studio audience laughter), sentences trailing off or running on even as the speaker's face signals that they are desperately seeking but not finding the conversational exit. Traditional sitcoms' treatment of embarrassment adheres to television's status as 'one-way

"window"' (Gray 2009: 156), whereas 'cringe' is most at home in what Brett Mills refers to as the 'surveillance society' (2008) – a world of CCTV, mobile cameras and reality TV.

 Like most contemporary forms of uncomfortable comedy, 'cringe' has a non-comic counterpart. If the grotesque comedy of *The League of Gentlemen* and *Psychoville* sometimes owes as much to horror as comedy and some black comedy can be seen as a kind of tragi-comedy (something like Rob Brydon's *Marion and Geoff* is a case in point), then 'cringe' is an affectivity shared by comedy and reality TV. *Big Brother* – a 'sitcom without closure' (Gray 2009: 158) – *The Jeremy Kyle Show*, *The Apprentice* and all manner of talent shows trade on misplaced narcissism and hubris, self-deception, epic stupidity and behaviour that (as the cliché goes) could only be watched through one's fingers. As Ben Thompson puts it, 'the commodification of the self which reality TV entails is also a comedification' (2004: 397). What makes David Brent ripe for ridicule is precisely his attempt to orchestrate his own fast-track to celebrity via his role in the documentary being shot at Wertham Hogg office supplies. Tim, on the other hand, evokes the reality show contestant often willed to victory by audiences by virtue of appearing the most 'real'. Tim can look as uncomfortable in front of the camera as anyone else, but he doesn't conspicuously *perform* in the way that David does. While David mistakenly believes himself to be half of a comic double act with Finchey ('I'm more character-based and he's more of a gag man'), Tim generates comedy more spontaneously, usually with Dawn as his partner-in-crime as they puncture Gareth's brittle self-importance. David looks to the camera for approval or to monitor how he thinks he's coming over on screen, while Tim's trademark glances seem directed at *us*. 'Can you believe this?' he seems to be saying, inviting us to cringe with him or, Brett Mills suggests, pleading with the audience to rescue him from his discomfort (2004a: 73). David is more sympathetic when the performance drops or is at least more spontaneous, such as his breaking down at the end of Series 2 or in the beautiful sequence that opens that series as Gareth starts singing 'Mah Na Mah Na' and a grinning David joins in (2.1). Tim is initially uncomfortable (we're getting *that* look), but ultimately can't

help smiling, surprised at his own delight and cueing us to feel similarly.

Peep Show eschews the 'mockumentary' format, even though its adherence to point of view shots creates the effect of its protagonists constantly being filmed (and that is how the series is partially shot, with cameras and mics attached to off-camera performers). But its emphasis on being monitored – including monitoring oneself – locates Mark and Jeremy in much the same world as the *Big Brother* contestant who needs to 'incorporate an awareness of how everything they do will look on screen into their behaviour without being *seen* to do so' (Thompson 2004: 392). Much of *Peep Show*'s comedy derives precisely from showing this management of the self through internal discourse. Jeremy usually finds it easier to rationalize the relationship between his inner and outer selves – 'This was definitely a good idea!' we often hear him telling himself with invariable inaccuracy. As he succumbs to Sophie's mother's advances, he thinks 'It's *almost* a moral decision, but not really because no one will find out' (4.1). But surveillance society, Mills argues, is more likely to produce a 'mistrust of the self, in which we judge our own actions even more harshly than others might' (2008: 58). While British sitcom characters, David Brent and Jeremy included, are often defined by their capacity for self-delusion, Mark Corrigan – arguably cringe comedy's most original creation – 'has no such security' (*Ibid.*: 58).

Peep Show combines the 'buddy' and the flatshare sitcom – if the title *Men Behaving Badly* hadn't already been taken, it might have greater claim to it. Mark and Jeremy update the dynamics of *Whatever Happened to the Likely Lads?* (BBC 1 1973–74) – one feckless and unreconstructed, the other seeking conventional respectability and domestic happiness with 'the one'. If *The Likely Lads* sometimes explored the comic potential of homosociality (see Medhurst 2007: 117–23), *Peep Show* is much more explicit in periodically threatening to derail the heterosexuality of what Medhurst refers to as 'Lads in Love'. Mark is '85% sure' he's heterosexual, initially tested by his attraction to his ridiculously hyper-masculine boss Johnson. Mark watches gay porn to double check his sexuality, frightened off by the first on-screen penis he sees. In the same episode, Jeremy is

struggling to recall 'the bad thing' he knows he did last night – Mark's gay porn brings back the blow jobs he exchanged with his dissolute musical collaborator Super Hans. As Mark imagines being Jeremy's boss at JLB finances, his thoughts take an unexpected turn – '"Jeremy, could you file this for me? Jeremy, could you take that for me? Jeremy, could you suck this for me?" Jesus – where did that come from?' (1.2). Jeremy briefly considers raping Mark after drugging him with Night Nurse so that he can throw a party without him – 'It's not like I'm going to rape him. I *could* rape him (*barely a pause*). I'm *not* going to rape him' (3.3). His calm inner voice suggests that this could go either way. Physical intimacy between them seems inevitable. They're forced to kiss during a spin-the-bottle game ('At least it's Mark. *Jesus – it's Mark!*' 2.1) and Jeremy is troubled by Mark's sister smelling like him when they have sex (3.4). As Medhurst argues, such a queering of the homosocial is more upfront than it would once have been in TV comedy's male pairings – audiences are so 'acutely aware of the homosexual penumbra that shades any homosocial comedy' that such jokes are positively expected (2007: 127). Even so, *Peep Show* brings an altogether more tactile dimension to this masculine comic dynamic.

The Office's non-comic components allow it the luxury of pathos and even sentimentality. Compare, for example, its treatment of office romance compared with *Peep Show*'s. We are never left in any doubt that Tim and Dawn belong together, however many times she goes back to the boorish Lee or turns down Tim's tentative attempts to break out of the 'friend zone'. *Peep Show* treats all relationships – especially sexual ones – as arbitrary, based on circumstances, opportunity and convenience, subject to fantasy and delusion. It suggests that the feelings we have for other people are primarily determined by how we see ourselves. People talk themselves into (or justify to themselves) their feelings for others, and then at some point see those feelings for what they really are (but, if necessary, will find ways of deluding themselves into holding onto them for a little longer). Mark's relationship with Sophie is almost as much the backbone of the first four series as the one he has with Jeremy, culminating in their traumatic abortive wedding (4.6). She is

usually the ostensible epicentre of his most excruciating humiliations. We first see Mark in the first episode of Series 1 rushing to share the bus with her, too stifled by reserve to tell her when she unknowingly sits on his hand. An office crush explodes into full-blown obsession when Sophie starts seeing cocksure, oleaginous Jeff, which suggests that Mark is most attracted to her within a competitive scenario. Some of the humour derives from Mark's awkwardness – he attempts to add a romantic note to an answerphone message by singing 'And then I go and spoil it all by singing something stupid like (*trailing off*) ... I *like* you' (1.2). Jeremy's face says it all – he might as well be watching a puppy die. But Mark will have his awkward gesture mimicked by a smirking Jeff, who sings the line back to him in the lift. By the start of Series 2, Mark's obsession is taking a darker turn – hacking into Sophie's emails to monitor how he's shaping up against Jeff. 'Oh, this is the last time,' he tells himself, 'I've really got to stop it. At least ration it – three times a day' (2.1). Naturally, she catches him, in spite of him pushing her in the face as he tries to close down the computer monitor before she can see what he's doing. His greatest humiliation comes as he attempts to get back into Sophie's life as her relationship with Jeff is hotting up (2.5). This involves first bonding with Jeff (reading lad mags to build up a 'Man Chat' list) and then pretending to be gay in order to be allowed near Sophie. It isn't a challenge for Jeff to see through this charade – 'Gay or not, there's no threat from you, pal. You could have your cock in her, but you still wouldn't have the balls to fuck.' This exchange makes particularly uncomfortable use of the point-of-view shooting style, cutting between Jeff's grinning face – the wide angle renders his presence unpleasantly invasive. The reverse shot, equally, shows us more than we might want to see of Mark's defeated, helpless face. When Tim is humiliated by similarly venal characters in *The Office* – Lee or the epitome of the joker-as-bully, Finchey – the comedy is suspended to allow the pathos to take over. Several episodes actually end on that note – his birthday ends with a quiz night victory reversed by Finchey throwing his shoe over a building while Lee pins his arms, leaving him pacing the car park alone in impotent frustration (1.3), while another episode closes on his discomfort after

a possessive Lee puts him up against the wall for appearing over-friendly with Dawn (2.1). And yet, while *Peep Show* never 'suspends' the comedy in the way that *The Office* does, I find Mark's close encounter with Jeff the hardest scene to watch of any in cringe-com. On the one hand, Jeff's smirk seems to dissolve the distance between spectator and screen. Moreover, while Mark doesn't exactly invite pathos – he's too implicated in his own misfortunes for that – he probably isn't deserving of humiliation in the way that, say, David Brent (mostly) is. Mark's self-questioning makes him as close to a moral centre as we get in *Peep Show* – more Tim than David, in some respects, if still some distance from Tim's more straightforward decency. He does possess a conscience and a moral compass and yet often finds himself doing terrible things (while being appalled by his own willingness to do them). While I've never watched any TV comedy through my fingers, this is a scene that for me crosses over into the unpleasurable, even before Mark is sent by Jeff to buy condoms and decides that he can only snatch a small victory by selecting whichever type will afford the least pleasure ('I win – in the most minor way possible'). We aren't just watching someone being humiliated, but also rationalizing the humiliation (and his complicity in it) to himself.

By Series 3, Mark and Sophie are finally together, whereupon romance starts to fade almost immediately. Nevertheless, the series climaxes with his planned proposal of marriage, prompted by a combination of social convention and the possession of Mega-deal vouchers for a weekend break. Lost on the moors with Jeremy, Mark is asked if he's ever considered that marrying Sophie might not be the best idea, given that she clearly annoys him. Jeremy asks Mark what he actually loves about Sophie.

MARK: Are you kidding? Everything! Her ... (*starts to flounder*) you know. I mean, she *has* changed a bit lately, but we were ... we had this connection.
JEREMY: (*unconvinced*) Riiiight ...
MARK: Which admittedly, is kind of going, but, you know, she's funny. Although now I wonder whether she really was funny or whether she was just being normal, but I liked her so much I thought she was funny.
JEREMY: Oh yeah, I know that one.

MARK: Plus, when I was at the height of Sophie madness, it was when, you know, watching her across a hot photocopier, the little looks, the funny doodles …
JEREMY: Before you really had a relationship?
MARK: Exactly. It's almost like the more we've got to know each other, the worse it's been. (*pause – it's starting to dawn on him*) I mean, we really have almost nothing in common.
JEREMY: Well, maybe that's a sign?
MARK: (*exultant*) Oh my God! I don't have to marry her! There might even be other women in the country who are willing to speak to me and now I can go out and find them! Or just give up on women and eat toasted sandwiches and watch TV!

(3.6)

Unfortunately for Mark, by the time he returns to the hotel, Sophie has found the engagement ring and accepts the proposal that he has not had the opportunity either to withdraw or to make. He later explains to Jeremy that 'it would have been too embarrassing not to accept the acceptance'. In one of the series' key defining moments, Jeremy – rarely so insightful – observes that his best friend has proposed by default to someone with whom he was almost pathologically infatuated, but doesn't actually love (or probably even like) 'out of embarrassment'.

Comedy with menace

'Welcome to Royston Vasey. You'll never leave!' reads the sign outside an unprepossessing northern town in rural surroundings – fair warning that its population includes an incestuous couple who murder strangers who come to their Local Shop, a hygiene and toad-obsessed couple who imprison their nephew, a butcher who sells something terrible and irresistible to select customers. Sometimes there are visitors who are more disturbing than Royston Vasey's inhabitants – a German paedophile who leaves a schoolboy buried in a rose garden, breathing through a small pipe ('Anarchy in Royston Vasey' 2.5), and the aforementioned circus ringmaster who only appeared in three episodes and yet has become emblematic of a series that seemed to scare almost as many people as it made laugh. Little wonder that *The League of Gentlemen* is often seen as the starting point

for the dark TV comedy of the late 1990s. Much of this darkness grew out the League's fannish affection for British Gothic cinema, particularly evident in a Christmas Special modelled on the portmanteau horror films of Amicus studios and ending with the return of Papa Lazarou as a nightmarish Santa Claus carrying another 'wife' off on his sleigh.

In Michael Steig's useful definition, the grotesque is 'the managing of the uncanny by the comic' (*ibid.*: 259). It represents a 'double paradox' that 'at once allays and intensifies the effect of the uncanny; in pure comedy, at the other end of the spectrum from the uncanny, the defence is complete, and detachment is achieved' (1970: 258). It leaves us in a 'state of unresolved tension' (*ibid.*: 260) – as the comedy of menace does, too – diverting threatening material 'in the direction of harmlessness, without completely attaining it'. The threatening comes closest to being rendered 'harmless' in the case of the series' two most popular characters, Tubbs and Edward, the married siblings who run the local shop. Murderous and abject – Tubbs suckles a pig and they make wedding party dips out of human excrement – they come to inspire affection through their childlike naivety and much-repeated catchphrases ('Can I help you at all?', 'This is a local shop for local people – there's nothing for you here!', 'Hello, hello, what's all this shouting, we'll have no trouble here!'). Moreover, they appear in the first two series, which are accompanied by the later-abandoned recorded laughter of a studio audience – not only do they cue laughter but other responses (the 'aaaahs' that Tubbs was starting to get as the series developed, a gasp of disapproval when Edward slaps her). But not all of the *League* diverts the uncanny in this way. Papa Lazarou most obviously manifests 'a state of unresolved tension'. Somewhere in between is the ongoing saga (as Papa might call it) of butcher Hilary Briss and his 'Special Stuff'. A lot of the *League*'s dark humour rests on 'saying too much' (the province of black comedy), where Hilary, if not quite 'Pinteresque', represents a vagueness that leads us to 'expect the worst'. The Special Stuff isn't quite 'beyond articulation' because it seems to lend itself to a finite number of explanations – cannibalism, hard drugs, bestiality, something with the unseemly allure of the nastiest porn imagi-

nable. When it creates a nosebleed epidemic in Series 2, we come closer to something that is beyond representation. The scenes in Series 1 and 2 that deal with Hilary and the Special Stuff lack clear jokes – they're often structured like sketches, but they don't build to clear comic pay-offs. The humour seems to derive from the teasing innuendo about what the threat might be, the withholding of information; the silences and glances that lend dreadful significance to what Wardle calls the 'satirical distortion of cliché' (1958: 88).

Psychoville (BBC 2 2009–) is not strictly a follow-up to *The League of Gentlemen*, but is written and partly performed by two members of the League (Reece Shearsmith and Steve Pemberton) and builds on Series 3's attempt to interconnect characters and narratives. In abandoning sketches altogether and having a more carefully constructed narrative – at least by the standards of a TV comedy – it initially moves more in the direction of black comedy than the combination of the grotesque and the comedy of menace that sometimes appeared in the *League*. The series appears to promise resolution and closure, its most uncanny sequences (a doll seemingly come to life, the terrifying Silent Singer) given more or less rational explanations, its unexplained elements hooks for further series. In Series 1, a letter containing the message 'I know what you did' brings together a group of sinister or eccentric characters (most of them former inmates of a mental institution) – an over-protective mother and her serial killer-obsessed son, a midwife convinced a baby doll will come to life, an embittered one-handed clown, a blind toy collector and a pantomime dwarf who falls for his vacuous leading lady. The series' standout characters, mother and son Maureen and David Sowerbutts, can be seen as variations on Tubbs and Edward, but refined to the point where they can operate outside the confines of sketches and interact with a wider world. Even the casting reinforces the comparison – Shearsmith (Edward, Maureen) the more aggressive and controlling of the two, Pemberton (Tubbs, David) an overgrown, misshapen infant. Both pairings combine the macabre and the taboo (incest and murder) with childlike pathos. Maureen, who brings to mind a homicidal Thora Hird, shifts from the mundane (playing her Bontempi organ, face

filled with delight) to the murderous without turning a hair. There's a joy for Maureen in discovering how much she enjoys killing people, a new hobby she can share with her son – it's 'given me a lift', she tells him (1.6). David, with his gaping mouth and pudding-bowl hair, may commit the murders physically but isn't the real monster of the pair, even though he's fond of 'strangles', a word that makes strangulation sound like it belongs in the same tactile continuum as 'cuddles'. Maureen and David are first introduced as she quizzes him on his serial killer knowledge while she scratches dry skin from his back – 'Go and get a dustpan and brush. I've got half your back between my legs' (1.1). Their relationship is inappropriately physical – she enjoys having his flakes of skin brushed from her crotch and both of them seem to enjoy her protracted tucking of his shirt into his trousers. In a subsequent episode, she chews up his food for him when he's being fussy over his dinner (1.3). If Orton mixes 'elegance and crudity' (Lawson 2003: 16) the *League* and *Psychoville* combine the macabre and the taboo with an uncanny ear for the banality of everyday speech. When they run a bath to drown their first victim, Maureen asks the doomed man if he has Matey bubble bath (specifically, a *child's* bubble bath, in a sailor-shaped bottle). When he shakes his head pleadingly, she interprets this as a simple response to her question and is outraged to later find a bottle of said bath foam in his bathroom – 'Look, he *did* have Matey – why lie?' (1.2). The richness of David and Maureen as comic characters is demonstrated by their getting an entire episode to themselves (1.4) – a showcase episode both in terms of fleshing out their back story (Maureen poisoned her abusive husband, but David finished him off unintentionally with sleeping pills) and its technical virtuosity, a pastiche of *Rope* (1948) that adopts Hitchcock's continuous takes. It opens, as *Rope* does, with the camera panning to the window of the apartment, cutting shortly after a scream from inside to a close-up of their victim being throttled. The tone shifts immediately into the incongruity of the domestic – Bernard Herrmann's shrieking *Psycho* strings give way to the soothing tones of Henry Kelly as we learn that we've been listening to the music on his 'Movie Magic' radio show. 'Shall I put the kettle on? I'm absolutely, gasping', says

Maureen. 'So was he,' replies David. These kinds of modal shifts provide a good deal of the humour, such as their respective explanations for the lure of serial killing:

> DAVID: God-like power over human life enables serial killers to compensate for childhood humiliations, or adult inadequacies, leading to feelings of potency and superiority which cannot be obtained in their day-to-day lives.
> MAUREEN: Yeah, like I say – more-ish.

The word 'more-ish' not only works to undercut David's textbook definition (not only elevated but clearly *memorized*), but brings us back to the kind of English vernacular we might associate with someone of Maureen's age, class and possibly regional background (my own sense is that 'more-ish' is a particularly northern word). It's a word most often applied to snacks, with the implication of an addictiveness that is harmless but probably fattening. Maureen is a woman of modest means and small pleasures, and murder has taken on roughly the same status as a packet of Pringles or Hob Nobs. When she strays from such vernacular, she is capable of exquisite malapropisms, such as her referring to a slip of the tongue as a 'Freudian clit' (1.4).

But if *Rope* gives episode 1.4 of the first series of *Psychoville* the veneer of the 'cinematic' (something *The League of Gentlemen* also aspired to in its rich production design and elegant photography), it also makes it look like what *Rope* was originally – a stage play. Several scenes are performed straight to the 'fourth wall', such as the 'cheering up' song (Black Lace's 'Superman') to which they perform the appropriate movements after the murder (Maureen's use of her cardigan as Superman's cape is particularly sublime). The episode deploys more farcical comedy than the rest of *Psychoville* – before Maureen and David can dispose of the body, they are interrupted by what appears to be a police inspector (who is actually an actor auditioning for Murder Mystery nights). The body is forever in danger of being seen (not unlike the one in Orton's *Loot*), hung on a door, covered with a coat, accidentally stabbed, clearly visible to the audience behind and outside of the inspector's gaze. Even before 'Chief Inspector Griffin' proves to be a camp young man

who works for Abbey National, every line and performance tic from Mark Gatiss speaks of repertory productions of Agatha Christie. By the time he reveals himself, Maureen has already blurted out her entire confession, declaring that David is 'my monster – I created him'. They manage to convince 'Griffin' that it's all part of the act, and he leaves – only to return for his coat just as they're about to move the body again. As David closes in, the camera moves to Maureen. She puts the 'cheering up' tape back on, albeit not loudly enough to entirely drown out the choking sounds. Initially, she winces and looks away, but then turns and looks – and smiles. In spite of the comedic disjunction between song and action, this is a sinister note on which to end the episode. Thus far, we have been led to believe that whatever 'lift' Maureen is getting, her primary motive is to protect her son. But that smile accords with a line later sung to David by waxwork serial killers (including Jack the Ripper) come to life:

> Take some advice from one killer to another
> There's always someone worse than you.
> In this case, it's your mother.

> (1.5)

Psychoville was probably always fated to be compared with *The League of Gentlemen*, favourably or otherwise. A Halloween Special (BBC 2 2010) particularly invites this in reworking the portmanteau horror-comedy format of the League's Christmas Special, sometimes seen as one of their defining moments (not least by me – Hunt 2008). If the League looked mainly to British horror film and TV for inspiration (Amicus studios,[5] the TV version of *The Woman In Black*, the BBC's M.R. James adaptations), it's interesting to see *Psychoville* also look to Asian horror, most notably in the story featuring blind toy collector Lomax – an eye transplant induces ghostly visions reminiscent of the Thai/Hong Kong horror film *The Eye*.[6] By using dreams or stories told by a 'friend of a friend', the *Psychoville* Special is able to both occupy a narrative 'bubble' outside series continuity (as the *League* Christmas Special did) and be part of that continuity. The climactic twist is not that the Special takes place *before* the final scenes of Series 1 (we are invited to infer that it

follows them) but that it partly happens *simultaneously* with them – we once again witness the explosion at Ravenhill Hospital that leaves us uncertain which major characters have survived.

Psychoville's second series is an even more confident and fully achieved affair. The tighter narrative perhaps comes at the expense of gag rate, which might explain why ratings virtually halved during the series' run (Anon. 2011). It isn't just that *Psychoville* progressively kills off most of its Series 1 characters – survivors include Mr Jelly and David, while the final scene hints that Maureen (succumbing to cancer, rather than the murder that befalls the others) is a potential candidate for resurrection (2.6). Most of the episodes end with dramatic, tragic or disturbing, rather than particularly comic, scenes – usually the murder of one of the central characters. In episode 2.1, Joy (Dawn French) is stabbed in the neck with a pencil, after which her killer adopts a distinctly post-coital demeanour, stroking the face of paralysed witness Jennifer and whispering to her gently, 'Don't tell anyone I was here.' While the absurdity of the weapon might undercut the scene if it appeared in a straight horror thriller, it still plays at the more 'disturbing' end of comic horror. Episode 2.3's final scene has Maureen play her chosen funeral hymn 'Abide With Me', which then plays over the removal of Lomax's body. Episode 2.5 climaxes with not only the murder of Lomax's helper 'Tealeaf' (Daniel Kaluuya), but the words 'Heil Hitler ... Schwarze' as he is shot by a man in a Nazi uniform. Thanks to Mel Brooks and others, we may no longer find Nazis shocking in themselves, but the racial slur carries more of a charge.

Allowing David to survive and leaving the audience with some hope of Maureen's return from the grave confirms that these two characters provide the most satisfying strain of dark tragi-comedy in *Psychoville*. There is a pathos in even their most murderous behaviour. David chides Maureen when he finds her dismembering a body in the bath, but when she asks 'Do you want to keep his willy?' he nods with an odd mixture of resignation and enthusiasm (2.4). Two particularly memorable setpieces stand out. In episode 2.2, David and Maureen organize a dinner party in order to dispatch the person they

wrongly believe is blackmailing them. A drunk Maureen decides to entertain her guests by pulling dark tights over her head, with ping pong ball eyes and a dirty blonde wig – she proceeds to mime to Tina Turner's 'Simply the Best'. The world of *Psychoville* is perhaps too grotesque for this to play as 'cringe' comedy, even though the comedy largely arises from Maureen's unacceptable behaviour and the unwitting racism of her performance. Unlike the more problematic 'blacking up' of *Little Britain* or Reeves and Mortimer's Marvin Gaye and Otis Redding, *The League of Gentlemen* (with Papa Lazarou's minstrel face) and *Psychoville* invite shocked laughter that requires a sense that something is wrong. Following Coppa's definition of black comedy, it is Maureen's body that 'says *too much*' (2009: 51). The scene pushes from the scandalous into the tragic when David can only stop her by shouting 'You've got cancer!' (which suggests that he is trying to stop her more out of concern for her wellbeing than a sense of moral propriety). After Maureen breathes her last, David sits her corpse between his legs and puts on the song 'Oops Upside Your Head', the two of them doing the distinctive 'rowing' dance that often accompanied the record in 1970s discos (2.5). Again, ambivalence is rife in the scene. There is 'sick' comedy in the manipulation of a corpse into 'dancing', but also the pathos of David still trying to demonstrate his love for his lifeless mother. And the scene can't help but rekindle the suspicion of a just-about-unconsummated incestuous dynamic – as he sits behind her, the thrusting motions that power the dance have a unmistakably sexual edge to them. It mirrors their first scene together in Series 1, where he sat between her legs as she brushed his back.

Psychoville's second series introduces some new characters as its original cast largely fall victim to murderous Inspector Finney, assassin for the nefarious Nanotech Corporation, engaged in a scheme to revive the cryogenically preserved head of a Nazi scientist. Of particular note here is librarian Jeremy Goode, who brings the series closer to the 'state of unresolved tension' (Steig 1970: 258) of the grotesque or the comedy of menace's evocation of that which is 'beyond articulation … unspeakable' (Coppa 2009: 51). Jeremy's bizarre alter-ego, the Silent Singer, is TV comedy's most nightmarish creation since

Papa Lazarou. Jeremy is a portrait in obsessive compulsion played with a mixture of quiet menace and an edgy fear of disorder by Shearsmith. His obsession with an unreturned book, *Fifty Great Coastal Walks of the British Isles Volume 2*, will escalate from anal obsessiveness (staring at the gap on the bookshelf) to mild harassment (arriving at the borrower's house and offering to help her look for it) to quietly threatening a child in her bedroom (2.3) and then kidnapping a small dog and making telephone threats of dismemberment (2.4). In one sense, the Silent Singer – materializing whenever chaos and disorder close in on Jeremy – is not 'beyond articulation' at all. Even before the psychological explanation in episode 2.5 ('I think he *was* my frustration'), we have probably worked out that the Silent Singer is a manifestation of Jeremy's inner turmoil – OCD incarnate with blonde pigtails and sharpened teeth. And yet, psychological closure doesn't necessarily bring reassurance. In a disturbing payoff, Jeremy flicks through the returned book and can see only blank pages (2.6). Instantly, the Silent Singer materializes in the two-way mirror of the police interrogation room. Jeremy starts to 'mirror' its strange cavorting – according to Pemberton and Shearsmith (on the DVD commentary), the mimed performance of a song that we can't hear. The reflection switches between Jeremy and the Silent Singer, but then even more troubling is a reverse shot which puts us *inside the mirror with the Silent Singer* (the book and everything else is back-to-front in this world). The Silent Singer might already have put us in mind of a David Lynch creation, not unlike the supernatural killer Bob in *Twin Peaks*. The notion of the mirror as a frightening alternate world is also reminiscent of the 'red room' in that series, a strange purgatory where dialogue and movements are performed backwards and then reversed to create a kind of woozy dream reality. The Silent Singer's movements (sometimes achieved by reversing footage) also evoke the jerky motion of Sadako from *Ring*, another monster threatening to break in from another world. In one scene, Silent Singer floats uncannily away from a bedroom window like one of the vampires in *Salem's Lot*. Where is the 'unresolved tension' between the uncanny and the comic here, as opposed to fully fledged nightmarish horror? A number of things keep the Silent

Singer at least partly in the realm of the comic, even though (as with Papa Lazarou) it is likely that some viewers might find him simply frightening.[7] As Pemberton and Shearsmith's explanation suggests, there is something inherently ridiculous about a ghostly manifestation that appears to be miming to a song, using a walking stick as a microphone much as a teenager in front of a bedroom mirror might use a torch (as Maureen does for her Tina Turner impression) or a deodorant stick. The Silent Singer is gender ambiguous – he has blonde pigtails, but referred to as 'he' by Jeremy. The fact that Shearsmith plays him offers no clues in a series with two other characters played in drag, except that it connects the character to Jeremy and hints at it being his inner (masculine) rage. It's also significant that, as in *The League of Gentlemen*, some (if not all) of the horror comes via intertextual references – to Lynch, J-Horror etc. – thus providing some distance for the cult-savvy fan. Jeremy's response is bathetically comic – 'Not *now*, Silent Singer' suggests in its wording (if not the delivery) that this is not only a regular occurrence but at worst an inconvenient one. If we probably by now know the rules with comedy that is simply 'black', with its licence to be inappropriate, the grotesque and the comedy of menace retain their power to induce a laughter that is genuinely uneasy.

Chris Morris's *Jam* originated on Radio 1 as *Blue Jam*. According to Radio 1 controller Matthew Banister, 'You couldn't put your finger on it . . . but almost everything in it was deeply disturbing . . . And sometimes you couldn't even articulate why it was you were worried about it' (quoted by Randall 2010: 209). The radio version was not confined solely to sketches, featuring strange interjections from DJs and other oddness, but many of its most disturbing sketches transferred to the TV version. As Brett Mills has observed, *Jam* and its 'remix' *Jaaam* refused both to 'make comedy which looks like it should' and 'offer the audience the kinds of pleasures most commonly associated with humour' (2007: 182). Its woozy, disorientating visuals and droning ambient soundscapes seemed designed to provoke unease and discomfort. The opening 'Welcome in *Jaaaam*' sequences were a warning of what was to come, nightmarish monologues accompanied by imagery that

wouldn't be out of place in a David Lynch film. At the start of Episode 4, the camera closes in – at first in slow motion and then suddenly accelerating – to Mark Heap in a newsagent's, angrily showing a headline ('Stop this sick idiot') to the other customers.

> NARRATOR (MORRIS): When shake your head at local paper story of a crime git. Then look again and see that he is you, this long-lens shifty bugger in a park.

Heap notices the other customers looking at him, looks more closely and recognizes himself in the photo (a flashback shows him attempting to swim naked through an empty pond in a park).

> MORRIS: When every call destroys your life, even though the phone ain't got a bloody plug (*Heap's partner on the phone, in obvious distress*). And when waking, wonder where you are, and find that most of you is asking where you've gone.

Heap wakes, initially in close up, and the camera cranes up to reveal his grotesque, shrivelled body, not unlike a tadpole with a human head. The camera sweeps around the room (seemingly a disused warehouse) wildly as he screams in terror. One of the camera movements locates Morris, a threatening presence in thick glasses. As he delivers the final part of the monologue, he materializes in different parts of the warehouse and then gloatingly next to Heap's bed.

> MORRIS: Then welcome. Mmmm. You arrested for copying dogs, welcome ... in *Jaaaaaam*. (*distorted*) *Jaaaaaam*. (*demonic voices shriek 'Jaaaaam' in reply*). (*distorted*) *Jaaaaaam*. (*demonic voices reply again – Morris laughs*).

The performances in *Jam* have been characterized by Andrew Billen as 'deadened rather than heightened naturalism' (2000: 39). Several sketches play on Mark Heap's gift for playing men so unassertive that they threaten to disappear, like the security guard who can't get out the warning that the lift is out of order with sufficient urgency or volume to prevent a series of people

falling to their probable deaths (Episode 6). But that's one of
Jam's lighter sketches – it wouldn't be out of place in an episode
of *Big Train* (which, as noted in Chapter 4, has most of the
same cast). *Jam* is remembered for its more disturbing material.
A couple trying to buy a house are in danger of being
'gazumped', a situation that the seller (who couldn't be anyone
but Heap, all insincere regret and passive-aggressive manipula-
tion) exploits to obtain increasingly bizarre sexual favours
(Episode 3). One of the milder ones is 'bagpiping' – 'That's
where he puts himself in your armpit.' Things turn darker when
the price goes up again. The wife offers him her husband's
disabled sister – 'She's very attractive and she wouldn't mind
what you do so much ... she's a bit *uncomplicated.*' When
Channel 4 were pressed to defend the sketch against
complaints, it was relatively easy to claim a satirical point – the
ruthlessness of the seemingly victimized couple – but the sexual
exploitation of the disabled is contentious in any context, partic-
ularly a comic one. Other sketches seem to go out of their way
to be unpleasant, like the foetus coffins that appear in a couple
of sketches. Dead, exploited or missing children are a recurring
theme. Competitive parents conspire to keep other people's
children out of the best schools by giving them T-shirts with
'Fuck Off' or 'Little Cunt' on them (Episode 3). Parents of a
missing child show little interest in a series of phone-calls
regarding his fate. When his body is found, they are quite happy
to identify it over the phone. The father tells his wife disinter-
estedly that the boy's been raped and strangled – 'That's a bit
much,' she replies, still reading her magazine (Episode 5).[8] In a
reversal some might find equally inappropriate, a small foul-
mouthed girl arrives to help dispose of a body. When the police
arrive, she gives the man away to protect herself – 'I am only
six,' she explains apologetically as he's taken away (Episode 4).

Morris has characterized some of the ideas in *Jam* as 'things
which if you wrote them down in two lines you would describe
as humorous. But they're *travelled*' (Hanks 2000: 4). In
Episode 3 a TV repairman (Heap) arrives at the home of a
couple (Eldon, Bulmore). 'Not working, is it?' he asks solici-
tously, but is already looking furtive, eyes darting nervously
when Eldon tells him that the TV is full of lizards. Sure enough,

there are lizards on the set – Heap checks that it's set up properly, that it has a good picture, apparently oblivious to the reptiles that have seemingly emerged from the screen. 'It's not really anything to do with me,' he tells them – the line implies a 'jobsworth' attitude, but his manner suggests that he's also hiding something. He adopts a condescending tone and when he suggests that the cable company might be sending lizards 'down the wire, by mistake' has the look of someone coming up with the best story he can think of at short notice. When they try to get him to accept responsibility, a slightly more aggressive tone creeps in – 'Sweep them up .. with windscreen wipers' – and he affects offence when Eldon swears, a mock-pained look on his face. But as Bulmore and particularly Eldon get angrier, Heap starts to enjoy himself. He accuses them of filling their own television with lizards, smirking at their ineffectual rage. When Eldon demands he give them his name, Heap answers that he's 'Mr Lizard' – he's starting to look positively deranged now, telling them that his boss is 'another Mr Lizard'. He laughs sibilantly and slithers his tongue at them as he leaves; Eldon is by now in tears as well as screaming in fury. Television repairmen who find reasons not to fix your TV, particularly when they can claim that it isn't their job to do so, are the stuff of the comedy sketch (or at least were about twenty years ago) – this is less contentious in its subject matter than some of *Jam*'s more notorious items. It's also possible to imagine a *Monty Python* sketch about lizards in someone's television that plays to the surreal silliness of the idea – Python could be 'sick' and even gross, but they tended not to go dark or particularly menacing, although Eldon's impotent rage is very much their territory. Heap's performance is a comic framing of the sinister – he's overplaying it by straight dramatic standards, eyes filled with madness. It's also one of the more conventionally shot items in the series – remove the subliminal drone from the soundtrack and it might look and sound like a fairly standard TV sketch. But it shares with Papa Lazarou's first appearance the sense of genuine madness intruding into someone's home – Eldon plays the distress relatively straight. It shares also the hint of something unspeakable. The comic by no means has the uncanny under control here. Heap seemingly *knows something*

that he isn't prepared to reveal or admit to the couple – his reaction to the first mention of lizards suggests that their presence comes as no surprise. By Coppa's definition, 'black comedy' treats sensitive subjects with 'inappropriate' levity (although what constitutes a 'sensitive subject' will inevitably be renegotiated over time), while the 'comedy of menace' is an example of an ostensibly humorous idea *travelling* (to use Morris's word) into more troubling territory. *Jam* was broadcast without end credits or ad breaks. On DVD, it seeks to trouble us further with its selection of viewing modes, including a fast forward, a 'lava lamp' mode and most aggressive of all 'Forced Viewing Mode', which informs you that you have stupidly chosen to watch every episode on perpetual repeat and will be forever unable to turn them off. Buried in a late-night slot with minimal publicity, *Jam* never approached the controversy of Morris's *Brass Eye*. But no comedy series has ever felt more like a strangely clinical experiment in what happens when you combine various 'comic', disturbing and unnerving ideas and effects, offer few clues as to whether the audience is meant to find them funny or not, and observe what emerges with detached curiosity.

Entertaining Ms Tyrell

> I am very drawn to extremes. I think Jill is the very antithesis of what a woman should be, and that, for some reason, appealed to me. (Julia Davis, quoted by Jeffries 2004: 45)

JILL: (*sadly*) I'll never have children.
CATH: (*sympathetic*) Really?
JILL: I don't like them, Cathy.

Nighty Night (1.6)

If comedy is already, even now, a predominantly masculine field, then its darker, edgier corners are even more of a boy zone. While cringe comedy encompasses some engaging, rounded female characters – Dawn in *The Office*, Sophie and Dobby in *Peep Show* – apocalyptic embarrassment somehow remains firmly in the fictional psyches of straight white middle-class men. Julia Davis is a particularly important figure then, not only for

existing at all but by being regarded as able to match, if not surpass, the envelope-nudging of Chris Morris and others. Davis began in an improvisational troupe with Rob Brydon and Ruth Jones, and was introduced by comic actress Arabella Weir to Graham Linehan and Arthur Mathews, who cast her in *Big Train*. She was one of several stars from that series to progress to *Blue Jam* and then *Jam*. She also toured with Steve Coogan, with whom she shares a talent for character comedy. One of her finest moments in *Jam* is her performance as Lucy Tiseman, the lonely woman who believes herself too uninteresting to make friends and so meets people by orchestrating accidents or tragedies – 'People never find you boring when they need help,' she reasons, her actions recorded for a video diary (Episode 4). Posing as a policewoman, she tells a mother that her son has been killed and then offers the distraught woman one of a pair of tickets for *Cats*. When the police come for Lucy, it's hard to tell whether she's giggling or crying. Davis would assume greater prominence in *Human Remains*, co-written with its co-star Rob Brydon, six mock-docs about grotesquely dysfunctional couples. In 'An English Squeak' (Episode 1), she plays aristocratic Flick, who claims vaginismus as the reason for not sleeping with put-upon husband Peter (Brydon). A husband 'is a little bit like having a pet', she tells us, sentiments that Jill Tyrell would probably agree with. She tortures Peter with recollections of her deceased fiancé Geoffrey, a 'huge, bright spectacular man' against whom her husband 'falls rather short'. 'Darling, your hand is in a fist,' she observes as Peter struggles to keep his forced grin on his face. But it was *Nighty Night* that put Davis at the forefront of British TV comedy, with a reputation as one of its 'darkest' talents.

In a piece on 'Women Behaving Badly', Gareth McLean calls Jill 'quite possibly, the most monstrous female character to appear on television ever' (2004: 16). A profile by Amy Raphael at the time of *Nighty Night*'s second series seeks to 'explain' the discrepancy between the 'demure, honest, and, free of make-up, quite beautiful' Davis she interviews and her creation: 'glamorous, made-up, heartless, devoid of empathy' (Raphael 2006: 8). Does she have a 'heart of darkness', Raphael wonders, a result of spending two years in bed with glandular fever in her

early twenties? If Morris is the calculating prankster and agent provocateur, Davis's capacity for transgression is as likely to be seen as a condition or form of possession – the 'nice' girl with a comic 'demon' inside her. Raphael even refers to Tourettes syndrome, an analogy also used by Rebecca Front (who plays Cath) in a DVD interview. In the Raphael piece, Brydon and Coogan are invited to 'analyse' her (although admittedly Morris has sometimes been pathologized more aggressively).

The 'unruly woman', as Kathleen Rowe defines her, 'reverberates whenever women disrupt the norms of femininity and the social hierarchy of male over female through excess and outrageousness' (1995: 30). Rowe connects this transgressive comic female to a 'cluster of qualities', some of which fit Jill better than others. Certainly, she 'creates disorder by dominating, or trying to dominate, men', but while the unruly woman can be associated with 'looseness and occasionally whoreishness', Rowe distinguishes her from the 'narrowly and negatively defined' sexuality of the femme fatale (*Ibid.*: 31). But Jill is as much femme fatale as unruly woman. Her power over men is entirely driven by her sexuality, even though she faces competition for Don from a younger woman in Series 2. Her body is not 'excessive or fat' (*ibid.*), but rather slim and attractive, often displayed in revealing or titillating outfits – chaps that expose her buttocks on her date with Glen, French underwear worn while jogging, a school uniform and 'Swiss Miss' outfit. The comedy is located here in the brazen transparency of Jill's bids for the male gaze or the inappropriateness of jogging in French knickers and skimpy top in a suburban street. But her body remains profoundly ambivalent, associated too with 'dirt, liminality ... and taboo' (*ibid.*). There are the references to 'filling the bowl twice' or her telling Glen that her vagina is 'tiny, like a cat's anus' (hard to tell whether that's meant to be a good or a bad thing) (1.2). When she learns that Don is about to have a vasectomy, she makes one last bid to be impregnated by him (2.4). She follows him to the clinic and alternatively masturbates and fellates him as he lies anesthetized on the operating table, his spurting semen ending up in someone's dinner (and on someone's glasses). The dinner must be scraped into Jill's vagina, legs wide open – 'Do you want some mash with that?'

asks her assistant Linda, shovelling it in. When that fails, she seeks to extract dried semen from the sheets of Cath and Don's young son, inserting a king size sheet between her legs. Geoff King argues that gross comedy involving the female body can be more transgressive because of the taboos that still surround it. In *Monty Python*'s 'Mr Creosote' sketch (in *Monty Python's Meaning of Life*) he suggests that notwithstanding all the projectile vomiting, Carol Cleveland excusing herself on the grounds of a 'particularly heavy period' is 'perhaps more transgressive of the representational norms of male-dominated culture than the main gross-out attraction' (2002: 76–77). In *Nighty Night*, this transgressive female body comes to the forefront, without a fat, vomiting man as the centre of attention.

Deborah Chambers makes a distinction between the unruly woman of sitcoms like *Absolutely Fabulous* and the 'female singleton sitcom', which emphasizes the '*neediness* of single women' (2009: 172). Jill is not literally single, although the announcement of Terry's malignant tumour drives her straight to a dating agency – she's furious when he appears to be recovering ('Terry, you cannot muck me about like this – I have made arrangements and that is that!' (1.3)). But she is pathologically needy, her erotic obsession with Don driving both series. The casting of Angus Deayton seems partly a joke at the expense of his former image as 'TV's Mr Sex', as well as the sex scandal that removed him from hosting *Have I Got News for You*. When he perms and bleaches his hair and jogs in a thong (2.2), he cuts a much more ridiculous physical spectacle than Jill does in her provocative Ann Summers chic – filmed in slow motion like Bo Derek in *10*. Don is clearly an entirely arbitrary object of desire, that desirability inextricable from Jill's sadistic relationship with Cath.

There is a question – the kind of question to which comedy rarely provides clear answers – about whether Jill is a genuinely subversive figure or one who reinforces dominant notions of femininity by being 'the very antithesis of what a woman should be', as Davis herself puts it. Some of this comes down to her relationship with poor, tormented Cath. Earlier, I characterized cringe comedy as the province of straight white middle-class

masculinity, but in *Nighty Night* some of the discomfort is
provoked by Cath's passivity, her inability to express 'proper'
anger, her passive aggression towards Don (little notes telling
him about things that have 'upset' her) and her gallery of
clenched smiles and nervous laughs that stand in for the more
troubling emotions she bottles up. There are problems with
seeing her multiple sclerosis as a metaphor for being 'crippled'
by middle-class English reserve, but there is reason to suspect
that this is how she was conceived as a character. The condition
of her body – sometimes wheelchair-bound or on crutches,
sometimes more mobile – becomes more and more connected
to Jill's presence in her life. Her legs are functioning again at the
start of Series 2, where she joins an alternative therapy centre in
Cornwall. There are glimpses of her genuine anger – prompted
to beat a pillow representing Jill, she pummels it violently before
dissolving into her forced smile, praised by condescending
therapist Jacques as a 'goodie girl' (2.2). When Jill arrives at the
centre, Cath is soon back in her chair, positioning it on the 'rage
rug' from where she can only express her rage as life being
'pretty blimmin' smelly!' (2.5). This, then, is an Ortonesque
dynamic, where the meek will be lucky to survive, let alone
inherit the earth. Attractive sociopaths at least go after what
they want (however inexplicable that desire might be), while the
passive, the respectable and the conventional can only expect to
fall beneath them. Series 1 exhibits extraordinary cruelty
towards Cath. When told that Cath needs to rest before a
dinner buffet for the three of them, Jill takes her out to deliber-
ately exhaust her (1.2) in an attempt to get Don to herself. She
parks her car some way from the café, leaving Cath to wheel her
chair up a steep hill. Jill drops hints about a piece of jewellery
she'd like as a present, but when Cath produces it for her,
declares it to be the wrong one, sends Cath trundling back to
replace it and then asks for the cash equivalent instead (on top
of constant demands for petrol money and other reimburse-
ments, 'otherwise it just gets nasty'). Cath is a Christian, and Jill
is happy to slap her cheek as many times as she's willing to turn
it. The more Cath plasters that smile on her face or laughs as
though everything is fine, the more we might be tempted to
think that this is what such politeness deserves. Jill may be a

monster, but the laughter she seems to invite partly places us on her side (temporarily liberated from the social imperative to empathize with the ill or the disabled – conscience anesthetized along with the 'heart'). While Series 2 is patchier and more repetitive than the first, seemingly trapped by the expectation that it 'go further' than the first series, its resolution supports this impression. When Cath, finally capable of expressing vengeful anger, battles with Jill on the edge of a cliff, her chair lands on top of Don's current lover (busty, widowed 'Sue 2'), killing her. Jill, too, is pushed off, fall cushioned by Don, who survives but in a semi-comatose state. Cath is arrested, leaving Jill in possession of her man (oblivious and drooling) at last.

Nighty Night was the last significant programme from the dark comedy cycle of this period until *Psychoville*. Pemberton and Shearsmith initially met some resistance in getting commissioned because broadcasters had largely turned towards lighter, more affirmative comedy, most paradigmatically *Gavin and Stacey* (in which Julia Davis would cameo, and Rob Brydon and co-writer Ruth Jones would play central roles). But if TV comedy was seemingly aiming for a lighter touch, controversy would never be far away, as we shall see in the next chapter.

Notes

1 For example, a series of Fred West jokes seem to be at least partly directed at 'estate agencies, tourism/heritage, gardening/DIY or family values' (Ellis 1996: 227).

2 Cringe comedy, on the other hand, thrives amidst the more developed characters and scenarios of sitcom.

3 Outside of comedy, sex is possibly the only other area where someone might actively seek embarrassment or humiliation as a source of pleasure. But, as *Little Britain*'s Marjorie Dawes would say, that's not for here.

4 The use of real celebrities playing themselves in these shows is double-edged – it offers us stars behaving badly while simultaneously reaffirming what 'good sports' they are to present themselves so unflatteringly. *Extras* works slightly differently, however, when it uses celebrities whose best days are behind them and whose stardom was more modest to begin with. Keith Chegwin playing himself as a bitter racist is very different from Ben Stiller being a vain arrogant Hollywood star. Chegwin and Les Dennis might either be braver or

more desperate, but there is a crueller edge to such portrayals because the playing field has rather more of a slope to it. While Gervais displays his ability to get top-drawer Hollywood stars to cameo alongside him, he seems to 'kick down' at these faded light entertainers. In some ways, *Hubris* might have made a better two-syllable title for the series.

5 The Amicus connection is still explicit in the story featuring Dawn French's character Joy, which reworks the EC comics story 'The Neat Job' filmed as part of *Vault of Horror* (1973). In both stories, a wife nagged by a husband obsessed with order and tidiness 'tidies' him away – or 'recycles' him in this case, his head becoming a gruesome Halloween pumpkin.

6 Ghostly children materializing on screen as Mr Jelly watches a DVD are also reminiscent of Japan's strain of techno-horror in films such as *Ring*.

7 Might that explain the loss of viewers? Papa Lazarou's first appearance seemed to have a negative effect on *The League of Gentlemen*'s ratings, even though he would become one of their most iconic cult figures.

8 See Chapter 5 for how that scene plays (in a DVD extra) with a laugh track on it.

8

Near the knuckle? It nearly took my arm off! British comedy and the 'new offensiveness'

I'm very different to Bernard Manning because I am being post-modern and ironic. Unlike Bernard Manning, I understand that what I'm saying is unacceptable. You might say, 'Does that make you better than Bernard Manning or much, much worse?'
Richard Herring[1]

'Offensive' comedy is divisive by nature. If we simply find a joke unacceptable, then we are unlikely to find it funny. Here the displeasure entirely undoes the comedy, although we might seek strategies to prevent our looking humourless – declaring the joke boring or predictable, rather than admitting to being offended. On the other hand, as we laugh at a near-the-knuckle joke, part of the pleasure might lie in imagining the offence of others – the 'passionless third person' who Freud suggests is required for a tendentious joke to be enjoyable (1976: 147). 'The thing about most of these professionally offensive comedians,' claims Stewart Lee, 'is that no one is ever actually offended. Everyone understands the parameters and operates within them, the audience and the performer' (O'Hagan 2009: 3). While some of the comedians Lee has in mind (Frankie Boyle, for example), have managed to offend people (usually outside their core audience), their 'outlaw' status does seem to largely involve projecting outrage onto an imagined other – the 'healers and the badge wearers' that Howard Jacobson is so dismissive of (1997: 37). The warnings to the 'easily offended' on live comedy posters and DVD sleeves seem designed to

flatter the 'inside' audience even as they banish the prudish and the 'politically correct'. Who, after all, wants to be regarded as 'easily offended'? A third response is the most interesting, perhaps because it captures a very modern dilemma for the left-liberal analyst of comedy – the tension between moral enlightenment and the persistent unruliness of humour. Jimmy Carr has said that his favourite sound in comedy is 'the laugh followed by the sharp intake of breath' (Moss 2009: 5). In his book on jokes, co-written with Lucy Greeves, he elaborates on this response. 'What's interesting is the order those two reactions come in. The laugh is always first. The joke has made them lose control of their social self-edit function, just for a moment' (Carr and Greeves 2007: 181). This will not come as news to Freudians and proponents of 'release theory' – 'the joke will evade restrictions and open sources of pleasure that have become inaccessible' (Freud 1976: 147). It may be that the joke and/or its teller have a technical virtuosity that bypasses our moral or political defence systems – as Andy Medhurst reminds us, 'it is perfectly possible ... to be amused by a joke which advances political positions you would otherwise find unacceptable' (2007: 21). But attached to this is the troubling possibility that such jokes betray the fact that we don't find these political positions quite as unacceptable as we might like to think (or, dare I say it, like others to think). And yet, as Jerry Palmer suggests, comedy needs to be 'genuinely surprising, and preferably a little shocking' (1987: 137). In certain contexts, 'unacceptable' views might have a better chance of making us laugh than, say, Ben Elton ending a routine with the words 'Sexism in comedy, watch out for it, thank you, goodbye' (quoted by Double 1997: 173).

'Offensive comedy' ranges from the high to the low, encompassing a wide range of comic modes, intentions (or, sometimes, errors of judgement), politics, audiences and contexts. Satirical comedy might be expected to offend by challenging accepted views, courting controversy, ridiculing and attacking for some kind of moral purpose (or so its proponents insist). According to Casper Melville, 'giving offence is essential if society is to challenge its orthodoxies and put power under proper scrutiny', adding – tellingly – that 'It's also a lot of fun' (2009: 77). To

view *Brass Eye* as satire is to justify its offence through the seriousness of purpose often claimed for Chris Morris,[2] but the outrage it provoked has become central to claims for its achievements, too. At the other end of the scale is comedy seen to pander to prejudices, to be unacceptably cruel and derogatory towards 'easy' targets. To use Littlewood and Pickering's useful phrase, such humour kicks down, not up (1998: 292). These sound like polarized distinctions, but it doesn't always work like that. Some of Frankie Boyle's gags appear to kick in both directions simultaneously – ostensibly satirical, but often steeped in misogyny, ageism (and, more recently, disablism). Offence also mutates in unexpected ways. For example, yesterday's mainstream comedy – especially if it deals with race – can become positively taboo, while jokes once regarded as lazily conservative can take on the glamour of 'edginess'. In a controversial piece in the *Guardian*, Brian Logan identified a 'New Offensiveness' in stand-up comedy, 'a world where all the bigotries and the misogyny you thought had been banished forever from mainstream entertainment have made a startling comeback' (2009a). Challenged by Richard Herring and Brendon Burns (two of Logan's notional 'new offenders'),[3] Logan retreated from the accusatory tone of his original piece, but maintained that 'we live in a post-PC world where there is anxiety on what is offensive and what isn't' (Logan 2009b).

In fairness to Logan, while he probably pointed the finger at the wrong comedians, he wasn't necessarily wrong about there being a 'new offensiveness'. A 2009 revival of Trevor Griffiths's play *Comedians* (1976) seemed to support his point about the politically conservative taking on an edgy allure (as it often does in discourses surrounding 'political correctness'). The middle act of the play shows us the stand-up routines of the aspiring comics trained by former stand-up Eddie Waters. Eddie has sought to lead them away from the 'easy' bigotry of mothers-in-law and 'paki' jokes to something more 'truthful', but his nemesis, talent scout Bert Challenor, has made it clear that the punters must laugh at all costs and playing to their prejudices is the most reliable route to pleasing what he clearly sees as the mob. Some of the comics stick to Eddie's principles – Mick Connor's gentle Irishman-in-England routine now seems the

most modern in its observational style – or exceed them alarmingly, like Gethin Price's violent agitprop mime. But several of the comics change course to achieve success, and deliver a crowd-pleasing performance of misogyny, racism and homophobia. When the play was first performed, I would speculate that few laughed at these gags (they were not intended to). Not only did Griffiths target a left-leaning audience, but such jokes were still quite close to the mainstream – thus, they were not only reactionary, but tired and overfamiliar. Some members of the audience with whom I saw the revived version laughed (quite loudly) at these jokes about thick Irishmen, Asians with broad accents and black men with huge penises, although the latter elicited something closer to Carr's laugh-gasp response. It wasn't easy to determine what the real source of this laughter was – ironic amusement that such jokes ever existed or pleasurable surprise at being given a licence to laugh at them. A further complication lay in the casting of popular comic actors like Mark Benton and Reece Shearsmith – did the audience laugh because they thought they were expected to? Jerry Palmer suggests that because 'professional comic performance demands adjustment to local conditions, it is unsurprising that ... it might not survive historical change' (1994: 161–162). But historical change can give as well as take away – somehow these 'unacceptable' jokes had become 'edgy', taboo-busting, and in the safe confines of a London theatre, pleasurably shocking. *Comedians* is often seen as anticipating the alternative comedy of the 1980s (Allen 2002; Stott 2005), which made a firm distinction between the 'edgy' and the simply reactionary. Not only has it been revived in an era where such lines seem to have blurred – where jokes about rape appear in the repertoires of popular stand-ups – but a more particular moment (the aftermath of 'Sachsgate') where 'offence' had drawn battle lines of a different kind.

Television comedy has rarely generated the kind of offence that greeted, say, *Monty Python's Life of Brian* (1979), while a lot of live comedy would never be considered fit to broadcast (see Davies 1996) – later in this chapter, I discuss two stand-ups who have found it particularly difficult to get onto television, Roy 'Chubby' Brown and Jerry Sadowitz. *Monty Python*'s most

aggressively 'tasteless' item on TV was 'The Undertaker's Sketch', broadcast at the end of their second series (BBC 2 1970) and culminating in a bereaved man being invited to cook and eat his dead mother. The BBC permitted this sketch only by having it framed self-consciously as 'unacceptable' – the outraged (and overacting) studio audience rush the stage and bring the sketch to an end. On British television, contentious comedy occupies an indeterminate space in between public service broadcasting's licence to be controversial on the one hand while remaining within the shifting boundaries of 'acceptable taste' on the other. In other words, it is institutionally determined. When the Broadcasting Standards Commission upheld 'in part' the complaints against three of the sketches in Chris Morris's *Jam* (Channel 4 2000), it 'acknowledged both the editorial remit of the Channel to provide innovative and challenging material' and judged the series to be 'an innovative satirical series that had a cutting edge, but in the process had inevitably pushed at the boundaries of acceptability' (Broadcasting Standards Commission 2000). The acknowledgement of the *inevitability* of such offence is telling – such an endeavour involved 'risk' and the complex 'balance ... between creative freedom and respect for human dignity and vulnerability' (*Ibid.*). The BSC was at one level speaking the same language as Channel 4's defence that *Jam* had been 'experimental and groundbreaking ... moral in tone and serious in intent', even as it judged that sketches about plumbers and dead babies, tiny coffins for terminated foetuses and the sexual exploitation of the disabled 'had gone beyond acceptable boundaries in their treatment of issues of particular sensitivity which required greater respect for the vulnerability of those depicted' (*Ibid.*). While *Jam* arguably probes 'acceptable boundaries' more than virtually any other series discussed in this book, its late-night time slot and comparative lack of publicity restricted its impact – the complaints recorded by the BSC amounted to a mere twelve. British comedy's biggest scandals – *Life of Brian*, *Brass Eye*, *Jerry Springer: The Opera*, 'Sachsgate' and some of Frankie Boyle's quips – were fuelled by extensive media coverage.

'It had no place on TV': *Brass Eye*

The original series of *Brass Eye* was preceded by the following press release: 'Watch this programme now because it will never be allowed a repeat.' There's more than a touch of swagger here – a *promise* of offence – less sense of the caution with which Channel 4 handled what would become its most controversial comedy series. Originally due to run on Tuesday nights in the six weeks leading up to Christmas 1996, *Brass Eye* was pulled at the last minute and re-scheduled for the start of 1997. Channel 4's nervous boss Michael Grade had been in extensive consulta-tion with the channel's lawyers in preparing a pre-emptive 'fantastic defence' of the series should the Independent Television Commission (ITC) take them to task (Mulholland 1997: 3). According to a Channel 4 spokesperson, the *Daily Mail* announced to Grade even before the series was broadcast that they intended to speak to the ITC 'about what we're going to do about your programme' (*Ibid.*: 4). Three particular controversies would emerge. Firstly, the episode entitled 'Decline' included a spoof musical about the Yorkshire Ripper, *Sutcliffe! The Musical*, which would be one of the casualties of Grade's re-cut.[4] Secondly, Morris would reward the Channel 4 head with a subliminal message flashed on the screen for 0.25 of a second – 'Grade is a cunt' – leading to an official investigation. Thirdly, one of the stylistic hallmarks of the series would be its capacity for tricking celebrities into making ridiculous state-ments about various fictitious causes – an imaginary drug called Cake, an elephant in captivity whose trunk was lodged up her own anus, the effects of 'heavy electricity' which (according to Richard Briers) was 'like being hit by a ton of invisible lead soup'. This would reach its apotheosis in the 2001 Paedophile Special, in which DJ Dr Fox informed us that paedophiles shared the same DNA as crabs ('There's no real evidence for it, but it is scientific fact'), Sebastian Coe held up 'Before' and 'After' photos of a supposedly disguised sex offender that were in fact pictures of the singers Hall and Oates, and comedian Richie Blackmore claimed that computer keyboards could give off vapours to make child users more suggestible to online predators (he sniffed his own by way of illustration). Morris's

'prank interviews' became central to debates about the moral value of his work – was he the modern Jonathan Swift or Jeremy Beadle with satirical pretensions? Christopher Dunkley in the *Financial Times* was one of several critics to describe Morris as 'a modern Swift capable of using television to identify some of the greater idiocies of the age' (2001: 14), while a letter to the *Independent* claimed, 'If Swift were writing today, I am sure a government minister would pop up to call his piece "unspeakably sick". Not, of course, that they would have actually bothered to read it first' (Horton, 2001: 2). The references to Swift located Morris within a respectable and legitimate use of 'offence' to make a satirical point. Swift's savage satirical essay 'A Modest Proposal' (1729) – an eighteenth-century 'dead baby joke', if you will – offers the selling of children as food as a solution to poverty in Ireland. Both Morris and Swift adopt the tone of their respective targets – the mixture of sensation and self-righteousness of popular news and current affairs, or what David Denby calls the 'smug, composed, all-knowing' complacency of the pamphlet writers Swift was targeting (2009: 30). As Lockyer and Attwood suggest, while satire has a greater licence to treat serious subjects as comedy, it has certain self-imposed limitations, too – it doesn't offer analysis as such and certainly doesn't see solutions as part of its remit. Indeed, to expect it to do so would be to misunderstand how it works as comedy. As Andrew Stott puts it, 'Swift offers no counter-argument that can either be correctly identified with the authorial position or be considered socially constructive' (2005: 113). Satire is 'indirect yet aggressive, and potentially divisive' (Denby 2009: 30), which means that it risks being misread, taken literally or seen to 'make light' of its subject. The 'non-constructive' stance of *Brass Eye* led to the 'fatal ambiguity' (Stott 2005: 109) that many discerned in the *Brass Eye Special* dealing with paedophilia, in particular.

Seeing Morris as 'the new Swift' is undoubtedly a minority view, and probably not one to push too far (although historical distance will inevitably have diluted the pleasure that might have been found in the offence produced by 'A Modest Proposal'). For one of Morris's celebrity 'victims', Claire Rayner, *Brass Eye* exploited 'genuinely held feelings and concerns in his victim in

a way that devalues satire' (Rayner 1997: 1). Ben Thompson appears to have some sympathy with this view when he finds celebrities' concern for Karla the elephant 'endearing' and 'touching' (2004: 315), rather than the kind of opportunistic issue-mongering that comes with 'hot' topics like drugs or child abuse. If Thompson detects a 'coldness' in Morris's work that seems to set him apart from the 'desire for change consistent with old-fashioned definitions of satire' (*Ibid.*: 313), a particularly nasty piece in the *Sunday Times* doesn't just accuse Morris of 'dumbing down' satire but actually pathologizes him, his 'disfiguring' birthmark and 'severe acne' identified as 'an abiding source of anger and self-loathing' (Anon. 1997: 3).

The 1997 series of *Brass Eye* has been inevitably overshadowed by its 2001 one-off return as what the *Daily Mail* (amongst others) called 'The Sickest TV Show Ever' (28 July 2001). It was the most complained-about television programme up to that point – the BBC broadcast of *Jerry Springer: The Opera* in 2005 currently holds that distinction. *Jerry Springer* is a slightly different case, which is why I haven't addressed it here. It originated on stage, where it had aroused comparatively little controversy and the campaign against it (including 65,000 complaints and a blasphemy case) was coordinated by a very specific fundamentalist pressure group, Christian Voice. The *Brass Eye Special* (also known under the title *Paedogeddon*) provoked more than 900 complaints to the ITC, almost 250 to the Broadcasting Standards Commission, and 2000 to Channel 4 (Lockyer and Attwood: 2009: 49.) The programme's reception context was exceptionally volatile. In the summer of 2000, the abduction and murder of seven-year-old Sarah Payne would lead to a wave of tabloid hysteria; most notoriously, the *News of the World*'s 'Name and Shame' campaign, which published photos of convicted paedophiles. Child abuse is never less than a contentious subject, but it escalated into a full-scale moral panic with a dash of vigilante action. A campaign demanded that communities be informed of paedophiles living in their area, protestors sought one of the sex offenders 'named and shamed' by the *News of the World*, and in a piece of semantic confusion many found blackly comic a paediatrician was attacked (*Ibid.*: 50–51). This was the context into which Chris

Morris hurled possibly the most incendiary half hour of comedy ever broadcast on terrestrial TV. Lockyer and Attwood characterize the programme's satirical intent as follows:

> *Paedogeddon* questioned the inconsistencies in contemporary dominant ideologies of childhood sexuality. On the one hand there is public outrage surrounding paedophilia, and on the other detachment from the commodification of childhood sexuality evident in children's clothing, advertising, and child beauty contests ...
> *Paedogeddon* also satirized the voyeuristic nature of media coverage of sex and crime. It criticized media hypocrisy where on the one hand the media are vehement in their treatment of paedophiles and paedophile crime, yet on the other hand often provide detailed information of the sex offences committed, and in some cases in 'prurient detail'. (*Ibid.*: 52)

The *Brass Eye Special* does all of these things. It sends up the 'name and shame' campaign by encouraging viewers to help locate a paedophile disguised as a school – 'Do you know him? Have you seen him? Please call.' Media sensationalism is taken to delicious extremes. A lurid reconstruction of the life of fictitious sex offender Jez North begins with the warning 'We believe that his story is actually too upsetting to transmit. We do so tonight only with that proviso' and concludes with an absurd fantasy of the hospitalized North being reconstructed by 'pervert mechanics' as a 'robo-plegic wrongcock'. When he is finally released, North is burned in a wicker phallus by an angry mob. Ideologies of childhood are addressed in two items in particular. Actual footage of teen pageants leads into a 'mockumentary' item on a child with surgically enhanced (pixillated) breasts. More tellingly, Morris invites Michael Hames, former Head of the Obscene Publications Branch, to scrutinize a series of grotesque 'modern art' collages that flirt with 'unacceptable' images of childhood – a large photo of child's head on the tiny body of a naked adult woman, a little boy's head on the body of a generously endowed greyhound, a Barbie-type doll with a dildo emerging from its nappy. The sequence graphically illustrates the arbitrariness of judgements about where boundaries can be drawn – when Morris swaps over two differently proportioned heads from different pictures, one of them becomes

'indecent'. However, *Brass Eye*'s offensiveness is rather more than a by-product of its satirical intent – it is central to the comic pleasures it offers.

In one sequence, the imperative to offend arguably compromises the satire. A fake news item refers to real-life child-killer Sidney Cooke. Over found footage of a space launch, we hear the following narration:

> Even our most drastic measures don't work. Last month, the notorious paedophile Sidney Cooke was blasted into space to spend the rest of his life aboard a one-man prison vessel, posing no further threat to children on earth. But it was revealed that an 8 year old boy was also placed on board by mistake and is now trapped alone in space with the monster. A spokesman said, 'This is the one thing we didn't want to happen'.

As is so often the case with *Brass Eye*, the presentation of the spokesman's words is note perfect – the words pop up on screen in different typefaces in a parody of TV news's graphics-fetishism, Morris adopts the tone of concerned gravity that is routinely deployed in certain types of sensitive news stories. Lucian Randall places the item in a context that is in danger of being forgotten. It was a satire of a specific episode of Channel 4's *Dispatches* (1998) that had used 'horror-movie touches' to sensationalize Cooke's story; 'portentous music, dramatic pauses, gravelly voiceovers and eerie shots of menacing housing estates in reconstructions of his hideouts' (Randall 2010: 236). But if this sharpens the satire it underlines a certain callousness, too. The brutally accurate parody of overheated responses to child abusers is consistent with the rest of the programme – firing paedophiles into space would have been one of the milder fantasy solutions circulating in the tabloid frenzy of 2000–1 – and the self-defeating mistake is pleasingly absurd. But making Cooke the 'notorious paedophile' in question is arguably one of the programme's misjudgements – by connecting an actual convicted child-killer to media and public over-reactions, it could be seen to imply that the entire subject of paedophilia was little more than hyperbole and hysteria. According to *Brass Eye* writer David Quantick, the Cooke item was 'Absolutely unjusti-fiable, but I think it's really funny ... Unjustifiable, because

what that is basically saying is "Isn't it funny that this real man raped children?" So morally, appalling, but worth it because it's a very good gag' (quoted by Randall 2010: 233). Such posturing seems to lend support to the insistence of the programme's many detractors that it 'trivialized' the subject and was insensitive to the suffering of real victims. But Quantick also asserts satiric intent (at least in the programme overall) – 'it satirized media attitudes to paedophilia and the hypocrisy and the way they are making money out of children's pain' (*Ibid.*). Quantick seems here to want to both occupy the moral high ground and position comedy as being above ethical concerns.

The furore that greeted the *Brass Eye Special* can't have surprised anyone, although a headline in the *Independent* asked the pertinent question, 'It was C4's most vetted programme. So how did it attract a record number of complaints?' (Jury 2001a: 3). The transmission had been delayed due to the disappearance of 15-year-old Danielle Jones in June 2001, and was finally shown on 26 July. Again, Channel 4 was very clear about how the programme conformed to its remit 'to ask hard questions about the way society and the media deal with its most difficult problems' (*Ibid.*).[5] They had made similar claims, rather less convincingly, about *Jam* in response to the (comparatively negligible) complaints made the previous year. The dead baby/plumber sketch, it insisted, was 'exposing the failing of the modern world where it was believed that everything could somehow be "made better" or "fixed"' (Broadcasting Standards Commission 2000). One might be forgiven for being unfamiliar with that particular social phenomenon. *Brass Eye* was more clearly satirical, which ostensibly made it easier to mount a defence for – Channel 4 boss Michael Jackson emphasized its 'sense of social purpose' (Ahmed 2001: 1) – but this was a much more public 'scandal' than the buried-in-the-schedule *Jam*. Its topic was as 'hot' as it was possible to be, its offence keenly anticipated, and it would make some powerful (if opportunistic) enemies. Amongst these were Culture Secretary Tessa Jowell, Home Secretary David Blunkett and Beverley Hughes, Minister with Responsibility for Child Protection (who controversially confessed to not having seen it). Scotland Yard's Internet and Obscene Publications Unit

was sent a copy, but did not pursue an investigation. But Jowell would be *Brass Eye*'s key antagonist:

> As a viewer and a parent, I think it is a great shame that a public service broadcaster has chosen to transmit this programme. If this is considered acceptable material then we are tearing down all the boundaries of decency on television. (*Ibid.*)

The Culture Secretary sought to give the ITC greater power to 'react quickly to complaints', but would later reassure TV chiefs that she 'did not want to censor programmes or interfere in scheduling' (Morris 2001: 5). Nevertheless, she continued talks with the ITC over 'the adequacy and speed of the system of complaints so it can best represent the public to broadcasters' (*Ibid.*). Channel 4 had appeared particularly unrepentant when they repeated the programme, even after the ITC reported the complaints to them. Indeed, Channel 4 remained comparatively unrepentant even after being instructed to make an on-air apology by the ITC and BSC – its apology reiterated its 'remit to make challenging programmes' and emphasized that 'the ITC accepted that a satire on public and media attitudes to paedophilia fell within that remit' (quoted by Lockyer and Attwood 2009: 57). Director of Programmes Tim Garden described the judgement as 'unclear and contradictory' (Jury 2001b: 1). The decision ultimately hinged on whether Channel 4 had given viewers adequate warning before the programme.

To get a sense of *Brass Eye*'s impact, it's instructive to look beyond the predictable splutterings of the *Daily Mail*. The press response divided in unexpected ways, without mapping clearly onto a distinction between left and right or tabloid and broadsheet. *The Times*, the *Daily Express*, the *Evening Standard*, the *Daily Star* and the *Independent* all published supportive pieces, although reviews were sometimes at odds with editorial pieces. While the more liberal *Guardian* was critical of government interference, it was consistently hostile to the programme itself. When Ros Coward bemoaned the 'know-it-all liberalism' of *Brass Eye*'s defenders in a piece whose title bluntly insisted that 'It had no place on TV', she was very much in tune with the paper's broader stance (Coward 2001: 15). An opinion piece judged that '*Brass Eye* was a deeply unpleasant piece of television

that degraded children much more than it satirised either the media or celebrities and politicians', concluding that the taboo about taking child abuse lightly 'exists for a good reason' (Anon. 2001: 17).[6] This brings us to the heart of what constitutes a 'suitable subject' for comedy – a very clear boundary has been established here.

Of course, such parameters shift – the 'paedo' joke has become as compulsory a part of the 'edgy' comedian's repertoire as the Irish joke once was to that of the frilly-shirted old-school club comic. Still, *Brass Eye* retains its power by refusing to simply deploy the paedophile as a convenient comic 'other', by probing the taboos and boundaries that it was thought to transgress. In a rare interview, Morris himself articulated a position entirely in accord with the more serious claims made for satirical comedy – 'If you make a joke in an area which is for some reason – normally random – out of bounds, then you might find something out, you might put your finger on something' (Leonard and Born 2001: 4).

For all of the outrage that *Brass Eye* generated, this was offensive comedy that was institutionally sanctioned. It was consistently supported and defended by Channel 4, and while the ITC and BSC instructed the channel to apologize, they were not able to say that it had been 'wrong' to broadcast the programme. Some of the humour discussed in the remainder of this chapter fell outside such approval, identified as failures of editorial judgement or breaches of guidelines. Edgy comedy forces us to take sides and *Brass Eye* fits a romantic, rebellious narrative of the subversive, biting joke that is threatened by the forces of consensus and constraint, the humourless and the enemies of nuance and irony. But comedy doesn't always lend itself to such polarized moral certainties. What happens when edgy comedy is less easy to admire or defend? Can we still make nuanced judgements in a context where *Daily Mail*-orchestrated backlashes are pitted against comedy that sometimes seems more cruel than contentious, aiming at easier targets than *Brass Eye* seemingly did?

'My pussy's so old it's haunted': 'tasteless' comedy after 'Sachsgate'

Jimmy Carr and Frankie Boyle have recently been the two most high-profile 'bad taste' comedians, sharing a high degree of popularity through a mixture of live stand-up and panel show appearances and a certain amount of controversy. In a 2007 edition of *Mock the Week*, during a section on 'what the Queen would never say during her Christmas speech', Boyle had Her Majesty announce that 'my pussy's so old it's haunted'. The full impact of that gag would not be felt until the following year, by which time he had quipped that Olympic swimmer Rebecca Adlington looked like 'someone who's looking at themselves in the back of a spoon'. How, he wondered, had someone with her looks attracted a good-looking boyfriend? She 'must be very dirty', he quipped, noting swimmers' ability in holding their breath. Carr, meanwhile, had already got into trouble for a joke about gypsies' lack of hygiene on a 2006 episode of the Radio 4 show *Loose Ends*. He was at the centre of a bigger storm when he delivered the following joke at a gig in Manchester on 23 October 2009 – 'Say what you like about those servicemen amputees from Iraq and Afghanistan, but we're going to have a fucking good Paralympics team in 2012.' Boyle's jokes were both told on television, and he was officially rebuked by the BBC Trust for the Adlington joke. As BBC trustee Richard Tait put it, 'the committee felt that the comments about Rebecca Adlington were humiliating, and this was exacerbated by the fact that she had not sought celebrity status or courted media attention' (Conlan 2009). Complaints about the 'Queen's haunted pussy' joke were dismissed by the Trust, who nevertheless noted its 'ageist and sexist overtones' (*Ibid.*). These gags might seem like a storm in a spittoon compared to *Brass Eye*, so how did they come to be so controversial?

The single most contentious piece of broadcast comedy since *Brass Eye* was a telephone prank played on an aging sitcom star. Welcome to 'Sachsgate'. On 18 October 2008, on a pre-recorded episode of Radio 2's *Russell Brand*, Brand and Jonathan Ross phoned Andrew Sachs for a pre-arranged conversation. The actor was not at home and Brand and Ross left a

series of answerphone messages that made explicit reference to Brand having had sex with Sachs's granddaughter Georgina Baillie. Ross's cry of 'He fucked your granddaughter!' would be the most ubiquitous soundbite from this episode. By the time of the report from Ofcom's Contents Sanctions Committee on 3 April 2009, Ofcom themselves had already received 1,039 complaints and the BBC 42,851. In a masterpiece of under-statement, the report observed, 'The number of complainants rose significantly after extensive media reporting of the content' (Ofcom 2009: 3). There had reportedly been about two until the *Daily Mail* and other tabloids got hold of the story. The *Daily Mail* hit the heights of torch-wielding disapprobation with a piece entitled 'Lest we forget' (Daily Mail Reporter, 2008a) – 'Sachsgate' appeared to have been upgraded to the status of war crime. It included a transcript of the entire exchange – as Charlie Brooker observed, they even transcribed parts of the phonecalls that had not been broadcast 'so its readers could be enraged by things no one had heard in the first place' (Brooker 2009: 254). Brand resigned, as did Radio 2 controller Lesley Douglas and Radio 2's Head of Compliance , while Ross was suspended without pay for three months. The BBC Trust condemned the 'deplorable intrusion' and directed the BBC to broadcast apologies on Radio 2. Ofcom found the BBC in breach of three broadcasting codes; 'adequate protec-tion for members of the public from the inclusion in such services of harmful and/or offensive material', failure to 'ensure that material which may cause offence is justified by the context' and 'infringement of privacy in programmes' (Ofcom 2009: 1). The BBC was fined a total of £150,000. Much was made of the failure of the BBC's editorial and compliance systems, which had admittedly been extensive. The unpredictable Brand had been identified as a 'high risk', yet the series had been made by an independent company (Vanity Projects) part-owned by Brand – its executive producer worked for Brand, its 'relatively inexperienced' producer was loaned out by the BBC. The programme had been pre-recorded and yet still gone on air with material that seemed guaranteed to generate the outrage that followed.

But while the BBC's perceived lack of accountability fuelled

much of the press agenda, heartless, arrogant comedians
bullying an elderly man was a good story in its own right. Brand
in particular became the *Daily Mail's bête noire*. When he posed
with two children at a film premier, a headline asked 'Who
would want their children to be pictured with Russell Brand?'
(Daily Mail Reporter, 2008b), as though the words prankster
and paedophile had become conjoined in the *Daily Mail*
imaginary. One *Mail* article, in particular, would define the
climate that followed 'Sachsgate'. 'Even as Russell Brand row
raged, BBC "comedians" were insulting the Queen' read the
headline (Koster and Martin 2008). The Queen's paranormal
genitalia were back and this time would truly haunt the BBC;
the *Mock the Week* episode would be repeated in the same week
that 'Sachsgate' blew up. The *Mail* framed this as flagrant
provocation – 'the corporation brazenly aired a highly offensive
remark about the Queen' – and quoted Mediawatch UK's John
Beyer who claimed, 'It compounds what is going on at the
moment' (*Ibid.*). The paper transcribed the entire 'What the
Queen would never say in her Christmas message' round and
announced that it 'had uncovered further examples of bad
language and degrading remarks given airtime by the corpora-
tion' (*Ibid.*).

The *Daily Mail's* role here was double-edged. On the one
hand, it gave these jokes an extra 'edge' – in the case of Russell
Brand, it also gave him a substantial amount of stand-up
material based on news coverage of 'Sachsgate'. In his
Scandalous tour of 2009, he incorporated TV news footage of
the scandal into his act, singing the words 'I am the News!' to
the *News at Ten* theme and addressing his admitted error of
judgement with a characteristically disarming mixture of self-
deprecation and braggadocio. But was the *Mail* simply being
Freud's 'passionless third party' or would it wield more cultural
power? A comment piece in the *Telegraph* set out its agenda
even more explicitly than the *Mail*, with a headline that claimed
'This could spell the end for the comedy of cruelty' (Anon.
2008). The BBC was 'dangerously divided from the majority of
people in this country', it claimed, deploying as evidence a
quote from Andrew Marr to the effect that it was a 'publicly
funded, urban organisation with an abnormally large number of

young people, ethnic minorities and gay people'. This confirmed (in case there was any doubt) that 'Sachsgate' served a more concerted attack from the right on public service broadcasting, but it also brought comedy more generally under scrutiny. The *Telegraph* asked, 'Could this be the week a line is drawn beneath the coarse vulgarity, the comedy of cruelty, the routine use of humiliation to "entertain"? It would be heartening to think so' (*Ibid.*).

'Cruelty', then, became the cohering theme for tasteless comedy – bullying, intimidation and humiliation in comic form. In a piece originally published in the *Guardian*, Charlie Brooker expressed concern that a 'likely outcome' of 'Sachsgate' was 'an increase in BBC jumpiness', a stifling of 'edgy comedy' (Brooker 2009: 256). Other comic writers and performers would join in with fighting the corner for contentious comedy. David Mitchell, criticized himself for a joke about Anne Frank getting a drum kit for her birthday, was perhaps the most eloquent of these:

> I have to believe that I'm not [sick] – that I can tell jokes about subjects which are not themselves a joke; that you can use how giggly audiences get when controversial topics are mentioned without condoning atrocities or belittling sacrifice; that saying something is 'not a fit subject for comedy' is like saying it's not a fit subject for fiction. (Mitchell 2009: 1)

Mitchell was writing after the publication of the BBC's Draft Editorial Guidelines, in particular Section 5 (Harm and offence) in the sub-section on intimidation and humiliation:

> Intimidation, humiliation, intrusion, aggression and derogatory remarks are all aspects of human behaviour that may be discussed or included in BBC output. Some comedy can be cruel but unduly intimidatory, humiliating, intrusive, aggressive or derogatory remarks must not be celebrated for the purposes of entertainment. Care should be taken that such comments and the tone in which they are delivered are proportionate to their target. (BBC Editorial Guidelines: 41)[7]

It is hard to separate the BBC Trust's ruling on the Adlington joke from the post-'Sachsgate' climate, especially given that it reversed an earlier decision by the BBC's editorial complaints

unit that it was not in breach of editorial guidelines. The episode of *Mock the Week* in question had been broadcast in August 2008, two months before the notorious Russell Brand broadcast. It had attracted 75 complaints – a mere sniffle compared to the epidemic of outrage that accompanied 'Sachsgate', but unusual for a programme whose audience expected a certain amount of contentious material. 'They [*Mock the Week*'s audience] don't usually complain. On this occasion quite a lot of people did complain,' observed Richard Tait (Plunkett 2009). Boyle would not be demonized in the same way that Brand was, but this was framed as another 'failure of editorial control'on a pre-recorded show (*Ibid.*).

The Adlington joke provided a test case for what could be considered 'proportionate' to one's comic target. While Adlington was a 'celebrity' of sorts, she had not 'sought' this status in the way that more 'appropriate' targets had. Comedy often invites us to side with the dissonant, the rebellious, the untamed and the unrepentant, but there is some virtue in stepping back from this romantic position. One might have little appetite for the values espoused by the *Daily Mail* and other attempts to recruit a 'silent majority' to eliminate all visible threats to the middle-class right (not just 'bad taste' humour but those 'unrepresentative' people that the *Daily Telegraph* felt had led the BBC astray). But 'Sachsgate', 'Adlingtongate', the Carr incident and Brian Logan's piece on 'The new offenders of stand-up' made comedians and fans of comedy understandably defensive, with the attendant danger of a position where contentious humour must be defended at all costs. The latter position is haunted furthermore by the fear of falling into that category of the 'easily offended'. Before we man the barricades for offensive comedy, it's worth turning to some critical voices that, while they are a considerable political distance from the *Daily Mail*, pose some genuinely awkward questions about comedy.

Is comedy actually our friend? 'Laughter in large groups of people always upsets and disturbs me,' writes Mikita Brottman, 'and I try to avoid being a member of an audience' (2004: xiii). Like the subject of her book, Gershon Legman, Brottman primarily sees fear and aggression in jokes – 'knowing what is

really going on during the joking process makes it almost impossible to enjoy another joke again, unless you are either extremely masochistic or in a process of deep denial' (*Ibid.*: 42). Few with an investment in comedy will want to buy this, but even Carr and Greeves suggest that Brottman's fears might not be unfounded. 'Comedians are not the kind of people you want to put in charge of protecting minority views. As a breed they're inherently with the mob' (2007: 192). The 'mob' is rarely far away in critiques of humour – 'edgy humour' has an easier ride when its audience can be imagined to be civilized, educated, discerning (and let's say it, middle class), which is why Frankie Boyle is on television and Roy 'Chubby' Brown mostly isn't (unless safely framed as the Mayor of Royston Vasey in *The League of Gentlemen*). Michael Billig sees ridicule as the 'social core' of humour, 'dark' not in a subversive way, but through its disciplinary role in ensuring that 'members of society routinely comply with the customs and habits of their social milieu' (2005: 2). In particular, he cautions against equating humour with rebelliousness:

> The position of the joking rebel is a valued one. It is much cele-brated in the entertainment products of the media. These products do not encourage their audiences to become rebels in an absolute sense, for their rebelliousness conforms to the standards of the time. (*Ibid.*: 209)

'Bigots' don't just laugh and make jokes, he argues, 'but they can also position their laughter as rebellious, mocking the seriousness of tolerance and reason' (*Ibid.*: 210). An interview in *Time Out* frames Frankie Boyle as the untamed rebel castigating the BBC for its 'Don't frighten the horses' timidity – 'Who gives a fuck? ... Who are these people? What authority do they have to judge comedy?' (Marshall 2009: 14). Under a picture of Adlington, they even added the caption 'Winalot? Frankie says "she looks like a beagle".' The Adlington joke can be seen to have a disciplinary function in mocking someone who has attracted a partner 'out of their league', as well as conforming to older comic traditions in which unglamorous women are by definition comic. 'Bigot' would be an inappropriate word for Boyle – like a lot of comedians, he challenges some dominant

political positions and reinforces others. But some of his targets have been all too consistent in their 'failure' to conform to dominant notions of femininity – Susan Boyle, Kerry Katona, Jade Goody – while at least two conform to middle-class distaste for the 'chav'. This is not to support censorship of the joke. Rather, I want to unpack some of the assumptions attached to his reputation for 'saying the unsayable'. Boyle's misogyny is part of his 'bad boy' image, a loose cannon who might say anything at any time. When invited to apologise for the Adlington joke, Boyle was sufficiently unrepentant to liken her to a beagle (*Ibid*.: 14). But in analysing the Adlington joke, one should not overlook its technical virtues. The notion of someone looking like they are reflected in a spoon is a pleasing comic image, like one of the comic physiognomies that Bergson speaks of – 'a face is all the more comic, the more nearly it suggests to us the idea of some simple mechanical action in which its personality would forever be absorbed' (1956: 76). With the gag about Adlington being 'very dirty', we have relocated to the rougher end of the playground – interestingly here, the nastier joke is less funny anyway, although we can't always rely on that balance.

The Queen's 'haunted pussy' is another story. This is one of those jokes that kicks 'up' and 'down' simultaneously. As a singularly (over-)privileged member of society, the Queen is 'above' Boyle, and it becomes possible to see those offended by the joke as themselves comical for their reverence towards the outdated royals. But as an older woman, the Queen is also subject to the 'sexism and ageism' that the BBC commented on. Freudians might wish to dwell longer than I propose to on the image of female genitalia rendered both abject and uncanny. Nevertheless, the joke became more subversive than reactionary, in a way that no one could have foreseen. Many felt that it enjoyed its definitive re-telling on *Newsnight* in the RP tones of presenter Emily Maitlis, grilling BBC Director General Mark Thompson on the 'risk' involved in broadcasting the joke. As Thompson formulated his reply, Maitlis repeated the joke even more forcefully, propelling her performance onto YouTube and *Have I Got News for You* amongst other places. It was as though the joke had become a mischievous entity in its own right, even

though that conceit relies on a very romantic notion of 'transgressive' comedy. To enjoy this spectacle was still to participate in sexist schoolboy smut – the posh, but sexy presenter saying 'pussy' to her boss – but it would nevertheless be a defining moment for post-'Sachsgate' comedy.

Carr's Paralympics joke pushes more buttons – disability, British troops – not because he is a more confrontational comic than Boyle but because it was produced in a live context, where there is generally a greater licence to test the boundaries of taste. As Carr observed:

> My audience aren't offended, but this other audience that reads the papers are offended. They're totally entitled to be offended by those kind of jokes, but they're normally not exposed to those kind of jokes. I know what the rules are on TV – what you can and can't say. (Moss 2009)

Nevertheless, sometimes live comedy 'escapes' its context to take on as great an offensive force as a broadcast joke; Billy Connolly's remarks about hostage Ken Bigley would be another example,[8] as would Stewart Lee's routine about *Top Gear* presenter Richard Hammond being decapitated during his famous car crash (in his 2009 show *If You Prefer a Milder Comedian, Please Ask for One*).[9] The *Sunday Express* and *Mail on Sunday* took up the Carr story, and there were statements from the Prime Minister's office, the defence secretary, the former commander of British forces in Afghanistan and the families of wounded soldiers. In contrast with Boyle's belligerence, Carr does not present himself as a rebel; rather, as someone who wants to see what he can get away with while still primarily positioning himself within a discourse of showbiz professionalism, a 'joke technician' as he calls himself – 'I'm just an entertainer, but things have moved on and it can't all be about nice stuff' (*ibid.*). There were critics who were prepared to argue that the Paralympics gag had a point to make, such as Dominic Maxwell in *The Times* who called it 'an absurdist response to a horrific truth' (2009). But Carr made no claims for the joke: 'There is a tendency, when someone is upset, to say, "Well, I was highlighting the tragedy." I wasn't. I was trying to make people laugh' (Moss 2009). Carr and Greeves caution against ironic

'meta-bigotry' (2007: 190), but while they acknowledge that 'most "offensive" jokes are not taboo-busting at all' but rather 'inherently conservative', they ultimately seem to suggest that this is simply the way things are:

> By mocking situations that we would otherwise find uncomfortable, by legitimizing our anxieties about people who are different and hard to relate to, these jokes perpetuate the status quo. They don't make things worse for the people they mock, but nor do they help us to understand them. That's not their job: they are jokes. It isn't the function or purpose of jokes to enlighten. Their use is to amuse. (*Ibid.*: 192)[10]

Carr frames his transgressions very carefully – 'If you think that's offensive, how about this one?' In one live show broadcast on Channel 4, he explicitly identifies a joke about oral sex with a child as the furthest he is prepared to go.[11] There are recurring cues that taboos and limits exist – Carr is testing the boundaries in a spirit of play, but knows that there are limits, acknowledges that there are limits. As William Paul puts it, 'a "too far" would not exist without the boundaries that aim at containment', meaning that 'sick' or 'gross' humour must 'inscribe boundaries to challenge, then set new boundaries' (1994: 420). In another joke, Carr suggests that women who repeatedly put up with domestic violence 'need a slap'. One need not look hard to find a source of offence here. Some might question whether a male comic should be making jokes about women being attacked at all, which is not only a question about 'appropriate' subjects for humour but appropriate tellers of such jokes. Secondly, even if one accepts that any subject can be joked about, there is the issue of whether the joke deals with such a sensitive subject appropriately or 'makes light of it' and invites us to laugh at domestic violence. But there's a bit more going on here than simple misogyny. The joke hinges on the incongruity between Carr's initial concern and his violent solution. And given Carr's callous persona, this also makes it at least partly a joke about masculinity – even when men are concerned for women's wellbeing, their solution is an aggressive one. This doesn't prompt me to recuperate the joke as subversive – it undoubtedly does 'make light of' a serious subject (and

Carr's act includes some fairly unambiguous rape jokes, so context isn't entirely on his side). But the joke balances the tendentious and the incongruous sufficiently for it to be hard to pin down who the butt of the joke is (or even if there is one). As Mary Douglas puts it, the sick joke 'plays with a reversal of the values of social life; the hearer is left uncertain which is the man and which is the machine, who is the good and who is the bad, or where is the legitimate pattern of control' (1975: 97).

The *Guardian* provides a list of Carr's favourite topics:

> disability ... rape, paedophilia, prostitutes, homosexuality, Aids, the physical and sexual abuse of pets, sex of all kinds (but especially anal), penises, breasts, vaginas ... excrement, the awfulness of the Welsh, the even greater awfulness of the Scots, fat women, fat Scots and people (fatness optional) with ginger hair. (Moss 2009)

That's every taboo, isn't it? Not quite – 'when someone in the Margate audience asks him a dubious question about immigration, he avoids making a joke and says he thinks immigration is a good thing' (*Ibid.*). Race is conspicuous by its absence from that list and remains one of the riskier boundaries for a 'politically incorrect' comedian who wants to be seen as edgy without seeming to be simply pandering to prejudice. Carr can joke about rape and domestic violence from within his ironically sardonic persona, but cannot afford to tell an 'ironically racist' joke.

The 'old offensiveness'

> I'm not a racist ... I just hate every cunt. (Roy 'Chubby' Brown, quoted by Jacobson 1997: 36)

Where is the line between the artful or ironic offence of the alternative comedian and the more unacceptable offensiveness of 'old school' stand-ups? Roy 'Chubby' Brown and Jerry Sadowitz – a 'blue' comic and a 'misanthropic anarchist' (Double 1997: 210), respectively – are arguably Britain's two most skilful offensive comedians. There are some striking similarities between them, even down to the mixture of obscenity and old-fashioned music hall (Brown's songs, Sadowitz's

magic). As Andy Medhurst puts it in the definitive account of
'Chubby':

> one of Brown's favourite tropes is the provocation of outrage.
> He and his audiences are engaged in a game of dare – will he
> dare say these outrageous things and will they dare to laugh at
> them? He rampages through taboo areas, unleashing jokes about
> paedophilia, making fun of disabilities, treating famines in Africa
> and earthquakes in India as source material for jibes. When even
> his audience finds the going hard, he rounds on them – 'Just got
> out of church, have you?' – and after especially on-the-edge
> remarks he takes satisfaction in confirming his status as the man
> who will go further than any other – 'Only me that can get away
> with that one'. Very occasionally, he miscalculates and pays the
> price – performing in a town at the centre of a much-publicised
> child abuse investigation, his opening line was 'I'm surprised
> there are so many of you here, I thought you'd all be at home
> fucking the kids', and his reward was to be booed off stage.
> (2007: 190)

This sounds uncannily like Sadowitz, tearing through the
Haiti earthquake and referring to Barack Obama as a 'black
cunt'. Sadowitz once 'paid the price' in Montreal, punched
unconscious after greeting the audience with 'Good evening,
Moose-fuckers!'. The 'game of dare' Medhurst identifies
arguably applies to most 'edgy' comedians, but particularly to
Sadowitz – his foulest tirades are often followed by a mock-
innocent 'Any questions?'. As the 'fucking the kids' episode
attests, Brown is prepared to court danger and take genuine
risks. Why then is Sadowitz regarded as one of comedy's
uncompromising, misunderstood geniuses, a risk-taker, while
Brown is regarded as peddling ignorance to the ignorant?

Both do jokes about race, although only Sadowitz frames
them as taboo. Brown's racist gags are more affirmative,
designed to elicit cheers and support, although Medhurst
contextualizes this ethnic exclusion as 'emblematic of the
declining, abandoned, stranded-by-change, hope-starved white
English North' (*ibid.*: 195). Sadowitz's racism is 'unreliable',
met with shocked laughter or just plain shock. After a stereo-
typical Asian accent, he adds 'He wasn't even Pakistani – I'm
just doing that for sheer fuckin' devilment!'. Intent carries

considerable weight in defences of contentious comedy, but Sadowitz refuses to make his entirely clear. Just how much of this does he actually mean? Sadowitz signals that this is a 'game', but the parameters of his persona remain uncertain – in one gag, he acts out an unpeeling of multiple layers of irony, always with another layer of bigotry and hatred underneath each one, ending with a Nazi salute (from a Jewish comedian, just to keep those signals mixed to the end). There is a danger to Sadowitz absent from the more TV-friendly Boyle,[12] that is either exciting or irresponsible, depending on your point of view (possibly both). While 'Chubby' inhabits a persona founded on the promise of 'going too far', it is not an ironic one that implies that there are more acceptable views that he and his audience can return to after the show. Brown speaks from a clearly defined (if exaggerated) position that offers 'a welcome, a place of refuge, a sense of belonging, a space that is simulta- neously warmly familiar to those whose faces fit and ferociously unforgiving to those whose faces do not' (*ibid.*: 194). Carr and Greeves explicitly warn against such a scenario – 'if you prefer your audience to be restricted to like-minded, able-bodied, similarly coloured individuals who will agree in advance with your personal agenda, then warning lights should be ringing' (2007: 196) – but, unlike Medhurst, they don't factor class into the equation.

The real differences between these two 'offenders' come down to audience and context. Firstly, Brown and Sadowitz are located within traditions possessing different levels of cultural capital. They illustrate perfectly the distinction Medhurst makes between the myth of 'romanticised alienation' (Sadowitz the uncompromising outsider) and the 'mass togetherness' of popular comedy (Brown the panderer to common taste) (2007: 202). Alternative and post-alternative comedy are strongly middle class in their appeal. Defences of Sadowitz usually rest on the contention that he is tweaking his audience's political sensibilities, 'assaulting their values' (Double 1997: 210). To the middle-class observer, Brown's audience is a 'rough' crowd – Jacobson is reminded of 'a game at Millwall' (1997: 136). Sadowitz's audience are a less intimidating prospect (unless you are in Montreal and you are Jerry Sadowitz) – almost as white as

Brown's, but considerably more affluent. At one level, Sadowitz sought the exact opposite of a 'like-minded' audience – his career began in the midst of 1980s alternative comedy, with its ethos of 'right-on gags for right-on punters' (Double 1997: 196). And yet, in other ways, this is an audience potentially more inclined, and possessed of the cultural capital, to discern the artfulness within Sadowitz's offensiveness, to credit him with calculated transgression rather than irresponsible bigotry.[13] Sam Friedman quotes a middle-class comedy fan who cites the 'absence of sophistication' as one of the reasons for wanting to 'glass' someone who likes Roy 'Chubby' Brown (British Sociological Association 2010). Middle-class offence is 'challenging', it seems, while working-class offensive comedy is equated with ignorance.

None of this is to play a game of 'Who's edgier than Who?'. Nor is it to ask (paraphrasing Richard Herring) whether Sadowitz is 'better' than Brown or 'much, much worse'. Carr, Boyle, Brown and Sadowitz each in their way remind us that different incarnations of 'offensive comedy' have their own boundaries and their own way of policing them. A comedian can only misbehave within a very specific context and contract with his or her audience. Still, 'edginess' requires a high degree of cultural capital and social privilege – it involves not only irony, but the cultural mobility to shift confidently between different identities and positions, the ability to know which 'unacceptable' views bestow permissible outlaw status and which are truly beyond the pale.

Better ... or much, much worse?

'Sachsgate', the BBC's draft editorial guidelines and the newsworthiness of 'tasteless' jokes created an impasse for 'edgy' comedy. The middle-class right co-opted instances of allegedly 'cruel' comedy into a larger attack on public service broadcasting, even extending its outrage to live comedy. Symbolically, the *Daily Mail* appropriated Michael McIntyre as all that was decent, inoffensive and middle class in British comedy (Lawson 2009), simultaneously condemning him to be a convenient pariah figure against which edgy comedy could define itself.

Casper Melville identifies a larger 'culture of offence' in the contemporary belief that 'we have the right to complain whenever we encounter something we don't like as long as we can couch it in terms of offence' (2009: 14). In asserting the 'right to offend', Melville is not taking the right-wing libertarian line on 'political correctness', even though he poses some difficult questions about 'identity politics'. The 'right to offend' doesn't absolve us from the need to exercise judgement, to avoid easy targets, to be prepared to offend one's own audience rather than the 'outsider' (*Ibid.*: 82).[14] But while critics of comedy might sometimes be judged pious or 'over-sensitive', offence is sometimes more legitimately 'taken' than others – 'identity politics' have arguably done more good than harm in the field of comedy, which has sometimes been guilty of playing the 'only a joke' card to justify attacks on the less powerful. Comedy that 'kicked down' – at 'unattractive' women, 'chavs' and others – seemed to have found a new acceptability that became difficult to criticize without sounding like the *Daily Mail*. Brian Logan identified the 'new offenders' on the fringes of stand-up comedy, whereas it seems to me that a more problematic 'new offensiveness' was closer to the mainstream.

Frankie Boyle continues to maintain his position in the British press as comedy's pre-eminent 'bad boy'. I'm reluctant to discuss a joke about Down's syndrome in his live show without hearing it in context, but Boyle would be rebuked by the BBC again for a joke on Radio 4's *Political Animal* in which he likened Palestine to a cake 'being punched to pieces by a very angry Jew'. Boyle wrote an impassioned, but characteristically evasive, response in the form of an open letter to the BBC (Boyle 2010) that established the moral and political intent of the joke. What he conspicuously didn't address was the actual sources of offence – one online blogger called it 'a very dangerous joke ... because of one word: Jew' (The Man Who Fell Asleep 2010). This then was an 'offensive' joke with apparent serious moral intent that had stumbled unintentionally into alleged anti-semitism. Boyle's 'untamed' comic persona is central to this problematic gag. In some ways, it's not hard to understand his choice of words – as an unacceptable word (in this context), 'Jew' has a power to shock that the word 'Israeli'

doesn't. The joke tries to balance the principled Boyle of satirical panel shows with the Frankie who 'says the unsayable', but here the taboo-breaker and the truth-teller are in tension. [15] In his open letter, Boyle castigated the BBC for their 'cowardice' and 'editorial procedures ... tightened further to stop jokes with anything to say getting past the censors' (Boyle 2010). He would mock them further in a sketch in his Channel 4 series *Tramadol Nights*, a series that appeared to attract more controversy than actual viewers. Ofcom would uphold a complaint made against Boyle's joke about Katie Price's disabled son – 'I have a theory about the reason Jordan married a cage fighter – she needed a man strong enough to stop Harvey fucking her.'

While Channel 4 awaited Ofcom's verdict, a piece in the *Guardian* featured contrasting takes on 'edgy' comedy from BBC's head of in-house comedy Mark Freeland and Channel 4's head of comedy Shane Allen (Dowell 2011). According to Freeland, the BBC was emerging from post-Sachsgate cautious-ness and was prepared for its comedy to 'say the unsayable', with one important qualifier – 'As long as your processes are right and you've made a judgement call you can back up.' Allen, perhaps understandably, was more belligerent, defending *Tramadol Nights* and accusing the BBC of timidity over Sachsgate. In defence of Boyle, he wondered whether 'class is at the root of it – he is from that working-class Glasgow comedy tradition and so much TV is navel-gazing and made for other people in the industry. He is not allowed to get away with it' (*Ibid.*). Given Channel 4's appetite for affluent young middle-class viewers, this was perhaps rather disingenuous – it is hard to imagine them extending the same supportive environment to someone like Roy 'Chubby' Brown. Boyle, after all, comes with the middle-class aura of satirical panel shows (which is where his abrasive presence worked best).

Other developments suggest that the BBC's cautious edginess might be more in tune with British comedy's current climate than Channel 4's laddish swagger. The immediate post-Sachsgate climate made comedians defensive and reluctant to criticize other comics. But in April 2010, Mark Watson broke ranks on his blog, commenting on Boyle's Down's syndrome

joke. He wondered whether 'in the 21st century, a rich success-ful and physically healthy man should be able to make tons of money by taking the piss out of Down's syndrome and pass it off as entertainment ... Pretty much since I became a comedian, I've wondered whether comedy awards itself too much licence by playing the hey-calm-down-we're-just-joking card, and thus making anyone who objects feel like ... well, a Daily Mail reader' (Watson 2010). Boyle didn't reply until after the furore over *Tramadol Nights*, calling Watson (in the Comments section of his blog) a 'notorious sellout' who sold his 'credibil-ity to sell cider' (Watson had advertised Magners Cider).[16]

With the possible exception of the Harvey Price gag, an exceptionally ugly one by any standards,[17] I'm inclined to question whether any of these jokes merited the amount of media and institutional attention they received – some laddish cruelty no worse than a lot of contemporary comedy, a poor choice of words that made a well-meaning joke sound racist. But in other ways they provided an opportunity to scrutinize the ethics of throwaway jokes that might have flown under the radar in a less volatile context. As Pickering and Lockyer argue, 'PC polemics' tend to close down debates (2009a: 25), but that doesn't exempt comedy from ethical scrutiny (which need not by any means be censorious in nature). Nor is it always enough to plead good intentions, as Boyle repeatedly has. Audiences can't always be expected to know (or even be interested in) the intentions behind a contentious joke, and in the 'ironic' climate comedy now resides in, it's easy enough anyway for comedians to make misleading claims regarding their intentions. The real issue – which doesn't lend itself to a neat formula – is the rela-tionship between a joke and the likely values and beliefs of its core audience. Does it reaffirm them or disturb them in some way? As the comic mind surveys the world, looking for mischief, we must expect it to overstep the mark – in other words, there are equal dangers of overreacting and playing the 'only a joke' card. One of comedy's jobs is to say the 'wrong' thing (but ideally without passing it off as the 'right' thing). Setting down guidelines on such matters as 'derogatory remarks' might seem antithetical to romantic views of the subversive power of comedy. But after the dust settled on Sachsgate, and even

allowing for the bleating of the *Daily Mail*, many seemed to conclude that of all the roles comedy might occupy, school bully wasn't one of the more attractive ones.

Notes

1 In his live show *Ménage à Un*, released on DVD in 2007.

2 Morris, however, rejects satire as 'essentially a conservative form ... As soon as you stand up in front of an audience, you're immediately relying on the consent of more than half the audience which neuters the whole exercise ... I've never really thought of what I do as satire. I think of it as opening my mouth before I can shut it' (quoted by Randall 2010: 194).

3 Logan quoted out of context a remark from Herring's *Hitler Moustache* show that 'racists have a point' (a prelude to an inspired dismantling of the logic of racism by claiming it recognizes fewer racial differences than liberals do). Logan later admitted that he hadn't seen the show at the time of the interview.

4 It was later restored for DVD release.

5 New Channel 4 boss Michael Jackson was more fully behind *Brass Eye*, even in its most troublesome incarnation, than Grade had been.

6 It's worth mentioning, too, that not all the programme's contributors were unanimous in finding the programme justifiable as satire. Graham Linehan had his name taken off the *Special*, feeling it had gone too far – 'There was quite a lot of stuff that was quite harsh and unpleasant. I thought it was like throwing a live grenade' (quoted by Randall 2010: 232).

7 This sub-section would remain almost unchanged in the final version of the BBC's current Editorial Guidelines that came into effect in October 2010 except for the qualifier that it applied to 'real people (as opposed to fictional characters or historic figures)' (BBC Editorial Guidelines 2010).

8 Bigley was a civil engineer held hostage and later executed by a militant Islamic group. While he was still being held hostage, Connolly remarked onstage, 'Don't you wish they would just get on with it?'. Connolly later claimed that the media's sensationalism of the story was the real target of his joke.

9 Hammond was seriously injured when a jet-powered car crashed during filming of an episode of *Top Gear*. Lee's routine uses the incident to satirize the cruel humour of the programme – 'It's a *joke* – like on *Top Gear!*'.

10 More recently, Carr aroused controversy again with a joke about Down's syndrome – 'Why are they called Sunshine Variety coaches

when all the kids on them look the fucking same?'. This time he would offer the most complacent of comedy's defences – 'You can't defend a joke ... because it's just, well, it's a joke' (quoted by Chipping 2011). If the theme of 'bullying' has been prominent in recent critiques of comedy, so has disabilism, as Ricky Gervais found out when he bullishly defended his use of the word 'mong' on Twitter.

11 Jerry Sadowitz has been telling a very similar joke for some time, but with the promise that he still has many more boundaries to cross.

12 As Stewart Lee astutely put it, Boyle is 'the acceptable face of the unacceptable' (2012: 10).

13 When the BBC attempted a vehicle for Sadowitz, *The Pall Bearer's Revue* (BBC 2 1992), its problem was how to 'frame' his offensiveness in the context of broadcast TV, where there might be consequences in the audience not 'getting' him. The result was an uneasy compromise, and Channel 5's Sadowitz vehicles would play down his stand-up act.

14 There has been a particular trend in recent years for comedians to tear into religion (mainly Christianity) in front of an audience of atheists. Admittedly, this is sometimes very funny, but the self-congratulatory applause gives new meaning to the phrase 'preaching to the converted'.

15 Boyle would make better shock use of a racist term (in this case 'paki') in one of his better *Tramadol Nights* routines as a way of making explicit the racism in news reports that prioritize western casualties in foreign news stories.

16 Harsh words from a man who does corporate comedy gigs and wrote a column for the *Sun*. In this instance, Watson's glass house probably had fewer windows to throw stones at.

17 But not quite as ugly as this one, also from *Tramadol Nights*: 'My Grandad's one of those people who can make you laugh just by reading a telephone directory. He's a spastic (giggles).' But if it's a nastier joke, it's also a more technically accomplished one in its pullback/reveal structure.

Conclusion

This book opened with a discussion of the post-alternative era as a 'Golden Age' – whether such a label was appropriate and, if so, when that Golden Age ended. While the first question is partly a matter of taste, an assumption inevitably underpins this book that this was a period of particular richness and significance for British TV comedy. On the other hand, the point of closure was not a question that I ever had any serious intention of answering – I had decided not to have the kind of cut-off point that Ben Thompson provides in *Sunshine on Putty*. While the noughties might not have generated as much fresh talent as the previous decade, distinguished work was still being produced by talent from that generation. However, as it turns out, there are reasons – political, institutional, and, as media delivery platforms mutate, technological – for seeing an era currently coming to an end. British broadcasting is in a period of recession and transition and the early signs are that this is not going to be a congenial environment for innovation or risk-taking. While *Stewart Lee's Comedy Vehicle* was, against expectations, re-commissioned, *Psychoville* seems to have a more uncertain future and panel shows look set to dominate the BBC's comedy output even more than they do already. And yet, again reinforcing the sense of an era ending, one panel show will not be continuing – *Shooting Stars*, Reeves and Mortimer's most successful TV show, was cancelled by BBC 2. However, I would prefer to end on a more positive note. DVD has played an important role in cementing the cult and canonical status of TV comedy series, but labels like 2Entertain (part of the BBC Worldwide's Consumer Products division) play an important

taste-making role in deciding what will be released in the first place. Some cult series seem fated to circulate only on torrent sites or on YouTube. One such example might have been Lee and Herring's *Fist of Fun*, until recently viewable only on fansites such as www.leeandherring.com while the BBC's DVD department announced that 'neither Sales nor Marketing believed that Lee and Herring had much sales potential in the current market' (quoted by Go Faster Stripe press release 2011). Independent comedy DVD label Go Faster Stripe, along with Lee and Herring themselves, would buy the rights to Series 1, released jointly by GFS and 2Entertain at the end of 2011. It is hard to think of any British comedy series that has been packaged more lavishly and lovingly than this series with 'little sales potential' – four discs that included not only the original six episodes but all surviving live studio rushes. While sales were modest by BBC standards and the set was only available via www.gofasterstripe.com it marked a significant intervention in the rediscovery of cult British TV comedy. Even if TV comedy is about to enter a prolonged lull, there is much from the last twenty years that still needs to be revisited – or enjoyed for the first time.

Bibliography

Abbott, S. (ed.) (2010) *The Cult TV Book*, London and New York: IB Tauris.

Ahmed, K. (2001) 'Sex spoof was justified, says TV boss', *Observer* (29 July), pp. 1–2.

Allen, T. (2002) *Attitude: Wanna Make Something Of It? The Secret of Stand-Up Comedy*, Glastonbury: Gothic Image Publications.

Anon. (1997) 'Joker with his brass neck in the noose', *Sunday Times* (23 February), p. 3.

Anon. (2001) '*Brass Eye* was degrading. But the government is wrong to interfere', *Guardian* (31 July), p.17.

Anon. (2008) 'This could spell the end for the comedy of cruelty', *Daily Telegraph* (30 October), www.telegraph.co.uk /comment/telegraph-view/3563133/This-could-spell-the-end-for-the-comedy-of-cruelty.html (accessed 20 November 2009).

Anon. (2011) '*Psychoville*'s Ratings Horror', *Chortle* (27 May), www.chortle.co.uk/news/2011/05/27/13370/psychovilles _ratings_horror (accessed 29 July 2011).

Armstrong, S. (2008) 'Alternative comedy: you've got to laugh', in R. Boycott and M. Etherington-Smith (eds), *25x4: Channel 4 at 25*, London: Cultureshock Media, pp. 71–73.

Barlow, A. (2005) *The DVD Revolution: Movies, Culture and Technology*, Westport, CT and London: Praeger.

BBC Editorial Guidelines (2009) 'Draft BBC Editorial Guidelines for Public Consulation', www.bbc.co.uk/bbctrust /assets/files/pdf/our_work/editorial_guidelines/draft_ed _guidelines.pdf (accessed 5 November 2009).

BBC Editorial Guidelines (2010) 'Section 5: Harm and offence – intimidation and humiliation', www.bbc.co.uk /editorialguidelines/page/guidelines-harm-intimidation/ (accessed 19 January 2012).

BBC Press Office (2009) *Psychoville* Press Pack (21 May), http://www.bbc.co.uk/pressoffice/pressrelease/stories/20 09/05_may/21/psychoville4.shtml (accessed 3 June 2009).

Bennett, J. and Brown, T. (eds) (2008) *Film and Television After DVD*, London and New York: Routledge.

Berger, P.L. (1997) *Redeeming Laughter: The Comic Dimension of Human Experience*, New York and Berlin: Walter De Gruyer.

Bergson, H. (1956) 'Laughter', in W. Sypher (ed.), *Comedy*, New York: Doubleday Anchor Books, pp. 61–190.

Betts, H. (2005) '*Nighty Night* review', *The Times* (7 September), p. 31.

Billen, A. (2000) 'Review of *Jam*', *New Statesman* (8 April), p. 39.

Billig, M. (2005) *Laughter and Ridicule: Towards a Social Critique of Humour*, London, Thousand Oaks and New Delhi: Sage.

Billington, M. (1996) *The Life and Work of Harold Pinter*, London: Faber.

Bolter, J.D. and Grusin, R. (2000) *Remediation: Understanding New Media*, Cambridge, MA and London: MIT Press.

Born, G. (2004) *Uncertain Vision: Birt, Dyke and the Reinvention of the BBC*, London: Secker and Warburg.

Boyle, F. (2010) 'Frankie Boyle letter about BBC in full', the *Daily Telegraph* (1 May), www.telegraph.co.uk/culture /tvandradio/bbc/7660232/Frankie-Boyle-letter-about-BBC-in-full.html (accessed 21 May 2010).

Bracewell, M. (2002), *The Nineties: When Surface Was Depth*, London: Flamingo.

Bradshaw, P. (2004) 'Review: *Shaun of the Dead*', *Guardian* (9 April), p. 15.

British Sociological Association (2010) 'Press Release: Class the key to what British find funny, new research says', www.britsoc.co.uk/NR/rdonlyres/61BA5A80–4FB8–44ED-A466–97E679C2711E/0/Class_the_key_to_what_

British_find_funny_new_research_says_1PR070410.doc (accessed 22 April 2010).

Broadcasting Standards Commission (2000) Upheld Complaint: *Jam*.

Broadcasting Standards Commission (2001) Upheld Complaint: *Brass Eye Special*.

Brooker, C. (2009) *The Hell of it All*, London: Faber.

Brookey, R.A. and Westerhaus, R. (2002) 'Hiding homoeroticism in plain view: the *Fight Club* DVD as digital closet', *Critical Studies in Mass Communication*, 19:1, 21–43.

Brottman, M. (2004) *Funny Peculiar: Gershon Legman and the Psychopathology of Humour*, Hillsdale, NJ: The Analytic Press.

Brown, M. (2000) 'And now on 2 ...', *Guardian* (11 December).

Brown, M. (2007) *A Licence To Be Different*, London: BFI.

Burns, B. (2009) 'There is no New Offenders Movement. We don't have a clubhouse', *Guardian* (31 July), www.guardian.co.uk/stage/2009/jul/31/brendon-burns-standup-comedian-brian-logan (accessed 31 March 2010).

Butcher, D. (2009) 'No laughing matter', *Radio Times* (27 June–3 July), p. 63.

Caldwell, J.T. (1995) *Televisuality: Style, Crisis and Authority in American Television*, New Brunswick, NJ: Rutgers University Press.

Caldwell, J.T. (2008) 'Prefiguring DVD bonus tracks: making-ofs and behind-the-scenes as historic television programming strategies prototypes', in J. Bennett and T. Brown (eds), *Film and Television After DVD*, pp.149–171.

Cardiff, D. (1988) 'Mass middlebrow laughter: the origins of BBC comedy', *Media Culture and Society*, 10:41, 41–60.

Carr, J. and Greeves, L. (2007) *The Naked Jape: Uncovering the Hidden World of Jokes*, London: Penguin.

Caughie, J. (2004) *Television Drama: Realism, Modernism and British Culture*, Oxford and New York: Oxford University Press.

Chambers, D. (2009) 'Comedies of sexual morality and female singlehood', in S. Lockyer and M. Pickering (eds), *Beyond a Joke: The Limits of Humour*, pp. 164–181.

Chipping, T. (2011) 'Jimmy Carr upsets tabloids with Down's

syndrome joke – but that's fine, apparently', *Holy Moly!* (25 November), www.holymoly.com/celebrity/blog/jimmy-carr-upsets-tabloids-downs-syndrome-joke-thats-fine-appare ntly60613 (accessed 25 November 2011).

Conlan, T. (2009) 'Frankie Boyle's "sexist" joke about Queen cleared by BBC Trust', *Guardian* (19 October), www.guardian.co.uk/media/2009/oct/19/frankie-boyle-mock-the-week/print (accessed 18 November 2009).

Cook, W. (1994) *Ha Bloody Ha: Comedians Talking*, London: Fourth Estate.

Coppa, F. (2009) 'The sacred joke: comedy and politics in Pinter's early plays', in P. Raby (ed.), *The Cambridge Companion to Harold Pinter*, Cambridge and New York: Cambridge University Press, pp. 43–55.

Coppa, F. (ed.) (2003) *Joe Orton: A Casebook*, New York and London: Routledge.

Coward, R. (2001) 'It had no place on TV', *Guardian* (31 July), p. 15.

Creeber, G. (ed.) (2001) *The Television Genre Book*, London: BFI.

Daily Mail Reporter (2008a) 'Lest we forget: or what the BBC won't let you hear', *Daily Mail* (30 October), www.dailymail.co.uk/news/article-1081663/Lest-forget-Or-BBC-wont-let-hear.html (accessed 24 November 2009).

Daily Mail Reporter (2008b) 'Who would want their children to be pictured with Russell Brand? Comedian makes his first UK appearance since Sachsgate', *Daily Mail* (12 December), www.dailymail.co.uk/tvshowbiz/article-1093935/Who-want-children-pictured-Russell-Brand-Comedian-makes-UK-appearance-Sachsgate.html (accessed 23 July 2010).

Dalton, M.M. and Linder, L.R. (eds) (2005) *The Sitcom Reader: America Viewed and Skewed*, Albany: State University of New York Press.

Davies, C. (1996) 'Puritanical and politically correct? A critical historical account of changes in the censorship of comedy by the BBC', in G.E.C. Paton, C. Powell and S. Wagg (eds), *The Social Faces of Humour: Practices and Issues*, pp. 29–61.

Davis, M.S. (1993) *What's So Funny? The Comic Conception of Culture and Society*, Chicago and London: University of Chicago Press.

Davis, T. (2008) 'It's comedy ...', *Televisual* (July), pp. 32–36.

Denby, D. (2009) *Snark*, London: Picador.

Dessau, B. (1996) 'Ted good it is, too', *Time Out* (3–10 March), p. 169.

Dessau, B. (1998) 'All aboard!', *Time Out* (4–11 November), p. 14.

Dessau, B. (1999) *Reeves and Mortimer*, London: Orion.

Dixon, S. and Falvey, D. (1999) *The Gift of the Gag: The Explosion of Irish Comedy*, Belfast: Blackstaff Press.

Doherty, T. (2001) 'DVD commentary tracks: listening to the auteurs', *Cineaste*, 26:4, 78–80.

Double, O. (1997) *Stand-Up: On Being a Comedian*, London: Methuen.

Double, O. (2005) *Getting the Joke: The Inner Workings of Stand-Up Comedy*, London: Methuen.

Douglas, M. (1975) *Implicit Meanings: Essays in Anthropology*, London and New York: Routledge.

Douglas, M. (1991) *Purity and Danger: An Analysis of Pollution and Taboo*, London and New York: Routledge.

Dowell, B. (2008) 'The sitcom is dead, long live the sitcom', *Guardian* (18 August), www.guardian.co.uk/mgeitf/sitcom (accessed 12 January 2012).

Dowell, B. (2011) 'Mark Freeland: BBC comedy should not be afraid to offend', *Guardian* (21 February), www.guardian .co.uk/media/2011/feb/21/mark-freeland-bbc-comedy-andrew-sachs (accessed 21 March 2011).

Duggins, A. (2012) 'The sketch show format is on life support. Time for a remedy', *Time Out* (February 23–29), p. 111.

Dundes, A. (1987) *Cracking Jokes: Studies of Sick Humour Cycles and Stereotypes*, Berkeley, CA: Ten Speed Press.

Dunkley, C. (2001) 'A bad case of missing the point', *Financial Times* (1 August), p. 14.

Dyer, R. (1973) *Light Entertainment*, London: BFI.

Dyer, R. (1992) *Only Entertainment*, London: Routledge.

Dyson, J., Gatiss, M., Pemberton, S. and Shearsmith, R. (2000) *A Local Book for Local People*, London: Fourth Estate.

Dyson, J., Gatiss, M., Pemberton, S. and Shearsmith, R. (2003) *The League of Gentlemen: Scripts and That*, London: BBC Books.

Dyson, J., Gatiss, M., Pemberton, S. and Shearsmith, R. (2007) *The League of Gentlemen's Book of Precious Things*, London: Prion Books.

Easthope, A. (1999) *Englishness and National Culture*, London and New York: Routledge.

Eco, U. (1984) 'The frames of comic "freedom"', in T.E. Sebeok, (ed.), *Carnival!*, Berlin, New York and Amsterdam: Mouton, pp. 1–9.

Eco, U. (1987) '*Casablanca*: cult movies and intertextual collage', in *Travels in Hyper-Reality*, London: Picador, pp. 197–268.

Edge, B. (2010) 'Comedy improvisation on television: does it work?', *Comedy Studies*, 1:1, 101–111.

Ellis, J. (2007) 'Is it possible to construct a canon of television programmes? Immanent reading versus textual historicism', in H. Wheatley (ed.), *Re-viewing Television History: Critical Issues in Television Historiography*, London and New York: IB Tauris, pp. 15–26.

Ellis, R.J. (1996) 'The sick disaster joke as carnivalesque postmodern narrative impulse', in G.E.C. Paton, C. Powell and S. Wagg (eds), *The Social Faces of Humour: Practices and Issues*, pp. 219–241.

Feay, S. (1997) 'How we met: Arthur Mathews and Graham Linehan', *Independent on Sunday* (10 August), pp. 50–51.

Finding, D. (2010) '"The only feminist critic in the village?": figuring gender and sexuality in *Little Britain*', in S. Lockyer (ed.), *Reading Little Britain: Comedy Matters on Contemporary Television*, pp. 127–143.

Fiske, J. and Hartley, J. (1978) *Reading Television*, London and New York: Routledge.

Fox, K. (2004) *Watching the English: The Hidden Rules of English Behaviour*, London: Hodder.

Free, M. (2001) 'From the "other" island to the one with "no west side": the Irish in British soap and sitcom', *Irish Studies Review*, 9:2, 215–227.

Freud, S. (1976) *Jokes and Their Relation to the Unconscious*, Harmondsworth: Pelican.

Friedman, S. (2011) 'The cultural currency of a "good" sense of humour: British comedy and new forms of distinction',

British Journal of Sociology, 62:2, 347–370.

Frith, S. and Horne, H. (1987) *Art Into Pop*, London and New York: Methuen.

Gardner, J.E. (2003) 'A normal family: alternative communities in the plays of Joe Orton and Caryl Churchill', in F. Coppa (ed.) *Joe Orton: A Casebook*, pp. 69–81.

Goldstein, J.H. and McGhee, P.E. (eds) (1972) *The Psychology of Humour: Theoretical Perspectives and Empirical Issues*, New York and London: Academic Press.

Goodwin, P. (1998) *Television Under the Tories*, London: BFI.

Graham, A. (2002) 'Comedy, the new drama?', *Radio Times* (5–11 October), p. 69.

Grant, C. (2008) 'Auteur machines? Auteurism and the DVD', in J. Bennett and T. Brown (eds), *Film and Television After DVD*, pp. 101–115.

Gray, F. (2009) 'Privacy, embarrassment and social power: British sitcom', in S. Lockyer and M. Pickering (eds), *Beyond a Joke: The Limits of Humour*, pp. 148–163.

Griffiths, T. (1976) *Comedians*, London: Faber.

Hall, J. (2006) *The Rough Guide to British Cult Comedy*, London and New York: Rough Guides/Penguin.

Hammond, M. and Mazdan, L. (eds) (2005) *The Contemporary Television Series*, Edinburgh: Edinburgh University Press.

Hanks, R. (2000) 'The distorted world of Chris Morris', *Independent Review* (20 April), p. 4.

Hari, J. (2005) 'Why I hate *Little Britain*,' *Independent* (22 November), www.independent.co.uk/opinion /commentators/johann-hari/johann-hari-why-i-hate-little-britain-516388.html (accessed 18 October 2011).

Harman, S. (2011) '*The Mighty Boosh*: femininity, female fan practices and the figure of the "fangirl"', unpublished paper.

Harris, J. (2004) *The Last Party: Britpop, Blair and the Demise of English Rock*, London: Harper Perennial.

Harvey, S. (1994) 'Channel 4 television: from Annan to Grade', in S. Hood (ed.), *Behind the Screens: The Structure of British Television in the Nineties*, London: Lawrence and Wishart, pp. 102–132.

Hemley, M. (2008) 'TV comedy lacks imagination, claims *Father Ted* creator', *Stage* (10 July), p. 5.

Herring, R. (2009) 'There isn't a "New Offensiveness"', *Guardian* (31 July), www.guardian.co.uk/stage/2009 /jul/31/richard-herring-standup-comedian-brian-logan (accessed 31 March 2010).

Hight, C. (2010) *Television Mockumentary: Reflexivity, Satire and a Call to Play*, Manchester: Manchester University Press.

Higson, A. (1996) 'Space, place, spectacle: landscape and townscape in the "kitchen sink" film', in A. Higson (ed.), *Dissolving Views: Rethinking British Cinema*, London and New York: Cassell, pp. 133–156.

Hills, M. (2002) *Fan Cultures*, London and New York: Routledge.

Hills, M. (2007) 'From the box in the corner to the box set on the shelf: "TVIII" and the cultural/textual valorisations of DVD', *New Review of Film and Television Studies*, 5:1, 41–60.

Hills, M. (2010) 'Mainstream cult', in S. Abbott (ed.), *The Cult TV Book*, pp. 67–73.

Hislop, I. (1994) 'Comic asides', *The Spectator* (1 October), p. 47.

Hoggart, P. (2009) 'The league of psychos', *Radio Times* (13 June–19 June), pp. 20–22.

Hollows, J. (2003) 'The masculinity of cult', in M. Jancovich *et al.* (eds), *Defining Cult Movies: The Cultural Politics of Oppositional Taste*, pp. 35–53.

Horner, A. and Zlosnik, S. (2001) 'Comic Gothic', in D. Punter (ed.), *A Companion to The Gothic*, Malden, Oxford and Carlton, Victoria: Blackwell.

Horton, J. (2001) 'Letter to *The Independent*' (31 July), p. 2.

Hughes, G. (1998) *Swearing: A Social History of Foul Language and Profanity in English*, London: Penguin.

Hunt, L. (1998) *British Low Culture: From Safari Suits to Sexploitation*, London and New York: Routledge.

Hunt, L. (2008) *BFI TV Classics: The League of Gentlemen*, London: BFI.

Hutchings, P. (2004) 'Uncanny landscapes in British film and television', *Visual Culture in Great Britain*, 5:2, 27–40.

Hutchings, P. (2007) 'Welcome to Royston Vasey: grotesque bodies and the horror of comedy in *The League of Gentlemen*',

Intensities 4, intensities.org/Essays/Hutchings.pdf (accessed 15 May 2008).

Huxley, D. (1998) '*Viz*: gender, class and taboo', in S. Wagg (ed.), *Because I Tell a Joke or Two: Comedy, Politics and Social Difference*, pp. 272–290.

Jackson, K. (1990) 'Surreal thing', *Independent* (26 May), p. 32.

Jacobson, H. (1997) *Seriously Funny: From the Ridiculous to the Sublime*, London, New York, Toronto and Auckland: Viking.

Jancovich, M. (2001) 'Naked ambitions: pornography, taste and the problem of the middlebrow', *Scope*, 20, www.scope.nottingham.ac.uk/article.php?issue=jun2001&id =274§ion=article (accessed 16 August 2011).

Jancovich, M. and Hunt, N. (2004) 'The mainstream, distinction and cult TV', in S.G. Jones and R. Pearson (eds), *Cult Television*, pp. 27–43.

Jancovich, M. and Lyons, J. (eds) (2003) *Quality Popular Television*, London: BFI.

Jancovich, M., Lazaro Reboll, A., Stringer, J. and Willis, A. (eds) (2003) *Defining Cult Movies: The Cultural Politics of Oppositional Taste*, Manchester: Manchester University Press.

Jeffries, S. (2004) 'I am drawn to extremes', *Guardian* (17 December), p. 45.

Jenkins, D. (2011), 'This one goes up to 100', *Time Out* (15–21 September), p. 80.

Jenkins, H. (2006) *Convergence Culture: Where Old and New Media Collide*, New York and London: New York University Press.

Jivani, A. (1998) 'Tears of laughter', *Time Out* (11–18 March), p. 179.

Johnson, C. (2005) *Telefantasy*, London: BFI.

Jones, L., (1991) 'In-jokes and idiocy', *Daily Telegraph* (28 March), p. 20.

Jones, O. (2011) *Chavs: The Demonization of the Working Class*, London: Verso.

Jones, S.G. (2000) 'Starring Lucy Lawless?', *Continuum: Journal of Media and Cultural Studies*, 14:1, 9–22.

Jones, S.G. and Pearson, R. (eds) (2004) *Cult Television*, Minneapolis: University of Minnesota Press.

Jury, L. (2001a) 'It was C4's most vetted programme. So how did it attract a record number of complaints?', *Independent* (30 July), p. 3.

Jury, L. (2001b) 'Channel 4 told to apologise for *Brass Eye*', *Independent* (7 September), p. 1.

Kaveney, R. (2005) *From Alien to The Matrix: Reading Science Fiction Film*, London: I.B. Tauris.

Kavka, M. (2005) 'Love 'n the real; or how I learned to love reality TV', in G. King (ed.), *The Spectacle of the Real: From Hollywood to Reality TV and Beyond*, Bristol and Portland, OR: Intellect Press, pp. 93–103.

Kavka, M. (2008) *Reality Television, Affect and Intimacy: Reality Matters*, Houndmills and New York: Palgrave Macmillan.

Kelly, D. (1990) 'Shake'n'Vic puts the freshness back'/'How to watch *Vic Reeves Big Night Out*: a cut out and keep guide', *New Musical Express* (26 May), pp. 14–15.

King, G. (2002) *Film Comedy*, London: Wallflower.

Klinger, B. (2006) *Beyond the Multiplex: Cinema, New Technologies and the Home*, Berkeley, Los Angeles and London: University of California Press.

Kompare, D. (2005) *Rerun Nation: How Repeats Invented American Television*, New York and London: Routledge.

Koster, O. and Martin, A. (2008) 'Even as Russell Brand row raged, BBC "comedians" were insulting the Queen', *Mail Online* (31 October), www.dailymail.co.uk/news/article-1081966/Even-Russell-Brand-row-raged-BBC-comedians-insulting-Queen.html (accessed 19 November 2009).

Lahr, J. (1976) 'Introduction', *Orton: The Complete Plays*, London: Eyre Methuen, pp. 7–28.

Landy, M. (2005) *Monty Python's Flying Circus*, Detroit: Wayne University Press.

Langford, B. (2005) '"Our usual impasse": the episodic situation comedy revisited', in J. Bignell and S. Lacey (eds), *Popular Television Drama: Critical Perspectives*, Manchester: Manchester University Press, pp. 15–33.

Lappin, T. (1998) 'High priests of comedy', *Scotland on Sunday* (1 March), pp. 16–17.

Lavery, D. (2008) '*Curb Your Enthusiasm*', in G.R. Edgerton and J.P. Jones (eds), *The Essential HBO Reader*, Kentucky: University of Kentucky Press, pp. 204–213.

Lawson, D. (2009) 'Heard the one about the comic who dares to be middle class and not coarse or cruel?', *Daily Mail* (18 November), www.dailymail.co.uk/tvshowbiz/article-1228782/Heard-the-comic-dares-middle-class-coarse-cruel.html (accessed 14 April 2010).

Lawson, D.S. (2003) 'The creation of comedy in Joe Orton's *Entertaining Mr Sloane*', in F. Coppa (ed.), *Joe Orton: A Casebook*, pp. 15–19.

Lawson, M. (2008) 'TV matters', *Guardian* (17 January), p. 35.

Lee, S. (2010) *How I Escaped My Certain Fate: The Life and Deaths of a Stand-Up Comedian*, London: Faber.

Lee, S. (2012) *The 'If You Prefer a Milder Comedian, Please Ask for One' EP*, London: Faber.

Leggott, J. (2010) '"There's only one way to find out!" *Harry Hill's TV Burp* and the rescue of invisible television', *Critical Studies in Television*, 5:1, 17–31.

Leith, W. (1999) 'Life support', *Observer Magazine* (2 May), p. 70.

Leonard, T. and Born, M. (2001) 'Needlessly shocking or a satirist in the tradition of Hogarth?', *Daily Telegraph* (31 July), p. 4.

Lewis-Smith, V. (1994) 'Smut with a touch of genius', *Evening Standard* (28 October), p. 51.

Lewisohn, M. (2003) *Radio Times Guide to TV Comedy*, London: BBC Worldwide.

Limon, J. (2000) *Stand-Up Comedy in Theory, or, Abjection in America*, Durham, NC: Duke University Press.

Linehan, G. (2007) 'A sitcom just isn't a sitcom without audience laughter', *Guardian G2* (19 November), p. 2.

Littlewood, J. and Pickering, M. (1998) 'Heard the one about the white middle-class heterosexual father-in-law? Gender, ethnicity and political correctness in comedy', in S. Wagg (ed.), *Because I Tell a Joke or Two: Comedy, Politics and Social Difference*, pp. 291–312.

Lockyer, S. (2010a) 'Chavs and chav-nots: social class in *Little*

Britain', in S. Lockyer (ed.), *Reading Little Britain: Comedy Matters on Contemporary Television*, pp. 95–109.

Lockyer, S. (ed.) (2010b) *Reading Little Britain: Comedy Matters on Contemporary Television*, London and New York: IB Tauris.

Lockyer, S. and Attwood, F. (2009) '"The sickest television show ever": *Paedogeddon* and the British press', *Popular Communication*, 7, 49–60.

Lockyer, S. and Pickering, M. (eds) (2009) *Beyond a Joke: The Limits of Humour*, Houndmills and New York: Palgrave Macmillan.

Logan, B. (2009a) 'The new offenders of stand-up comedy', *Guardian* (27 July), www.guardian.co.uk/stage/2009/jul/27/comedy-standup-new-offenders (accessed 31 March 2010).

Logan, B. (2009b) 'Reporting on comedy's new offenders wasn't meant to offend', *Guardian* (31 July), www.guardian.co.uk/stage/2009/jul/31/richard-herring-brendon-burns-comedy (accessed 31 March 2010).

Logan, B. (2010) 'The rise of the rape joke', *Guardian* (10 September), www.guardian.co.uk/lifeandstyle/2010/sep/10/rape-jokes-in-comedy (accessed 10 September 2010).

Lovell, T. (1996) 'Landscapes and stories in 1960s British realism', in A. Higson (ed.), *Dissolving Views: Rethinking British Cinema*, London and New York: Cassell, pp. 157–177.

Lury, K. (2005) *Interpreting Television*, London: Hodder Arnold.

Lusted, D. (1998) 'The popular culture debate and light entertainment on television', in C. Geraghty and D. Lusted (eds), *The Television Studies Book*, London and New York: Arnold, pp. 175–190.

Maconie, S. (2008) *Pies and Prejudice: In Search of the North*, London: Ebury Press.

Malik, S. (2010) 'How *Little Britain* does "race"', in S. Lockyer (ed.), *Reading Little Britain: Comedy Matters on Contemporary Television*, pp. 75–94.

The Man Who Fell Asleep (2010), 'Frankie Boyle is a prick', http://themanwhofellasleep.wordpress.com/2010/05/02/fra/, (accessed 14 July 2010).

Marshall, E. (2009) 'You want me to apologise? F*** you!' (interview with Frankie Boyle), *Time Out* (29 October–4 November), pp. 14–16.

Martin, A. (1997) 'Every inch the young comedian', *Daily Telegraph* (31 October), p. 19.

Mather, N. (2006) *Tears of Laughter: Comedy-Drama in 1990s British Cinema*, Manchester: Manchester University Press.

Matthews, N. (2000) *Comic Politics: Gender in Hollywood Comedy After the New Right*, Manchester: Manchester University Press.

Maxwell, D. (2009) 'Frankie Boyle, Rebecca Adlington and the limits of taste in comedy', *The Times* (3 November), http://entertainment.timesonline.co.uk/tol/arts_and_entertainment/stage/comedy/article6899806.ece (accessed 18 November 2009).

McCabe, J. and Akass, K. (eds) (2007) *Quality TV: Contemporary American Television and Beyond*, London and New York: I.B. Tauris.

McCann, G. (1998) *Morecambe and Wise*, London: Fourth Estate.

McDonald, P. (2007) *Video and DVD Industries*, London: BFI.

McKechnie, K. (2007) *Alan Bennett*, Manchester: Manchester University Press.

McLean, G. (2004) 'The witches', *Guardian* (19 April), p. 16.

Medhurst, A. (2007) *A National Joke: Popular Comedy and English Cultural Identity*, London and New York: Routledge.

Mellor, G.J. (1972) *The Northern Music Hall*, Newcastle Upon Tyne: Frank Graham.

Melville, C. (2009) *Taking Offence*, London, New York and Calcutta: Seagull Books.

Mills, B. (2004a) 'Comedy vérité: contemporary sitcom form', *Screen*, 45:1, 61–78.

Mills, B. (2004b) '*Brass Eye*', in G. Creeber (ed.), *Fifty Key Television Programmes*, London: Arnold, pp. 26–30.

Mills, B. (2005) *Television Sitcom*, London: BFI.

Mills, B. (2007) '"Yes, it's war!" Chris Morris and comedy's representational strategies', in L. Mulvey and J. Sexton (eds), *Experimental British Television*, Manchester and NewYork: Manchester University Press, pp. 180–194.

Mills, B. (2008) '"Paranoia, paranoia, everybody's coming to get me": *Peep Show*, sitcom and the surveillance society', *Screen*, 49:1, 51–64.

Mills, B. (2009) *The Sitcom*, Edinburgh: Edinburgh University Press.

Mintz, L.E. (1985) 'Standup comedy as social and cultural mediation', *American Quarterly*, 37:1, 71–80.

Mitchell, D. (2009) 'No more edgy humour? You must be joking', *Guardian* (8 November), www/guardian.co.uk /commentisfree/2009/nov/08/david-mitchell-comedy/print (accessed 8 November 2009).

Monk, C. (2007) 'London and contemporary Britain in *Monkey Dust*', *Journal of British Cinema and Television*, 4:2, 337–360.

Montgomerie, M. (2010), 'Mischief and monstrosity: *Little Britain* and disability', in S. Lockyer (ed.), *Reading Little Britain: Comedy Matters on Contemporary Television*, pp. 111–125.

Morley, P. (1990) 'Greatest British double act', *New Statesman* (6 July), p. 34.

Morreall, J. (ed.) (1987) *The Philosophy of Laughter and Humour*, Albany: State University of New York Press.

Morris, N. (2001) '*Brass Eye*: ministers say no plan to interfere', *Independent* (31 July), p. 5.

Moss, S. (2009) 'Jimmy Carr: "I thought my paralympics joke was totally acceptable"', *Guardian* (5 November), www.guardian.co.uk.culture/2009.nov/05/jimmy-carr-paralympics-joke/print (accessed November 5 2009).

Mowatt, I. (2010) 'Analysing *Little Britain* as a sketch show', in S. Lockyer (ed.), *Reading Little Britain: Comedy Matters on Contemporary Television*, pp. 19–33.

Mulholland, J. (1997) 'Mock horror', *Guardian* (10 March), pp. 3–4.

Musson, A. (2007) 'Graham Linehan: a delightful interview', *Mustard*, 01, 16–23.

Musson, A. (2011) 'The Mustard interview: John Lloyd', *Mustard*, 06, 16–25.

Neale, S. (2001) 'Sketch comedy', in G. Creeber (ed.), *The Television Genre Book*, pp. 62–65.

Neale, S. and Krutnik, F. (1990) *Popular Film and Television Comedy*, London and New York: Routledge.

Norman, M. (1994) 'Hurry on back to Harry', *Evening Standard* (29 September), p. 45.

Nuttall, J. and Carmichael, R. (1977) *Common Factors/Vulgar Factions*, London, Henley and Boston: Routledge and Kegan Paul.

Oddey, A. (ed.) (1999) *Performing Women: Stand-Ups, Strumpets and Itinerants*, Houndmills and London: Macmillan Press.

Ofcom (2009), Ofcom Contents Sanctions Committee (3 April), www.ofcom.org.uk/tv/obb/ocsc_adjud/BBCRadio2TheRussell BrandShow.pdf (accessed 21 October 2009).

O'Hagan, S. (2009) 'Interview: Stewart Lee', *Observer* (6 December), www.guardian.co.uk/culture/2009/dec/06 /stewart-lee-comedy-interview/print (accessed 7 December 2009).

Oring, E. (2003) *Engaging Humour*, Urbana and Chicago: University of Illinois Press.

Page, E. (2008) *Horribly Awkward: The New Funny Bone*, London and New York: Marion Boyars.

Orton, J. (1976) *The Complete Plays*, London: Eyre Methuen.

Palmer, J. (1987) *The Logic of the Absurd*, London: BFI.

Palmer, J. (1994) *Taking Humour Seriously*, London: Routledge.

Palmer, J. (1996) 'Permission to joke: some implications of a well-known principle', *Semiotica*, 110:1/2, 23–36.

Parker, D. and Parker, M. (2005) 'DVDs and the director's intentions', in T.E. Wartenberg and A. Curran (eds) (2005), *The Philosophy of Film: Introductory Text and Readings*, London: Blackwell, pp. 123–131.

Paton, G.E.C., Powell, C. and Wagg, S. (eds) (1996) *The Social Faces of Humour: Practices and Issues*, Aldershot: Arena.

Paul, W. (1994) *Laughing Screaming: Modern Hollywood Horror and Comedy*, New York: Columbia University Press.

Pearson, R. (2010) 'Observations on cult television', in S. Abbott (ed.), *The Cult TV Book*, pp. 7–17.

Perryman, N. (2008) '*Doctor Who* and the convergence of media: a case study in "transmedia storytelling"', *Convergence*, 14:1, 21–39.

Pettie, A. (2007) 'Interview with Graham Linehan', *Telegraph* (19 August), p. 51.

Pettitt, L. (2000) *Screening Ireland: Film and Television Representation*, Manchester: Manchester University Press.

Pickering, M. and Lockyer, S. (2009a), 'Introduction: the ethics and aesthetics of humour and comedy', in S. Lockyer and M. Pickering (eds), *Beyond a Joke: The Limits of Humour*, pp. 1–26.

Pickering, M. and Lockyer, S. (2009b) 'The ambiguities of comic impersonation', in S. Lockyer and M. Pickering (eds), *Beyond a Joke: The Limits of Humour*, pp. 182–199.

Plunkett, J. (2009) '"Failure of editorial control" blamed for Frankie Boyle's Rebecca Adlington joke', *Guardian* (5 November), www.guardian.co.uk/media/2009/nov/05/frankie-boyle-rebecca-adlington-joke/print (accessed 24 September 2009).

Porter, L. (1998) 'Tarts, tampons and tyrants: women and representation in British comedy', in S. Wagg (ed.), *Because I Tell a Joke or Two: Comedy, Politics and Social Difference*, pp. 65–93.

Powell, C. and Paton, G.C. (eds) (1988) *Humour in Society: Resistance and Control*, Houndmills, Basingstoke and London: Macmillan.

Putterman, B. (1995) *On Television and Comedy: Essays on Style, Theme, Performer and Writer*, Jefferson, NC, and London: McFarland.

Rampton, J. (1998) '*Big Train*', *Independent* (2 November), p. 10.

Rampton, J. (2000) '*Black Books*: interview with Dylan Moran and Graham Linehan', *Guardian* (7 September), p. 4.

Randall, L. (2010) *Disgusting Bliss: The Brass Eye of Chris Morris*, London, New York, Sydney and Toronto: Simon and Schuster.

Raphael, A. (2006) 'Comedy is a safe place to go', *Daily Telegraph* (15 April), pp. 8–9.

Rayner, C. (1997) 'Brassed off: Chris Morris conned me. And I'm not laughing', *Observer* (9 February), p. 1.

Read, J. (2003) 'The cult of masculinity: from fan-boys to academic bad-boys', in Jancovich *et al.* (eds), *Defining Cult*

Movies: The Cultural Politics of Oppositional Taste, pp. 54–70.

Reeves, V. (2006) *Me: Moir Volume One*, London: Virgin.

Reynolds, S. (2011) *Retromania: Pop Culture's Addiction To Its Own Past*, London: Faber.

Richards, D. (2010) 'Cult TV and new media', in S. Abbott (ed.), *The Cult TV Book*, pp. 179–188.

Richardson, D. (2003) 'Special stuff and precious things', *Ultimate DVD*, 49 (November), pp. 26–30.

Rixon, P. (2003) 'The changing face of American television programmes on British screens', in M. Jancovich and J. Lyons (eds), *Quality Popular Television*, pp. 48–61.

Ross, A. (1998) *The Language of Humour*, London and New York: Routledge.

Rowe, K. (1995) *The Unruly Woman: Gender and the Genres of Laughter*, Austin: University of Texas Press.

Sabin, R. (1993) *Adult Comics: An Introduction*, London and New York: Routledge.

Sangster, J. and Condon, P. (2005) *TV Heaven*, London: Collins.

Seyler, A. (1990) *The Craft of Comedy*, London: Nick Hern Books.

Shade, R. (2010) 'Take my mother-in-law: "old bags", comedy and the sociocultural construction of the older woman', *Comedy Studies*, 1:1, 71–83.

Shepherd, S. (2003) 'A coloured girl reading proust', in F. Coppa (ed.), *Joe Orton: A Casebook*, pp. 41–53.

Shields, R. (1991) *Places on the Margin: Alternative Geographies of Modernity*, London and New York: Routledge.

Smith, J. (2005) 'The frenzy of the audible: pleasure, authenticity and recorded laughter', *Television and New Media*, 6:1, 23–47.

Stallybrass, P. and White, A. (1986) *The Politics and Poetics of Transgression*, London: Methuen.

Staunton, T. (1996) 'Give 'em enough pope', *New Musical Express* (9 March), p. 26.

Steig, M. (1970) 'Defining the grotesque: an attempt at synthesis', *Journal of Aesthetics and Art Criticism*, 29, 253–260.

Stevens, D. (2005) 'Excruci-fiction: HBO's Sunday night

cringe-comedy lineup', *Slate* (12 September), www.slate.com /id/2126840 (accessed 1 September 2010).

Stott, A. (2005) *Comedy*, New York and London: Routledge.

Styan, J.L. (1968) *The Dark Comedy: The Development of Modern Comic-Tragedy*, London and New York: Cambridge University Press.

Sweet, M. (2005) *Shepperton Babylon: The Lost Worlds of British Cinema*, London: Faber.

Tate, G. (2009) 'The odd couple', *Time Out* (18–25 June), p. 144.

Taylor, S. (1998) 'Life after Ted', *Observer Review* (8 November), p. 18.

Thompson, B. (1995) 'In the name of the Father', *Independent on Sunday* (23 April), p. 2.

Thompson, B. (2004) *Sunshine on Putty: The Golden Age of British Comedy from Vic Reeves to The Office*, London: Harper Perennial.

Thompson, J.O. (1982) *Monty Python: Complete and Utter Theory of the Grotesque*, London: BFI.

Thornton, S. (1995) *Club Cultures: Music, Media and Subcultural Capital*, Cambridge: Polity Press.

Tusepak, J. (2008) 'Amazon customer review: *Little Britain* series 1–3 DVD box set', www.amazon.co.uk/product-reviews/B000IJ7GWI/ref=cm_cr_pr_hist_1?ie=UTF8&showViewpoints=0&filterBy=addOneStar (accessed 11 August 2011).

Viner, B. (1995) 'Doubled up laughing', *Mail on Sunday* (7 May), p. 5.

Voigts-Virchow, E. (2005) 'History: the sitcom, England: the theme park – *Blackadder*'s retrovisions as historiographic meta-TV', in G. Allrath and M. Gymnich (eds), *Narrative Strategies in Television Series*, Houndmills and New York: Palgrave, pp. 211–228.

Wagg, S. (1996) 'Everything else is propaganda: the politics of alternative comedy', in G. Paton *et al.* (eds), *The Social Faces of Humour: Practices and Issues*, pp. 321–347.

Wagg, S. (ed.) (1998) *Because I Tell a Joke or Two: Comedy, Politics and Social Difference*, London and New York: Routledge.

Wales, K. (2006) *Northern English: A Social and Cultural History*, Cambridge: Cambridge University Press.

Walters, B. (2005) *BFI TV Classics: The Office*, London: BFI.

Walters, J. (2008) 'Repeat viewings: television analysis in the DVD age', in J. Bennett and T. Brown (eds), *Film and Television After DVD*, pp. 63–80.

Walz, R. (2000) *Pulp Surrealism: Insolent Popular Culture in Early Twentieth Century Paris*, Berkely and Los Angeles: University of California Press.

Wardle, I. (1965) 'Comedy of menace', in C. Marowitz, T. Milne, and O. Hale (eds) *New Theatre Voices of the Fifties and Sixties: Selections from Encore Magazine 1956–1963*, London: Eyre Methuen, pp. 86–91.

Watson, M. (2010) 'Blog: a light-hearted look at Down's syndrome' (11 April), www.markwatsonthecomedian.com/web/2010/04/11/a-light-hearted-look-at-downs-syndrome/ (accessed 19 July 2010).

Wheatley, H. (2006) *Gothic Television*, Manchester and New York: Manchester University Press.

White, A. (1993) *Carnival, Hysteria and Writing: Collected Essays and Autobiography*, Oxford: Clarendon Press.

Widdicombe, J. (2007) 'Laughing in the face of fashion', *Such Small Portions: A Comedy Digest*, www.suchsmallportions.com/pagesfinal/features/grahamlinehan.htm (accessed 16 May 2008).

Williams, L. (1981) *Figures of Desire: A Theory and Analysis of Surrealist Film*, Berkely, Los Angeles and Oxford: University of California Press.

Williams, L. (1995) 'Film bodies: gender, genre and excess', in B.K. Grant (ed.), *Film Genre Reader II*, Austin: University of Texas Press, pp. 140–157.

Williams, S. (1997) 'Keeping it surreal', *New Musical Express* (14 May), p. 29.

Wilmut, R. (1980) *From Fringe to Flying Circus: Celebrating a Unique Generation of Comedy 1960–1980*, London: Methuen.

Wilmut, R. (1985) *Kindly Leave the Stage: The Story of Variety 1919–1960*, London: Methuen.

Wilmut, R. and Rosengard, P. (1989) *Didn't You Kill My*

Mother-in-Law? The Story of Alternative Comedy in Britain From the Comedy Store to Saturday Live, London: Methuen.

Wollaston, S. (2004) '*Nighty Night* (review)', *Guardian* (23 March), p. 22.

Yentob, A. (2006) 'Inside story: the rebirth of the sitcom', *Independent* (30 January), www.independent.co.uk/news /media/inside-story-the-rebirth-of-the-sitcom-525090.html (accessed 29 September 2011).

Index

Note: 'n.' after a page reference indicates the number of a note on that page.